MOVED TO TEARS

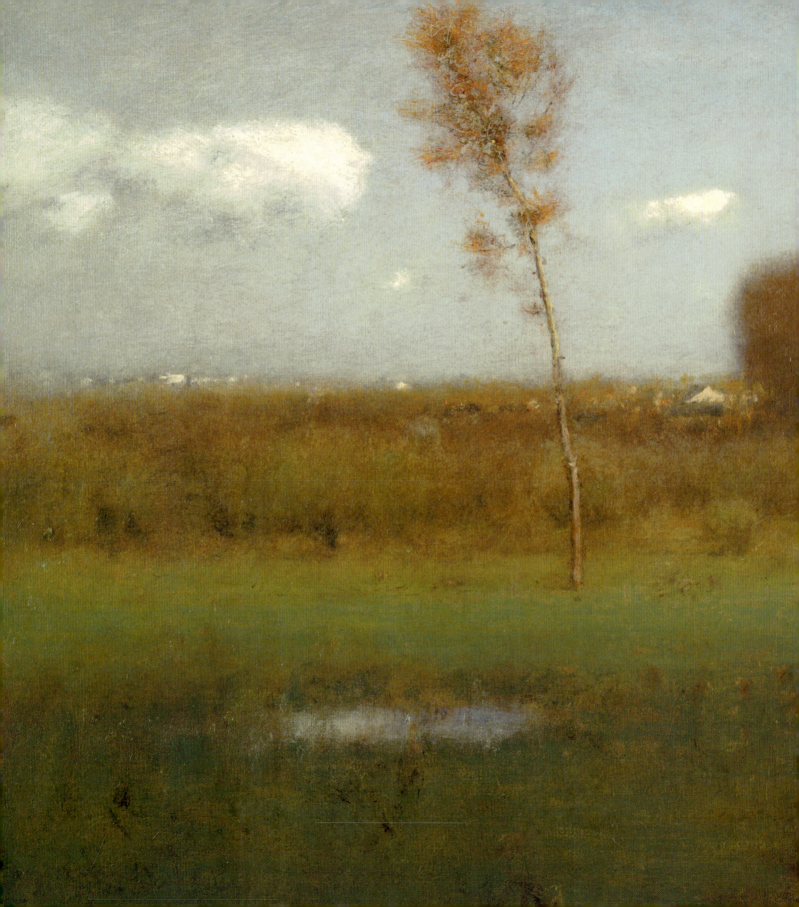

MOVED TO TEARS

Rethinking the Art of the Sentimental in the United States

REBECCA BEDELL

PRINCETON UNIVERSITY PRESS
PRINCETON AND OXFORD

Copyright © 2018
by Princeton University Press

Published by
Princeton University Press
41 William Street
Princeton, New Jersey 08540

In the United Kingdom:
Princeton University Press
6 Oxford Street, Woodstock
Oxfordshire OX20 1TR
press.princeton.edu

Jacket illustrations:
(front) George Inness, *Home at Montclair*
(detail), 1892. Oil on canvas, 30⅛ × 45 in.
(76.5 × 114.3 cm). Sterling and Francine
Clark Art Institute, Williamstown.
© Sterling and Francine Clark Art Institute,
Williamstown, Massachusetts
(photo by Michael Agee).

(back) Frank Lloyd Wright, Fallingwater,
designed 1934–35, constructed 1936–37.
Bear Run, PA.

Illustrations in front matter:
p. i, detail of fig. 43; pp. ii–iii, detail of fig. 53;
p. vi, detail of fig. 86; p. viii, detail of fig. 52

Illustrations in chapter openers:
p. xii, detail of fig. 2; p. 12, detail of fig. 14; p. 38,
detail of fig. 30; p. 64, detail of fig. 36; p. 82, detail
of fig. 42; p. 104, detail of fig. 71; p. 132, detail of
fig. 82; p. 172, detail of fig. 109; p. 180, detail of fig. 31.

All Rights Reserved
Library of Congress Control Number: 2017957437

British Library Cataloging-in-Publication Data
is available

This book has been designed by Diane Gottardi and
composed in Adobe Caslon Pro by Amy Storm.

Printed on acid-free paper. ∞

Printed in China

10 9 8 7 6 5 4 3 2 1

ISBN 978-0-691-15320-9

TO MY MOTHER
Jeanne F. Bedell

TO MY FATHER
Frank C. Bedell

CONTENTS

ACKNOWLEDGMENTS

Gratitude is one of the sentimental emotions and I have a great deal of it to express here. Since I began work on this project nearly eight years ago, I have been the beneficiary of the help, advice, and support of an ever-widening circle of friends and colleagues. They are surely among what Adam Smith called "the gallant and generous part of mankind." For all that they have given to me, I thank them.

Many friends and colleagues across the country have shared their expertise, providing information and advice, asking good questions at just the right moment, and helping me track down elusive works of art: Tim Barringer, Patricia Berman, Graham Boettcher, Sarah Burns, Sue Canterbury, Linda Ferber, Elizabeth Kornhouser, Anna Marley, Meredith Martin, Emily Neff, Alex Nemerov, Elizabeth Oustinoff, Tim Peltason, Richard Rossello, Brenton Simons, Jon Swanson, Bill Truettner, Rebecca Zurier, and my much-missed Wellesley colleague the late Miranda Marvin. Marci Hahn-Fabris and Maggie DeVries in Wellesley College's Library and Technology Services, as well as Jeanne Hablanian in the Art Library, and the excellent staff in the Interlibrary Loan Office, offered much-appreciated help with images and loans.

I also would like to thank the administration and Board of Trustees of Wellesley College for the two years of sabbatical support that allowed me to both launch and complete this project.

At Chicago's Newberry Library, at a session of the Newberry Seminar in American Art and Visual Culture organized by Sarah Burns and Diane Dillon, attendees' invigorating

discussion of my chapter on Sargent and Cassatt provided me with invaluable suggestions for revising not only that chapter but other parts of the manuscript as well. At Wellesley, members of the Long Eighteenth Century Working Group—Simon Grote, Julie Walsh, Kate Grandjean, and Alison McIntyre—generously read and responded to an early draft of my chapter on Peale and Trumbull. Alan Wallach provided me with two venues for presenting my ideas about sentimental landscapes, inviting me to speak at his Boston University seminar on Hudson River School painting and accepting my paper on nostalgic landscapes for a session at the 2017 College Art Association meeting. I am grateful both to the students in the seminar and to the audience at CAA for their stimulating questions. To Alan, I express my deep appreciation for his constant encouragement and support. My fellow Americanists at the Association of Historians of American Art twice offered me opportunities to present my research at their biennial conference, and I benefited greatly from the informed and engaged responses to my papers on Winslow Homer in 2016 and the sentimental art of the Revolutionary War era in 2010.

The students in my 2011 seminar on sentimental art—Stephanie Anklin, Maddie Block, Ally Brown, Simi Oberoi, Sarina Taylor, Emily Tramont, and Emma Weinstein-Levey— helped me revise and refine my ideas about the sentimental. My colleagues in the Art Department offered me the opportunity to teach that course, and supported me in countless other ways as well. I am grateful to them all.

For their careful reading of an early version of my chapter on Andrew Jackson Downing, I thank my generous friends and colleagues Peter Fergusson, Martha McNamara, James O'Gorman, Jay Panetta, and John Rhodes. Paul Fisher graciously read and commented on my Sargent-Cassatt chapter. Jennifer Danly offered wise advice on the introduction, as Sarah Cohen did for my chapter on social reform. I cherish their constant friendship. Bill Cain, in Wellesley's English Department, also gave me much helpful advice.

My good friends Wendy Greenhouse, Erica Hirshler, and James Oles always answered my calls for help, reading multiple drafts, often on short notice, with keen attention to the flaws in my writing and thinking. Lucy Flint provided superb editorial advice on the entire manuscript. One friend in particular, Janet Headley, offered her unstinting support from the project's inception. She not only read every word, but sustained me with her humor, encouragement, and fully engaged interest. My conversations with all of these friends complicated and enriched my understanding of my topic.

At Princeton University Press, I am grateful to my editors Hanne Winarsky, who first accepted the book project, and Michelle Komie, who has seen it through to publication. Two anonymous readers posed challenging questions and offered wise suggestions for revision; I express here my deep gratitude to them. I wish also to thank the members of the

Princeton University Press editorial board who likewise made excellent suggestions. Lauren Lepow expertly copyedited the manuscript. Tom Broughton-Willett prepared the index. Steven Sears guided the book's production.

As always, I was buoyed by the love of my family: Alex Steinbergh, Wren Steinbergh, Betty and Lincoln Spurgeon, David Steinbergh and Corinna Pringle, Shauna Steinbergh, Jeanne Bedell, Frank and Lois Bedell, Matthew Bedell, Louise Maranda, and John Bedell.

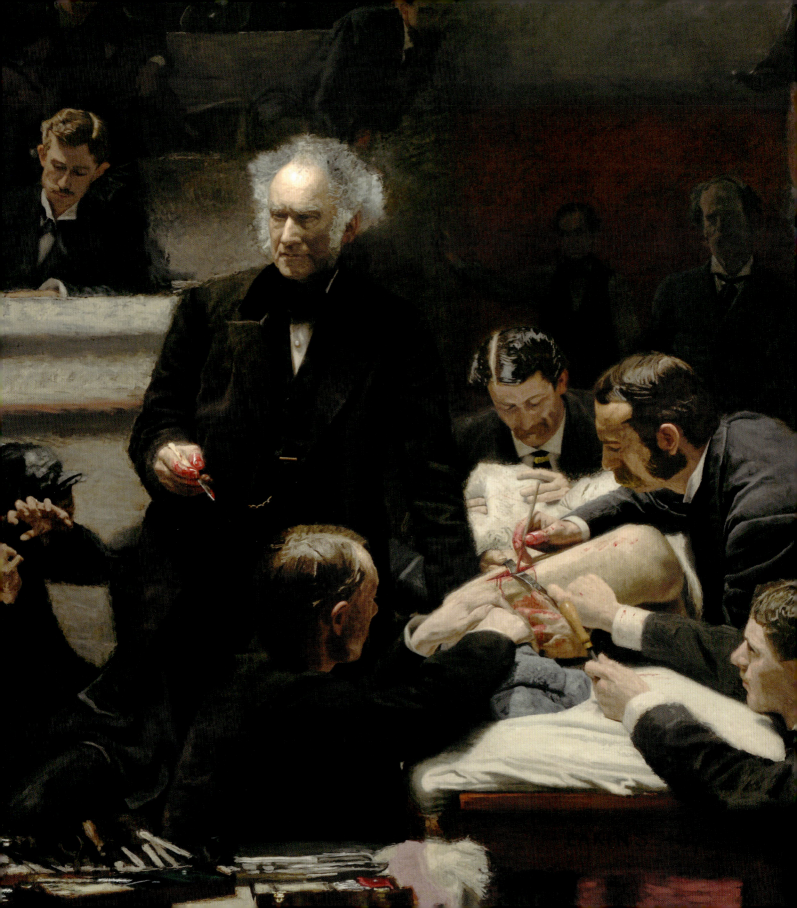

INTRODUCTION

Among the politer terms of abuse, there are few so effective as "sentimental."
—I. A. Richards, *Practical Criticism* (1929)

In the Palace of Fine Arts at the 1893 Chicago World's Fair, one work of art consistently drew crowds: Thomas Hovenden's *Breaking Home Ties*, 1890 (fig. 1). Set in a humble farmhouse interior, this image of a mother bidding farewell to her city-bound son was by nearly every account the most popular painting at the fair. Few of the nation's prominent art critics chose to address it, but reporters from across the country, some acknowledging up front that they knew little about art, devoted long paragraphs to its narrative, describing the scene and the emotional and psychological state of each figure. Some confessed that lumps rose in their throats as they gazed on it; almost all recounted the tears shed by others. Lips quivered, eyes welled, even "strong men" cried openly before it.[1] Many were moved by the scene to share with those around them their own experiences of leaving home—"the 'heart-break' chapter of their own lives"—their memories of families left behind, in some cases never to be seen again. The painting created a community of feeling, striking "the chord which makes all hearts akin, sympathy," as one Chicagoan said.[2] It connected viewers to each other and to a shared past, one that seemed to be receding ever more quickly, driven by the very forces, including advancing technology, being celebrated elsewhere at the fair.

Most of us would immediately identify *Breaking Home Ties* as sentimental. For many, this designation carries at least a trace of condescension and dismissal. Hovenden's painting is exactly what we expect of sentimental art: a heart-tugging domestic genre scene, set in the country, addressing a familiar subject in a realistic, easily comprehensible style, endorsing traditional values in resistance to social change, and appealing to a popular

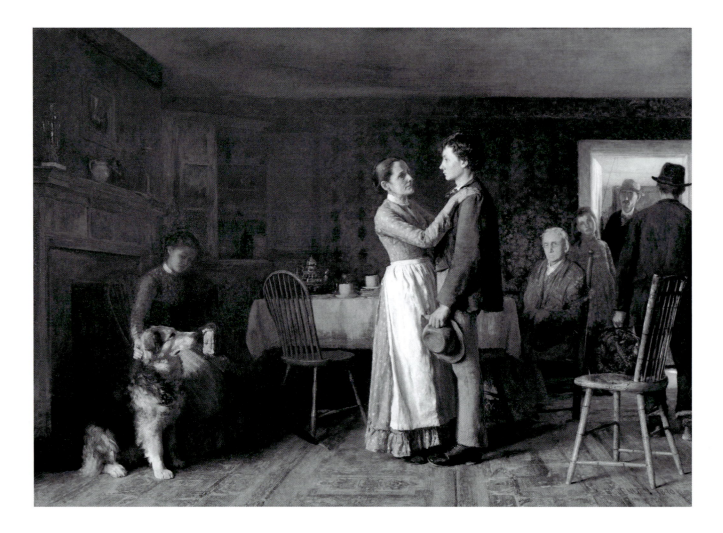

audience. This is not the sort of sentimental art that will form the primary focus of this book. Rather than dwelling on artists such as Hovenden, Lily Martin Spencer, and Eastman Johnson whose domestic and rural scenes are widely accepted and discussed as sentimental in the current literature, I concentrate on artists and genres whose sentimental dimensions have long been ignored, suppressed, and denied.

Over the course of the last 150 years, "sentimental" has become one of the most negative terms used in the field of art history and criticism. From the advent of modernism to the present, the word has carried such disapproving connotations that we have been blinded to the diversity and value of sentimental art, of which *Breaking Home Ties* represents only one variety among many. My aim in this book is to rehabilitate the sentimental, expanding and transforming our understanding not just of the term, but of the genre's place in the art and architecture of the United States. From the Revolutionary War to World War I, its presence was far more pervasive, its influence more powerful, its cultural work more consequential, and its manifestations more complex than any account has yet acknowledged.

Animosity toward sentimental art emerged first in France in the mid-nineteenth century in tandem with the rise of realism, formalism, and the avant-garde. This attitude of disdain took some time to cross the Atlantic, taking firm root in the United States only around the turn of the twentieth century. In the following decades, modernist attacks on the sentimental intensified to the point that it became the abject other, both beyond and beneath notice. The word came to serve as a catchall for nearly everything that modernism scorned: the popular, the commercial, the feminine, the domestic, the tenderly emotional.

Clement Greenberg, the powerful midcentury advocate of formalist abstraction, conflated sentimental art with kitsch, dismissing it as intellectually lazy, morally complacent, and aesthetically deficient.[3] In contrast to the innovative, intellectually challenging work of the avant-garde, kitsch, as Greenberg defined it, is low- or middlebrow, trite, shallow, formulaic, offering cheap emotional stimulation to those unable or unwilling to engage in serious intellectual response; it is both a symptom and a product of mass culture. "To oppose kitsch," wrote the critic Harold Rosenberg in 1959, "makes one appear automatically a champion of the arts."[4] The *Oxford English Dictionary* continues to define "kitsch" as "garish, tasteless, or sentimental art, objects, or design," and other dictionaries offer "sentimentality" as a synonym. In this formulation, "sentimental" is a form of indecorous emotional pandering, seducing gullible viewers with an appeal to their softer emotions.

During World War II and its aftermath, when the nationalist propaganda of Hitler's Germany and Stalin's Soviet Union exploited sentimental imagery and its emotional appeal to shared sympathies to advance their agendas, many intellectuals came to consider it not just insipid but dangerous, a means by which totalitarian regimes could manipulate the

masses. So tenacious have these negative views of the sentimental been that in the early 2000s artist Kiki Smith declared it a "maligned territory," one of art's last taboo subjects. As recently as 2015, photographer Sally Mann expressed her wariness of "the deadly mine-fields of sentiment, that most disputed artistic territory."[5] For serious, ambitious artists like Mann and Smith, to engage the tender emotions associated with the sentimental is to risk condemnation and ridicule. The sentimental may be legitimately invoked only in ironic terms, such as pop artist Roy Lichtenstein's images of teary-eyed comic-strip women expressing their hopelessness and despair in speech bubbles.

Yet the sentimental has not always been regarded with such suspicion and scorn. "Sentiment," a thought prompted by a feeling, is an old word dating back to the Middle Ages. "Sentimental" appeared much later—in mid-eighteenth-century Britain—and was used from then until the early years of the twentieth century to mean, in its simplest sense, "full of or appealing to tender feelings." In 1811, a Boston newspaper explained to its readers that "sentimental" means "the language [of] the heart."[6] More deeply, the sentimental is about human connectedness—connectedness to others, to place, to the conditions of our existence; it involves a forging of bonds across divides of time, space, and difference. It asks us to conceive of ourselves in relation to others, to imagine ourselves in their place and to feel for them, in some measure, as for ourselves, recognizing a common and shared humanity. It is a means by which to relate to and apprehend the world.[7]

In the eighteenth and nineteenth centuries, the sentimental was animated by and invested with socially transformative ambitions, and assumed powerful and prominent roles in American society. Politicians, writers, and artists sought to rouse sentimental feelings to unify the nation during and in the wake of devastating wars. Military leaders were moved by the sentimental to rethink their treatment of captured and wounded opponents. Social reformers relied on it to rouse the public to action, to convince them to help alleviate the suffering of others, including slaves, prisoners, laboring children, and abused animals. Etiquette books, children's primers, and Sunday sermons sought to cultivate tender, sympathetic feelings in the nation's citizens, in part to counter what some considered the heart-hardening impact of such forces as urbanization and market capitalism. Sentimental values played a central role in reshaping the family from a patriarchal, disciplinary institution into a more egalitarian unit, its members bound by mutual affection. American writers of every genre—poetry, drama, novel, essay—responded to the sentimental's values and ambitions, following the lead of their British counterparts, including Laurence Sterne and Oliver Goldsmith in the eighteenth century and William Makepeace Thackeray and Charles Dickens in the nineteenth.[8]

The sentimental's emphasis on sociability and mutual support stimulated the creation of, and soaring membership in, a host of fraternal and other social organizations, such as the Odd Fellows, the Freemasons, and the Washingtonians (a widely popular mid-nineteenth-century society that drew together alcoholics to support each other as they sought to give up drink).[9] Sentimental appeals advanced the building of schoolhouses, churches, hospitals, rural cemeteries, and public parks, as well as the preservation of important historic sites, such as Mount Vernon. Cultural historian Shirley Samuels rightly describes nineteenth-century sentimentalism as a "national project," though its ambitions extended beyond the boundaries of the nation-state to envision affectional bonds stretching across the Atlantic and around the globe.[10]

During the many decades covered by this book, the word "sentimental" was used descriptively, appreciatively, and pejoratively. As its dramatically varied use suggests, the proper place of the sentimental in American society was the subject of constant and vigorous public debate: What value, what roles should the feelings be accorded in the private and, most particularly, the public sphere? In the US political realm, the word at first was used largely in a positive sense, summoning the sentimental bonds of affection that many hoped would unite the citizens of the new nation. It was most often allied then with such other words as "patriotic" and "moral." By the 1830s, however, newspaper editors and legislators were already slinging it as a derogatory term, accusing abolitionists of being "dupes of a lachrymose sentimentality" and of promoting what South Carolina senator John C. Calhoun called "sentimental legislation" against the slave trade.[11] Opponents of the Mexican War (1846–48) were labeled "sentimental bewailers of bloodshed" given to "puling sentimentality about Mexican wrongs and American atrocities."[12] These detractors claimed that sentimentalists were moved only by emotions, while their own positions were grounded in stern-minded, rational, practical considerations. This use of the word persists today. As just one example, in 2016 an irate poultry farmer described proponents of cage-free eggs as "'sentimentalists' interfering in the raising of livestock."[13]

When it comes to the visual arts, however, in the United States "sentimental" was used almost exclusively in a descriptive or positive sense into the later nineteenth century.[14] While many would have banned the softer emotions from politics, most considered the attempt to move or touch the viewer a legitimate, indeed expected, aim of art. Eighteenth-century French writer Denis Diderot expressed his desire for art that would "move me, astonish me, break my heart." Nineteenth-century British critic John Ruskin called for a "noble Picturesque" that would infuse landscape and genre painting with "sympathy" and "heart." And the editor of the American magazine *Appletons' Journal* insisted in 1878 that the "true and lasting value of painting" lies in its ability "to link itself closely to the heart

of the spectator." These and other powerful and prominent voices argued for the essential role of feeling in the creation and appreciation of art.[15] They contended that art should grow from what Ruskin called the creator's "communion of heart with his subject," and should catalyze sympathetic connections among artist, subject, and viewer.

"Sentimental art" is defined neither by style nor by subject. It is not bound to particular techniques, mediums, or materials. Rather, it is art that employs a mode of address intended to develop empathetic bonds and to represent and elicit the "softer emotions," among them tenderness, affection, pity, compassion, patriotism, and nostalgia. This is the view of sentimental art that prevailed in the United States into the late nineteenth century, when modernism recoiled from the sentimental and caricatured it as the artistic equivalent of a tepid pablum dispensed by tenderhearted women in nurseries and sickrooms.

Adherents to both realism and formalism, the two major modernist movements in the United States at the turn of the twentieth century, vilified the sentimental and defined themselves against it. They devalued its appeal to tender feelings as an aim unworthy of art. In rhetoric laced with elitism and misogyny, they claimed that sentimental art appealed primarily to women, immigrants, and the lower classes. They located its artistic expression in genre scenes of happy families and barefoot boys, and in popular commercial art: calendar prints, greeting cards, and, by the mid-twentieth century, television soap operas—forms that were seen as particularly appealing to women. Literary historian Suzanne Clark contends that "this reversal against the sentimental helped to establish beleaguered avant-garde intellectuals as a discourse community defined by its adversarial relationship to domestic culture."[16]

In the opening years of the twentieth century, just as modernism was taking firm root in the United States, critics such as Charles Caffin and Sadakichi Hartmann were writing the first substantial histories of the nation's art.[17] They were doing so at a time of pervasive concern about the growing feminization of American culture, a concern particularly acute among male professionals in the art world, where women were assuming increasingly prominent roles.[18] Having absorbed modernism's contempt for the sentimental, they constructed their narratives around what they considered the "manly" realist strain in American art, mentioning the sentimental only as a weakness, a failing of less accomplished artists. In establishing their canon of worthily masculine masterpieces—objective, scientific, "muscular" works—they elevated Thomas Eakins's *Portrait of Dr. Samuel Gross (The Gross Clinic)*, 1875, to the status it continues to occupy today as one of, if not first among, the greatest American paintings (fig. 2). Its elevation at that moment seems especially significant, since, more explicitly than any other work of art produced in the United States to that point, it disparages emotionality, which it binds to the feminine by con-

Fig. 2.
Thomas Eakins, *Portrait of Dr. Samuel D. Gross (The Gross Clinic)*, 1875. Oil on canvas, 8 ft. × 6 ft. 6 in. (243.8 × 198.1 cm). Gift of the Alumni Association to Jefferson Medical College in 1878 and purchased by the Pennsylvania Academy of the Fine Arts and the Philadelphia Museum of Art in 2007 with the generous support of more than 3,400 donors.

trasting the patient's cringing mother to the calmly rational and heroic scientist and surgeon Dr. Gross. These critics, suppressing the strong strain of sentimental sympathy in Eakins's late portraits, lauded him for being "coldly and dispassionately analytical" and celebrated his "brutality" as an antidote to the nation's plague of "blasé, sweet-caramel artists."[19] *The Gross Clinic* emblematizes the masculinist culture with which these critics sought to identify themselves, and which they promoted and endorsed through their writings.

Thus was modernist disdain for the sentimental inscribed almost from the beginning in the published story of the nation's art. Even the most recent textbooks in the field maintain this stance. They validate as unsentimental the figures at the core of their narratives: "Without indulging in sentimental melodrama, [Winslow] Homer . . ."[20] And, to the extent that they engage sentimental art, they center it in nineteenth-century feminine domestic culture, particularly in the work of genre painters such as Lily Martin Spencer. As one author puts it, "In painting, sentimentalism is exemplified in the work of Lily Martin Spencer. . . . [Her] images glorify the domestic piety of female-dominated sentimental culture."[21] These narratives often deploy the term "sentimental" as the bad opposite to something better, as when one scholar states that Mary Cassatt's "paintings of mothers and children are not sentimental depictions, but rather serious, and often monumental, renditions of the processes of nurturing that were women's socially prescribed tasks."[22] The artist, in other words, is serious because she is not sentimental. In the following pages, I hope to make clear that these views give us a limited and misleading understanding of the sentimental and its place in American art.

For more than a hundred years, from the late eighteenth century to the late nineteenth century, the sentimental was one of the most vital, protean, productive forces shaping the nation's art. It defined for art an activist, interventionist role in the public realm. It ascribed to art the power to touch, educate, and transform its audience's feelings, to connect them to others, and, through these means, to effect social change. For artists such as Charles Willson Peale and John Trumbull, who deployed their sentimental creations in the urgent effort to stabilize the Union in the wake of the Revolutionary War, the modernist conception of the art experience as an isolated individual's aesthetic response to "color space relations"—as American cubist Stuart Davis described it—would have seemed extraordinarily impoverished.[23]

The sentimental's influence was pervasive, touching almost every category of subject matter—history, portraiture, landscape, genre scenes, religious art, animal imagery—and a wide range of media, including painting, sculpture, printmaking, photography, architecture, and landscape design. Scarcely an artist was untouched by it. Even at the end of the nineteenth century, when hostility toward the sentimental was beginning to take hold, artists

worked in keen awareness of its commercial potential and popular appeal, negotiating sometimes complex relationships with it, as was the case with Winslow Homer, John Singer Sargent, and Mary Cassatt.

The sentimental's rhetorical power was recognized and used by artists from an array of communities, including black abolitionists and white apologists for slavery, advocates of "woman's sphere" and campaigners for women's rights, commercial advertisers and critics of market capitalism. That is to say, the sentimental was (and is) politically multivalent. Some have cast it as a mechanism of white middle-class hegemony. It was that, but much more, including an agent of radical social reform.

The sentimental was as important to the reception as it was to the production of art, shaping audience expectations and responses. Viewers raised or trained within what Shirley Samuels has called "the culture of sentiment" tended to approach works of art expecting and desiring to be moved.[24] In responding to the subject matter of pictorial art, they drew on their own physical and emotional experiences to project themselves imaginatively into the represented world, attempting to feel with and for the characters in the artwork. The viewer's trickling tears or quickened heartbeat were not embarrassments, but rather signs of an awakened humanity. To respond to sentimental art was a fully embodied imaginary, emotional, and sensory experience.

In the six chapters that follow, I examine the varied and shifting forms that sentimental art has assumed in the work of artists and architects in the United States, as well as in the work of selected Americans active in Britain and France. The temporal scope is from the late eighteenth century—when sentimental art was widely admired and fully participating in the remaking of the social and political order—to the early twentieth century, when modernist rhetoric convinced serious artists to feel ashamed of any engagement with the sentimental, at which point it became, as Sarah Burns has written, part of "an alternative aesthetics of the popular."[25] The chapter arrangement is broadly but not strictly chronological, with chapters 2 and 4 breaking the temporal arc to follow their individual topics from the antebellum era to the cusp of or into the twentieth century.

My opening chapter addresses the history paintings, portraits, and various public spectacles created by Peale and Trumbull in their efforts to support the formation and continuing viability of the new United States. Chapter 2 concentrates on the relations between sentiment and social reform, especially on racist and antiracist imagery, including abolitionist woodcuts, romantic racialist illustrations, and Henry Ossawa Tanner's genre and religious paintings. Tanner's works both advocate for the national acceptance of African Americans' humanity and dignity and, in those works produced during his years as an expatriate in France, push back against the virulent anti-Semitism of the era. Chapter 3 turns

to architecture and landscape design, and to the social and political value accorded "home feeling" in the antebellum era. In the 1840s and 1850s, Andrew Jackson Downing designed houses and residential grounds that were meant to both symbolize and facilitate the formation of sentimental domestic bonds. He hoped that his sentimentalized homes would help counter the feverish pursuit of wealth and the "spirit of unrest" that he felt were destabilizing the nation.

Chapter 4 focuses on landscapes: the new rural cemeteries, the paintings of the Hudson River School, and the Barbizon-inflected works of George Inness, all invested by their creators with healing ambitions. Over the period covered by this book, various sentimental emotions rose to the fore, then receded: patriotism, sympathy, home feeling. This chapter considers the increasing prominence of nostalgia from the antebellum years into the late nineteenth century. In chapter 5, I consider the case of Winslow Homer, an artist who has been consistently described as unsentimental in the scholarly literature from the early twentieth century to the present. I argue that he was engaged with the sentimental throughout his career, and that he is, in fact, one of the greatest of American sentimental artists. Since antipathy toward the sentimental arose first in France in the mid-nineteenth century, in chapter 6 I turn to Paris, where Sargent and Cassatt were among the first American artists to confront and respond to it.

My understanding of the sentimental draws on and extends the work of a number of important scholars, most from outside the discipline of art history, who since the 1980s have fought entrenched modernist contempt to excavate, rejuvenate, and rehabilitate it. The philosopher Robert C. Solomon dissects the "century-old prejudice" against "sentimentality and the emotions" and defends them "as essential to life."[26] Jane Tompkins, in her book *Sensational Designs: The Cultural Work of American Fiction, 1790–1860* (1985), challenges modernist standards of literary value, asking us to consider the important cultural work taken on and accomplished by sentimental texts. *The Culture of Sentiment: Race, Gender and Sentimentality in Nineteenth-Century America* (1992), an influential collection of essays edited by Shirley Samuels, makes a compelling case for sentimentalism's centrality to nineteenth-century US culture. Three other important essay collections—Mary Chapman and Glenn Hendler, eds., *Sentimental Men: Masculinity and the Politics of Affect in American Culture* (1999), Milette Shamir and Jennifer Travis, eds., *Boys Don't Cry? Rethinking Narratives of Masculinity and Emotion in the U.S.* (2002), and Cathy N. Davidson and Jessamyn Hatcher, eds., *No More Separate Spheres!* (2002)—have done much to deconstruct the long-standing association of the sentimental with femininity by calling attention to American men's participation in a range of sentimental cultural practices. Other scholars, such as

Joycelyn Moody in *Sentimental Confessions* (2001), have examined the adoption of sentimental literary conventions by African American writers.

A number of historians and literary scholars, including Michael Bell, David Denby, Markman Ellis, Sarah Knott, David Marshall, John Mullan, and William Reddy, have clarified the sentimental's origins in the Enlightenment theory of moral sentiments and the eighteenth-century culture of sensibility, while establishing its vital role in the dramatic social and political upheavals of that time, including its undergirding of the French and American Revolutions.[27] James Chandler has extended its reach from the philosophy and literature of eighteenth-century Britain through the writings of Charles Dickens, James Joyce, and Virginia Woolf into the Hollywood films of Frank Capra.[28] Lynne Festa, Renato Rosaldo, Laura Wexler, Marcus Wood, and others have fixed attention on the dark side of the sentimental, emphasizing its complicity in imperialism, colonialism, violence, and repression—its use as a tool, not to liberate others, but to control them.[29]

The pioneering work of literary scholars has done much to shape my understanding of the sentimental. In one area, however, my views depart from theirs. Many have identified sentimental literature with distinctive formal constructions, generally including clichéd plots, stereotyped characters, exaggerated emotional displays, familiar and accessible language, and the "careful management of points of view."[30] These are, for the most part, traits that set sentimental writing so defined outside the compass of "good" literature. For decades, art historians, aware of this definition of the sentimental, sought artistic parallels, finding them primarily in genre scenes of domestic and country life. This reinforced the impression that the sentimental was but a minor thread in the art of the United States (and of other countries as well). For my part, I do not see the sentimental as bounded in either art or literature by particular formal choices, and feel that the focus on them has constricted our ability to perceive the extent to which sentimental values and ambitions have pervaded cultural productions from the eighteenth century onward.

Only very recently have art historians begun to contribute to the reclamation of the sentimental, our efforts perhaps suppressed by the still-powerful hold of modernism's antisentimental rhetoric.[31] I hope that the story I tell will serve as a corrective to the misleading views and questionable judgments we find in all too many histories of and monographs on American art, even today. But more than that, through this book I seek to redefine and revitalize a wide range of works of American art and the contexts for interpreting and appreciating them more deeply. American artists from Peale and Trumbull to Tanner and Sargent understood the power that resides in art's ability to move the viewer to tears.

The Revolutionary Art and Politics of Sentiment

Charles Willson Peale and John Trumbull

CHAPTER ONE

In the new United States, in the decades just after the Revolutionary War, the works of art described as sentimental were markedly, even surprisingly, different from those we consider sentimental today. In 1790 a Boston commentator visited John Trumbull's studio and found the artist "busily engaged in his great undertaking"—his series of Revolutionary War paintings. The visitor pronounced Trumbull's works "sentimental, elevated, and just."[1] The word was also applied to portraits of public figures such as George Washington and Alexander Hamilton, and to the grand illuminations, processions, and fêtes that celebrated and commemorated important national events, such as the Fourth of July and Washington's presidential tours.[2] No taint of the feminine, the commercial, or the saccharine had yet attached itself to the term. Instead, it was used with approbation to denote works of art capable of moving the spectator and inspiring communal feelings, especially patriotism. These qualities allowed sentimental works to play valued roles in the political realm.

"Sentimental" was then a new word, barely a few decades old. It had arisen in Great Britain in the mid-eighteenth century, a product of the Enlightenment culture of feeling. Even more so than in Britain, in the United States it early on bound itself to the masculine, the public, and the political, intertwined with a new faith in the possibility of individual and societal transformation.

The period of the New Republic arrived within the last years of the Enlightenment. Though still popularly characterized as the Age of Reason, the Enlightenment was at least as much, if not more so, the Age of Feelings. Many of the most prominent European

philosophers of that era—including David Hume, Jean-Jacques Rousseau, Adam Smith, and Lord Shaftesbury—looked to sentiments as a means of transforming the social and political order. Rejecting Calvinist notions of innate depravity and predestination, as well as Hobbesian views on the necessity for authoritarian government, these men (in varied ways and to various degrees) argued for the fundamental goodness of human nature and for a natural capacity for compassion and sociability. They asserted the ability of individuals to assess and improve their moral characters, and, ultimately, they advanced the possibility of creating a more just, moral, and civil society.[3] Feelings were essential to this because, as Hume explained, they rather than reason impel us to action.

At the core of these discussions were the "social affections," that is, the emotions that bind us together, creating familial and social cohesion, including love, affection, tenderness, pity, gratitude, benevolence, and patriotism. These, the sentimental emotions, were frequently contrasted to the "selfish passions"—such as hatred, greed, and lust—that cause division. The social affections were in turn made possible by sensibility, an inborn trait that allows us to feel with and for our fellow beings. The sympathy or fellow feeling generated by sensibility was considered the foundation of our morality. When properly cultivated, it could compel individuals to act for the public good, and could thus be harnessed to generate social and political reform. These beliefs provided the philosophical foundation for what was known at the time as "sentimental political union"—a concept that would exert a significant influence during the formative years of the United States.[4]

At the close of the Revolutionary War, the new nation's survival was far from assured. The years following the end of hostilities were a time of anxious political and social instability, when many feared that the Union was in danger of imminent disintegration. The former colonies were no longer united in a military campaign against a common enemy. Without the threat of military force, without a king to whom everyone owed obeisance, and without the traditional hierarchy of dependencies that had given structure to colonial society, what, many asked, could keep the young nation from falling apart? One answer proffered at the time was "sentimental political union." Nathaniel Chipman, a federal judge from Vermont, explained the concept in his *Sketches of the Principles of Government*, published in 1793 and widely excerpted in the nation's newspapers and journals. In a republic, Chipman wrote, "the powers of government are supported not by force, but by the sentiments of the people"—by the people's "sentimental attachment . . . to the community, its constitution, and its laws." In a republic, therefore, it is "necessary to cultivate a sentimental attachment to the government."[5] Art of all sorts, from small-scale prints to grand public fêtes, could and did play a part in this endeavor.

Probably no two American artists were more deeply engaged in this project than John Trumbull (1756–1843) and Charles Willson Peale (1741–1827). Both were committed to the survival of the new nation. Both served in the Continental Army. Both were bound by ties of friendship to the republic's political leaders, including George Washington, Benjamin Franklin, and Thomas Jefferson. Both regarded art as a medium of sociability, a vital agent in the formation of social relationships. Through their work, they sought to model and to catalyze sentimental political union, fostering bonds of sociability and affection among the citizens of the new nation.

Yet their approaches to this project—the forms their art took, the venues they chose for its display, and the audiences they cultivated—were shaped by their widely divergent political stances. Trumbull, a Harvard-educated member of the Federalist elite and son of the governor of Connecticut, imagined the new nation as governed by an aristocratic elite, entitled to rule in part by virtue of their greater natural sensibility. Peale, whose father arrived in Maryland from London as a convicted and deported felon, and who himself endured what he described as seven years of "servitude" in apprenticeship to an Annapolis saddler, was a political radical, an associate of Thomas Paine.[6] His vision of the new nation was far more democratic than Trumbull's, embracing universal white male suffrage, education and professional training for women, and the gradual abolition of slavery. Through his intertwined political and artistic activities, he sought to advance his vision of nationhood as, to use historian Benedict Anderson's words, "a deep, horizontal comradeship."[7]

Both Peale and Trumbull were swept up from their youths onward in the transatlantic culture of sensibility, which, emanating outward from intellectual centers such as London, Edinburgh, and Glasgow, was promoting new notions of the individual, new ideals of manhood, new forms of political association, and new practices of sociability. Their reading, their friendships, their political and military engagements, and their artistic training in London under Benjamin West (1738–1820) immersed them in its fundamental tenets. They became acquainted with that new beau ideal of manhood, "the man of feeling": humane, compassionate, benevolent, and courteous, suppressing self-interest in favor of the public good. They likely would have agreed with Adam Smith that "our sensibility to the feelings of others, so far from being inconsistent with the manhood of self-command, is the very principle upon which that manhood is founded."[8] They also believed that voluntary association should be the basis of social contracts, including citizens' relations to their government. Certainly both valued public affections, embraced public duties, and committed themselves to supporting through their sentimental works the experiment in Enlightenment principles that was the United States.

CHARLES WILLSON PEALE

Peale was a patriot, a radical Whig, who enlisted as a common soldier in the Philadelphia militia a month after the declaration of independence. He was also, his biographer and descendent Charles Coleman Sellers writes, "a sentimentalist."[9] When John Adams paid his first visit to Peale's Philadelphia studio in 1776, he described the painter in a letter to his wife, Abigail, as a near caricature of the man of feeling: "a tender, soft, affectionate Creature. . . . He has Vanity—loves Finery—Wears a sword—gold Lace—speaks French—is capable of Friendship, and strong Family attachments and natural Affections." To those who subscribed to the Enlightenment culture of sensibility, as Adams did at this point in his career, friendship, attachments, and affection were not just personal traits, but social and political ones—the glue that would hold society together in the absence of monarchical power.

Adams was struck by a number of paintings in Peale's studio that, to him, gave expression to the artist's sensibility. One was Peale's portrait of his wife, Rachel, weeping over their dead baby (fig. 3). This "moving picture," Adams wrote, "struck me prodigiously." Another was a large group portrait of Peale's family (fig. 4). Begun about 1772, it represents the artist (standing on the left, head bent, by the easel), his siblings, his mother, his wife and infant daughters, and the family nurse. An apple peel twines from the edge of a fruit plate as a punning family signature. On the easel, a canvas with three loosely brushed female figures clasping hands is inscribed with the words *Concordia Animae*. Adams found this sentiment well expressed by the family group in "a happy Chearfulness in their Countenances, and a Familiarity in their Airs towards each other."[10] Peale later added another symbol of family fidelity, a portrait of his beloved dog, Argus.[11]

The Peale Family, as this painting is known, was the artist's most ambitious attempt at a conversation piece, a mode of portraiture that gave visual expression to new ideals of family emerging within the culture of sensibility.[12] Rigid patriarchal authority and harsh child-rearing practices were rejected as despotic. Instead, reciprocal bonds of affection would serve to unite families, while parents—both fathers and mothers—would practice gentler, noncoercive forms of guidance. Peale endorsed this view, writing, "Let the Parents who have Children forbear to beat them. . . . Let Love and not fear be the mover to good works."[13]

In *The Peale Family*, Peale consciously rejects patriarchal hierarchies. At the apex of each of the two intersecting triangular groups of figures, he places a woman: his sister Margaret Jane on the left, and the old family nurse, Peggy Durgan, on the right.[14] Yet he also, more subtly, calls attention to his own authority within the family. The activity that has brought the group together is a drawing lesson that Charles Willson is offering his brother

Fig. 3.
Charles Willson Peale, *Rachel Weeping*,
1772, enlarged 1776, repainted in 1818.
Oil on canvas, 36¹³⁄₁₆ × 32¹⁄₁₆ in.
(93.5 × 81.4 cm). Philadelphia Museum
of Art. Gift of the Barra Foundation,
Inc., 1977.

Fig. 4.
Charles Willson Peale, *The Peale
Family*, 1773–1809. Oil on canvas,
56½ × 89½ in. (143.5 × 227.3 cm).
The New-York Historical Society
Museum. Gift of Thomas Jefferson
Bryan, 1867.298.

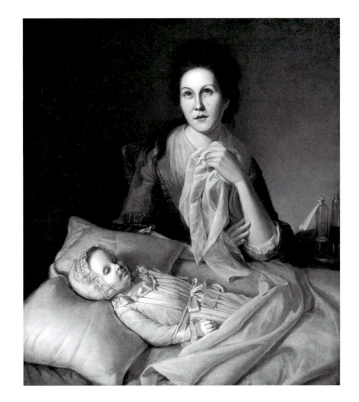

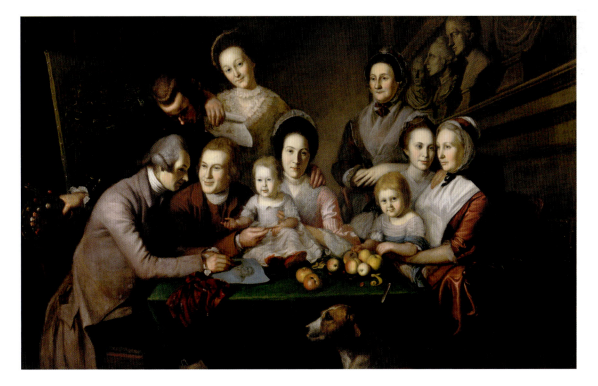

St. George, who sketches their mother and her granddaughter across the table. Margaret Jane holds a drawing, and James, seated next to St. George, holds a pencil, suggesting that they too are participating in the lesson. Setting aside gender distinctions, Peale educated not only his siblings, but many of his children and his nieces in the art of painting. His brother James, several of his sons, and two of his nieces would later pursue artistic careers.

Within months of Adams's visit to his studio, Peale would be swept up in military and political service. In December 1776, having been elected lieutenant of his militia group, he marched with his men to join General Washington at Trenton. He fought in the battles of Trenton and Princeton, and endured the winter encampment at Valley Forge. Between military maneuvers, Peale deployed the leather-working skills he had developed as a saddler to make moccasins for his bootless men, raced home to check on his family, and practiced his portrait trade, finding and filling many commissions for portrait miniatures among the army's officers. His subjects included George Washington, with whom he dined on at least one occasion during that long, trying winter.[15]

By then Peale had known Washington for almost six years. In 1772, he had spent several weeks at Mount Vernon, invited there by Martha Washington to paint her husband's portrait. Over the following years, Washington would submit himself to Peale's brush at least six more times.[16] In January 1779, the Supreme Executive Council of Pennsylvania commissioned Peale to paint a full-length portrait of Washington to hang in the council chamber so that "the contemplation of it may excite others to tread in the same glorious and disinterested steps, which lead to public happiness and private honor."[17] The Washington that took shape on Peale's canvas was not the cold, reserved, distant figure remembered by many who met him in those years. Instead, Peale drew on his knowledge of British rococo portraiture, gained from his studies in London (1767–69), to conjure a man of sensibility: sociable, engaged, his upright military bearing lightened by the graceful curves of his posture and clothing (fig. 5). Washington appears confident and relaxed, genial and forthcoming. A hint of a smile softens the direct address of his outward gaze, a gaze that meets ours.

Peale would amplify the smile in later copies and mezzotints of the image (fig. 6). Smiling was then newly acceptable in portraiture, its way smoothed by the more open expression of feelings encouraged by the culture of sensibility.[18] It spoke of inner benevolence and openness to friendship. In Washington's case, it conveyed a sense of his personal interest in the nation's citizens. The twenty replicas of the portrait Peale painted and the many mezzotint versions he sold testify to its popularity. Copies of the image by other printmakers extended its distribution.[19] This was the Washington who entered people's homes and public buildings, inspiring feelings of intimacy and affection. This was the man as his contemporaries wished to imagine him, a man whom they often described as "our friend Washington."[20]

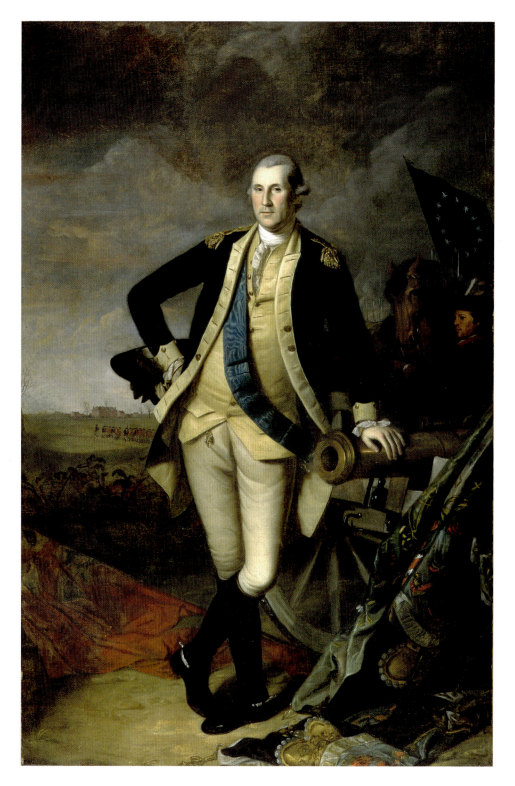

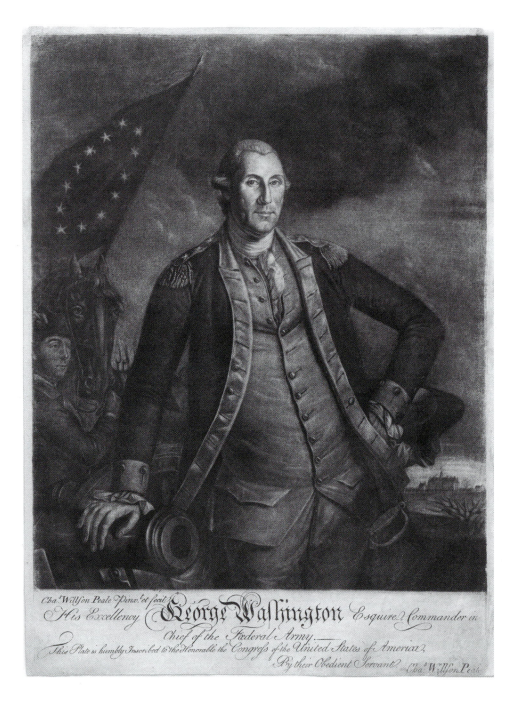

Fig. 6.
Charles Willson Peale, *His Excellency George Washington*, 1780. Mezzotint. Image: 9⅞ × 11⅞ in. (25.1 × 30.2 cm). Sheet: 14 × 10⅛ in. (35.5 × 25.7 cm). National Portrait Gallery, Smithsonian Institution, Washington, DC. Gift of the Barra Foundation.

Peale's political engagement extended far beyond his service in the Continental Army. Through the 1770s and 1780s, Philadelphia, where he made his home, was bitterly divided by partisan politics (between Whigs and Tories, Constitutionalists and Anti-Constitutionalists, Federalists and Anti-Federalists). Peale was in the thick of these battles—disputes that at times erupted in mob violence, including assaults on him and his family. He served as chairman of the Whig Society, which supported the Pennsylvania Constitution of 1776, the most radical in the former colonies, providing for a unicameral legislature and universal white male suffrage. He was elected to a single term in the Pennsylvania Assembly (1779–80), the term when the gradual abolition of slavery was made the law of Pennsylvania.[21] He was a member of a civic committee that handled the confiscated estates of Tories, and another that sought to enforce price controls. Through these fraught and busy years, as well as the decades that followed, he deployed his artistic talents in support of his radical political beliefs and the ideals of sentimental political union.

Peale was "always ready," he said of himself, "to give . . . aid to keep up the spirit of the times."[22] He seems to have felt that one of the most effective ways to do this was through the creation of public spectacles, including parades and illuminations. Such civic rituals drew large numbers of citizens into the streets, where emotions were readily communicated from person and to person, and participants could literally see themselves as part of a body politic. As historian David Waldstreicher has made clear, "parading is politics," and, in the early republic, such festivities could be deployed to advance both "a divisive politics and a unifying nationalism."[23] The events Peale orchestrated partook of both.

In September 1780, soon after Benedict Arnold's traitorous plot to deliver West Point to the British was uncovered, Peale was called on to help Philadelphia's radicals stage a ritual punishment.[24] Such ceremonies had a long history in the colonies and Europe. Peale had witnessed one in Newburyport, Massachusetts, in 1765, at the height of the Stamp Act crisis. There an effigy of the local stamp collector had been hanged, shot, burned, and torn to pieces, an event so terrifying to the collector that, according to Peale, "he left the Town Secreetly."[25] To rouse and focus public anger on Arnold's treason, Peale created a float to serve as the centerpiece of a parade (fig. 7). A two-faced General Arnold was seated in a cart with a black-clad devil standing just behind him, shaking a bag of money near his ears. The effigy was escorted through the streets by a contingent of Continental Army officers, a drum and fife corps, and "a numerous concourse of people."[26] The ceremony culminated in a bonfire into which the effigy was cast. The event drew people together to celebrate their delivery from the hands of a traitor, but it equally served as a warning to those still harboring Tory sentiments. Threat was as central to the event as rejoicing.

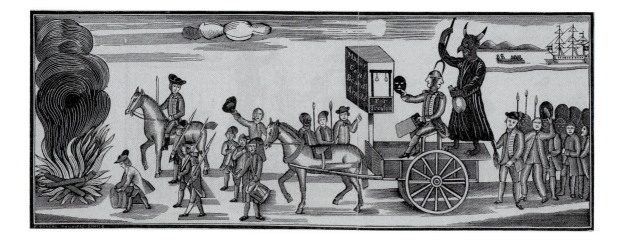

Fig. 7.
Newspaper illustration of Peale's effigy
of Benedict Arnold. September 30, 1780.
Library of Congress, Washington, DC.

With the surrender of Lord Cornwallis and Washington's election as the nation's first president, Peale turned his efforts away from ritualized violence and definitively toward promoting sentimental political union. In 1781, when news of Washington's decisive victory at Yorktown and Cornwallis's surrender reached Philadelphia, Peale immediately set to work filling the windows of his home with illuminated transparencies in celebration of the event. In the central window of his three-story house, he placed paired portraits of General Washington and General Rochambeau, the leader of the French forces, "framed with palm and laurel branches." The elaborate iconography of the rest of the display, described in detail in the local newspapers, traced the progress of the war, from its beginnings shown on the first floor (with references to the Stamp Act and the battles of Lexington and Bunker Hill) to the prediction on the top floor of a glorious future for the new nation, complete with allegorical figures of Agriculture, the Arts, and Commerce. During the evening illumination on November 27, "people were flocking from all parts of the town to obtain a sight of these beautiful expressions of Mr. Peale's respect and gratitude to the conquering hero."[27] The display provided a focal point for public gathering and rejoicing, a place for patriotic sentiments to ignite and spread. The lengthy newspaper accounts further disseminated and deepened its influence.

Eight years later in April 1789, in anticipation of the newly elected President Washington's arrival in Philadelphia, Peale joined with others to create an appropriate welcome to their city. At Gray's Ferry, where Washington would cross the Schuylkill River, they constructed an elaborate stage set for the welcoming procession (fig. 8). Triumphal arches of evergreens framed both ends of the bridge, created by "Mr. Gray himself, the ingenious Mr. Peale and others, and in such style as to display uncommon taste in these gentlemen." Flags fluttered from shrubbery lining its sides, and a mechanism was erected to drop a

Fig. 8.
The elaborate stage set erected by
Peale and others at Gray's Ferry for
the welcome of Washington to Phila-
delphia on April 20, 1789. Engraving
by James Trenchard for the *Columbian
Magazine*, May 1789. Library of Con-
gress, Washington, DC.

Fig. 9.
Triumphal Arch constructed for the
reception of Washington in Boston,
1789. Painted on it are the words "To the
man who unites all hearts." Engraving
by Samuel Hill for the *Massachusetts
Magazine*, January 1790. Library of
Congress, Washington, DC..

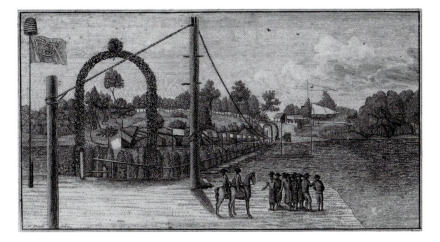

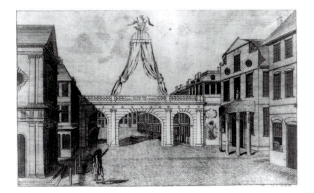

"civic crown of laurel" onto Washington's head as he passed beneath. According to an account in the *New-York Packet*, on the appointed day, more than twenty thousand citizens of "all classes and descriptions" lined "every fence, field and avenue between bridge and city," and many fell in with the procession escorting the president. It was, one participant noted, a manifestation of "joy and affection . . . displayed by a grateful people to their patriot benefactor," an occasion on which "universal joy . . . inspired every heart."[28]

This was not a singular event. Similar ceremonies were staged throughout the former colonies, and their repetition was central to the creation of national feeling. Newspapers carried lengthy reports of the celebrations, and hearing of others' efforts, one town after another formed committees to orchestrate their own.[29] In the town of New Alexandria, Pennsylvania, this group called itself the "Sentimental Society."[30] During Washington's presidential tour of 1789, he visited not only Pennsylvania, but also New York, Massachusetts, Connecticut, and New Hampshire. Along his route, triumphal arches were erected, sometimes emblazoned—as in Boston—with the words "To the man who unites all hearts" (fig. 9).

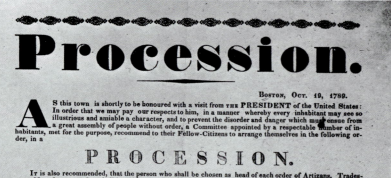

Fig. 10.

Broadside explaining the organization of the reception of Washington in Newburyport, Massachusetts, 1789. Library of Congress, Washington, DC.

Citizens gathered to cheer him, some walking and riding for hours, even days, to join the throngs. Odes were written and sung, bells rung, flowers strewn, and fireworks set off in the evening skies.

In a number of towns on Washington's tour, including Boston and Newburyport in Massachusetts, communal processions were organized to avoid "danger and disorder" while permitting "every inhabitant" to "see so illustrious and amiable a character."[31] These processions were simultaneously hierarchical and inclusive, directed from above but allowing for individual initiative. Broadsides informed inhabitants of how to participate (fig. 10). Militia and artillery headed the parade. Behind them marched town officials, then clergy-

men, physicians, lawyers, and merchants, followed by artisans in alphabetical order by trade, from bakers to wheelwrights. Schoolmasters were asked to attend with their pupils. Even "Strangers" to the town who might wish to participate were allotted a place in the procession. Anyone not seeing his calling represented could join whichever division seemed most appropriate. In Boston, each group was requested to create and carry a white flag emblazoned with an appropriate insignia. All were to march ahead of the president to a designated point, then part to either side of the road so that the president could pass between them on horseback, allowing everyone to see their "beloved Washington." The editor of the *Salem* [MA] *Mercury* hailed the political value of such events; he quoted the French statesman Turgot on the necessity of "publick spectacles," for "it is in these meetings that the heart expands itself to love, to friendship, to benevolence . . . and that insensibly we learn to reunite under the same comprehensive idea, inhabitants of the country, and the country itself."[32] While Americans of this era, including the *Salem Mercury* editor, recognized the crucial role of print—especially newspapers—in disseminating political views, they also valued public gatherings as vital venues for the promotion of social affections. Such feelings, it was believed, were best cultivated in person-to-person meetings, where they could be spread by, to use Hume's word, "contagion."[33] These communal expressions of feeling played an essential role in nation building, allowing Americans to feel themselves part of the imagined community of the new nation, bound with ties of sympathy to their fellow citizens.[34] Such certainly was Peale's view.

Despite all the effort that he poured into the creation of public spectacles, probably none of Peale's contributions to the advancement of patriotic sentiment and social harmony was more ambitious than his museum. Evolving from a small display of his own paintings in his home-based studio into a multiroom collection of portraits, natural history specimens, and ethnographic artifacts housed in the Pennsylvania State House (now known as Independence Hall), it was one of the first museums of art and science in the Americas. Peale conceived the museum as a republican institution, promoting the universal education, civic virtue, and fraternal feelings that he and many like-minded men and women of his time believed were essential to the survival of a republic. He boasted that in contrast to the restrictive admission policies of many European institutions, his museum was open to the public for a modest twenty-five-cent admission fee, with evening hours to ensure that working people could visit.[35] Art historian David Brigham's valuable demographic analysis of the museum's annual subscribers for 1794 allows insights into the museum's social reach. Subscribers included not only twenty US senators, sixty-eight US representatives, and more than forty merchants, but also scientists, ironmongers, grocers, carpenters, tailors, sea captains, and a baker.[36]

Encouraging the public to view the museum as a collective republican enterprise, Peale invited wide participation in shaping the collection. He requested donations through notices in the local papers and through personal solicitations. Donors received handsomely engraved letters of thanks, emblazoned with the motto "From tiny grains are mountains made."[37] Peale also acknowledged contributions through newspaper notices about new acquisitions, and through the prominent display of donors' names on the museum's object labels. Those acknowledged in this way included George Washington (who sent Peale two golden pheasants that had been gifts from Lafayette), Thomas Jefferson (who donated artifacts from the Lewis and Clark expedition), and Benjamin Franklin (who contributed mineral specimens).[38] To donate, then, was to ally oneself with these eminent men. It was to feel that one was participating in an important national endeavor, advancing American science and education. The museum, as Peale presented it, was not his alone but a product of the collective energies of the American people. It was both founded on and promoted the ideals of sentimental political union.

In the museum, portraits of Revolutionary heroes and other notable Americans were arrayed in rows above glass cases filled with minerals, insects, and taxidermied animals (fig. 11). The orderly rows of natural history specimens, arranged according to Linnaean principles, were meant to illustrate the diversity, beauty, and harmonious order of God's creation. Peale hoped, according to historian David Ward, that this display of "nature's harmony

Fig. 11.
Charles Willson Peale and Titian Ramsay Peale, *The Long Room, Interior of Front Room in Peale's Museum* 1822. Watercolor over graphite pencil on paper, 14 × 20¾ in. (35.6 × 52.7 cm). Detroit Institute of Arts. Founders Society Purchase, Director's Discretionary Fund.

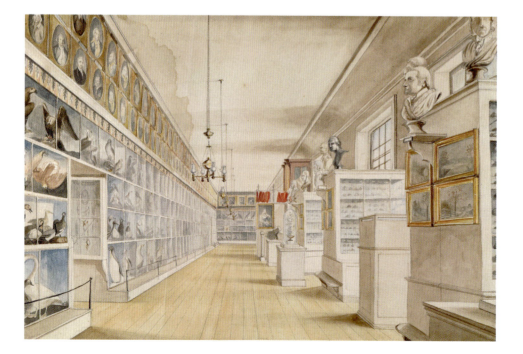

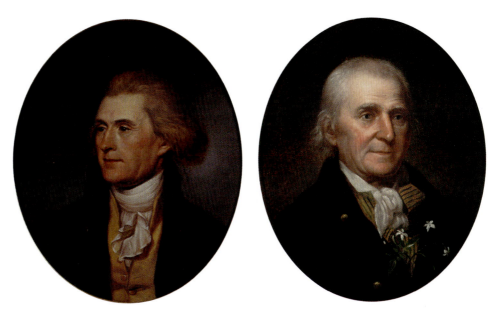

Fig. 12. (left)
Charles Willson Peale, *Thomas Jefferson*, 1791–93. Oil on canvas, 24 × 20 in. (60.9 × 50.8 cm). Independence National Historical Park, Philadelphia.

Fig. 13. (right)
Charles Willson Peale, *William Bartram*, ca. 1808. Oil on canvas, 23 × 19 in. (58.4 × 48.3 cm). Independence National Historical Park, Philadelphia. Bartram was an accomplished botanist.

would teach humans a lesson in greater harmony between individuals."[39] Meanwhile, the portraits, a meritocracy of men of varied class origins, presented models of civic virtue and patriotic sacrifice. The placement of the portraits above the specimen cases both implied the elevated position of the subjects, eliciting respect for them, and emphasized the place of human beings at the head of the Great Chain of Being. Peale explained to one visitor how the museum might bolster fellow feeling and lead to greater civic harmony: "Persons however estranged by each other, by private piques, by Religion or Politicks, here meet, as by accident, and have a concordance of sentiment in admiring the wonderful works of creation. . . . Here finding a similarity of Sentiment their prejudices subside and on a better acquaintance [they] find less cause for discention [*sic*]."[40]

Peale reinforced his cherished theme of social cohesion through the style and presentation of the portraits (figs. 12, 13).[41] Their uniform size and bust-length format, their identical framing with softening oval insets, their hanging side by side with frame touching frame, together with the warm lighting and the benevolent smiles playing across many of the faces, combine to create an impression of social concord and political solidarity. The figures appear as a brotherhood of public-spirited men united in a common cause: the creation of a new nation. Political factions dissolve here, with Democratic Republicans such as Thomas Paine and Thomas Jefferson standing shoulder to shoulder with staunch Federalists such as Alexander Hamilton and John Jay. Elite Virginia planters join Philadelphia brewers. Baltimoreans confederate with Bostonians. Together they offer visual testimony to Peale's commitment to sentimental political union.

As his leadership of the Whig Society suggests, Peale held strongly partisan political views, yet he also shared George Washington's concern that sectionalism and political factionalism were the greatest threats facing the fragile new nation. Hence his career-long commitment to fostering sentimental feelings among the nation's citizens, drawing them together as both cocreators and spectators of public celebrations and civic institutions, cultivating in them communal affections for their fellow citizens, the nation, and its leaders.

JOHN TRUMBULL

John Trumbull (1756–1843), like Peale, sought through his art to develop and strengthen sentimental political union.[42] Yet his politics and social values were more conservative and cosmopolitan. A proud member of the Society of the Cincinnati, a fraternal organization formed by American and French officers who served with Washington in the Revolutionary War, Trumbull preferred leadership by an elite of well-educated, well-born, propertied men.[43] Sensibility, in his view, was an attribute of the refined, distinguishing them from the lower order of common men. Such views permeated his art.

The eight paintings of his great Revolutionary War series sought to define a pantheon of American heroes and a mythology of founding events around which a national identity could cohere.[44] He hoped that the paintings would create a community of feeling among viewers, catalyzing in them shared emotions of affection and gratitude toward those who sacrificed to bring this country into being. In this respect, Trumbull's project aligns with Peale's ambitions of national unification, but in many other ways his patrician, class-bound perspective carried him in different directions. His conception of his audience, the themes he sought to convey, as well as the sentimental emotions he aimed to represent and evoke, differed substantially from Peale's. While Peale sought to engage a broad swath of citizens of varied class, occupation, gender, and age, Trumbull imagined his core audience as a cosmopolitan masculine elite. In particular he sought to foster sentimental feelings of brotherhood and reconciliation among a transatlantic fellowship of military officers and political leaders, the milieu in which he himself moved.

Trumbull was introduced in his youth to the Enlightenment culture of sensibility. His education, his military service, and his friendships, especially his close association with Thomas Jefferson—with whom he lived in Paris for a number of months in the late 1780s while working on his Revolutionary War paintings—immersed him in its values. Jefferson was deeply read in the literature on sensibility, not only in the moral sentiment philosophy of Shaftesbury, Hume, and others, but also in the new genre of the sentimental novel,

including Laurence Sterne's *Tristram Shandy* and *A Sentimental Journey*, which Trumbull purchased for him in London in 1789. From such readings, Jefferson derived a belief in humans' innate disposition toward sociability and benevolence, and would look to the social affections as an essential means of uniting American citizens. He took a keen interest in Trumbull's series, perhaps himself suggesting the subject of the most famous of the paintings, *The Declaration of Independence*, which the artist began while living with Jefferson.[45]

Trumbull attended Harvard College, graduating in 1773, as the colonies were heading toward war. One of his favorite classes was Moral Philosophy, in which he encountered the ideas of the Scottish Enlightenment, including an emphasis on the role of the affections in moral, social, and political life.[46] The core text was David Fordyce's *Elements of Moral Philosophy* (1754).[47] Fordyce asserted the universality of an inborn "moral sense" that "interests us in the concerns of others," constrains our selfish passions, and impels us to act for the greater social good.[48] For this Scottish philosopher, compassion was crucial to the development of both individual moral character and just political systems, which ought to promote and secure "the Happiness, the Rights and Liberties of Mankind."[49] From these foundational beliefs, Fordyce derived a liberal, even liberationist, politics, advocating the abolition of slavery as well as the rights of citizens to rebel against tyrannical governments. In words that must have resonated with the young Trumbull, he declared: "A real public consists of freemen, choosing or consenting to laws themselves. . . . To watch over such a System; to contribute all he can to promote its Good by his Reason, his Ingenuity, his Strength, and every other Ability, whether Natural or Acquired; to resist, and, to the utmost of his Power, defeat every Incroachment upon it . . . is the Duty, the Honour, the Interest, and the Happiness of every Citizen; it will make him venerable and beloved while he lives, be lamented and honoured if he falls in so glorious a Cause, and transmit his Name with immortal Renown to the latest Posterity."[50] Fordyce also defined an important role for the arts in the promotion of "public affections," arguing, for example, that "from admiring the virtues of others in moral paintings," the observer would "come to approve and imitate them himself."[51]

In a 1789 letter to Thomas Jefferson, Trumbull echoes Fordyce's views in explaining his rejection of the statesman's offer of a private secretary position:

> The greatest motive I had or have for engaging in, or for continuing my pursuit of painting, has been the wish of commemorating the great events of our country's revolution. I am fully sensible that the profession, as it is generally practiced, is frivolous, little useful to society, and unworthy of a man who has talents for more serious pursuits. But, to preserve and diffuse the memory of the noblest series of

actions which have ever presented themselves in the history of man; to give to the present and the future sons of oppression and misfortune, such glorious lessons of their rights, and of the spirit with which they should assert and support them, and even to transmit to their descendants, the personal resemblance of those who have been the great actors in those illustrious scenes, were objects which gave a dignity to the profession, peculiar to my situation.[52]

Trumbull added that he felt he was particularly suited to this task since he had "borne personally a humble part in the great events which I was to describe."[53] He had served for a year and a half in the Continental Army, from May 1775 to October 1777, until he resigned in a fit of pique over what he took to be the late awarding of his commission as lieutenant colonel. Perhaps feeling some remorse, the next year he volunteered as General John Sullivan's aide-de-camp as the Continentals sought to retake Rhode Island from the British. He returned home at the end of the short campaign.

Trumbull's early months in the army included a brief stint as second aide-de-camp to General Washington. He also witnessed, from a distance, the Battle of Bunker Hill. A year later, in June 1776, he was ordered to serve in upstate New York as a deputy adjutant general, tasked with assessing the condition of the troops—"the wretched remnant of the army" (about five thousand men) that had been driven by the British from Canada. He later recounted that he confronted there "in all their horrors, the calamities of unsuccessful war. . . . I did not look into tent or hut in which I did not find either a dead or dying man."[54] During his long months of military service, Trumbull encountered violence, suffering, incompetence, and disorder, but also many instances of courage and compassion. It was the latter that he sought to memorialize in his Revolutionary War paintings.

If Trumbull's Harvard education provided him with an intellectual introduction to the culture of sensibility, the army introduced him to its practical implementation. Leaders of both the Continental and British armies embraced and advanced new ideals of military heroism and military camaraderie that had arisen within it.[55] These ideals emphasized the military hero's compassion and benevolence as much as his courage and bravery. They also laid great stress on cosmopolitanism: true sociability and fellow feeling would, according to the values of sensibility, cross traditional boundaries of region, country, class, and race. This gave rise to the idea that officers would show compassion not just for their own troops but for the enemy as well.

While eighteenth-century sentimentalism in its most utopian forms sought to break down class and racial barriers, this martial sentimentalism tended to be more conservative and class bound. It was espoused primarily by the upper echelons of the military, many

of whom believed that the elite had stronger and more developed sensibilities than the lower classes. Within the Continental Army, senior officers such as General Robert Howe sought to unify the officer corps, to which Trumbull belonged, by diminishing competition and emphasizing instead sentimental values of fraternity and sympathy.[56] When Trumbull looks back on his military service in his autobiography, he dwells at length on displays of sympathy and humanity on the battlefront, devoting multiple pages to British commander Sir Guy Carleton's exemplary treatment of American prisoners of war. Sir Guy ordered his surgeons to treat the prisoners' wounds and then released them once they had given "their parole that they would not again take up arms against Great Britain." Trumbull thought this strategy of kindness and mercy so effective in diminishing the soldiers' will to fight that he had them sent immediately home, so that they would have no opportunity to communicate their warm feelings for Sir Guy to the other troops.[57]

Trumbull's Revolutionary War paintings were deeply embedded within the eighteenth-century culture of sentimentalism, which affected both their content and their public reception. They give pictorial expression to its ideals, with one of their most prominent themes being the compassion and benevolence shown by officers on both sides of the conflict.[58] For Trumbull's contemporaries—those who had lived through the upheavals of the war and its aftermath, those who had fought in and lost friends and family to it—the paintings could evoke a crescendo of sentimental emotions: patriotic pride, gratitude, and a keening sympathy with those who had both lost and given so much. Abigail Adams, for example, had a profound response to Trumbull's *The Battle of Bunker's Hill*, 1786, when she encountered it that year in the artist's London studio (fig. 14). She was bound by ties of affection to many who had died in the war, as well as schooled in the culture of sensibility, which encouraged viewers to draw on their own physical and emotional experiences to project themselves imaginatively into a picture's world. Stirred by the artist's ambition to, in her words, "immortalize by his Pencil those great actions, that gave Birth to our Nation," as well as, undoubtedly, her personal memories of watching the battle from a nearby hilltop, she found that "looking at it, my whole frame contracted, my Blood Shivered, and I felt a faintness at my Heart."[59]

Trumbull was greatly concerned with the historical accuracy of his series, yet he held his sentimental ideals dear enough that he was willing to introduce fictional incidents to support them. In the very center of *The Battle of Bunker's Hill*, British major John Small strides in from the right to prevent his grenadier from bayoneting the fallen American general Joseph Warren (fig. 15). Trumbull himself referred to this invented incident as a "pictorial liberty." He told his nephew-in-law that he introduced the scene "to afford an opportunity to do honor to [Major] Small." Small had, according to Trumbull, shown

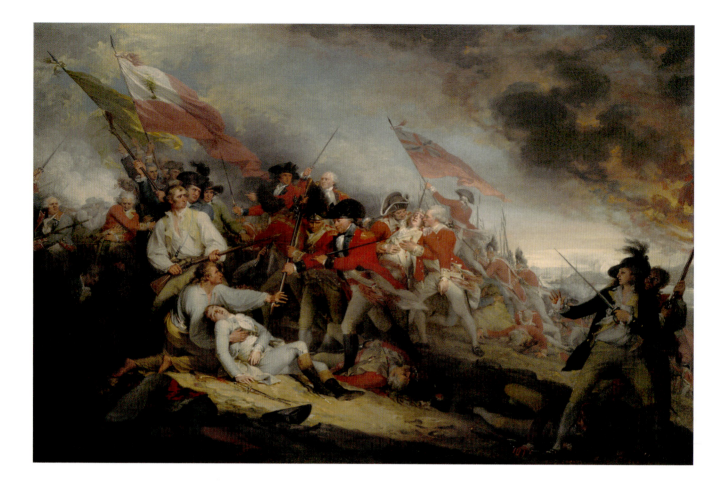

Fig. 14.
John Trumbull, *The Death of General
Warren at the Battle of Bunker's Hill,
June 17, 1775,* 1786. Oil on canvas,
25 ⅝ × 37 ⅝ in. (65.1 × 95.6 cm).
Yale University Art Gallery, New Haven.
Trumbull Collection, 1832.1.

Fig. 15.
Detail of Major Small preventing the
bayonetting of General Warren. John
Trumbull, *The Death of General Warren
at the Battle of Bunker's Hill, June 17, 1775*,
1786. Oil on canvas, 25 ⅝ × 37 ⅝ in.
(65.1 × 95.6 cm). Yale University Art
Gallery, New Haven. Trumbull
Collection, 1832.1.

"humanity and kindness to American prisoners," and therefore the artist showed him performing "a deed of mercy."[60] Many years later, in 1817, just after Trumbull was commissioned by the national government to create enlarged versions of four of his Revolutionary War subjects for the walls of the US Capitol rotunda, a tempest erupted in the Boston papers over whether or not Trumbull had overemphasized this theme, with one critic charging that in *The Battle of Bunker's Hill* Trumbull had celebrated "'British clemency' at the expense of his country's honor," elevating the active Major Small over the "prostrate" General Warren.[61]

In another painting of the series, *The Capture of the Hessians at Trenton, December 26, 1776*, 1786–1828, General Washington appears on horseback at the center of the image, directing one of his officers to care for the wounded Hessian commander Colonel Johann Rall (fig. 16). Though the scene is an imagined one, Washington did order his men to treat the captured Hessians with humanity, and it is possible that he met Rall as his own men were carrying him off the battlefield.[62] A dense cloud of battle smoke frames Washington's head like a luminous white halo as he looks down upon the Hessian officer with what Trumbull's nephew-in-law described as "an expression of deep sympathy and concern."[63]

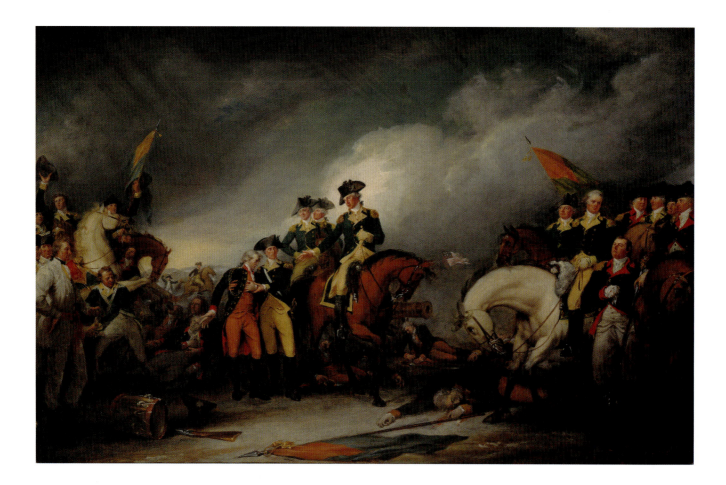

The carefully balanced tripartite composition lends an aura of religious solemnity to the scene. Trumbull said that he chose this subject "for the express purpose of giving a lesson to all living and future soldiers in the service of [their] country, to show mercy and kindness to a fallen enemy."[64] These were lessons in sentimental military heroism.

These paintings by Trumbull draw on another aspect of eighteenth-century sentimentalism—its integration with Christian beliefs. Hugh Blair (1718–1800), a Presbyterian minister, professor of rhetoric and belles lettres at the University of Edinburgh, and leading member of the Scottish Enlightenment, was perhaps the most prominent proponent of this Christianized understanding of the sentimental. In the United States of Trumbull's day, Blair's writings were much more widely known than those of Adam Smith or David Hume. His sermon "On Sensibility," for example, which presents sensibility as "an essential part of a religious character," was widely excerpted in American newspapers and periodicals.[65] It makes a case for Jesus as the archetypal man of feeling and for the New Testament

Fig. 16.
John Trumbull, *The Capture of the Hessians at Trenton, December 26, 1776*, 1786–1828. Oil on canvas, 20⅛ × 30 in. (51.1 × 76.2 cm). Yale University Art Gallery, New Haven. Trumbull Collection, 1832.5.

as abounding in passages that enjoin sensibility's cultivation: "We are commanded to love our neighbour as ourself . . . to be tender-hearted; to bear one another's burdens, and so to fulfill the law of Christ." Blair contends that sensibility, "a most amiable and worthy disposition of mind," deepens piety, encourages men to feel for their brethren, and prompts them to relieve others' suffering, thus improving the state of society. Indeed he asserts that this "favourite and distinguishing virtue of the age" has already "abated the spirit of persecution" and "even tempered the horrors of war."[66]

Trumbull had himself witnessed the impact of sensibility's values on the battlefield, and he joined Blair in underscoring their religious resonances. In *The Capture of the Hessians at Trenton, December 26, 1776*, Washington gestures toward the wounded German officer with outstretched arm and open palm, echoing the pose of Jesus in many images of Christ healing the sick, such as that by Rembrandt (fig. 17). To a pious Congregationalist like Trumbull, Washington's action modeled Christlike compassion and benevolence. Here, we witness Trumbull's sentimentalism functioning not only to kindle patriotic emotions in the viewer, but also—part of the same point—to heighten the significance of George Washington for the predominantly Christian new nation.

Trumbull summons before us a George Washington far different from Peale's (see figs. 5, 6). Both drew on the values of sensibility in shaping their images, yet Peale sought to humanize the powerful general, while in *The Capture of the Hessians*, Trumbull approaches deification. Peale renders Washington as amiable and accessible, drawing him closer to the people, inspiring feelings of affectionate regard. Trumbull ennobles, elevates, and distances him. His Washington solicits awed admiration and reverential gratitude. Gratitude, like affection, is a sentimental emotion, connecting us to others, yet it may also, as here, assert and reinforce social and political hierarchies.

Trumbull's and Peale's differing political values inflected not only their paintings, but also the ways they imagined and reached out to their audiences. Peale's conception of his audience was capacious, encompassing the entire citizenry of Philadelphia and, beyond that, of the nation as a whole. With his illuminations, floats, and triumphal arches, Peale took his art to the people, into the streets. When he first sought subscribers to his museum, he carried his subscription book from door to door, soliciting the patronage not just of the nation's political leaders, but also of carpenters, schoolmasters, and grocers. While he certainly hoped and intended to make a living from his artistic activities, he sought in the process to nurture national unity. He attempted to tailor his artistic production to his conception of the needs and interests of his countrymen.

Trumbull certainly believed that he too was working with the interests of the country at heart as he memorialized the events of the nation's founding, yet he seems not to have striven as Peale did to reimagine the role of art and the nature of patronage to conform to republican ideals, taking his cue instead from European models. This is unsurprising, since he began his Revolutionary War series in London in 1785, stimulated by a suggestion from his teacher Benjamin West, and began and nearly completed many of the paintings during his years abroad in Britain and France. As he launched his series, he confidently expected that it would "tempt" Europeans as well as Americans.[67]

Trumbull originally envisioned not selling the paintings but rather using them as the basis for high-quality engravings that he would offer through subscription. He sought subscribers first among the new nation's elected representatives and foreign ministers. He suggested that the federal government might wish to follow the lead of the king of France, who by custom ordered "one hundred copies of all elegant works engraved by his subjects," which he "distributed as presents to foreigners of distinction and taste."[68] He also sought the help of General Lafayette to locate subscribers in France, though this effort was thwarted by the outbreak of the French Revolution.

Trumbull did not place his Revolutionary War paintings on public exhibition, either abroad or in the United States, until 1818, when he began showing the four large replicas

of Revolutionary-era subjects that he produced for the US Capitol to paying audiences in major American cities, including Boston, Philadelphia, and New York. One could argue that charging twenty-five cents for admission to see the paintings was somewhat churlish of him, since they were handsomely paid for by the federal government and were thus the property of the American people. Nevertheless, the lack of public exhibition during the years Trumbull was working on the original series, together with their inception abroad, meant that those who saw them then were members of the elite—American, British, and French—who encountered them in Trumbull's various studios or at other private venues, such as Jefferson's home in Paris. It was in some ways natural, then, that this was the audience the artist saw in his mind's eye when he chose the incidents and characters for his pictures, and that at a time of high tension among these national groups, he not only aimed to create pictures that might please them all, but also sought through his imagery and themes to draw them together in sentimental fellowship, recognizing the heroism, magnanimity, and tender feelings that all had displayed in the course of the war.

At the end of their long lives, neither Trumbull nor Peale felt that their efforts to advance sentimental political union through their art had met with the success or the degree of public and institutional support they had hoped for. Subscriptions to their patriotic prints rarely recompensed their efforts, or even their costs. Attendance at their exhibitions was always lower than they expected or desired. Congress declined to support their agendas, refusing to nationalize Peale's museum or purchase Trumbull's Revolutionary War series. Trumbull's vision of reconciliation among the elites of Britain, France, and the United States was dimmed and dashed by the French Revolution and the War of 1812, and the factionalism that Peale lamented in the wake of the Revolutionary War hardly diminished with the passing years. Yet in the long run, their images have played an essential part in the construction of national memory. Many Americans continue to envision the founding events of the nation and the faces of the founders through these images, and thereby come to feel all the more deeply the sentimental bonds of nationhood that in visual art Peale and Trumbull were among the first to affirm.

Sentiment and Social Change

Slavery, Race, and the Art of Henry Ossawa Tanner

CHAPTER TWO

In the fractious political climate of the Jacksonian era, sentimental political union came to seem impossibly naive and ineffectual, as indeed many had seen it in earlier decades as well. Yet sentimentalism maintained its politically charged position on the public stage throughout the nineteenth century and into the twentieth, providing philosophical underpinnings and powerful rhetoric for many of the nation's teeming social reform movements and humanitarian campaigns, including abolitionism, child welfare, temperance, and women's rights. These efforts were part of what political scientist Michael Barnett has called the "Humanitarian Big Bang," the transatlantic "revolution in moral sentiments and the emergence of a culture of compassion," which, he asserts, "is one of the great unheralded developments of the last three centuries." Since the advent of the Enlightenment, many in the United States as well as in Britain and Western Europe have reimagined their ethical obligations to humanity, vastly expanding the compass of their care to embrace those distant and different from themselves.[1] While during and immediately after the Revolutionary War patriotism had been the ascendant sentimental emotion, in the antebellum era sympathy, compassion, pity, and benevolence came to the fore.

The key term in this development is "sympathy," literally "feeling with." Its foremost theorist was the Scottish philosopher Adam Smith, whose *Theory of Moral Sentiments* (1759) offered the Enlightenment's most sustained discussion of the human propensity for compassion. In the book, Smith contends that even "the greatest ruffian" among us is endowed at birth with a capacity for sympathy that, when nurtured and sustained, interests

us in the concerns of others and fits us for society. This sympathy, he argues, arises from an "imaginary change of situations" with the sufferer. In perhaps the most famous passage in the book, he explains: "Though our brother is upon the rack, as long as we ourselves are at our ease, our sense will never inform us of what he suffers. . . . It is by the imagination only that we can form any conception of what are his sensations. . . . By the imagination we place ourselves in his situation, we conceive ourselves as enduring all the same torments, we enter as it were into his body, and become in some measure the same person with him. . . . His agonies, when they are thus brought home to ourselves . . . begin at last to affect us, and we then tremble and shudder at the thought of what he feels." This imaginative projection into the mind and body of another gives rise to the "fellow feeling" that compels us when we hear his "plaintive voice of misery" to "fly to his assistance."[2] It is not only that we feel the pain of the sufferer (in a less intense, more distanced form), but also that we are prompted to take action. Sympathy produces changes in behavior, and as a consequence, Smith believed, its cultivation could transform society.

Smith's conception of sympathy, a form of perspective taking, corresponds to what current philosophical and psychological theory refers to as "high-level empathy." The philosopher Amy Coplan defines this as "a complex imaginative process in which an observer simulates another person's situated psychological states while maintaining clear self-other differentiation."[3] The word "empathy" ("feeling into") was unavailable to Smith, since it was not coined until 1908. While there is considerable debate about whether empathy is *necessary* for moral or ethical behavior, substantial evidence, especially the research of psychologists such as C. Daniel Batson, indicates that empathic concern motivates us, as Smith suggests, to alleviate others' suffering, even at a cost to our own welfare.[4] Whether the actions prompted are in the best interests of the sufferer, or of society more generally, is another question, which needs to take into account differing circumstances.[5]

The role Smith and other Enlightenment philosophers assigned to imagination and visualization in stimulating fellow feeling and prompting benevolent activity opened a place for the arts in humanitarian campaigns. In the nineteenth-century United States, dozens of artists—printmakers, photographers, sculptors, and painters, including Henry Ossawa Tanner, sought to advance social justice by transporting their audiences into imaginative inhabitation of the experiences and sensations of others. In addressing the feelings, the emotions, the hearts of their audiences, these artists situated themselves in the domain of the sentimental, which is concerned, above all, with the affective connections that bind us to others.

ABOLITIONIST IMAGERY

Participants in the era's social reform movements understood well the effectiveness of sentimental imagery in swaying public opinion and opening purses. Angelina Grimké, one of the fieriest social activists of the nineteenth century, was a women's rights advocate and an abolitionist who repudiated her South Carolina family's slaveholding. She wrote in 1836: "Until the pictures of the slave's sufferings were drawn and held up to the public gaze, no Northerner had any idea of the cruelty of the system, it never entered their minds that such abominations could exist in Christian, Republican America."[6] That same year, the editors of the *Herald of Freedom* offered an impassioned argument for the use of "pictorials" in the antislavery cause. They posed the question "Why do we use them?" and answered, drawing upon the language and logic of the sentimental, "because we would rouse feeling, would awaken and fix the attention; because we would carry the whole heart with us." Reason, they assert, is of little worth "unless the sympathies and affections of man be aroused to give to its decisions energy and effect." They argue that pictures imprint themselves more deeply on the mind than words, carrying the reader into scenes of the slaves' torments "as tho' he were among them and of them, an eyewitness and partaker of their woes." Abolitionists, they conclude, "know the influence of visual impressions."[7]

Among the most important vehicles for bringing abolitionist imagery before the public were the almanacs produced by antislavery societies in major northern cities from the 1830s into the 1850s.[8] With printings in the tens of thousands, and costing only about six cents, these almanacs reached a wide audience in the North and penetrated, marginally, into the South. They integrated an almanac's standard astronomical information, such as tide charts and daily sunrise/sunset times, with images and writings supporting the abolitionist cause. Small-scale wood engravings, usually one per month, were often accompanied by captions and short essays that amplified their sentimental appeals.

One example, the illustration for July in *The American Anti-Slavery Almanac* of 1838, depicts an enslaved family torn apart by the sale of the father (fig. 18). The scene takes place on a road before a substantial house. The figures are pressed into the foreground and arranged in a triangle that conveys both their power relations and the narrative's emotional essence. To the left, a mother and children raise their hands in supplication and despair as the mounted white slave driver at the center, his whip raised to the apex of the triangle, drives the father, on the right, away from his family. The father stands still, his feet firmly planted, as he turns to fix his gaze, probably for the last time, on his wife and children. Yet despite the firmness of his stance, a rope binds his hands and tethers him to the horse; the

rightward slant of the other figures' bodies and the gait of the horse seem to propel him forward, widening the space between him and his family as we look on. The caption beneath the image directly addresses the reader: "Consider the desolation which would be brought upon YOUR family, if the head of it should be taken away."⁹

The intimate address of the caption, the personal appeal, the cry from the page, is enhanced by both the almanac's format and its function. These are slim, paperbound, pocket-sized volumes, only about 4 × 7 inches in size—light enough and small enough to be held easily in the hand. They were an integral part of families' domestic routines, often consulted on a daily basis. Each time the almanac's readers opened its pages to check the time of high tide or moonrise (the engraving described above shared its page with a chart laying out the month's lunar cycles), they were reminded that while they were carrying out the ordinary activities of the day, elsewhere others were enduring or succumbing to unspeakable horrors.

In some of the almanacs, such as the Boston-published *New England Anti-Slavery Almanac*, the reader moved by such thoughts could find, in the front of the volume, suggestions for action. There a list with the heading "Things for Abolitionists to Do" directs them to speak and write for the slave, to "plead his case everywhere," to petition their legislatures for the immediate abolition of slavery and for the "repeal of all laws graduating rights by the *skin*," to distribute antislavery publications, to "work for free people of color," and to see that "your schools are open to their children," that merchants take them on as clerks, mechanics as apprentices, and physicians as students, and that "if the place of worship which you attend has a negro seat," you "go and sit in it."¹⁰

GOING AWRY

As powerful and effective as sentimental appeals could be in advancing abolitionist and other social reform efforts, they could also go markedly, dangerously awry. Marcus Wood has argued that images and narratives of the horrific physical abuse of enslaved people fed an eroticized fascination, and were produced and consumed, at least by some, as sadomasochistic pornography.[11] Even the best-intentioned humanitarian efforts were, and are, laced with pity and paternalism, which establishes and reinforces status divides. Those who extend their sympathies and care feel elevated above the suffering. So satisfying may some find these feelings that they come not only to seek out, but also to crave others' suffering as opportunities to indulge in and display their sympathetic, charitable natures. This is the argument that Friedrich Nietzsche makes with scornful force later in the century in *Beyond Good and Evil* (1886) and *The Anti-Christ* (1888).

Moreover, all too often humanitarian efforts such as abolitionism have been carried out without inquiry into the interests and desires of those who are being "helped." Many white abolitionists and Christian missionaries, for example, publicly espoused discourses of human equality while also subscribing to pseudoscientific notions of racial and cultural hierarchies. They believed in the superiority of their own cultural norms and sought to impose them on others, without truly believing or desiring that those they were aiding would ever rise to an equal status with themselves. In his searing indictment of Harriet Beecher Stowe's *Uncle Tom's Cabin*, the most famous sentimental novel of the nineteenth century, James Baldwin excoriates the author for reducing her black characters to ciphers for suffering, denying them the fullness and complexity of true personhood. He argues that her characterizations, in which race is the defining trait, "actually reinforce . . . the principles which activate the oppression which they decry."[12] Literary scholar Laura Wexler considers sentimental texts such as Stowe's to be mechanisms of white middle-class domination, tools in an imperialist project "aimed at the subjection of different classes and . . . races."[13]

Wexler also turns her incisive gaze on visual imagery. She describes "before" and "after" photographs taken of Native American children at turn-of-the-century Indian schools, such as the Carlisle Indian Industrial School in Carlisle, Pennsylvania. Pictures were taken when the children arrived and again some months later (figs. 19, 20). In the "after" images, the boys' hair is shorn, and the girls are clothed in gingham dresses neatly covered with white aprons. Sometimes the children are seated on swings or at tables with checkerboards, suggesting conformity to the norms of white middle-class childhood. Such photographs assured the schools' benefactors that these children were being "civilized," the discourses of domestic sentiment and benevolence masking the cruelty of stripping the children of their families, clothing, religion, and language.

Fig. 19.
John N. Choate, "Before" image of four Pueblo Children at the Carlisle Indian Industrial School, ca. 1880. Cumberland County Historical Society, Carlisle, PA.

Fig. 20.
John N. Choate, "After" image of four Pueblo Children at the Carlisle Indian Industrial School, ca. 1880. Cumberland County Historical Society, Carlisle, PA.

The sentimental is a politically malleable rhetoric. It is inherently neither progressive nor conservative. While it has been effectively deployed in advancing radical social reforms, it has also been turned against them. For example, both during and after the Civil War, apologists for slavery drew on sentimental discourse to conjure a benign institution of caring masters and grateful, contented slaves. Typical of this group was the postbellum writer James Lane Allen (1849–1925), a white Kentuckian. His "Mrs. Stowe's 'Uncle Tom' at Home in Kentucky" appeared in the October 1887 issue of *Century Magazine*, illustrated with seventeen wood engravings by Edward Kemble (1861–1933). Allen assures his readers of the "mildness" of Kentucky slavery. The slaves were so well cared for (with only "bad ones" sold South) that, he believes, history will eventually adjudge it a virtuous institution that "greatly elevated and humanized" its subjects. He attributes what he considers the excellent state of race relations in the Kentucky of his day to the "kind, even affectionate, relations of the races under the old regime." These "have continued with so little interruption that the blacks remain content with their inferiority, and lazily drift through life."[14]

Kemble's illustrations reinforce Allen's assertions of tender, mutual affection between owners and slaves. In the image captioned "The Mistress," an elderly, sunken-eyed enslaved woman lies abed in her rustic cabin (fig. 21). She folds her hands as in prayer, seemingly offering thanks for the appearance of her white owner, who has just stepped through the

Fig. 21.
Edward W. Kemble, "The Mistress,"
illustration for James Lane Allen,
"Mrs. Stowe's 'Uncle Tom' at Home
in Kentucky." *Century Magazine*,
October 1887.

Fig. 22.
Edward W. Kemble, "Saving His
Master," illustration for James Lane
Allen, "Mrs. Stowe's 'Uncle Tom' at
Home in Kentucky," *Century
Magazine*, October 1887.

door with a crock of steaming soup in her hands. Furthering the religious imagery, Kemble deploys the light streaming through the window to form a halo around the head of this angel of mercy.

In "Saving His Master," Kemble picks up on Allen's description of faithful slaves accompanying their young owners into the Confederate army, carefully watching over them on and off the battlefield (fig. 22). In this image, a middle-aged black man, his beard graying and his clothing tattered, wades across a stream with his wounded blond owner in his arms. The young man in his Confederate uniform—so young that he appears hardly more than a boy—is unconscious. His head tilts back and his right arm dangles uselessly at his side in a pose obviously derived from that of Jesus in Michelangelo's Vatican *Pietà*. In the distance, against a turbulent sky, men with rifles seem to be searching for the pair, a detail that Kemble employs to heighten the scene's dramatic tension and enlist our sympathies with the hunted. Here Kemble seeks to depict what Allen insists is missing from accounts of Southern slavery: "*the love*" (italics original).[15]

THE MISTRESS.

SAVING HIS MASTER.

HENRY OSSAWA TANNER

During this period, as Allen and Kemble were joining other white authors and artists in creating a sentiment-saturated imagery of black inferiority and grateful subservience, Henry Ossawa Tanner (1859–1937) enlisted his art in campaigns for social justice and racial equality. The Pittsburgh-born African American artist, who studied under Thomas Eakins at the Pennsylvania Academy of the Fine Arts from 1879 into the 1880s, first turned his artistic attention to such issues in 1893, so I begin his story then. While his work is itself not entirely free from race and class prejudice, Tanner became one of the foremost sentimental painters of his time, using the language of sentiment to unsettle and reorient our perceptions of others and eloquently show our connectedness to them.

Thirty anniversaries of the Emancipation Proclamation had passed when the World's Columbian Exposition opened in Chicago in 1893. The great "White City," illuminated at night by more than a hundred thousand electric bulbs, commemorated Columbus's landing in the Americas and marked the United States' arrival as a major world power. Many prominent African Americans saw the exposition as a significant opportunity for racial advancement and hoped that it would enable them to highlight their achievements since Emancipation.

The Congress on Africa, an eight-day symposium held that August in conjunction with the fair, provided one such forum. The speakers, both black and white, from Africa, Europe, and the United States, included Henry Tanner, then a thirty-four-year-old art student home temporarily from Paris.[16] His painting *The Bagpipe Lesson*, 1892–93, a genre scene set in Brittany, was on view at the fair (fig. 23). According to a symposium participant, Tanner's paper, "The American Negro as Painter and Sculptor," "claimed that actual achievement proves negroes to possess ability and talent for successful competition with white artists." Another speaker "stated facts about American negroes in manufactures and trade that were a revelation to many." Yet despite these notes of optimism, other speakers drove home the nearly overwhelming challenges faced by African Americans, some unintentionally, as when the former Confederate general Glenn argued that slavery had had a "civilizing" influence on American blacks.[17] In truth, the great majority of African Americans were little better off in 1893 than they had been in the immediate aftermath of the Civil War, facing an epidemic of lynchings, consignment to menial jobs, disenfranchisement, segregation, and daily humiliations. When Frederick Douglass took the conference stage, he denounced, "in the voice of the storm," the notion that the United States had a "Negro Problem." The problem, he thundered, "is whether the American people have honesty enough, loyalty enough, honor enough, patriotism enough to live up to their own Constitution. . . . We intend that the American people shall learn of the brotherhood of man and the fellowship of God from our presence among them."[18]

Fig. 23.
Henry Ossawa Tanner, *The Bagpipe Lesson*, 1892–93. Oil on canvas, 45 × 68¾ in. (114.3 × 174.63 cm).
Collection of the Hampton University Museum, Hampton, VA.

Tanner heard. The sentiments would have been familiar to him. His own father, Benjamin Tucker Tanner (1835–1923), a bishop in the African Methodist Episcopal Church, who had also prepared a paper for the Chicago conference on African Americans in journalism, had for some time vigorously argued, according to his biographer, that blacks "were God's instrument . . . to make America live up to her declared principle of 'liberty and justice for all'" and that "if so-called Christians really accepted the truth of Jesus Christ's teachings, they would accept all men as brothers."[19]

Though Henry Tanner had grown up with such beliefs, something about his experiences in the summer and fall of 1893—his time at the World's Columbian Exposition, his reencounter with the shocking brutality of American racism after two virtually prejudice-free years in Paris, his deepening engagement in the A.M.E. Church during his months at home—moved him to turn his art in a new direction.[20] He left behind the Barbizon-inflected landscapes that had preoccupied him through much of the previous decade, and never repeated the humorous genre of *The Bagpipe Lesson*. Instead, his art took a profoundly sentimental turn. His paintings became soft-spoken yet deeply felt meditations on injustice, prejudice, and ethnic hatred, subtly addressing issues of social justice through the language of sympathy. The central aim of his art became, as he explained in 1924, quoting from Shakespeare's *Troilus and Cressida*, "to give the human touch 'which makes the whole world kin' and which ever remains the same."[21] From 1893 on, words such as "sympathy," "pathos,"

"tenderness," "heartfelt emotion," and "depth of feeling" become key terms both in reviews of Tanner's work and in his own assessments of his art.

Tanner was a man of feeling. His writings evidence repeatedly his acutely sympathetic responses to others' pain and his belief in the virtues of such sympathy. In discussing his painting *The Wise and Foolish Virgins*, 1907–8 (location unknown), he expressed his desire "to take off the hard edge too often given to that parable." Instead of representing the wise virgins as "good but cold and unlovable . . . I attempted to show that they were sympathetic for their sisters in distress, and that this sympathy was one of their beauties."[22] Visiting Cairo in 1897, Tanner witnessed "the return of Egyptian soldiers from the Soudan campaign." Happy groups embraced each returning man: "Such rejoicing I have never seen—I rejoiced with them. But I saw some sad faces standing on the outskirts of the crowd—possibly waiting for sons or husbands who never came. This alone destroyed one's complete happiness—it did seem they would be torn to pieces."[23] His intense identification with the suffering of others could affect him powerfully enough to interfere with his ability to paint. During World War I, he fled from his French home to England, where he found himself unable to work: "One reads the papers all day—but only once in a while, thank God, does one realize the suffering and despair that is contained—a sentence like 40 killed, 400 killed, 4000 missing, 400,000 losses. How many loving, carefully raised sons in that number, how many fathers, how many lonely wives, mothers, children, sweethearts, waiting for the return that never comes . . . this is why I cannot work."[24]

Tanner's expansive empathy, his compassionate regard for the suffering of others, his extraordinary ability to think himself into their circumstances and imagine their psychological and emotional states, was the wellspring of his art. For Tanner, a devout Christian, sympathy also had a sacred significance. As it was for Enlightenment thinkers, such as the Scottish minister Hugh Blair (whose writings Tanner's father admired),[25] it was a Christian virtue, enjoined on Christ's followers by Paul in his Epistle to the Romans: "Rejoice with them that do rejoice, and weep with them that weep" (Romans 12:15). It created a community of feeling that transcended nation, culture, and ethnic group. It "made the whole world kin."

Tanner's turn toward sentimental subjects seems to have begun with an assignment from *Harper's Young People* in 1893. He was to illustrate a tender, tear-welling story, "Uncle Tim's Compromise on Christmas," by the popular white Southern writer Ruth McEnery Stuart (1849–1917).[26] In the three-page story, a black grandfather and his orphaned grandson share a shabby hut on a Louisiana plantation—whether before or after the end of slavery is unclear. On one smoke-stained wall of the hut hangs a musical instrument: "The only thing in the world that the old man held as a personal possession was his old banjo."

So many times had the old man promised to pass it to the boy when he died, that the child, who longs to own the instrument but cherishes his grandfather far more, has come to associate it with "death and utter loneliness." Uncle Tim's Christmas compromise is to give the instrument to the boy with the understanding that they will share it as long as they are together in this life.

Written in Southern black dialect, with honeysuckle-scented nights and fond memories of the "marster," this story of love transcending poverty stands out as an example of romantic racialism. But if there is condescending pity in Stuart's handling of her characters, there is none in Tanner's pictorial response, neither in his illustration nor in the painting that grew from it, his most famous, and perhaps most sentimental picture, *The Banjo Lesson*, 1893 (figs. 24, 25).[27] Both images drew inspiration from one particular passage in Stuart's story: "At all hours of the day or evening, old Tim could be seen sitting before the cabin, his arms around the boy, who stood between his knees, while, with eyes closed, he ran his withered fingers over the strings, picking out the tunes that best recalled the stories of olden days that he loved to tell into the little fellow's ear. And sometimes, holding the banjo steady, he would invite little Tim to try his tiny hands at picking the strings."

In *The Banjo Lesson*, Tanner, with his tender, sympathetic regard for his characters, his respect for them as human beings, and his attentiveness to their feelings, bestows on them the protective power of his esteem. He endows them with the dignity of their self-possession. The elderly man and child are posed at the center of the canvas in a pool of

Fig. 25.
Henry Ossawa Tanner, *The Banjo Lesson*, 1893. Oil on canvas, 49 × 35½ in. (124.46 × 90.17 cm). Collection of the Hampton University Museum, Hampton, VA.

warm light. Both are completely absorbed in the music lesson, the child concentrating on his fingering, the grandfather's head slightly cocked and eyes downcast as he listens intently. The grandfather is seated, spread legged, on a straight-backed chair; the pose is stable, pyramidal, a metaphor for his steadying presence in his grandson's life. His form encloses the boy's, allowing us to feel their bonds of affection.

The arrangement of the figures into a single, centered, stable form is familiar from countless religious paintings. But it is light more than any other device that sanctifies the scene. Firelight (from the hearth on the right) and sunlight—interior and exterior illumination—envelop the pair. The light that floods across the back wall, painted with feathery strokes of pastel pink, blue, yellow, and white, forms a halo around the pair's heads. Its luminous glow also transforms the still life on a countertop behind them into a domestic altar of snowy white cloth, vessels, and broken bread. The painting celebrates, in its quiet way, the sacrament of love.

When Tanner explained his attention to African American subjects at this moment in his career, he used the language of the sentimental. He wrote of his "desire to represent the serious, and pathetic side of life among them." White artists "who have represented Negro life have only seen the comic, the ludicrous side of it, and have lacked sympathy with and appreciation for the warm big heart that dwells within such a rough exterior." Sympathy for him was key: "He who has most sympathy with his subject will obtain the best results."[28] Such sympathy suffuses and consecrates *The Banjo Lesson*.

Some have seen an element of condescension in Tanner's rendering of his subject: he is a member of the African American elite, painting a poor Southern sharecropper, offering through that representation a model of serious, sober, decorous behavior that many members of the Talented Tenth, like himself, believed was essential for racial uplift. But for me what is more noteworthy is Tanner's effort here to bridge the difference between himself and the figure he represents—and to invite us to do the same. This is, after all, one of the commitments we find repeatedly in sentimental art: to feel and come to value the experiences of persons different from ourselves.

With *The Banjo Lesson*, Tanner spoke back to those who had questioned the ability of black artists to create great art; he also answered those, like the ex–Confederate general at the Congress on Africa, who sought to cast African Americans as less civilized, less feeling, than whites. He took to heart and put into action Frederick Douglass's words at the fair: "We intend that the American people shall learn of the brotherhood of man and the fellowship of God from our presence among them."

William S. Scarborough, an African American scholar of classical languages and a Tanner family friend who read Bishop Tanner's paper at the Congress on Africa, considered

The Banjo Lesson a salvo in the battle for social justice and racial equality. He wrote in 1902, when he was serving as vice president of Wilberforce University, "When 'The Banjo Lesson' appeared many of the friends of the race sincerely hoped that a portrayer of Negro life by a Negro artist had arisen indeed. They hoped, too, that the treatment of race subjects by him would serve to counterbalance so much that has made the race only a laughing-stock subject for those artists who see nothing in it but the most extravagantly absurd and grotesque." But, he continued, "This was not to be."[29] By 1895, Tanner had returned to France where he would live, with occasional extended trips back to the United States, until his death in 1937. In France, he turned away from African American subjects and instead focused on biblical scenes, becoming one of the greatest religious painters of his time. This both was and was not a change of direction for him. Tanner's subjects shifted, but he continued to highly value the sentimental and remained dedicated to social justice.

TANNER IN PARIS

In paintings such as *The Resurrection of Lazarus*, *Nicodemus Visiting Jesus*, *Two Disciples at the Tomb*, *Daniel in the Lion's Den*, and *The Annunciation*, Tanner pressed home his constant themes: human kinship, universal brotherhood, and the equality of all before God. Dewey Mosby, Jennifer Harper, and other scholars have argued that Tanner chose biblical subjects that resonated with the historical and contemporaneous struggles of African Americans. These subjects, according to Mosby, "are easily linked to messages of human rights and social justice, and they relate to issues of equality."[30] While accepting these arguments, I would add that during his time in Paris, Tanner's humanitarian spirit expanded to embrace issues of anti-Semitism as well. He folded these concerns into his broader consideration of human dignity and spiritual equality, and drew on the values and techniques of sympathy to address them through his art.

Such a concern would have been in keeping with the values of Tanner's family. The views that Tanner's father expressed show traces of anti-Catholic and anti-Semitic prejudice, but he nevertheless maintained that members of one oppressed group should stand up in support of others. In that spirit, he vigorously opposed the Chinese Exclusion Act of 1882 and "urged Christians to protect the Chinese from mob actions in California."[31] In 1890, not long before his son left for art school in Paris, Bishop Tanner spoke out against the persecution of Russian Jews, for "if black is not to give to white, how can white be expected to give to black."[32]

In Paris, Henry Tanner found himself finally free of the daily torments of American racism. He reported that in France "I never suffered anything on account of my color."[33] Yet he could not have escaped reading and hearing of the virulent anti-Semitism that infected so many in France, especially during the years of the notorious Dreyfus affair. He must have understood, as well as anyone in France, what it meant to be subjected to such persecution. How could he, with his acute sensitivity to the suffering of others, not be affected by it? Tanner's niece, Sadie Tanner Mossell Alexander, recalled that her uncle had such overwhelmingly emotional reactions to prejudice that he generally chose "to deal with this problem obliquely."[34] His religious paintings were one outlet. While I do not wish to reduce them to allegories of social justice and racial amity, I share with others the belief that these were among the meanings that they bore.

The Resurrection of Lazarus, 1896, established Tanner's reputation in Paris (fig. 26).[35] Accepted for the Salon of 1897, it was awarded a third-class medal, won the endorsement of critics, and was purchased by the French government for the Musée du Luxembourg. There it joined a tiny handful of American paintings, including Whistler's *Arrangement in Gray and Black: Portrait of the Artist's Mother*, 1871 (now in the Musée d'Orsay). Tanner knew well that his success was not his alone. Booker T. Washington reported that Tanner "feels deeply that as the representative of his people he is on trial to establish their right to be taken seriously in the world of art."[36] The honors won by *The Resurrection of Lazarus* were widely reported in the American press. A writer for an African American newspaper, the *Cleveland Gazette*, described the hanging of Tanner's canvas in the Luxembourg Gallery as "the greatest victory the American Negro has ever won. . . . Surely this victory which this colored painter has obtained for his downtrodden brethren is the beginning of a new era for them, an era that shall place them in the front ranks of civilization."[37] Tanner's family proudly offered photographs of the painting for sale in the pages of the *Western Christian Recorder*, an A.M.E. Church publication.[38]

The painting represents one of the most astonishing of Jesus's miracles, his raising of his faithful follower Lazarus from the dead. The scene takes place in a cavern, lit by unseen torches whose flames create dramatic lights and shadows on the faces and figures of those gathered at the grave. Jesus stands with his hands outstretched, his fingers crooked upward, summoning Lazarus to rise. Lazarus, in the immediate foreground, half sits, half reclines within the grave. The onlookers respond to the miracle in theatrical gestures of wonder and awe. Their eyes widen in amazement; their mouths gape; they lift their hands in thankful jubilation and clasp them in prayer. They have seen the promise of Christian resurrection fulfilled.

Fig. 26.
Henry Ossawa Tanner, *The Resurrection of Lazarus*, 1896. Oil on canvas, 37 3/8 × 47 13/16 in. (95 × 121.5 cm). Musée d'Orsay, Paris.

As many observers have noted, then and since, the painting owes a significant debt to Rembrandt, the artist Tanner esteemed above all others, in its tawny palette, its dramatic chiaroscuro, and its emotional depths. Many years later, Tanner explained his admiration for the Dutch artist to the young painter Hale Woodruff (1900–1980), describing Rembrandt's ability to combine "a sense of order, structure, and organization" with "the important elements of humanity and feeling." He expressed a special reverence for *The Hundred Guilder Print (Christ Healing the Sick)*, which he certainly had in mind when he was creating *The Resurrection of Lazarus* (see fig. 17). The etching's composition, he told Woodruff, is "tremendous in its impact," the "dark and light areas help create the drama which one can feel and sense," and the subject, "a man showing his compassion for his fellow man," is "eternally moving." Woodruff felt that Tanner, through his discussion of Rembrandt, was expressing "those precepts which had guided him" and formed him as an artist.[39]

By the time Tanner painted *The Resurrection of Lazarus* in 1896, a long rhetorical tradition in the United States had linked this biblical story with black emancipation. Lazarus figured in slave work songs and spirituals, and abolitionists compared his resurrection to the freeing of bondsmen and women from the long dark night, the living death, of slavery.[40] In 1827, Angelina Grimké, in her *Appeal to the Christian Women of the South*, told the story of Lazarus, then added: "This is just what Anti-Slavery Societies are doing; they are taking away the stone from the mouth of the tomb of slavery." Sojourner Truth compared herself to Mary and Martha, summoning Jesus to the aid of their brother Lazarus.[41] The Reverend Henry Ward Beecher, Harriet Beecher Stowe's brother, likened the education of blacks in the wake of Emancipation to the removal of the bandages from Lazarus's eyes.[42] So pervasive was the Lazarus trope that at least some of Tanner's American viewers are likely to have linked his painting's subject to "the struggles and hopes of Black Americans," as scholar W. H. Burgess and others have suggested.[43]

Tanner's inclusion of a black man among Jesus's followers could have encouraged such associations. This turbaned African's presence also does something more. Tanner's father wrote extensively about the issue of race in the Bible. He pointed out the tendency of whites to assume that if racial identity is not mentioned in the Bible, then a character must be white. This, he observes, is not true. The people in the Bible are quite diverse. In his 1869 essay "The Negro's Origin," he writes that inhabitants of the postdiluvian world sprang from the sons of Noah: Shem, Ham, and Japheth, the progenitors of the yellow, black, and white races.[44] Countering the claims of white racists that Noah's cursing of Ham condemned his black descendants to perpetual inferiority and servitude, Bishop Tanner argues both that Noah cursed not his son Ham but the land of Canaan, and that the Bible contains no indication of prejudice against the black race: Solomon had Hamitic blood, Moses

married an Ethiopian, and "Symeon that was called Niger," a black man, helped Jesus carry the cross to Calvary.[45]

Henry Tanner, in his religious paintings, seems to have been as intent as his father on unsettling contemporary assumptions and expectations of the appearance of biblical characters. In *The Resurrection of Lazarus*, he assembled a heterogeneous group of witnesses at Lazarus's tomb: men and women, young and old, with skin shades varying from pale cream to dark coffee. Next to the black African stands a man with the broad pale face of a white European, and next to him, on the far left, a woman who could be an Arab. By Bishop Tanner's reckoning, they represent the three branches of Noah's descendants, unified here as testators to the miracle of resurrection. There is no hierarchy, no segregation, in the fellowship of Christ. This is brilliantly conveyed by the composition. Jesus and his followers form a single compositional unit, a triangle. Triangular compositions are conventionally used to represent hierarchies, but not so here. The slanting sides of the triangle rise and meet at the top of the canvas in the strip of white light that marks the entrance to the cavern. The triangle peaks not in the figure of a main protagonist but in figures so blurred by darkness and distance that any identifying features are illegible. Any viewers could read themselves into this crowd. Moreover, where the right side of the triangle reaches the foreground, it is picked up by the curving arm of the bearded man supporting Lazarus. This curve continues through Lazarus's outstretched arm and flows leftward along the edges of the white cloth back up to the woman on the far left and into the left edge of the triangle. Thus the triangle becomes an oval, unifying all the figures in a compositional analogue of the inclusiveness of Christian community.

For Tanner's contemporaries, however, it was not the diverse array of followers in *The Resurrection of Lazarus* that they found most striking but the representation of Jesus. Art historian Alan Braddock has argued that in paintings such as *Lazarus* and *Nicodemus Visiting Jesus*, 1899, Tanner created "an ambiguous racial construction of Christ" (fig. 27). This "figure of universality," he contends, "offered a critique not simply of racism, but of 'race' itself as an epistemological category."[46] But in Tanner's time, viewers both French and American, black and white, invariably read Tanner's Jesus not as racially ambiguous but as a Jew— and conspicuously so, with sparks of anti-Semitism occasionally flaring in their descriptions. A critic for *L'Artiste* admired "the majesty" of Christ in *The Resurrection of Lazarus* "in spite of undeniably Semitic features."[47] Scarborough wrote of the picture that Tanner "studied to 'put race in it,' . . . showing us the Jew as he must have lived and looked nearly twenty centuries ago."[48] A critic for the *Outlook* noted the "Hebrew types" in *Nicodemus Visiting Jesus*.[49]

Fig. 27.
Henry Ossawa Tanner, *Nicodemus
[Nicodemus Visiting Jesus]*, 1899.
Oil on canvas, 33¹¹⁄₁₆ × 39½ in.
(85.57 × 100.33 cm). The Pennsylvania
Academy of the Fine Arts, Philadelphia.
Joseph E. Temple Fund.

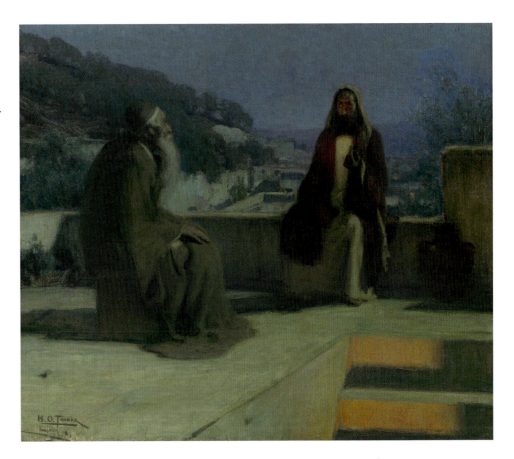

Tanner represented Jesus and other Jewish figures in his paintings with the lean faces, thick black hair, prominent noses, and, to use Tanner's own word, "swarthy" complexions that conform to contemporary stereotypes of Jewish appearance.[50] One could conclude from this that Tanner shared to some extent in the anti-Semitic prejudices of his time. Perhaps he did, and yet while viewers immediately identified the figures as Jews, they also commented repeatedly on the "magical, sympathetic quality" with which Tanner invested them.[51] Unlike most religious painters, he did not align spiritual grace with conventional and, especially, European-defined physical beauty. What he did do was to treat his biblical characters with "deep reverence" and "sympathetic comprehension," as a writer for *Current Literature* noted in 1908.[52] He sought to transport his viewers into their presence and, emphasizing a shared humanity, open paths to empathetic identification with their thoughts, feelings, and circumstances. Tanner complicates our responses to race and ethnicity, invoking stereotypes in scenes and subjects that make us question them: thoughtfully, and with great skill, he makes us see difference differently.

The *Outlook* critic felt himself empathetically engaged by *Nicodemus Visiting Jesus*. In this twilight scene, Nicodemus and Jesus converse earnestly on a Jerusalem rooftop. The elderly Nicodemus, a Pharisee and ruler of the Jews, has come secretly at night to hear more of Jesus's teachings. He would become a convert and be present at the Crucifixion, helping to lower Jesus from the cross and prepare his body for burial. Tanner conveys the intensity of their meeting. Nicodemus is seated on a low block, his hands on his knees, leaning forward and listening raptly. His gaze directs ours to Jesus, who, though set farther back in the pictorial space, commands the scene. Seated on the roof's parapet and silhouetted against the evening sky, his form is frontal, stable, pyramidal, the steadying center of the unfolding narrative. Light floods up a stairwell, glowing apricot on the stairs' risers, and perhaps reflecting onto Jesus's breast, though that mysterious white glow may also be an emanation from within. The most sharply focused passages in the painting are Jesus's right hand, lifted in a gesture of speech, and his piercing eyes. He is telling Nicodemus, "Except a man be born again, he cannot see the kingdom of God." Tanner makes manifest that Jesus not only sees but also is of that kingdom. The *Outlook* critic found himself thoroughly absorbed in the scene and deeply impressed by the artist's "heartily expressed emotion" and ability to engage the viewer's sympathies. He writes: "So subtle is the painter's power as not only to make one feel that which the characters of the picture, Christ and Nicodemus, are exchanging—one may even dare to think their thoughts after them."[53]

Another critic, Florence Bentley, writing in the *Voice of the Negro*, further emphasizes the emotional, sentimental dimension of Tanner's work, especially as it involves his Jewish characters. She was struck by the compositional simplicity of Tanner's *Two Disciples at the Tomb*, which had just then, in 1906, been purchased for the permanent collection of the Art Institute of Chicago (fig. 28). This nocturnal scene depicts the half-length figures of Peter and John peering into Jesus's empty tomb, as the miracle of his resurrection dawns on their faces. "The men," Bentley observes, "are very plain looking and of a strong Jewish type." Yet through the faces of these "two poor Jews," Tanner "tells a human story which finds its way into every human heart."[54]

Eliciting sympathetic feelings toward Jews bore special meaning in the years of the Dreyfus affair, which dragged on from the mid-1890s into the 1910s.[55] In October 1894, at just about the time that Tanner returned to Paris, the French army officer Captain Alfred Dreyfus (1859–1935), an Alsatian Jew, was arrested and accused of passing military secrets to the Germans. Within months, he was convicted of high treason and sentenced to life imprisonment. While he and his family protested his innocence, an anti-Semitic Parisian newspaper, *La Libre Parole*, dissatisfied with the lightness of his sentence, campaigned for his execution. In January 1895, in an event widely reported and illustrated in the press, Dreyfus was subjected to a

Fig. 28.
Henry Ossawa Tanner, *Two Disciples at the Tomb*, ca. 1906. Oil on canvas, 51 × 41⅞ in. (129.5 × 105.7 cm). The Art Institute of Chicago. Robert A. Waller Fund, 1906.300.

ritualized public humiliation, "The Degradation," in which he was stripped of his military rank as crowds shouted, "Kill him! Dirty Jew! Judas!"[56] He was then deported to Devil's Island in French Guiana, where he was held in solitary confinement, chained at night. Slowly, through 1896 and 1897, evidence began to surface that Dreyfus had been framed.

Bringing the affair to a crisis point, the novelist Émile Zola published an open letter in January 1898 under the famous headline "J'Accuse . . . !" indicting the French government and military for orchestrating Dreyfus's downfall. In the following months and years, Dreyfusards and anti-Dreyfusards battled in the press, on the streets, and even in parlors where longtime friends split over the case. Mary Cassatt (pro-Dreyfus) and Edgar Degas (anti-Dreyfus), for example, rowed so violently that they long refused to see each other.[57] It inflamed popular anti-Semitic sentiments and wicked them to the surface, sparking riots in Paris in 1898. Not until 1906 was Dreyfus's innocence finally proclaimed, and not until 1915 did he return to military command. That October a headline in the African American newspaper the *Appeal* blared, "Dreyfus at Last Gets Vindication, Given Command after Twenty Years of Degradation." The black American press had followed the affair from its

beginnings, finding many parallels between the injustices and humiliations suffered by Dreyfus and the treatment of blacks in the United States.[58]

It was in this environment of volatile, poisonous, publicly expressed anti-Semitism that Tanner painted his Hebrew characters. His first religious painting and his first painting of a Jew was *Daniel in the Lion's Den*, 1896 (location unknown). The Old Testament prophet Daniel was a trusted counselor to King Darius the Mede. Jealous political rivals plotted Daniel's demise, pressuring Darius into signing a decree prohibiting prayers to anyone but himself. When Daniel continued to pray to his God, he was taken up, condemned to death, and, after nightfall, thrown into a lion's den. When Darius checked on Daniel the following morning, he found, much to his relief, that Daniel was unharmed, saved by faith in his God. Of all of Tanner's religious subjects, this story of a persecuted Jew unjustly imprisoned resonates most strongly with the Dreyfus case, as Mosby and others have pointed out.[59]

The original painting is now known only from a black-and-white photograph (fig. 29). Tanner, however, returned to the subject in a similar composition sometime in the early years of the twentieth century (fig. 30). Daniel's features, like Jesus's in *The Resurrection of Lazarus*, would have made him immediately recognizable to Tanner's contemporaries as a Jew, and the artist elicits our fearful concern for him, emphasizing his aloneness and vulnerability. Painted in melancholy blue-green tones, the setting is far more like a prison than the "den" described in the Bible, and Daniel's figure is dwarfed by its vast, high-ceilinged

Fig. 29.
Henry Ossawa Tanner, *Daniel in the Lion's Den*, as reproduced in *Brush and Pencil*, June 1900. The original painting is now unlocated.

Fig. 30.
Henry Ossawa Tanner, *Daniel in the Lion's Den*, ca. 1907–18. Oil on paper mounted on canvas, 41⅛ × 49 15⁄16 in. (104.46 × 126.84 cm). Los Angeles County Museum Art. Mr. and Mrs. William Preston Harrison Collection (22.6.3).

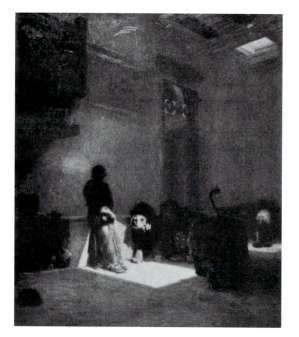

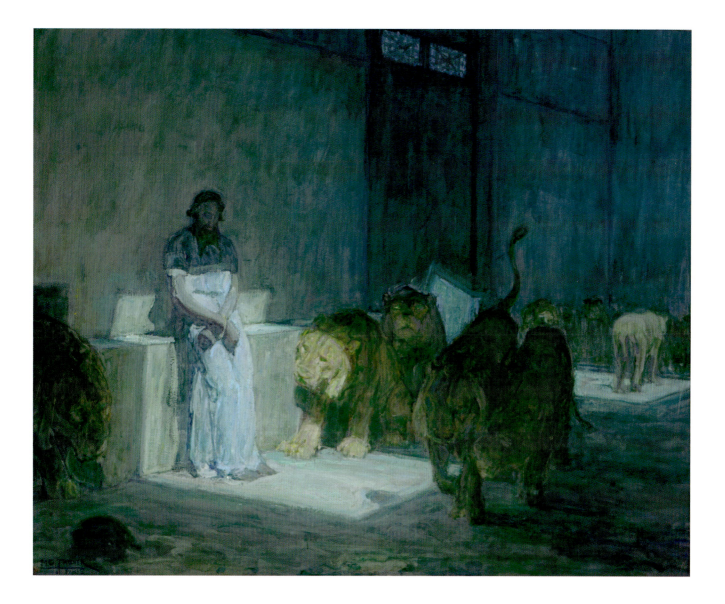

space. Shadows fall across his face, and his hands are bound before him. The only light falls from windows high above. We realize that Daniel has spent the night in complete darkness, awaiting his fate, as lions prowled about him. It is now morning, and in an amusing touch, rare in Tanner's art, a rounded shadow at the right edge of the foreground block of sunlight may be cast by the head of King Darius looking down to check on his valued adviser.

Of all of Tanner's paintings, though, *The Annunciation*, 1898, is to my mind the work that most successfully and most powerfully garners our sympathetic identification with a biblical character, while simultaneously upending contemporary expectations of the subject's representation (fig. 31 and detail on p. 180). In *The Banjo Lesson*, Tanner sacralized the domestic; in *The Annunciation*, he domesticates the sacred.[60] He includes no halos, no lilies, no crystal vases, no blond Gabriel in rich, courtly robes. Instead we see a "young Jewish peasant sitting on the edge of a couch, wearing the common striped cotton of the Eastern women of the poorer class," as a writer for *Brush and Pencil* described the scene in 1900.[61] Tanner, a man of faith, believed that the divine could enter human lives—as it had on a Nazareth night two thousand years ago. He summons before us a real Jewish girl in a real Palestinian home. He drew on a recent trip to Egypt and Palestine to give the setting geographical and tactile specificity: a rough-laid stone floor, a wrinkled rug, and thick adobe walls.

An otherworldly radiance, so intense that we feel we should shield our eyes, has awakened Mary and driven the night shadows from her room. In the Annunciation story, Gabriel informs Mary that she has found favor with God. Tanner gives us some sense of the attributes that drew God's attention. This teenager neither shrinks nor flees from the miraculous presence, but clasps her hands to steady her fears, fixes her eyes on it, and listens attentively, light shining on her brow. She appears vulnerable in her overlarge robe with her bedclothes rumpled around her. Yet, at the same time, she radiates alertness of mind and inner strength. This is the girl who when informed that she will bear a child is not subdued into silence but considers what the angel has told her and poses a question back to him, "How shall this be, seeing I know not a man?"

Mary commands the pictorial space, holding her own, both intellectually and compositionally, against the divine blaze. Tanner deploys the springing of the arches just above her head to direct attention to and visually strengthen her figure. At the same time, he makes her believably human, and we, knowing the heaviness of the fate that God is imposing on her, are drawn to this brave and intelligent girl. The *Philadelphia Inquirer*'s critic, summoning the language of the sentimental, found Tanner's "sympathetic" representation of Mary both "intensely human" and "infinitely tender."[62]

Tanner departed from most representations of the Annunciation not only in portraying Mary as a dark-haired Jewish peasant, but also in conceiving an angel without human form.

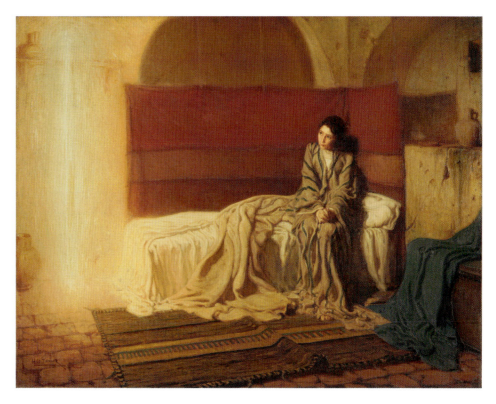

Fig. 31.
Henry Ossawa Tanner, *The Annunciation*, 1898. Oil on canvas, 57 × 71¼ in. (144.8 × 181 cm). Philadelphia Museum of Art. Purchased with the W. P. Wilstach Fund, 1899.

In this painting, as in his *The Disciples See Christ Walking on the Water*, ca. 1907 (Des Moines Art Center), divine figures appear only as shimmers against the fabric of the phenomenal world. They are raceless and genderless beings of pure spirit. In the physical world, humans may be categorized by the shape of their features and the color of their skin, but in the spiritual realm, as Tanner envisioned it, souls are liberated from all the indignities and sufferings of corporeality. Through the all-inclusive radiance of holy light, all persons become one, all equal in God's eyes.

In 1913, Tanner was the guest of honor at the annual meeting of the NAACP, and would be a faithful contributor to the organization for many years.[63] But it was through his art, above all, that he stood against prejudice and injustice. In his early genre paintings, such as *The Banjo Lesson*, he asserted the full equality, humanity, and dignity of African Americans. In his later religious paintings, he repeatedly encouraged his predominantly Christian, and, in France, Catholic viewers to remember that Mary, Jesus, and other esteemed biblical characters were Jews, the chosen of God, and bearers of divine grace. With principled compassion, he carried forward the work of Frederick Douglass and of his father, Bishop Tanner, embracing the artistic strategies and emotional registers of the sentimental to insist on universal human kinship and the necessity of feeling with and for each other.

Andrew Jackson Downing and the
Sentimental Home

CHAPTER THREE

The sentimental, Shirley Samuels has written, lay "literally at the heart of nineteenth-century American culture."[1] In the antebellum era, sentimental cultural productions—that is, productions intended to develop empathetic bonds and to evoke softer emotions such as tenderness, affection, pity, and nostalgia—were assigned vital social roles. They were to increase attachment to home and country, provide a corrective to the heart-hardening mechanisms of market capitalism, foster sympathy for the less fortunate, and elevate moral character. No single place was considered more important to the cultivation of sentimental feelings than the family home. Andrew Jackson Downing (1815–1852), the most influential American writer on architectural and horticultural topics at midcentury, believed that "the mere sentiment of home, with its thousand associations, has . . . saved many a man from shipwreck in the storms of life."[2] This chapter will explore the ways that Downing, through his designs for houses and home grounds, sought both to symbolize and to facilitate the formation of sentimental domestic bonds.

Historians have situated Downing, along with painters such as Lily Martin Spencer and authors such as Harriet Beecher Stowe, within the nineteenth-century "culture of sentiment," while Charles Willson Peale and John Trumbull have been associated with the eighteenth-century "culture of sensibility." Reading in the scholarly literature, one could easily gain the impression that these are two distinct historical movements. Indeed, scholars have tended to cast them in very different terms. According to many of these accounts, the serious, masculine culture of sensibility arose within the philosophical and political

ferment of the Enlightenment. It then succumbed in the last years of the eighteenth century to, among other things, the horrors of the French Revolution, for which it was, in part, blamed.[3] On the other hand, historians have centered the culture of sentiment in the Victorian era, often eliding it with an essentially feminine "cult of domesticity."

This dichotomizing into distinct movements, however, owes more to the separation of fields within the academy, with scholars specializing in either the eighteenth or the nineteenth century and locating their chronicles within their chosen epochs, than it has to do with the historical boundaries of the sentimental project—the transformation of society through the cultivation of sympathy. My research has led me to understand the culture of sensibility and the culture of sentiment as phases of the same development, which shifts somewhat in character over time, but is essentially the same. It continually draws its impetus from moral sentiment philosophy and Lockean sensationalism, valuing the social affections as means of individual and societal transformation. It employs, from the eighteenth into the later nineteenth century, the same vocabulary of "sensibility," "sentiment," and "sentimental," the terms ever intertwined. It was consistently under suspicion and attack from the late eighteenth century onward, accused of suppressing rational thought and fostering debilitating emotional weakness. It also involved, always, both men and women.

Women were regarded, in both centuries, as possessing greater natural sensibility than men. This, Adam Smith argued, was all the more reason to nurture and cultivate men's social affections, and much sentimental culture in both the eighteenth and nineteenth centuries made the softening and reforming of men's emotions a central goal. Downing, for example, once described his overarching ambition as bringing "men back to their better feelings."[4] Yet a historical awareness of sentimental culture's importance to men nearly disappeared in the twentieth century. Modernist critics, from the later nineteenth century onward, assigned the sentimental to women as part of their efforts to devalue it. Beginning in the 1970s, feminist scholars laid positive claim to sentimental culture for women, as they pushed back against modernist denigration of women's cultural work. They celebrated, for instance, antebellum women's production of sentimental fiction.[5] Only recently have scholars further overturned the antisentimental and antifeminist biases of modernist accounts to restore the place of men in sentimental culture as both producers and consumers.[6]

Fervently committed to domestic sentiment, Downing played a crucial role in the development of American sentimental culture. Through him, we see the sentimental's extension into a range of artistic practices, including architecture and landscape design, and perceive its significance for political change. Downing envisioned his designs accomplishing cultural work that extended far beyond the domestic sphere to bring about broader trans-

formations in American society. His ambitions situate him, along with Trumbull, Peale, and Tanner, within the reformist political vein of the sentimental.

In Washington Irving's "The Legend of Sleepy Hollow" (1819–20), a story much admired by Downing, the lanky protagonist, Ichabod Crane, arrives at the farmstead of Baltus Van Tassel, intent on courting the farmer's daughter, Katrina. Enraptured by her rosy cheeks, and even more so by the prosperous abundance of her "paternal domain," he envisions how the farm might be "readily turned into cash, and the money invested in immense tracts of wild land, and shingle palaces in the wilderness." He imagines himself wedded to Katrina, placing her "on the top of a wagon" and "setting out for Kentucky, Tennessee, or the Lord knows where."[7] Oblivious to Van Tassel's attachments to his home and his daughter, Ichabod would tear away both from the farmer to satisfy his own voracious appetites and restless disposition. He is Irving's embodiment of the selfish, avaricious, unsettled aspects of the Yankee temperament. In his fictional realm, Irving was able to drive off Ichabod with the aid of a ghost and a well-aimed pumpkin. In the real United States during the tumultuous decades of the early to mid-nineteenth century, it was far less clear how these worrisome traits of the American character might be countered.

Concern about Americans' feverish pursuit of wealth and their restless disposition to change (manifested in westward migration as well as the influx of youths into cities) runs as a refrain through antebellum writings—both fiction and nonfiction, by foreign visitors and native authors alike. While acknowledging that these traits were playing an important role in building the nation, many feared that, at the same time, they were undermining morals, weakening family bonds, breaking intergenerational ties, destabilizing local institutions, and, ultimately, threatening the stability of the nation itself. British visitor James Johnston observed in 1851 that in his travels through New England and New York he had found "scarcely any such thing as local attachment—the love of place. . . . Speaking generally, every farm from Eastport in Maine to Buffalo on Lake Erie is for sale."[8] J. H. Hammond, author of *The Farmer's and Mechanic's Practical Architect* (1858), worried that "these frequent changes of residence . . . are destructive of much of that home-feeling which is essential to the education of the affections and moral sentiments."[9]

Downing often expressed similar concerns, lamenting that Americans "are too much occupied with *making a great deal*" and too much subject to the "*spirit of unrest*" that "makes of a man a feverish being . . . unable to take root anywhere" (italics here and in all subsequent quotations by Downing are original).[10] While he admired "the energy of our people," he also valued "the love of order, the obedience to law, the security and repose of society, and the partiality to localities endeared by birth or association, of which it is in some degree

the antagonist."[11] Yet rather than simply wringing his hands over the state of American society, Downing proposed a remedy, at least a partial remedy, rooted in what he called "rural improvement." By increasing the "home expression" of country houses and their grounds, by making rural dwellings as comfortable, convenient, and beautiful as possible, he sought to heighten their "moral influence" and strengthen those chains of affection that bound the inhabitants to each other and to their home ground.[12] As family members engaged in improving their dwellings, and in planting and nurturing tree groves, orchards, vines, and flower gardens, they would, Downing believed, discover a new spirit of repose. Their domestic enjoyment would increase and their local attachment deepen to the point that they would no longer feel the lure of the alehouse or the city or the distant western territories. Indeed, they would become better citizens, their patriotism strengthened, since the "love of country is inseparably connected to the *love of home*."[13]

Downing's approach to rural improvement was fundamentally sentimental. His designs for rural dwellings and gardens were to make their appeals to the hearts of their inhabitants and onlookers; they were to instill and draw out those softer feelings at the core of the sentimental: affection, sympathy, tenderness, attachment, and nostalgia. As Downing put it, he sought to create homes "in whose aspect there is something to love." A house, he wrote, should have rooms "where all domestic fireside joys are invited to dwell" and "something in its aspect which the heart can fasten upon and become attached to, as naturally as the ivy attaches itself to the antique wall, preserving its memories from decay."[14] Those who inhabited such homes would find their hearts opened, their social sympathies increased, and their benevolent impulses heightened. Those who simply gazed on such homes would feel the stirrings of nostalgia as they recalled their own childhood surroundings or perhaps recollected happy homes of which they had heard or read.

Downing's employment of a sentimentalized rationale for his house and garden designs became increasingly pronounced over the years, reaching its height in the late 1840s and early 1850s. In the course of his short career (he was killed in a steamboat accident on the Hudson River at age thirty-six), Downing published three major books on domestic architecture and garden design: *A Treatise on the Theory and Practice of Landscape Gardening, Adapted to North America* (1841; hereafter *Landscape Gardening*), *Cottage Residences* (1842), and *The Architecture of Country Houses* (1850), all of which passed through numerous editions.

THE BRITISH CONNECTION

Both the texts of these books, which address the history and theory of architecture and landscape design, and the designs themselves owe a significant debt to European architectural and landscape theory and to British pattern books of the late eighteenth and early nineteenth centuries, especially those of John Claudius Loudon (1783–1843). Yet, as indebted as Downing was to these works, they do not seem to have been the source for his sentimentalized vision of domestic architecture and landscape gardening.

Late eighteenth- and early nineteenth-century British architectural pattern books often contain sentimental rhetoric, but, for the most part, it assumes different forms and is used to address different ends than in Downing's publications.[15] Both Downing and his British sources extol the quiet joys of rural life as an antidote to the corruptions of commerce and fashion, but from there they diverge. The British authors describe the picturesque Old English cottage and the "wild hedge-rows and irregular plantations" of the English countryside with a tender nostalgia—a nostalgia suffused with patriotism and a longing for the "Old England" that seemed to be rapidly disappearing in the face of encroaching modernity and the legislated enclosure of what had been open fields and common lands.[16] Such sentimentalized descriptions were especially common during the years of the Napoleonic Wars (1803–15), when these traditional forms were threatened not just by modernity, but also by the possibility of French invasion. The authors' proffered designs for thatched-roofed cottages, Tudor villas, and informal, naturalistic landscapes both evoked and sought to preserve something of this Old England. They were, to that extent at least, sentimental designs.

A number of the British authors also enlisted the sentimental in the service of social reform.[17] With appeals rooted in the language and assumptions of class privilege, they sought the help of their readers, whom they generally assumed to be wealthy members of the nobility and gentry, in ameliorating the wretched living conditions of the British poor. They appealed to their readers as genteel "men of feeling," seeking to touch their hearts, arouse their pity, and inspire their beneficence, picturing for these men the great good they could do by building model cottages for their poor but worthy tenants. Their books offer designs for cottages and even whole villages, usually in traditional styles that would blend harmoniously and picturesquely with an estate's existing architecture as well as the local scenery. Thus the new cottages would be both comfortable for the tenants and aesthetically pleasing to the landowner.

Although Downing would call on American men of wealth to create houses and grounds that could serve as models of refined taste for their fellow citizens, he never issued the sort of sentimental appeals on behalf of the poor that the British authors did. Indeed,

one of the charges leveled against Downing by his American critics was his lack of attention to those of modest means; even the price of his books, they pointed out, was beyond the reach of many Americans. Not that these critics advocated having the rich build housing for the poor as British authors promoted, but they did want Downing to help the poor figure out how best to help themselves.[18]

While Downing's sentimental rhetoric owed little to British sources, his designs for sentimental homes drew significant inspiration from Loudon's notion of the "Expression of the End in View." For Loudon, an influential British architectural and horticultural writer, this was one of the fundamental principles of architectural design. In essence it meant that each building should visually express the use for which it is erected. For a house, this required emphasizing those aspects of its form that differentiated it from other building types such as barns and factories: chimneys, windows filled with glass, porticoes and balconies suggesting "comfort and elegant enjoyment," and "turrets and projections" invoking "commodiousness and convenience."[19] This notion that particular architectural forms could be expressive of domestic ideas and ideals would become essential to Downing's formulation of a sentimental domestic architecture. He would draw on this idea to create a symbolic vocabulary of forms that he could deploy to articulate what he called "home feeling" in his designs.

Yet, as reliant as Downing was on British sources, he was keenly aware that he was writing for a different audience living under unique social, political, economic, and physical conditions, and that he needed to modify his borrowed designs and theories to suit their new American setting. Indeed, both his *Landscape Gardening* and his *Cottage Residences* include in their extended subtitles the words "adapted to North America." Downing would follow the British pattern books in offering designs for picturesque rustic cottages and villas in various styles, including the Tudor, Elizabethan, and Gothic, but he discarded thatched roofs and clay walls as inappropriate for the American climate, removed crenellated battlements as out of place in the generally peaceful American countryside, and offered nothing comparable to the palatial estates so common in the British books. He also adopted a more egalitarian rhetoric, suppressing the language of class privilege and promoting republican ideals, though his advice to readers that they select a design in keeping with their social station—encouraging farmers, for example, to choose only "plain" buildings—led some critics to charge him with elitism.[20]

Downing's elevation of the sentimentalized concept of home into a central theme of his works—his insistence on the creation of a domestic architecture that could "touch the heart" and foster "home feeling"—seems to have been another way in which he sought to adapt his foreign sources to the needs and interests of his American audience. He was,

after all, writing at a time when John Howard Payne's "Home, Sweet Home" (1822) was among the most popular songs in the country, when every Sunday ministers offered sermons such as "The Blessings of Home," and when the nation's newspapers and journals were daily publishing more poems, short stories, and essays on topics such as the joys of domestic life, the pangs of homesickness, and the anguish of leaving home. In many of these literary works, the ideal home is pictured as a snug, vine-covered cottage, framed by trees, and graced by a flower garden filled with roses and hollyhocks. Downing offered his American readers practical advice and concrete plans for creating just such a home.[21]

ASSOCIATIONISM AND DOMESTIC DESIGN

Downing's understanding of how houses and gardens might operate on the feelings was grounded in European aesthetic and epistemological philosophy, especially theories of associationism and environmental determinism. In an address delivered at the Massachusetts Horticultural Society's annual fête in 1848, Downing declared, "I am, sir, an associationist."[22] He thus openly professed his allegiance to the ideas of the Scottish philosopher Archibald Alison, whose 1790 *Essays on the Nature and Principles of Taste* established the fundamentals of associationism. According to Alison, the pleasure we derive from looking at objects arises not from the forms of the objects themselves but from the trains of associations—the ideas and emotions—that the objects arouse in our minds. In his own writings, Downing refers to this as the "beauty of expression" or the "beauty of sentiment." Departing from Alison, however, he also recognizes, following classical architectural theory, a "beauty of form" residing in such features as proportion, symmetry, variety, and unity. Drawing on the work of other British aesthetic theorists, such as William Gilpin and Uvedale Price, he argues that forms are in themselves capable of expressing and provoking emotions. A symmetrical, unified composition, for example, would tend to induce feelings of calm. Downing believed that together the beauty of sentiment and the beauty of form were responsible for the delight we derive from both the built and the natural environment.

Applying associationist theory to domestic architecture, Downing (following Loudon's lead) argued that for a house to evoke the warm, pleasurable associations of "home," it needed to look specifically like a house, and not like a barn or a Greek temple or a feudal castle. In the December 1847 issue of the *Horticulturist*, the journal he edited from 1846 until his death in 1852, he illustrates how to imbue a building with domestic associations. The frontispiece contrasts two houses; according to Downing, one educes appropriate home feelings and the other does not (fig. 32).

FIG. 37. THE NEW ENGLAND SUBURBAN DWELLING

FIG. 38. DESIGN FOR IMPROVING THE SAME.

Fig. 32.
The top image represents a "typical" New England suburban dwelling. The lower image shows the same building "improved" to heighten its domestic character. Frontispiece to the *Horticulturist*, vol. 2, December 1847.

The top image, as its caption explains, represents a typical New England "suburban dwelling." A simple variant on the Greek revival style, the house is a rectangular box with a peaked roof and a gable-end entrance. The entrance façade is adorned with Doric corner boards visually supporting a plain entablature, cornice, and pediment. These architectural details, together with the building's white paint, suggest a temple front, sparking associations with the public buildings of pagan antiquity.

The lower image represents the same building "improved" to give it a more domestic character. The classicizing details have been removed, and the building has been repainted a quiet gray or fawn color, so that it will better harmonize with its natural surroundings. More importantly, Downing emphasizes those aspects of the building that evoke sentiments proper to a home, such as protection, support, warmth, comfort, and welcome. The eaves in the "improved" dwelling project about two feet from the façade. Functionally, they protect it from inclement weather and help keep the upper story cool in the summer.[23] Metaphorically, they reinforce the impression of shelter and safety, as does the increase in overall roof area. The brackets beneath the eaves are "not only for actual support, but to suggest the idea of support directly to the eye."[24] The vertical board and batten siding, advocated by Downing as more economical, durable, and truthful than clapboarding, was to suggest strength and permanence.[25] Of the veranda stretching across the front, Downing writes that such porches become, in the warm seasons of the year, "the lounging apartment of the family," and hence suggest ideas of comfort. The veranda also offers visitors a "friendly preparation" before they enter the house, and visually reinforces the building's domestic character, since a "house in which the front door is bare, is not always easily distinguished from an office or any place of business."[26] Finally, chimney tops, Downing argues, are so "associated with all our ideas of warmth, the cheerful fire-side, and the social winter circle" that "they should in all dwellings not only be boldly avowed, but rendered ornamental."[27] He thus replaces the low squat chimney in the upper image with a taller, more decorative, more prominent version. Together, these features, according to associationist theory, would act on the viewer's imagination, inspiring thoughts of the pleasures of domestic life, and enable the building to, in a phrase Downing often used, "touch the heart."

Associationist theory led Downing to develop a symbolic approach not only to architecture, but also to landscape gardening. A garden, with its associations of rootedness, nurturance, and growth, was as essential to establishing home feeling as the dwelling itself. In *The Architecture of Country Houses* (1850), Downing makes this point with another contrasting pair of images (figs. 33, 34). One represents a "small bracketed cottage," which, despite the projecting eaves and ornamental chimneys that mark it as a home, appears rather bleak and bare. It "wants," he writes, "the softening and humanizing expression" that plant-

Fig. 33.
A small bracketed cottage without plantings. From A. J. Downing, *The Architecture of Country Houses* (1850).

Fig. 34.
A small bracketed cottage with plantings. Design II from A. J. Downing, *The Architecture of Country Houses* (1850).

ings can give.[28] In the other, he shows the same house "*affectionately* embosomed in foliage."[29] Graceful trees and flowering shrubs frame the house, while vines clamber over its arbors and entrance porch. It thus exhibits, he writes, "a good deal more *feeling*."[30]

Of all plantings, none heightened the domestic expression of a dwelling more effectively than vines. A drapery of wisteria, roses, honeysuckle, ivy, grapes, or even hops could transform a "soulless habitation into a home that captivates all eyes."[31] Vines' associations with domestic felicity were particularly strong because, Downing held, they were never planted by architects or builders, but only by a home's inhabitants, usually mothers and daughters, who nurtured them as "a labor of love offered on the domestic altar." They thus

always expressed "domesticity and the presence of heart."[32] As vines clung to porch columns and bound themselves to walls, they became metaphors for domestic attachment and for the support that the stronger members of a family offered the frailer. A graceful drapery of well-tended vines could also act as a "philter" against that "spirit of unrest" that kept Americans continually on the move. Downing assured his female readers that when their husbands and brothers found their homes wreathed in sweet-smelling verdure, they "would no more think of giving up such houses, than they would of abandoning you."[33]

While Downing wrote extensively about the ways that the physical appearance of dwellings could give visual expression to the warmth and comforts of domestic life, he also understood that it was the inhabitants' active involvement in the creation and embellishment of their dwellings that most effectively engendered the sentiments that made the house a home. Our "love of home," he writes, "will be sure to grow with every step we take to add to its comforts, or increase its beauty."[34] Horticultural pursuits, in particular, would root the family to its home ground. He argued that planting saplings and caring for tender plants would suppress the destructive impulses unleashed by clearing land, and would bring "men back to their better feelings."[35] Children who were raised engaging in such activities would "sigh no more for town or city life, but love with intense affection every foot of ground they tread upon, every tree, and every vine, and every shrub, their hands have planted, or their tastes have trained."[36] To plant trees and watch them grow and develop over the years, to see vine tendrils twining up the arbors one has built, to gather fruit from one's own orchard or flowers from one's own garden, to see a home made beautiful through one's own efforts—such things created both fond memories and "that feeling of pride in home that has so much share in fostering the simple virtues that make after-life [that is, life after leaving the childhood home] so happy."[37]

While much scholarship on the antebellum United States has cast the home as woman's domain and the center of a feminized domestic piety, Downing never presented the sentimentalized home, at least never exclusively or even principally, as a feminine realm. He recognized certain gendered divisions of labor and space. He assumed, for example, that women would oversee the kitchen, as well as care for the flower garden and vine drapery, while he assigned the care of the rest of the grounds, including the kitchen garden and orchard, to the male members of the family. Yet he imagined mother and daughters, father and sons, all gathering at the end of the day in the parlor or family room. At the heart of his vision of the home lay an ideal of companionate domestic relations—of family members working together to beautify their house and embellish its grounds. To him, the dwelling place was always the "family home."

The ungendered nature of Downing's conception of home is borne out in the illustrations to his volumes. The figures included in his designs for ideal homes and grounds appear in ever-varying combinations: single men, single women, men with children, women with children, couples, families, families and servants, and families with guests. Both men and women are shown in entranceways, on porches, and on the home grounds, stationary, coming, and going. In his illustrations, as in his texts, Downing makes clear that the home belongs to male and female, young and old alike. In the image captioned "Regular Bracketed Cottage" in *The Architecture of Country Houses*, a woman stands on the porch, seemingly moving toward a man who is comfortably "settled" into his chair (fig. 35). Between the couple, two posts draped with voluptuous vines, presumably planted by her, frame a rustic bench composed of bent branches, possibly made by him (since Downing explains how to construct such benches in a number of his publications). Together, these details imply the couple's conjoined efforts in creating the comforts and beauties of their home.

Fig. 35.
"Regular Bracketed Cottage." Design IX from A. J. Downing, *The Architecture of Country Houses* (1850).

THE MORAL INFLUENCE OF THE HOME

Downing believed wholeheartedly that rural dwellings could exert a profound moral influence. He shared this belief with many others, both European and American, who accepted, as he did, that the environment in which one lived, particularly the environment in which one was raised, had a lasting effect on one's moral character. Now sometimes referred to as environmental determinism, this theory had become well-established in British architectural literature at least as early as the late eighteenth century, and was often used by British writers, including Loudon, to direct attention to the housing of the nation's poor. Ultimately, the theory has its roots in the proto-Enlightenment epistemology of John Locke, who postulated that at birth the mind is a tabula rasa to be shaped by experiences derived from sense perceptions. Locke's theory led him to place great emphasis on childhood education and experiences: "The little and almost insensible impressions on our tender infancies have very important and lasting consequences."[38] Locke's ideas underlay much of the stress placed on the home environment and on home education in the nineteenth-century United States. In a review of Downing's *The Architecture of Country Houses* for the *New Englander*, the Connecticut minister N. H. Eggleston writes, "The importance of the home world is probably felt at the present day more deeply than ever before." This was particularly true, Eggleston felt, in relation to children, as more and more people were recognizing "how much the place of a child's residence has to do with a child's character."[39] Hence he argued for the great importance of Downing's schemes for the improvement of rural residences.

Downing viewed the country home as an agent of moral and social reform, capable of exerting its influence over children, certainly, but over adults as well. "There is nothing," Downing writes, "that more powerfully affects the taste and habits of a family—especially the younger members of it—than the house in which it lives.[40] As Eggleston noted in explaining Downing's underlying reasoning: "The world of ideas, thoughts, and feelings is most intimately connected with the world of matter, and the former world will take its tone and shape very much from the latter."[41] Family members, Downing believed, would respond unconsciously, or, to use his word, "insensibly," to their home environment—their feelings and their characters would be molded by its traits. A neat, orderly, well-arranged home would likely instill habits of neatness and orderliness in its inhabitants. On the other hand, a squalid, ill-kept house, arranged without thought to the comfort and convenience of the residents, and with little in its appearance to distinguish it from a barn, would likely produce coarse and brutish manners. As Gervase Wheeler, an architect and pattern-book author who was much influenced by Downing, wrote, "The neat cottage tempts the indwellers to a neatness in harmony, and leads them to adorn the little garden-plot, and cultivate

flowers, and the children have at life's early steps a perceptive appreciation of beauty given by their home associations, which never leaves them, even amid the distraction of business pursuits."[42] To Eggleston, "a properly constructed dwelling," built according to the designs in Downing's books, would "educate its inhabitants, generation by generation," begetting "in them the home feelings which rightfully belong to such a place."[43]

THE VALUE OF COUNTRY LIFE

Crucial to the morally elevating and heart-softening influence of the homes Downing described and promoted in his writings was their location in the countryside. "In the United States," he wrote, "nature and domestic life are better than society and the manners of towns."[44] While cities could harden and corrupt a man's character by exciting his passions, feeding his vanity and ambition, and sharpening his competitive and acquisitive urges, the country offered occupations "full of health for both soul and body. . . . The heart has there, always within reach, something on which to bestow its affections."[45] In the country, a man's life was united to "the life which animates all creation," for there he was in the presence of nature, and hence in the presence of God.[46] Surrounded by the beauties of nature, his heart would be constantly uplifted, while rural activities, especially the cultivation of the soil, would strengthen his body, calm his mind, and lead him to cherish with "tender affection" the grounds he tended.

Such a connection to nature was lauded as therapeutic by a reviewer of Downing's *Landscape Gardening*, who argued that horticultural pursuits have a "sanative virtue" that will "surely exert a spell over all the heart's malignant diseases, banishing its selfishness, assuaging the fever of its ambition, restraining the rage of its revenge, and quelling its every baser passion. . . . When we till the ground under the open expanse of heaven, out in the glorious presence of God's works, we are invited to a free and loving communion with the Spirit of Solitude and of Life."[47]

In his house and garden designs, Downing sought to give visual expression to that ameliorating intimacy with nature that a rural residence allows. In this, he was again following British precedents. While city homes were often tall and narrow—forced upward by high lot prices—a country home, Downing argued, should spread out across the ground, looking as though it had grown naturally from its site. To enhance this impression, it should be built, if possible, from local materials, and painted, if necessary, a soft, "natural" hue. Downing several times quoted Sir Joshua Reynolds's advice on how to select the color for a country dwelling: "Turn up a stone, or pluck up a handful of grass by the roots, and see what is the

Fig. 36.
"A Lake or River Villa." Design XXXII from A. J. Downing, *The Architecture of Country Houses* (1850). Downing describes this design as suitable for the wild, picturesque scenery of the Hudson Highlands where its irregular roofline would echo the broken, hilly terrain.

colour of the soil where the house is to stand, and let that be your choice."[48] The building's design should also take its cue from the character of local scenery. For example, in a hilly or mountainous area, the dwelling's roofline could be boldly varied with towers, gables, and pinnacles, but in a tamer terrain, a more subdued roofline was the better choice (fig. 36).

Grounds likewise should be laid out to enhance the harmony between the home and its setting. Like the house, they should respond to the character of the local environment. In a wild, wooded area, the landscape design could be strikingly picturesque, with spired conifers in irregular groupings, occasional thickets, and bare outcroppings of rock (fig. 37). In a more settled, domesticated area, the landscaping should tend toward softer, rounder, more manicured forms (fig. 38). In keeping with the well-known guidance of the English poet Alexander Pope, who urged landscape gardeners to "consult the genius of the place," Downing advised the purchaser of a country home to carefully study the existing advantages of his site, and to preserve as many of its surface features and well-developed trees as possible.[49] For those amateur landscape gardeners seeking inspiration beyond the plans in his books, Downing recommended consulting nature's own creations. On their country walks and drives, they should observe the majestic grouping of trees, the intricate thickets, and the sunny expanses of open meadows composed by nature's own hand.

For a country residence to exert its proper moral and spiritual influence, Downing advised, both house and grounds should be designed to enhance the inhabitants' appreciation and enjoyment of their rural setting and entice them to spend time out of doors. Grounds should be arranged to take advantage of any attractive views, and the home's windows should be disposed to look out over them. In the ideal country house, verandas,

terraces, and balconies offered comfortable places to sit and enjoy the home's lawns and gardens. Sweet-smelling shrubs planted near the house, where their odors could waft through open windows, enticed the occupants onto the grounds, and gently curving graveled walks drew them out farther to explore its more distant corners. The more time the family spent in the open air, discovering the beauties of natural forms and tending their gardens, the greater would be their understanding and appreciation of God's works and their attachment to their home.

Those who engaged in rural improvement, Downing argued, could consider themselves public benefactors, for when a man's neighbors saw his beautified home and grounds, their competitive and emulative instincts would be aroused and they would exert themselves to

improve their own homes. A true benefactor, however, would extend his concerns beyond his own homestead. He would campaign for the improvement of his entire neighborhood (as Downing did in his hometown of Newburgh, New York). He would see that trees were planted, roads tended, and pigs and chickens banned from the village streets. When villagers saw graceful elms arching over clean roads and neat homes set into well-tended gardens, their affection for their hometowns would increase, and they would be more disposed to "settle" there. Furthermore, following the logic of environmental influence, such a pleasant town would induce "order, good character, and virtuous deportment . . . in the lives and daily conduct of its people."[50] Rural improvement thus had the potential to exert a political influence, affecting the moral health not only of individuals, but also of communities and even the entire nation.

Downing's works were widely consulted and broadly influential. Dozens of architects and architectural writers followed his example in producing house pattern books that promoted sentimentalist agendas. Such books include Oliver Smith's *The Domestic Architect* (1852), Gervase Wheeler's *Homes for the People* (1855), and *Village and Farm Cottages* (1856) by Henry Cleaveland, William Backus, and Samuel D. Backus.[51] Journals such as the *New Englander*, *North American Review*, *Knickerbocker*, and *United States Magazine and Democratic Review* published glowing reviews of Downing's work and endorsed his sentimental approach. Beginning in 1846, *Godey's Lady's Book*, under the editorship of Sarah Hale, published hundreds of house patterns, some of them lifted directly from Downing's books.[52] As the most widely circulated magazine in the antebellum United States (with 150,000 subscribers in 1860), it introduced sentimental domestic architecture to a nationwide readership of women.[53]

Publishers of agricultural journals joined *Godey's* in disseminating Downing's ideas across the country, reproducing his plans, along with their sentimentalist rationales. The editor of the *Ohio Cultivator*, for example, urged his subscribers to read Downing's books and to engage their offspring in the embellishment of their dwellings so that the children would grow up with a true "love of home."[54] The *Southern Planter* (published in Richmond, Virginia) echoed these sentiments, advising readers who were about to build a home to consult Downing's books so that they could erect "a fit temple in which to enshrine those holy domestic ties which are the boast and the happiness of our people."[55]

In 1849, the author Catharine Sedgwick told a friend that Downing's books "are to be found every where, and nobody, whether he be rich or poor, builds a house or lays out a garden without consulting Downing's works. Every young couple who sets up housekeeping buys them."[56] This was hyperbole, and yet there is no question that Downing, more than any other single figure, was responsible for developing and popularizing sentimentalized architectural and landscape styles, and envisioning for them vital social roles.

| Sentimental Landscapes |

CHAPTER FOUR

"Lord-a-mercy, what a beautiful, sentimental place this 'ere [Mount] Auburn Cemetery is," exclaimed an elderly woman on a visit to the site in 1834.[1] Few scholars today write about or talk about landscapes as sentimental, unless it is to dismiss or demean them as kitsch, as when Barbara Novak, in *American Painting of the Nineteenth Century* (1969), accused members of the Hudson River School of producing "sentimental potboilers that pleased the lowest common denominator of public taste."[2] In the nineteenth century, however, it was commonplace to approvingly describe landscape paintings, rural cemeteries, and public parks as sentimental, acknowledging their origins in the creator's feelings and commending them for touching those of the observer. What mattered was the appeal that the place or work of art made to the human heart.

Many of the era's sentimental landscapes were created, at least in part, as antidotes to the fears and uncertainties, the disruptions and upheavals—both personal and societal—of the times. Deriving their affective power from a faith in the soothing restorative powers of nature and a nostalgic longing for those aspects of nature, both wilderness and pastoral, that were being lost to progress, they offered artistically crafted "natural" places of solace and refuge. They also commemorated, recuperated, and in some cases—as in the formation of state and national parks—salvaged bits of what was being lost. Implicit in these landscapes are tensions between belonging and estrangement, possession and loss.

MOUNT AUBURN

Rural cemeteries, like Mount Auburn, were the most obviously sentimental of the era's landscapes (fig. 39). Like Downing's Gothic Revival cottages, they sprang from the social reformist impulses of the antebellum era. The reformers in this case set out to ameliorate the anguish and terrors of death. They surveyed the common graveyards of their day and saw bleak, grim places overgrown with rank weeds and crowded with slate tombstones from which gruesome death's-heads leered. The grounds were at times so spongy with decay that feet sank into the graves. Such places heightened death's horrors. Moreover, they were a national disgrace. Care for the dead, many noted at the time, is a marker of a society's state of civilization, and the "indifference and neglect" shown by Americans toward their burial sites was "a reproach," indicative of a lack of feeling both for the deceased and for those who mourned them.[3]

Reformers sought to replace these forbidding graveyards with spacious, carefully planted, well-tended "cemeteries," a term they preferred owing to its origins in the ancient Greek word for "places of repose." The burial grounds they envisioned would be for the living as well as for the dead, a new type of funerary landscape, where "the magnificence of nature might administer comfort to human sorrow, and incite human sympathy," as one of the founders of Mount Auburn wrote.[4] These "gardens of graves," enthused an early visitor to Mount Auburn, would be "a sort of public declaration, that in an age of scrip [certificates of money or stock shares], avarice, corporations, and brass, some still retain heart and memory and the gentle and sacred thoughts that unite us with the departed."[5]

Fig. 39.
R. Brandard after W. H. Bartlett, *Cemetery of Mount Auburn*. Steel engraving from N. P. Willis, *American Scenery* (London, 1840). Wellesley College, Special Collections.

As the first of the nation's rural cemeteries, Mount Auburn, laid out in 1831, was a model for dozens that followed, including Laurel Hill in Philadelphia and Green-Wood in Brooklyn. The founders of Mount Auburn were "unabashed sentimentalists," according to the cemetery's most prominent historian, Blanche Linden.[6] These members of the New England elite opposed the contagion of commercialism, which was creating a nation of "hard, practical people" indifferent to the dead, and sought to create in Mount Auburn "a resistless pleader" in the "good cause of the heart."[7] They addressed their work, above all, to the emotions, envisioning a spot that would "cultivate moral sentiments and sensibilities," chasten "the selfishness of avarice," and rebuke "the restlessness of ambition."[8]

Showing particular concern for the grief-stricken and the dying, the cemetery's design would "combine all advantages which can be proposed to gratify human feelings or tranquilize human fears."[9] Death would appear not as the frightful threshold to eternal damnation, but as a natural part of the cycle of creation, as well as a domesticated realm where family and friends would be united for eternity. Mount Auburn was to be a nonprofit, nondenominational, and public institution, democratically open to rich and poor, Christians and Jews, black and white—though, in practice, the cost of the lots placed them beyond the reach of most.

The proprietors chose a place of existing natural beauty on the western outskirts of Cambridge, Massachusetts, a spot then known as Sweet Auburn, seventy-five acres of finely variegated landscape composed of hills, hollows, streams, and groves. Henry Dearborn, president of the Massachusetts Horticultural Society, provided the initial design, a soothing landscape of soft edges and gentle curves. Winding paths drew visitors into the embrace of a verdant nature cultivated to appear in sympathy with the bereaved. Trees arched their protective branches over burial sites, and mounded shrubs shielded graveside mourners from the eyes of passersby.

Plantings were chosen to heighten perception of the passing seasons, each of which offered its particular comforts. Autumn, for example, noted one early observer, "by a general decay, gives the heart an impression of universal sympathy."[10] Attention to the seasonal cycle also impressed on visitors the integral place of death in the rhythms of creation, and encouraged in many a comforting perception of bodily resurrection of a sort more natural than Christian. As Joseph Story noted at the cemetery's consecration, here "the body may return to the bosom of the earth, to be peacefully blended with its original dust."[11] Taken up by the landscape's verdurous growth, it would, as another noted, rise again "into light and loveliness."[12]

Two decades after the founding of Mount Auburn, as enthusiasm for rural cemeteries swept the nation, Downing wrote admiringly and approvingly of the sentimental attrac-

tions offered by this new landscape form: "It awakens at the same moment, the feeling of human sympathy and the love of natural beauty, implanted in every heart. His must be a dull or trifling soul that neither swells with emotion, or rises with admiration, at the varied beauty of these lovely and hallowed spots."[13] Like Downing's architectural work, the rural cemetery movement testifies to the value and importance that Americans accorded the sentimental, not only in their private lives, but also in the public life of the nation. Its softening influences, its emphasis on sympathetic connections, provided what many considered a necessary counter to what Downing called "the utilitarian feeling of the day."[14]

Fig. 40.
Thomas Cole, *Expulsion from the Garden of Eden*, 1828. Oil on canvas, 39 ¾ × 54 ½ in. (100.96 × 138.43 cm). Museum of Fine Arts, Boston. Gift of Martha C. Karolik for the M. and M. Karolik Collection of American Paintings, 1815–1865. Photograph © 2018 Museum of Fine Arts, Boston.

HUDSON RIVER SCHOOL

The sentimental is centered in the profound human desire for connectedness—connectedness to others *and* connectedness to place. Its dramatic tensions and its emotional charge arise at times from the effort to establish these bonds, but more often from the yearning for, the attenuation of, and the severing or loss of them. Many paintings of the Hudson River School are haunted by such longing and loss.

For Thomas Cole, loss is the foundation of our relation to landscape. In his early painting *Expulsion from the Garden of Eden*, 1828, Adam and Eve are being cast out of Paradise (fig. 40). The tiny figures have just crossed a slender natural bridge that separates the luminous landscape of Eden, visible in the upper right quadrant, from the dark, craggy, storm-ravaged terrain outside its borders. Beams of light thrust like bayonets from Eden's arched entrance, impelling the couple onward. These diagonal beams, the wind-bent palms, and the direction of the couple's movement all drive our gaze leftward into the darkness. Yet the slight backward turn of Adam's head and the right-pointing triangle of his upraised arm (fig. 41), together with the Western propensity to read paintings from left to right, create compositional and psychological tension, pulling us, against the major thrust of the composition, back to Eden. This is the melancholic backward glance of nostalgia, the yearning for connection to a distant time or place, the longing for a space set apart from the onward rush of progress, linear time, and history.

Nostalgia, one of the core sentimental emotions, is derived from the Greek words *nostos*, "return home," and *algos*, "pain." It was originally conceived and understood as a medical condition.[15] In 1688, the Swiss physician Johannes Hofer coined the term to describe a painful affliction, a longing for home so powerful and debilitating that it could result in death. It maintained this usage into the later nineteenth century. During the American Civil War, the US Sanitary Commission reported 2,588 cases of nostalgia, with thirteen result-

Fig. 41.
Detail of Adam and Eve. Thomas Cole,
Expulsion from the Garden of Eden,
1828. Oil on canvas, 39¾ × 54½ in.
(100.96 × 138.43 cm). Museum of
Fine Arts, Boston. Gift of Martha C.
Karolik for the M. and M. Karolik
Collection of American Paintings,
1815–1865. Photograph © 2018 Museum
of Fine Arts, Boston.

ing in death.[16] For nineteenth-century Americans, it was a condition to be taken seriously, one that powerfully affected both mind and body.

Nostalgic longing surely predated its seventeenth-century naming, yet literary scholar Svetlana Boym has argued that nostalgia is preeminently a condition and a symptom of modernity. "Nostalgia and progress," she writes, "are like Jekyll and Hyde: doubles and mirror images of one another." She contends that nostalgia is "a defense mechanism in a time of accelerated rhythms of life and historical upheavals."[17] The Hudson River School artists and their contemporaries lived at a time of unprecedented, disorienting change as the market revolution, the transportation revolution, massive immigration, and westward migration upended their world—a time conducive to nostalgia.

Nostalgia assumes multiple guises. It may be personal or communal, progressive or reactionary, restorative or destructive. It may serve imperialist aggressors or displaced refugees. It has had, over the years, both attackers and defenders. Its fiercest critic, the anthropologist Renato Rosaldo, has denounced nostalgia's complicity with imperialism and racism, arguing that it has provided a mask of innocence for brutality and destruction.[18] Others have accused it of falsifying the past, suppressing critical faculties, inciting dangerous nationalisms, and lulling us into complacent acceptance of reactionary ideologies.

Nostalgia's defenders, on the other hand, assert that it has positive, affirmative, future-oriented implications and applications. Recent studies in psychology, for example, suggest that nostalgia is calming, assuages loneliness, and stabilizes identity by connecting our past to our present selves.[19] More broadly, nostalgia may promote social cohesion, stimulate creativity, provide a platform from which to survey and critique the faults and flaws of the present, and impel progressive social change.[20]

Nostalgia is a keynote of Hudson River School paintings, manifesting in a multitude of forms. In some instances, the artists addressed the private longings of patrons; in others, they engaged nostalgia's more public, political roles. Speaking to the former, Samuel Osgood wrote in *Harper's New Monthly Magazine* in 1864:

> Every man who has lived in the country and made his fortune in the city must be haunted by charming scenes about the old homestead that he would gladly keep before him in his more artificial life. What would you or I give, dear reader, to get hold of Kensett, Hart, Colman, Inness, Haseltine, Cropsey, Casilear, Gignoux, Bierstadt, or Church for a month or two, so as to have them take suitable sketches of the charmed spots about the old country home, and in due season enshrine them in gems of choice art that would make great Nature our household friend, and carry into the shady side of life all the sunshine and witchery of our early days.[21]

Fig. 42.
Thomas Cole, *View of Boston*, 1839.
Oil on canvas, 34 × 47 ⅛ in.
(86.4 × 119.7 cm). Private Collection,
Minnesota Marine Art Museum,
Winona.

Both Thomas Cole and Asher Durand found themselves responding to patrons' desires for images that would connect them with the homes of their youthful past. In 1839, Cole's patron Joshua Bates, a Boston-born, London-based financier, wrote from London to express his gratitude for "the view of Boston which you have been so kind as to paint for me." He added that it "reminds me of home so much that [I] long to jump on board a steamboat and walk over the scenes myself."[22] The painting that Cole produced for Bates situates the viewer on a Roxbury hilltop, gazing north over a sunny summer landscape, across open pastures and wooded hills, to the distant city of Boston, where the State House dome gleams against the horizon (fig. 42).

Fig. 43.
Asher Durand, *Study from Nature: Stratton Notch, Vermont*, 1853. Oil on canvas, 18 × 23 ¾ in. (45.7 × 60.3 cm). The New-York Historical Society Museum. Gift of Lucy Maria Durand Woodman, 1907.21.

Fifteen years later, in 1854, Chicago lawyer Mark Skinner wrote Durand to remind the artist of his promise to paint a view of Vermont's Green Mountains. The painting, Skinner said, would "revive in my memory continually the glorious scenery amidst which my childhood was spent & towards which my spirit yearns more & more as years fade by."[23] The picture Durand painted for Skinner is lost, almost certainly destroyed in the Great Chicago Fire of 1871, which incinerated the lawyer's home.[24] However, a carefully painted study survives, produced on-site in Vermont (fig. 43). At the center of the picture, a delicate, arching branch frames Stratton Notch, the "picturesque gap in the Green Mountains made by Bowen brook" that Skinner fondly recalled and asked to be memorialized in his letter to Durand.

These are nostalgic landscapes, landscapes of remembrance and desire, personal, private versions of what Pierre Nora calls *lieux de mémoire*, sites where "memory crystallizes and

secretes itself."[25] Cole and Durand created these paintings to serve as catalysts and conduits for memories—not their own memories, but those of their patrons, in particular their patrons' memories of a distant home and a distant youth, a fondly remembered yet irretrievable past. The emotions evoked are simultaneously a deep dimension of personhood and a commodity the artist has provided on request. Given the malleability of memory, the artists' vivid pictorial summoning of these sites must have mingled, overlapped, and overwritten their patrons' dimmed and distorted recollections of these places from which they had been so long separated.

Nostalgia is often described as a bittersweet emotion, combining the sweetness of recollection and the comforting fantasy of return with the bitter knowledge that such return is impossible. What is longed for is not just a place, but a place at a time gone by, a place therefore forever beyond reach. As if acknowledging this, both artists push the locus of the owner's nostalgia, Boston for Bates and Stratton Notch for Skinner, into the deep distance. Pictorial space becomes an analogue for the years and miles separating the viewer from the scenes of his early biography.

The foregrounds in both paintings, however, are rich in visual and tactile detail. Cole describes tall stalks of mullein and the variegated, pebbly texture of Roxbury puddingstone (fig. 44), a detail the artist noted in a pencil sketch for the picture, writing across the foreground "conglomerate of purplish hue" (fig. 45). Such specific botanical and geological details could serve as mnemonic sparks to the imagination as well as testify to the artist's attentive presence on the scene.

Fig. 45.
Thomas Cole, *Boston from an Old Fortification at Roxbury*, 1839. Pencil on paper, 8 ⅞ × 13 ½ in. (21.5 × 34.3 cm). The Detroit Institute of Art. Founders Society Purchase. William H. Murphy Fund.

Cole's foreground details and composition also invoke and allude to the works of the seventeenth-century master of the pastoral landscape, Claude Lorrain (1600–1682). Cole did this in many of his works, but here the allusions carry an added weight of meaning. In many paintings by Claude, such as *Pastoral Landscape*, 1646–47, trees parenthetically frame the scene and funnel our attention deep into the depicted space toward the glowing horizon (fig. 46). In the foreground, figures engage in quiet rural activities, most often tending their herds and flocks. Claude's idealized images of the Roman *campagna*, often studded with ancient Roman ruins, were themselves suffused with nostalgia for the Arcadian delights described in Virgil's poetry. Not only does Cole's *View of Boston* make use of the Claudian compositional formula, but the shepherd and his flock, while perhaps a sight he encountered wandering Boston's Blue Hills, seem transposed from one of Claude's landscapes. These elements link Cole's painting to the long pastoral tradition in landscape and literature. They signify the past and the yearning for a distant, lost Arcadia, thus underscoring the nostalgic dimension of Bates's painting. Claude functions for Cole as a resource for his fulfillment of a patron's desire for a sentimental scene, a place that Cole through his art both recalled and transformed.

Durand's foreground choices seem equally significant. Although *Study from Nature: Stratton Notch, Vermont* is not the final painting created for Skinner, the study too seems to have been composed with the theme of nostalgia in mind. Durand has laid across the foreground a huge splintered limb, so recently fallen that leaves still cling to its branches. It carries associations of past strength and vigor as well as of loss. Its thick, shaggy bark is painted with impastoed strokes that catch the light. Its roughness, both pictorial and actual, heightens our sensory awareness, evoking touch as well as sight. The limb blocks our path,

Fig. 46.
Claude Lorrain, *Pastoral Landscape*,
1646–47. Oil on canvas, 40 ⅜ × 52 ¼ in.
(102.4 × 132.7 cm). Putnam Foundation,
Timken Museum of Art, San Diego.

forming a threshold, a liminal space. To cross it is to move from the concrete specificity and tactility of the physical, phenomenal world into the mistier realm of memory.

Though Durand created the view of Stratton Notch as a site for Skinner's solitary, private reminiscences, nostalgia permeated his entire landscape oeuvre. While Cole traced the origins of landscape nostalgia to Adam and Eve, Durand located it in childhood: his own, his viewers', and, increasingly over time, the nation's. In 1838, at the beginning of his career as a landscape painter, he wrote Cole of his ambition to convey through his works "the delicious reveries of my youthful days."[26] Later, in his "Letters on Landscape Painting" (1855), he argued that for those who traced "their first enjoyment of existence . . . to the country," a "true" landscape painting "becomes companionable, holding silent converse with the feelings . . . and, at times, touching a chord that vibrates to the inmost recesses of the heart." Such landscapes, he wrote, will conjure "the haunts of his boyhood," and, as the viewer wanders in his imagination along their painted paths, "pleasant reminiscences and grateful emotions will spring up at every step."[27]

Fig. 47.
Asher Durand, *An Old Man's Reminiscences*, 1845. Oil on canvas, 39 5/8 × 59 1/4 in. (100.6 × 150.5 cm). Albany Institute of History and Art. Gift of the Albany Gallery of Fine Arts.

Fig. 48.
Detail. Asher Durand, *An Old Man's Reminiscences*, 1845. Oil on canvas, 39 5/8 × 59 1/4 in. (100.6 × 150.5 cm). Albany Institute of History and Art. Gift of the Albany Gallery of Fine Arts.

In *An Old Man's Reminiscences*, 1845, Durand describes a figure lost in such reveries. In the shaded foreground, a white-haired man sits under an oak (fig. 47). The tree is riven at the base, rotting from within, its leaves tinged with brown, though the others around it are green, still in full summer leafage. The elderly man leans forward on his cane and gazes across a stream into the hazy sunshine of the middle and far distance, where, perhaps only in his mind's eye, children play in sun-dappled fields and lovers tryst beneath trees (fig. 48). This is a landscape of memory, of gentle melancholy, of tender recollection and aching loss.

Less obviously allegorical, yet equally nostalgic, is Durand's *Strawberrying*, 1854 (fig. 49). In this warmly lit early summer landscape, a girl gathers berries along the wooded shore of a shallow, calm river. Several paths lead into the landscape: the leftmost, a rocky uphill track, rises to a field where farmers are industriously sowing; the middle one directs us into a shaded bower, its further destination uncertain; and the rightmost glides along the river toward the steeple of a distant church and the luminous horizon. In *An Old Man's Reminiscences*, the path that opens in the left foreground terminates at the man's feet; he has reached its end. In *Strawberrying*, the multiple paths suggest the open possibilities of childhood.

When a critic for the *New-York Daily Times* encountered *Strawberrying* at the National Academy of Design exhibition in 1854, he responded to it much as Durand imagined a country-bred man might. He wrote that it evokes "the spirit of youth and hopeful life. . . . Scarcely one of the hundreds who gaze on this picture with delight will leave it without

recalling the days of their youth—the bright, active, strawberrying time of life."[28] Durand himself believed that imaginatively meandering through the quiet, familiar scenes of his pictures, like *Strawberrying*, would awaken sentimental feelings of attachment to the past, to home, and to family. For him, nostalgia was a positive, restorative, therapeutic emotion, an antidote to the abrasions of the onrushing world, as well as a social good, "soothing and strengthening," as he put it, the viewer's "best faculties."[29]

Like other Hudson River School painters, Durand deployed nostalgic elements to express his acute sense of loss at the passing of the wilderness, in what Renato Rosaldo would term imperialist nostalgia, mourning what we have ourselves destroyed.[30] Durand's *Progress*, 1853, for example, painted for the railroad entrepreneur Charles Gould, seems to simultaneously celebrate and lament the advance of American civilization (fig. 50). A sunlit path carries us deep into the scene, following the route of technological advancement from the telegraph poles of the foreground, past a canal, a mill, and a railroad to the distant burgeoning city with its busy wharves. There clouds part and light floods down as though God himself is blessing this scene of American progress.

Yet the diagonal wedge of foreground, which fills nearly half the canvas, is entirely given over to wilderness. From this wooded, rocky perch, two Native Americans gaze out over the transforming landscape (fig. 51). Curiously, the path of progress is not laid open at the viewer's feet. It seems to begin just off the canvas in the lower right-hand corner, while viewers are invited to step onto the rocky ledge and share the Native Americans' perspective on the scene. Angela Miller astutely notes that through this configuration Durand has "qualified the meaning of progress by conveying a sense of longing for the ostensibly timeless and unchanging existence of nature's indigenous inhabitants."[31]

In multiple canvases, Durand used the backward glance of nostalgia to subtly register his dissent from national ideologies of progress and manifest destiny. Such is the case with his *Landscape with Covered Wagon*, 1847 (fig. 52). Here he summons an expected landscape formula, only to subvert it. The covered wagon wending its way into the distance was an accepted symbol of national expansion. Typically, in images of westward migration the wagon moves toward the open, inviting landscapes of the frontier, but this is not what Durand represents. His wagon, with a man and child trudging hand in hand behind it, is about to turn the bend and disappear into the shadows. In a moment, the family will be lost from view, their fate and destination uncertain. The luminous vista of mountains and river just behind them represents not the promised land of the West, but the familiar beauties of the Hudson River valley—the home they are leaving behind.

The composition is similar to Cole's *Expulsion from the Garden of Eden*: the leftward movement of the travelers is countered by the rightward lure of home and its pleasures.

Fig. 50.
Asher Durand, *Progress,* 1853. Oil on canvas, 48 × 71 ⅞ in. (121.9 × 182.8 cm). Formerly in the Jack Warner Collection at the Westervelt-Warner Museum of American Art, Tuscaloosa, AL. Private Collection.

Fig. 51.
Detail of Native Americans. Asher Durand, *Progress,* 1853. Oil on canvas, 48 × 71 ⅞ in. (121.9 × 182.8 cm). Formerly in the Jack Warner Collection at the Westervelt-Warner Museum of American Art, Tuscaloosa, AL. Private Collection.

This is a painting not about the promise of the West, but about what is being lost and left behind. Here the backward gaze of nostalgia suggests the costs of migration and expansion: conceptions of the future are linked to deep feelings about the past from which we have separated ourselves. The cultural geographer John Wylie has asked, "Is landscape always already nostalgic?"[32] The answer is surely yes. Landscapes, even those that seem to be future directed, are predicated on loss and longing.

Fig. 52.
Asher Durand, *Landscape with Covered Wagon*, 1847. Oil on canvas, 26 ½ × 36 in. (67.3 × 91.4 cm). Indianapolis Museum of Art, Gift of Mrs. Lydia G. Millard.

THE LATER NINETEENTH CENTURY:
GEORGE INNESS

In the years after the Civil War, Hudson River School painting began to fall from favor, as new European-born landscape styles, such as the French Barbizon mode, claimed the allegiance of artists and the attention of patrons and critics. Yet even as styles changed, "sentimental" remained a term of critical approbation in relation to landscape art. This was true even in the century's waning years, when critics were increasingly applying the word to figure paintings in a negative sense, to disparage them as trite and predictable in subject and cloyingly sweet in mood.[33] They continued, however, to approvingly designate as "sentimental" those landscapes that they saw as originating in and arousing strong feelings, those that they believed reached for and achieved more than materialist description or novelty of subject or effect. Assessing the state of art in Boston in 1886, the *Art Amateur* referred to D. Jerome Elwell as "one of the most original and the most sentimental—in the best sense of that word—of our landscapists."[34] In 1894, a critic for the *Philadelphia Inquirer* praised the landscape painter Leonard Ochtman for "striving for the sentimental rather than the material side of his subject."[35]

Many late nineteenth-century critics disparaged what they considered blunt recordings of nature's physical appearance, shorn of its vital spirit and spiritual resonance. They rejected

both the painstaking geological and botanical detail of Hudson River School paintings and what many of them adjudged to be the superficial opticality of the impressionists, whose paintings were, in their minds, mere transcriptions of transient effects. The landscapes that they admired as "sentimental" stood apart from the supposedly rational, objective realm of empirical science and aspired to more than the representation of external facts. They looked beyond the materiality of nature to its connections to humanity, to the thoughts, sensations, and moods it aroused in the artist and the observer.

Proponents of sentimental landscapes believed, with the editor of *Appletons' Journal*, that "the true scope and purpose of landscape-painting . . . is to delight by sentiment and beauty, and not to surprise by vehemence and novelty."[36] These writers opposed the sentimental to the sensational, as well as to the material. In contrast to the huge, Barnumesque "sensation pictures" of artists such as Albert Bierstadt, sentimental landscapes did not lure viewers with exotic, novel, or theatrical effects. They kept their distance from commercial entertainment culture.

At midcentury, the pastoral landscapes of Durand and other Hudson River School artists had struck many observers as sentimental. But by the end of the century these works had come to seem too objective, too bound to material fact to deserve that term. By that time, the mantle of preeminent sentimental landscape painter had fallen on George Inness (1825–1894). He was then widely considered the greatest landscape painter in the country for his misty, emotionally evocative canvases.[37] In 1905, the critic Samuel Isham, in his *History of American Painting*, placed Inness at the head of a group that he called "the sentimental, or 'tonal' landscape painters."[38]

As early as 1860, a Boston critic sympathetic to Inness's Barbizon-inspired style favorably contrasted his *Noonday* (location unknown), an evocation of summer's "sultry warmth and broad repose," to the mountain grandeur of Albert Bierstadt's *Lake Lucerne*, 1858 (National Gallery of Art). Inness's picture "is sentimental in its character, and nobly so," the critic wrote, sensing in it a depth of emotion absent in Bierstadt's panoramic vista, which he described as "purely rhetorical . . . striving only for pictorial effect."[39]

Emotion, feeling, and sentiment are key terms in nineteenth-century critics' assessments of Inness's work, as well as in the painter's own accounts of his landscapes. In perhaps his best-known statement about the value and function of art, Inness said: "A work of art does not appeal to the intellect. It does not appeal to the moral sense. Its aim is not to instruct, not to edify, but to awaken an emotion. This emotion may be one of love, of pity, of veneration, of hate, of pleasure, or of pain; but it must be a single emotion, if the work has unity . . . and the true beauty of the work resides in the beauty of the sentiment or emotion which it inspires."[40] The most beautiful emotion was, in his mind, love. This

was not only the emotion that he sought to convey and evoke in his viewers, but also the emotion that he felt in response to his subject. Inness declared, "He who is daily giving us beautiful representations has loved what he has painted, and his love has been wisdom to him."[41]

A follower of the Swedish mystic Emanuel Swedenborg (1668–1772), Inness believed that love for one's fellow man and love for one's subject arose, ultimately, from God's love, which animated all of Creation.[42] Through his landscapes, he sought to awaken viewers' perception of that animating love. "The true end of Art," he said, "is not to imitate a fixed material condition, but to represent a living motion. The intelligence to be conveyed by it is not of an outer fact, but of an inner life."[43] In all his landscapes, he seeks to convey an impression of vital living spirit, often through the evocation of fleeting effects: effulgent sunsets, rising mists, scudding clouds, shimmering moonlight. These effects engender not only a sense of nature's vitality, but also an impression of something elusive, just beyond our reach, that Inness identified with "the subjective mystery of nature with which wherever I went I was filled."[44]

Inness had a particular affection for what he called "the civilized landscape." In 1878, he told an interviewer, "Some persons suppose that landscape has no power of communicating human sentiment. But this is a great mistake. The civilized landscape peculiarly can, and therefore I love it more and think it more worthy of reproduction than that which is savage and untamed."[45] It was really, however, just one phase of the civilized landscape that he felt moved to paint: the pastoral. For many years, he had a studio in New York City, yet he never painted its streets. In 1885, he settled in the suburban town of Montclair, New Jersey, twelve miles from New York, yet town life too makes no appearance in his art. It was the rural landscape of pastures, orchards, and farmsteads that held his affections. Even into the era of the Gibson Girl, the female figures in his pictures continue to wear sunbonnets and homespun. This attachment to the pastoral casts an aura of nostalgia over his scenes, eliciting a yearning for forms of life that were fading into the past. As the critic John C. Van Dyke said of Inness in 1903, when he painted "an Indian summer afternoon, there was a drowsy hum of nature lost in dreamland, and with the indefinable regret of things passing away."[46]

In *October Noon*, 1891, Inness addresses more directly than usual the loss of the pastoral landscape (fig. 53). The central theme of the painting is change. It represents a sparkling bright Indian summer day in the countryside, a few small clouds drifting overhead. The canvas is divided horizontally into bands of grass, trees, and sky. Into this simple compositional structure Inness introduces details that activate the landscape, endowing it with history and human meaning, as the inviting rural scenery of the right yields on the left to the suburban and the urban.

Fig. 53.
George Inness, *October Noon*, 1891.
Oil on canvas, 30 ⅝ × 44 ⅝ in.
(77.8 × 113.4 cm). Harvard Art
Museums/Fogg Museum, Cambridge.
Bequest of Grenville L. Winthrop.

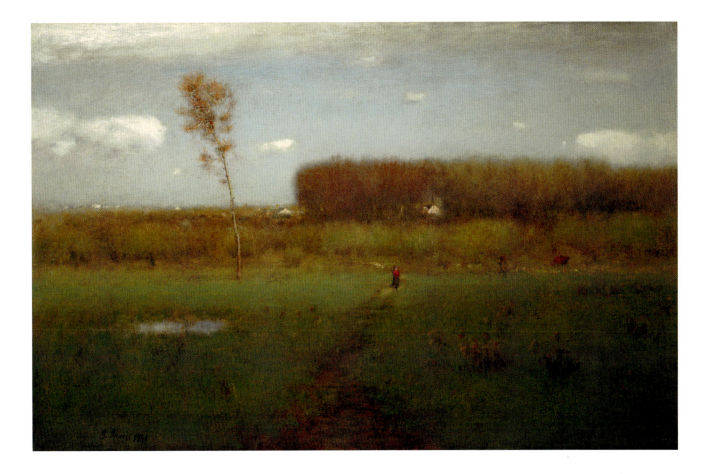

The right and left sides of the picture are strikingly different. A field of intense, vivid green fills the lower half of the composition. A beaten path opens in the foreground, just to the right of center, leading across the field to what appears to be an apple orchard. Deep into its length, a woman walks toward us, her blouse a bright red punctuation mark that pulls us into the scene (fig. 54). She seems to have emerged from the orchard and perhaps from the white house nestled in the thick stand of woods just behind it. Smoke ascends from the home's chimney, and a mysterious white aureole encompasses it in a magical protective glow.

In the most jarring passage in the picture, the thick woods that embower the house end abruptly halfway across the canvas. Does this mark a lot line, the owners on either side with differing desires and ambitions? The haloed house in the woods has a twin on the other side, another white house—yet without surrounding trees. Flecks and dots of paint suggest other buildings crowded near it in a suburban enclave, while, still farther to the left on the far horizon, light gleams on the structures of a distant city.

Fig. 54.
Detail. George Inness, *October Noon*, 1891. Oil on canvas, 30 ⅝ × 44 ⅝ in. (77.8 × 113.4 cm). Harvard Art Museums/Fogg Museum, Cambridge. Bequest of Grenville L. Winthrop.

Inness differentiates the two halves of the painting in other ways as well. The dense forest on the right is countered on the left with a single tree—a tall, delicate, spindly tree—a shape generally assumed by trees that are growing in a grove, cramped by their fellows, stretching ever higher in competition for light. Its form suggests that though it stands alone in the field, it was once part of now-vanished woods. Even the orchard, which stretches from one side of the canvas to the other, differs on the right and left. On the right, its trees are painted with soft strokes of warm yellow-green, while a reddish-brown smudge suggests a cow grazing among them. To the left, the colors are more subdued, with browns predominating over greens in the orchard foliage, and black marks of trunks and branches standing out more markedly. Although a clear brilliant light pervades the entire scene, such details underscore Inness's keen sympathy with the pastoral. Much like Cole's *Expulsion from the Garden of Eden* and Durand's *Landscape with Covered Wagon*, the temporal theme moves us from right to left, toward the future, but other details, such as the path and the red of the figure's blouse, draw us toward the rural landscape on the right, giving compositional form to nostalgic longings.

Wanda Corn writes of the turn-of-the-century tonalist style in which Inness's landscapes are generally situated, "If one were to characterize in a word the feeling created by viewing such works, it might be 'loss'—a pervasive though understated melancholy which these artists felt as their familiar world succumbed to alien and mechanical forces," those of modernity.[47] *Home at Montclair*, 1892, as much as any of Inness's pictures, is suffused with that wistful yearning (fig. 55). It represents Inness's own homestead, muffled in a mantle

Fig. 55.
George Inness, *Home at Montclair*, 1892. Oil on canvas, 30 ⅛ × 45 in. (76.5 × 114.3 cm). Sterling and Francine Clark Art Institute, Williamstown.

of snow and wintry twilight haze. In the foreground, smears and scratches of black pigment resolve themselves into small birds flitting among the dried stalks of the past summer's flowers. A low rustic fence stretches diagonally from the foreground to the left distance, where the sun is about to sink below the horizon, its dying light spreading a soft peach glow across the sky.

On the far side of the fence, in the shadowed distance beyond a dark cedar tree, a cluster of wooden buildings is partially hidden behind the bare branches of an apple orchard. Smoke rises from the house at the right, while near the leftmost building, the gray blur of a figure moves against the snow. The wafting smoke, the embracing orchard, and the golden haze create an impression of domestic felicity despite the winter chill. Yet the wide stretch of frozen fields that separates the observer from that home produces feelings of loneliness and longing. The scene is so softly painted, the forms so gauzy, and the homestead pushed so far into the distance that it seems to be receding and dissolving before our eyes—a pictorial elegy, rich with sentimental feeling, for a passing way of life.

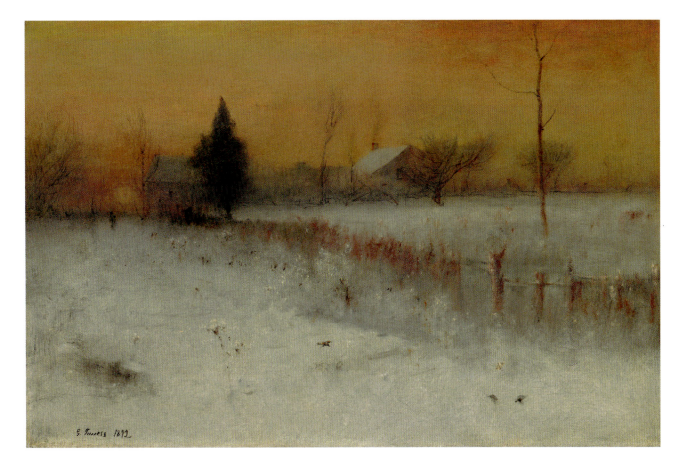

Sentimental Homer

CHAPTER FIVE

Winslow Homer was not sentimental. This is an opinion expressed repeatedly and emphatically in the extensive critical and scholarly literature on the artist: his figures are "not sentimentalized"; he "avoids any hint of sentimentality"; he "remains resolutely unsentimental."[1] I argue the opposite: that Homer is, in fact, among the greatest, if not the greatest, of American sentimental artists. Though Lloyd Goodrich believed that Homer "never tried to express subjective emotions," my sense is that "subjective emotions" were the wellspring of his art and are fundamental to the hold his paintings have on us.[2] His work is deeply and profoundly empathetic, often tender, as well as broadly and pervasively nostalgic.

Homer knew the sentimental well. He came of age in an era when "sentimental" was a widely used descriptive term applied to cultural productions ranging from valentines to sermons. The public could attend lectures about "Sentimental Novelists—Currer Bell [Charlotte Brontë] and [Nathaniel] Hawthorne."[3] New songbooks promised "popular airs and melodies . . . both sentimental and comical."[4] Gift books, albums, and the popular journals of the day gathered offerings of fiction and poetry that were "moral, descriptive, and sentimental," accompanied by illustrations described as "comic and sentimental, all artistic."[5] The sentimental was a highly valued and sought-after category of commodity, defined by its appeal to "the feelings of the heart," as one newspaper commentator explained it in 1852.[6]

During his many years working for the pictorial press, from the 1850s into the 1880s, Homer created within and responded to these varied categories of cultural production:

Fig. 56.
Winslow Homer, *Katy Darling*, ca. 1854.
Sheet music cover, lithograph, 13 × 10 in.
(33 × 25.4 cm). Library of Congress,
Washington, DC.

Fig. 57.
John Karst after Winslow Homer,
*The Cold Embrace, "He Sees the Rigid
Features, the Marble Arms, the Hands
Crossed on the Cold Bosom."*
Wood engraving. Sheet: 15 × 10 ½ in.
(38.1 × 26.67 cm). Illustration for *Frank
Leslie's Chimney Corner*, June 24, 1865.

descriptive, comic, and sentimental. He produced sheet music covers for sentimental songs, such as "Katy Darling," in which a young man kneels on the grave of his sweetheart and tells her of his love (fig. 56). He created illustrations for sentimental verse and fiction, such as the short story "The Cold Embrace," about the drowning of a young woman (fig. 57). When he first exhibited his oil paintings at the National Academy of Design in 1863, his choice of submissions, *The Last Goose at Yorktown* and *Home, Sweet Home*, suggest that he sought to display his facility in both comic and sentimental imagery (figs. 58, 59). A critic writing for the *New Path* recognized Homer's attention to these two genres, noting that in his response to the Civil War, he had avoided battle scenes and had instead "looked only on the laughing or sentimental side."[7] *The Last Goose at Yorktown*, in which two Union soldiers creep up on a sleeping goose, was Homer's comic entry. George William Curtis, writing for *Harper's Weekly*, called it a "neat bit of humor."[8]

In contrast, *Home, Sweet Home* immediately signaled its sentimental theme with its title, summoning the words and tune of a song familiar to all who stood before it.[9] The *Evening Post*'s critic described the scene as "of the pathetic order, and tender in its humanity to the last degree, representing as it does the bitter moment of home-sickness and love-longing which comes upon two brave men in camp on hearing the band play the air which recalls all priceless things from which they are separated. The delicacy and strength of emotion which reign throughout this little picture are not surpassed in the whole exhibition."[10] This writer judged the painting in sentimental terms—its ability to appeal to tender feelings—and found it compelling and moving. The painting was marked "sold" on the exhibition's second day.[11]

Fig. 58.
Winslow Homer, *The Last Goose at Yorktown*, 1863. Oil on canvas, 14 ¼ × 17 ⅞ (36.2 × 45.4 cm). Private Collection.

Fig. 59.
Winslow Homer, *Home, Sweet Home*, 1863. Oil on canvas, 21 ½ × 16 ½ in. (54.6 × 41.9 cm). National Gallery of Art, Washington, DC. Patrons' Permanent Fund.

Fig. 60.
Winslow Homer, *The Fisher Girl*,
1894. Oil on canvas, 28 ¼ × 28 ¼ in.
(71.8 × 71.8 cm). Mead Art Museum,
Amherst College. Gift of George D.
Pratt (Class of 1893).

Always attentive to the market ("I will paint for money at any time, any subject, any size"),[12] Homer recognized throughout his career the popular appeal and salability of the sentimental. In 1900, he wrote to his New York dealer, Knoedler, about his painting *Fog*, 1894, now known as *The Fisher Girl*: "If you want more sentiment put into this picture I can with one or two touches—in five minutes time—give the stomach ache that will suit any customer" (fig. 60). Perhaps sensing that his cynicism had gotten the better of him, he added in the next sentence, "Asking you to overlook these extra remarks."[13] He did repaint the picture two years later, and declared it "much improved."[14] Whether this involved heightening its sentiment, or how he might have done that, is difficult to say without knowledge of its earlier state. Yet Homer's inclination toward the sentimental was deeper, more genuine, and more meaningful than a calculated ploy to win the attention of a sentimental public.

The art that attracted Homer at the beginning of his career and guided him in establishing his personal style was consistently sentimental, as was the work of the artists with whom he formed friendships during his years in Boston and New York from the 1850s through the 1870s. Joseph E. Baker, Homer's fellow apprentice at Bufford's Lithographic and Publishing House in the 1850s, recalled an incident from those days. The two were visiting a Boston picture gallery when Homer announced, "I am going to paint." When asked "what line of work he was intending to take up," he pointed to a kitchen scene by the French painter of sentimental genre subjects Pierre-Édouard Frère (1819–1886) and said, "Something like that, only a [damned] sight better."[15]

Homer had set his sights on rivaling and surpassing an artist who was then extravagantly admired by critics and public on both sides of the Atlantic. John Ruskin, Clarence Cook, and James Jackson Jarves all lauded this leader of what was called at the time the "French school of sympathy," enthusing over his "exquisite" scenes of attractive, well-scrubbed peasant children in humble cottage interiors (fig. 61).[16] Ruskin praised Frère's "communion of heart with his subject."[17] When Frère's painting of a little girl attending to a kitchen task, *Shelling Peas* (location unknown)—perhaps the same work that Homer saw—was exhibited at the Boston Athenaeum in 1858, a critic for the *Evening Post* was entranced by the "inexpressible witchery" of its "tender sentiment."[18] We can only speculate on whether Homer would have agreed with such assessments. We do not know what he might have found to admire in Frère's work, nor what he hoped to improve on. He does seem to have absorbed from the French artist an interest in the anecdotal and feeling treatment of childhood, something that would blossom in his work in the 1870s.

Sympathy, literally "feeling with," is critical to the sentimental experience of art. Literary historian Glenn Hendler contends that "the experience of sympathy is the narrative and affective core" of the sentimental.[19] It is through the "movement of sympathy" that viewers are situated in relation to both the sentimental work of art and its creator.[20] As discussed in chapter 2, this sympathy involves an act of projection and imaginative identification. It demands thinking ourselves into the place of another, whether the artist or his subject, and drawing on our own experiences to imagine others' feelings—emotional, mental, and physical. Through sympathy, we feel connected to the subjects of the work of art, but we feel connected too to the artist who is, himself, sympathetically connected to his subjects. The work, the artist, and the viewer are bound together in a circuit of sentimental communication.

In nineteenth-century sentimental art, the act of sympathetic understanding sometimes takes place across and reinforces a status divide. Viewers are invited to make sympathetic connection across boundaries of class, gender, age, and race while, paradoxically, remaining at a distance. Pressing this point, scholars such as Lynne Festa and Laura Wexler argue that such movements of sympathy make invidious distinctions between those who feel and those who are felt for, between the subjects and objects of sympathetic understanding.[21] Frère's paintings, for example, elicited from middle-class audiences feelings of compassion for peasant children, even as they bolstered the viewers' security in their superior status, an effect reinforced by the slightly elevated point of view that Frère adopts in many of his canvases.

Perhaps some of Homer's works show, in Festa's phrase, this "redundant humanizing of the already human."[22] It could be said that, for instance, *Sunday Morning in Virginia*, 1877, a representation of African Americans conceived for a white audience, emphasizes the subjects' pathetic poverty, piety, and ignorance as much as (or more than) their aspirational ambitions (fig. 62). Homer's images of black life, however well intentioned they may have been, were painted from the perspective of an outsider, much like Frère's images of French peasant life, and this, to be sure, must be part of any full assessment of Homer's work and career.[23] But, in general, Homer painted from his own deeply felt embodied experiences and emotions, and encouraged in viewers an egalitarian identification with his subjects rather than a condescending compassion or pity. That is, he asks us, in Adam Smith's terms, to feel *with* them, rather than *for* them.

Another member of the French sympathetic school had a much more visible and more lasting impact on Homer's art than Frère: Jean-François Millet (1814–1875).[24] John La Farge, the only person, Homer said, with whom he enjoyed talking about art, claimed that Homer had come to know the work of the French Barbizon school in the 1850s, making drawings from "the French lithographs we had here," and possibly seeing "a few Millets."

This experience, La Farge believed, was the "foundation . . . in great part" of Homer's "genius." What Millet offered was a "vision of emotional art." His "characteristic paintings are . . . the expression of perpetual deep feelings" unified with a "severe realism," both made possible by the artist's intimate engagement in the rural life he represented. Millet's art opposed that of "official artists," such as Alexandre Cabanel and Jean-Léon Gérôme, who appealed to "those who desired to be amused by paintings rather than to be moved." Emotions, feelings, the ability to touch the viewer were, La Farge implies, as fundamental to Homer's art as they were to Millet's. Writing this assessment in 1908, La Farge was also making the case that realism and sympathy could be effectively and powerfully conjoined, as he, presumably, found them to be in Homer's art as well as in Millet's.[25]

Boston in the 1850s and 1860s was probably the best place outside France to become acquainted with Millet's work. William Morris Hunt (1824–1879), who studied with Millet for two years in the village of Barbizon, had returned home to Boston in 1854 with a trunkful of Millet's works. He took on a proselytizing mission, proclaiming the French painter's greatness to local art students and collectors, a number of whom he persuaded to invest in Millet's work. Hunt and his fellow collectors lent their acquisitions to local exhibitions, including those at the Boston Athenaeum, beginning in 1854. When Hunt established a spacious studio in Boston's Mercantile Building in 1864, he lined the walls with both his own paintings in the Barbizon style and Millet works from his excellent collection,

which included the famous *Sower*, 1850, and such sensitive images of children as *Shepherdess Sitting at the Edge of a Forest*, ca. 1848–49 (figs. 63, 64). Hunt held receptions in his new studio, creating yet another Boston venue where Homer might have studied Millet's paintings as well as Hunt's works inspired by the French master.[26]

In 1859, Homer moved to New York City, settling into the New York University Building with a convivial group of fellow artists, including a number who would share his interest in both Frère and Millet. Eastman Johnson (1824–1906), twelve years Homer's senior, was producing by the 1860s "sweetly serious" images of childhood that were being compared favorably to Frère's.[27] Eugene Benson (1839–1908), another painter of sentimental genre scenes in the manner of Frère, would make his mark primarily as a critic, writing insightfully about the work of both Johnson and Homer.[28] He also was among the first American critics, perhaps the first, to appreciate Millet.

Fig. 63.
Jean-Francois Millet, *The Sower*, 1850. Oil on canvas, 40 × 32 ½ in. (101.6 × 82.6 cm). Museum of Fine Arts, Boston. Gift of Quincy Adams Shaw through Quincy Adams Shaw, Jr., and Mrs. Marian Shaw Haughton. Photograph © 2018 Museum of Fine Arts, Boston.

Fig. 64.
Jean-Francois Millet, *Shepherdess Sitting at the Edge of a Forest*, ca. 1848–49. Oil on canvas, 12 ¾ × 9 ¾ in. (32.4 × 24.7 cm). Museum of Fine Arts, Boston. Gift of Quincy Adams Shaw through Quincy Adams Shaw, Jr., and Mrs. Marian Shaw Haughton. Photograph © 2018 Museum of Fine Arts, Boston.

In June 1864, Benson published an account of his recent trip to Boston. Perhaps he made this journey at his friend Homer's urging or even in Homer's company, since Homer was then still traveling often to Boston to visit his family in suburban Belmont. Benson had hoped to see Hunt's studio but, finding Hunt out of town, turned his attention to private collections, where he discovered Millet. Comparing him to Charlotte Brontë, he declared the French painter "profound."[29] "Looking at his pictures, you are conscious of a subtle and almost depressing sentiment, most always pathetic." His figures "have no happiness to know. They look heavy with gross cares, hardened with increasing labor, and vindictive and brooding. . . . They look like souls groping through matter."[30] The emotional range of this "sympathetic" or sentimental artist, Benson maintains, extends far beyond the "sweetly serious" tone of Johnson's work with its implication of tender gravitas, to encompass despondency and despair. Benson's responses to Millet were among the most sensitive published by any American critic in the nineteenth century.

Homer's own response to Millet is evident in paintings such as *The Brush Harrow*, 1865 (fig. 65). Nicolai Cikovsky has called this work "perhaps the most tenderly sensitive and perceptive of all of Homer's paintings of the Civil War."[31] Here Homer modifies the anecdotal treatment of adorable childhood found in Frère with a narrative reticence, a sobriety,

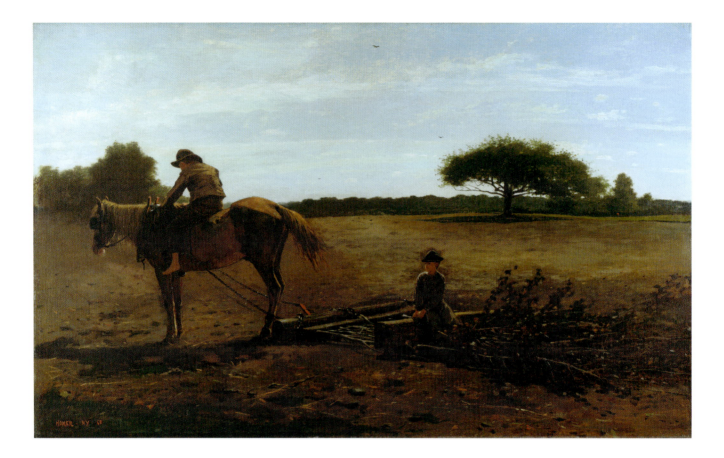

an emotional deepening, a somberness of tone—both emotional and pictorial—surely derived from Millet yet at the same time very much his own. That the painting relates to the Civil War dawns on the viewer only slowly. It seems at first a still, peaceful scene of country childhood, like so many of Homer's later images. But as we become absorbed in the work, as we linger over the details and take in their meanings, its complicating darker implications and moods begin to come through ever more fully.

Under a strong midday sun, two boys and a broken-down horse sow seed in a stony field. The fully leafed-out trees and their slightly rusty tones suggest that the boys are coming very late to the task of spring planting, or, perhaps, that the scene represents not spring planting, but rather the early fall planting of winter wheat, which usually took place in September or early October.[32] Rather than attending school, the boys attempt the work of men, their harsh lot underscored by each detail. As in many paintings by Millet (see fig. 63), the scene is backlit, with a figure silhouetted against a bright sky and the faces shrouded in shadow or turned away. The children are too burdened by their cares to make any effort to ingratiate themselves to us. Millet-like too is the subdued coloring, with boys, horse, field, and trees all described with the same brown tonalities, set off against, not the soft diffused light of Millet's France, but a hard, clear blue North American sky. The younger boy's figure, in drab, collarless homespun, half disappears into the earth, and both boys are nearly overwhelmed by the wide expanse of bare ground, stretching out to the ridge of trees at the far horizon. The field's breadth underscores the near impossibility of their task.

The older boy, no more than twelve, sits barefoot astride the unsaddled horse. This is no powerful draft animal: its mane is thin and limp, and bones protrude from its hindquarters. The boy hunches forward, a hand in the horse's mane, perhaps attempting to urge it into a walk. It remains still, unable or unwilling to drag the heavy harrow.

The smaller boy sits on a crossbar, his gaze soft and pensive. In a gesture as tender as any in Homer's work, the artist touched the curve of the boy's cheek with a stroke of palest pink (fig. 66). Another, rougher stroke defines a tear in the boy's shirt at the shoulder. He holds something, perhaps a feather, lightly, absently, his thoughts far away. He is too young to grasp the magnitude of the challenges he and his brother face. It is moving, too, that while they are together, the boys are separate, disconnected. No look or gesture binds one to the other. The impact of the scene would be very different if Homer had placed the figures in a closer or more intimate relationship with each other. At the moment, they both seem unaware of the danger the smaller boy is in. Were the horse to jerk forward, he could be crushed by the harrow's heavy bars.

In the foreground, we see the poor quality of the soil, strewn with rocks and broken sticks. In the distance, in a passage possibly culled from Millet's *Sower*, birds descend to

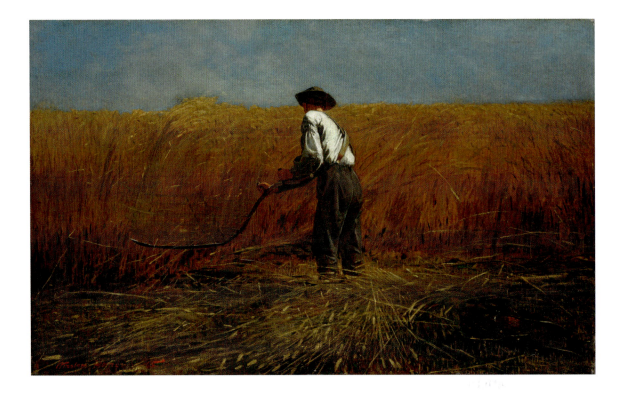

peck at the yet-to-be-covered seed. Little in the image bodes well for the boys, in the work they have undertaken or in the future that awaits them. Homer's sentimental art here is melancholy, even desolate.

Homer painted *The Brush Harrow* the same year as *The Veteran in a New Field*, and the two, I think, should be considered together (fig. 67). The same size and the same format, they were both created in the months immediately following Appomattox. We might think of them as companion pieces, as a Reconstruction diptych. In *The Veteran in a New Field*, a farmer has returned from the war. He is back in his home fields, having cast aside his army jacket to reap the thick, shoulder-high wheat. It is a sober yet hopeful image of national renewal.[33] *The Brush Harrow* represents a field to which no veteran has returned. More than 600,000 men, possibly as many as 750,000, died in the Civil War, at least one in five of those who served.[34] Hundreds of thousands of families were shattered by the loss of husbands, fathers, sons, and brothers, and many of those families consequently slid into destitution. In *The Brush Harrow*, Homer follows the convulsive aftershocks of the war into the country-side, subtly and poignantly materializing the suffering endured far from the battlefield.

Critics faulted Homer's Civil War paintings for their crude color and lack of finish, but as one allowed, "feeling cannot be learned; execution can. Mr. Homer is full of the

Fig. 67.
Winslow Homer, *The Veteran in a New Field*, 1865. Oil on canvas, 24 ⅛ × 38 ⅛ in. (61.3 × 96.8 cm). The Metropolitan Museum of Art, New York. Bequest of Miss Adelaide Milton de Groot (1876–1967), 1967.

former."[35] Like this *New York Leader* writer, many American critics in the 1860s and 1870s were in sympathy with the sentimental, all the more so in the aftermath of a devastatingly destructive war.[36] They called for an art of deep and true feeling, and valued works that forged compassionate bonds between viewer and subject. As the editor of *Appletons' Journal* put it: "The true and lasting value of a painting must be its power to suggest, to awaken, to touch the imagination or the sympathies, to link itself closely to the heart of the spectator."[37]

Homer received his most positive reviews when he elicited an emotional connection to his subjects. This was true throughout his career, and this critical approbation surely strengthened and extended the sentimental currents of his art. In the early 1870s, this painter of Civil War scenes began to charm his audience with images of one-room country schools. As Margaret Conrads writes, *The Country School*, 1871, "won the critics' affections" and "tugged at viewers' hearts" (fig. 68).[38] Such schools, then disappearing across the country, touched nostalgic chords in many observers, including a critic for the *Aldine*, who wrote: "Every person from the country knows the powerful associations lingering around the old red schoolhouse. . . . No spot in the whole world is so full of histories and memories."[39] Claire Perry has pointed out that Homer deliberately represented an "old-fashioned classroom" with side benches instead of the rows of desks that had become standard by the 1870s.[40]

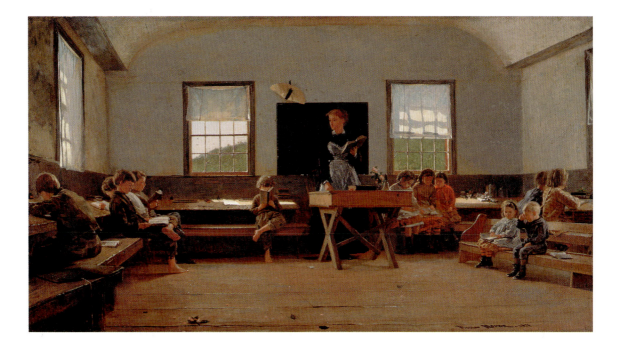

Homer understood well the beckoning lure of nostalgia—that melancholy and wistful longing for the past that literary scholar Svetlana Boym has described as "a defense mechanism in a time of accelerated rhythms of life and historical upheavals."[41] For those of Homer's generation who endured the traumas of the Civil War, the hopes and betrayals of Reconstruction, and the disorienting impact of dramatic, unprecedented technological change, nostalgia provided a refuge and a balm.

In 1876, critics were captivated by the newly completed *A Fair Wind*, now called *Breezing Up*, a painting of boys enjoying an afternoon sail, and they readily yielded to its invitation to sensory and emotional empathy (fig. 69). One noted of the boys, "They sway with the rolling boat, and relax or grow rigid as the light keel rises or sinks upon the waves. Every person who has been similarly situated can recall how, involuntarily, his back stiffened or his knees bent as he felt the roll of the waves beneath him." For this critic, the painting summoned sensations of "vigorous" boyhood.[42] Even the *New York Tribune* critic Clarence Cook, who routinely humiliated artists, including Homer, with his savage reviews, stood transported before it: "No eye that delights in salt water, and in the sight at least of a sailboat bounding over it . . . but must admit . . . that there is not anywhere—at home, in France, or even in England—a painter capable of its mate. It has always been reckoned a difficult task to paint people in a boat . . . yet here we see it done to perfection . . . with such ease and yet such certainty that we make one with them and cut the foam as glad as they."[43] Homer's mastery of the human figure, his ability to evoke sensations, and, especially,

Fig. 69.
Winslow Homer, *Breezing Up
(A Fair Wind)*, 1876. Oil on canvas,
24 3/16 × 38 3/16 in. (61.5 × 97 cm). National
Gallery of Art, Washington, DC.
Gift of the W. L. and May T. Mellon
Foundation.

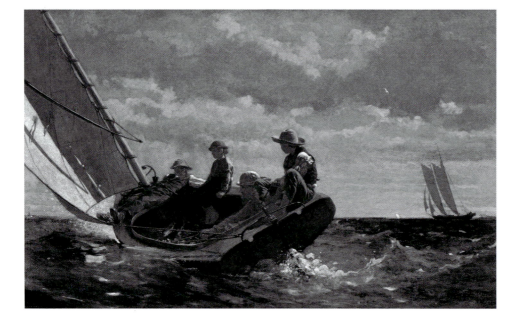

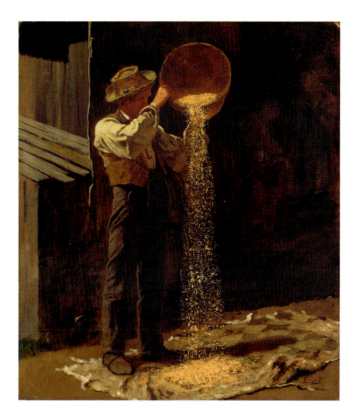

Fig. 70.
Eastman Johnson, *Winnowing Grain*,
ca. 1873–79. Oil on composition board,
15 ½ × 13 ⅛ in. (39.37 × 33.34 cm).
Museum of Fine Arts, Boston. Bequest
of Martha C. Karolik for the M. and
M. Karolik Collection of American
Paintings, 1815–1865. Photograph
© 2018 Museum of Fine Arts, Boston.

sense memories of swelling waves and windblown spray, enabled these critics to connect across the years with their boyhood selves.

During his years in New York, Homer belonged to a group of genre painters—including John George Brown (1831–1913), William John Hennessy (1839–1917), Enoch Wood Perry (1831–1915), Thomas Waterman Wood (1823–1903), as well as Eastman Johnson—whose work centered on nostalgic images of American country life. Twentieth-century art historians excised Homer from this group, dismissing the rest as, in the words of one midcentury critic, "revoltingly sentimental."[44] But this excision, as Sarah Burns has shown, distorts the historical record. Homer was "one of the pack," linked to the others by a "a dense web of crisscrossing lines."[45] They sketched together in the countryside, had studios in the same buildings, belonged to the same clubs, shared the same subjects—agricultural abundance, rural community, and carefree outdoor childhood—and appealed to the same human sympathies. In general, Homer's paintings are more broadly brushed and his detail more abbreviated, but at times his works are so close to theirs, and theirs to his, that it is difficult to distinguish individual styles, as in Homer's and Johnson's images of solitary farmers (fig. 70, and see fig. 67). Undeterred, critics have continually pointed to attributes of Homer's

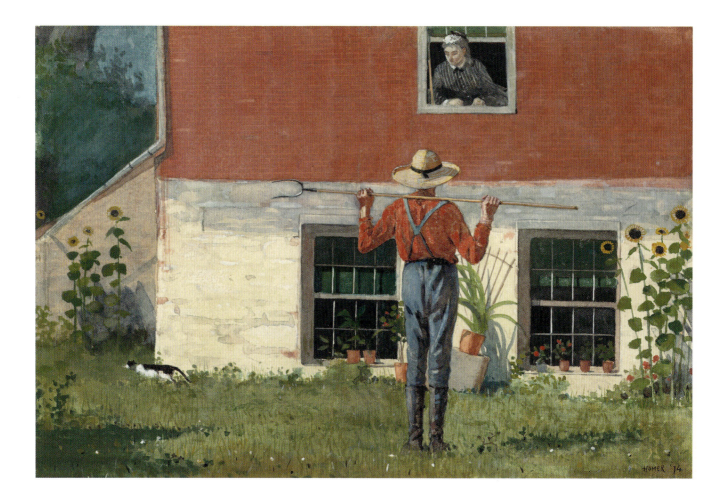

work that they believe distance it from the others, and from the sentimental more generally: his cool reticence, his narrative ambiguity, his anonymous figures, and his repression of detail. These traits may be found in the works of his peers as well, but more important to understanding Homer as a sentimental painter is that these choices all demand more of us as viewers, relying on us to supply what Homer has deliberately omitted and suppressed. In asking more of us, he heightens our imaginative and sympathetic investment in the images. That is, these artistic choices made him a better sentimental painter rather than an unsentimental one.

Homer deployed a number of these tactics in *The Rustic Courtship*, a watercolor of 1874 (fig. 71). A young man stands awkwardly in a farmhouse yard, seeking to woo a smartly dressed woman who looks down on him from a second-story window. His vulnerability is palpable. With his sunburned hands steadying the hayfork across his shoulders, he recalls

a man on a cross, his pose open, his heart exposed. Homer offers no assurance that he will be accepted. Though the young woman leans out the window toward him, all else underscores her aloofness: her elevated position, her downcast and sidelong gaze, and the red and white rectangles of the farmhouse wall that divide her space from his.

The composition further contributes to the scene's psychological tension. Its vertical center drops through the farmer's upraised left forearm. To the right, his strong vertical form, the stand of tall sunflowers, and the dark rectangles of upper and lower windows anchor the image. But the visual heaviness of this side is dynamically balanced by a pull toward the more open left. The tines of the hayfork, the diagonal of the rainspout, and the movement of the cat all lure us leftward. The woman's black and white costume and catlike face connect her to the slender feline that slinks off toward the edge of the picture. Through this visual linkage, Homer slyly hints that her thoughts and desires too are straying from the farmer.

As in so many of Homer's pictures, the narrative here balances on a fulcrum, the protagonist poised between acceptance and rejection, hope and anxiety. That he stands with his back to us in no way lessens our engagement with him. If anything, it deepens it, stimulating our imaginative identification with the figure. We are asked to align ourselves with this young man, to draw on our own experiences to intuit his thoughts and feelings, to think ourselves into the movements of his consciousness, to imagine his mingled yearnings and fears as he poses his question and awaits an answer.

The figure seen from behind—the *Rückenfigur*—is a recurring motif in Homer's art, appearing dozens of times, from *The Veteran in a New Field* of 1865 to *Driftwood* of 1909 (see fig. 80). These figures are male and female, child and adult, human and animal. Depending on their compositional placement, they resonate variously in their psychological impact. When, as in *The Rustic Courtship* or *The Fox Hunt*, 1893, the back-turned figures are centered in the scenes and placed close to the picture plane, our point of view literally aligns with theirs, heightening our emotional engagement and psychological investment (see fig. 75). When, on the other hand, Homer sets the figures deep within the pictorial space or off to the side, as in *Driftwood* or *The West Wind*, 1891 (Addison Gallery of American Art), our vantage point no longer lines up with theirs. In these cases, the figures' turned backs and hidden faces make us feel more acutely our separateness from them—our inability to share their perspective or know their thoughts. Even with the centered figures, the turned backs exclude us even as they invite us in, simultaneously offering and denying the possibility of connection. They are iconic representations of sentimentalism's central theme: the yearning for human connection and communion.

Fig. 72.
Winslow Homer, *Sketch of Two Girls*,
1879. As reproduced in *The Art Journal*,
n.s., vol. 6 (1880).

HOMER'S LATER YEARS

Some scholars concede that there is a sentimental strain in Homer's paintings of the 1860s
and 1870s, but nearly all deny that it continues into the latter half of his career, insisting
that it disappears after his English sojourn of 1881–82 and his resettlement in Prout's Neck,
Maine, where he lived from 1883 until his death in 1910. But the more fully we study Homer
in relation to the sentimental, the more we can perceive how much it remained the foundation
of his art. Homer never rejected sentimental art; early, middle, and late, he embraced its narrative
and anecdotal qualities, its nostalgic sentiments, and its invitation to empathetic engagement.

In 1880, the *Art Journal* affirmed that Homer had succeeded in his early ambition to
surpass Frère. Reproducing one of the artist's recent sketches of sunbonneted country girls,
the writer declared it "as sweet and winning as anything Édouard Frère ever put his mark
upon, while it has none of the weakness of touch which is sometimes to be regretted in the
pictures of the great Frenchman" (fig. 72).[46] Throughout his career, Homer's sentimental
work was richly complex. It combined, as this critic recognized, strength and tenderness,
as well as humor and sobriety, separation and connection.

The American art world was "in the midst of an era of revolution" in the 1880s as new
waves of European influence were transforming both art and art criticism.[47] The antisenti-
mentalist rhetoric of realism and the art for art's sake movement was fitfully, and soon
forcefully, taking hold, recasting "sentimental" from a descriptive term into a pejorative,
tainted with associations of triviality, prettiness, and effeminacy. (See chapter 6 for a fuller
discussion of this transition.) Many American critics continued to value the traits long
associated with the sentimental—feeling, sympathy, tenderness—but they were increas-

ingly unlikely to use the word "sentimental" to describe what they considered expressions or evocations of true feeling. The connotations of the term were shifting; it could still be invoked in a positive sense, but just as much, or more, it carried with it disapproval, skepticism, even hostility. William Dean Howells (1837–1920), the influential champion of literary realism, skewered sentimental fiction in his 1885 realist novel *The Rise of Silas Lapham*, satirizing and caricaturing those "books that go for our heart-strings" as "Slop, Silly Slop."[48]

Partisans of both realism and formalism claimed Homer as their own. Kenyon Cox, an advocate of the decorative formalism of the aesthetic movement, declared that Homer's "mastery of design is perhaps his most striking endowment."[49] On the other hand, Sadakichi Hartmann, a proponent of realism, conjured a different Homer, "aggressive in disposition, . . . engaged in a bitter warfare against all conventionality, . . . claiming that nature, studied from the standpoint of observation and discernment rather than that of intellectuality or sentiment, should be the only foundation of art." Hartmann was counting on Homer and his "brother artist Thomas Eakins" to oppose with their "rough, manly force" the "prevailing tendency" of American art "to excel in delicacy."[50] For those of Hartmann's disposition, Homer was the "greatest exponent of Realism" in the United States, "our Courbet."[51] Such critics devalued sentiment and sympathy, yet their arguments make clear how crucial these elements were for them; they signified the formidable, indeed in some accounts dangerous, theory and practice of the sentimental against which tough-minded realism was obliged, aesthetically and morally, to position itself.

Homer was well aware of, and responded to, these new stylistic currents—despite the many claims made during and after his lifetime that he was an entirely original artist, uninfluenced by outside sources.[52] In 1877, for example, caught up in the aesthetic movement, he joined with fellow artists to form the Tile Club, meeting Wednesday evenings to paint decorative tiles.[53] He also deepened his interest in the aesthetics of Japanese prints, which had a lasting impact on his art. Yet he never accepted Whistler's art for art's sake dictum that a painting is primarily an arrangement of lines, shapes, and colors, nor Whistler's demotion of subject matter, narrative, and emotion as of little to no account. Few of Homer's thoughts about contemporary artists have come down to us, but one of them concerns Whistler: "I don't think those symphonies and queer things Ruskin objected to will live any great while."[54] Homer's judgment was mistaken, but this matters less than the insight that this remark gives us into the aims and sources of his own art.

Homer's attentiveness to French realism ran deeper. He had been familiar with it since at least the 1860s, when his friend Eugene Benson wrote numerous appreciations of Millet, Courbet, and the Barbizon school, and when one of the major artistic events in Boston was the 1866 purchase and exhibition of Courbet's *La Curée*, 1856 (now called *The Quarry*),

a large-scale hunting scene and the first important picture by Courbet acquired in the United States (fig. 73).[55] Homer may even have visited Courbet's major exhibition on the Place de l'Alma during his 1866–67 Paris sojourn. It was not, however, until the mid-1880s that American critics in any number began to compare Homer to Courbet. It may have been such comparisons that ignited Homer's keen competitive spirit and led him to challenge Courbet, taking on many of the French artist's favorite subjects—hunting scenes, trophy fish, winter landscapes, and seascapes—examples of which Homer could have seen in New York and Boston.

American critics especially admired Courbet's animal and hunting scenes. In 1886, one wrote of the dogs in *The Quarry*, "If it had not been for Courbet we should never have known that it was possible for a man to paint the suppleness, the litheness of dogs in motion, so perfectly."[56] Might Homer's series of hound paintings, created from the summer of 1889 on, have been his response (fig. 74)? Is *The Fox Hunt*, 1893, as recent scholars have suggested, Homer's answer to Courbet's *Fox in the Snow*, 1860 (figs. 75, 76)? If so, Homer's is

Fig. 73.
Gustave Courbet, *The Quarry (La Curée)*, 1856. Oil on canvas, 82 ¼ × 72 ¼ in. (210.2 × 183.5 cm). Museum of Fine Arts, Boston. Henry Lillie Pierce Fund. Photograph © 2018 Museum of Fine Arts, Boston.

Fig. 74.
Winslow Homer, *Hunting Dogs in a Boat*, 1889. Watercolor with sponging and scraping over graphite on paper, 14 × 20 inches (35.6 × 50.8 cm). Museum of Art, Rhode Island School of Design, Providence.

Fig. 75.
Winslow Homer, *The Fox Hunt*,
1893. Oil on canvas, 38 × 68½ in.
(96.5 × 174.0 cm). The Pennsylvania
Academy of the Fine Arts, Philadelphia.
Joseph E. Temple Fund.

Fig. 76.
Gustave Courbet, *Fox in the Snow*,
1860. Oil on canvas, 33¾ × 50⅜ in.
(85.73 × 127.95 cm). Dallas Museum of
Art. Foundation for the Arts Collection,
Mrs. John B. O'Hara Fund, 1979.7.FA.

"a damned sight better." It is, to my mind, one of the greatest paintings ever produced in the United States, one that invites our intense empathetic identification with an animal, imagining the fox's rising fear and panic as sharp-beaked crows, their lustrous black wings spread menacingly above its head, prepare to dive. Though the fox is lunging forward, it has sunk belly-deep in the snow, hampering its escape. The wild rose hips on their delicate branches, so red against the snow, seem to presage the spatter of blood.

Courbet may have inspired and affected Homer's art, but ultimately Homer stands distinctly apart from him, for the American artist's work is tempered invariably by allegiance to the sentimental. Those who have cast Homer as the American Courbet insist on his brutality, his unflinchingly objective representations of violence and death. What they suppress are the empathy, the tenderness, and the nostalgic yearning that course through the whole of his work—the dimensions of Homer's art that link him to Millet and to the tradition of American genre painting, and that connect him to the culture and history of the mid- to late nineteenth-century United States.

Fig. 77.
Winslow Homer, *Old Friends*, 1894.
Watercolor and opaque watercolor, over
graphite, with scraping, on off-white
wove paper, 21 ½ × 15 ⅛ in.
(54.6 × 38.4 cm). Worcester Art
Museum. Museum Purchase, 1908.3.

Homer's move to Prout's Neck was, in part, a retreat from modernity, from the new culture that science, technology, and industry had begun to dramatically create. Not a total retreat, to be sure: Homer's brother Charles drove about the Neck in his new automobile. But Homer preferred, when possible, that a horse-drawn wagon deliver him to and from town and train, and he shunned the use of a telephone.[57] In his small, tidy studio-home, directly fronting rocks and sea, he was, he reported with some delight, "four miles from telegram and P.O. & under a snow bank most of the time."[58] There, he established a space where he could live according to the rhythms of an earlier era. In his art, his stern fishermen and axe-wielding Adirondack guides carry on with their work as they had throughout the century, though now and then he did acknowledge that their days were passing by.

In *Old Friends*, a watercolor of 1894, a gray-bearded Adirondack woodsman lays his hand affectionately against the trunk of a massive tree and gazes upward into its distant boughs, which are likely bare (fig. 77). While the trees around it still wear their green summer foliage, its own leaves lie in autumnal heaps at its base. White patches and rust-colored streaks mark the places on the trunk where its bark has peeled away. It is dying, or already dead. The man offers it a tender and reverential farewell—one that extends more broadly to the Adirondacks and to a way of life that Homer had known. He was painting at a

moment when conservation groups were organizing to protect and preserve the North Woods of New York from the depredations of clear-cutting and ever-expanding tourism. Three years earlier, *Forest and Stream Magazine* had reported that "the Adirondacks, as known to the sportsmen, are in large measure passing away."[59] Homer's painting, as Helen Cooper has suggested, is "a requiem . . . for the artist's beloved wilderness."[60]

Well into the Prout's Neck period, Homer's work remains a nostalgic and storytelling art. Yet the narratives become more concentrated, the stakes of the outcomes higher, and the feelings more fraught and piercing. Paintings such as *The Fog Warning*, 1885, and *Lost on the Grand Banks* of the same year (Private Collection) are gripping in the incidents they depict and penetrating in their emotional intensity (fig. 78). In both, muffling fog and heavy seas imperil fishermen who ride out their fate in fragile, shell-like dories. Brave determination and concentrated action thinly mask their helplessness. Both dories ride the crest of waves; momentarily, they will plunge into a trough of the sea, a plunge we anticipate in our guts. The empathy the paintings engender is physical as well as emotional. The paintings are all the more thrilling because, even as they bear witness to Homer's investment in sentimental art, they radically heighten the relentless power and magnitude of nature— a force that is immeasurably beyond that of any person, and that makes any and all changes on the national scene seem transitory. By this phase in Homer's career, his concern is with the sheer reality of the human condition—that we are part of an infinitely complex, threatening, and humbling world, and, time bound, must come to terms with time and death.

Few of Homer's contemporaries who stood before these paintings were unmoved. Without using the word "sentimental," critics responded to the pictures' powerful impact, reporting themselves awed by "true feeling" and "stirred as by some noble epic."[61] To William Howe Downes, art critic for the *Boston Transcript* and Homer's first biographer, the paintings spoke "to the emotions and sympathies, appealing to the inextinguishable human reverence for the modest and brave man's performance of the day's duty."[62]

The sentimental, according to literary historian David Marshall, involves not just the "capacity for feeling, but more specifically the capacity to feel the sentiments of someone else."[63] This is what Homer asks of us. He asks us to empathize physically, emotionally, psychologically, and sensorially with his characters, whether human or animal. He does not allow us to believe that we can fully apprehend the situations and feelings of others, but he challenges us to try, as he challenged himself, in the permanent human quest for connection.

Integral to this challenge was Homer's experimentation, throughout his career, with shifting points of view; he continually conveyed himself and his viewers into different subject positions. Having painted the Civil War from the Union side, he then carries us into the Confederate trenches, placing us with a soldier looking back at the Union line in *Defiance: Inviting a Shot before Petersburg*, 1864 (Detroit Institute of Arts). In his schoolhouse pictures, he describes, in some, the joyous, explosive release of children freed from the classroom, but turns back, in others, to regard the teacher still confined inside, bored and brooding. In his paintings of Cullercoats, in England, he attends to the fishwives waiting on the shore for their men to return. Once he settles on Prout's Neck, he follows the men out to the fishing banks. But the most astounding of these psychological investigations are the paintings in which he shifts from the perspective of hunters and fishermen to their prey, revealing, in Marc Simpson's words, "the artist's poignant identification with the hunted."[64]

In *Life-Size Black Bass*, a watercolor of 1904, Homer sinks us into the dark waters of Florida's Homosassa River, gill to gill with a large-mouthed bass (fig. 79). The slender arabesque of a fishing line whips across the page from lower left to lower right before curving upward toward the fish's mouth, where a scarlet fly conceals the razor-sharp hook piercing its lower lip. It has risen half out of the water, its white underbelly exposed to us. Its red gills flare as it thrashes to free itself. The flash of red, the natural color of the fish's gills, is shockingly intense, erupting against the subdued, nearly monochromatic landscape. Homer brings us so close to the fish that we can count its scales and see the curvature of its gleaming eye. The tight cropping compels our sympathetic engagement, propelling us to imagine its feelings and sensations. Is it experiencing searing pain and rising panic as it nears its death?

Fig. 79.
Winslow Homer, *Life-Size Black Bass*, 1904. Watercolor over graphite on ivory wove paper, 13 ¼ × 20 ¾ in. (35 × 52.6 cm). The Art Institute of Chicago. Bequest of Brooks McCormick.

In *Life-Size Black Bass*, as in *The Fog Warning*, *The Fox Hunt*, and so many of his works, Homer takes on a conventional sentimental subject: a figure in distress. Yet in choosing his protagonists, he pushes us to extend the range of our empathy and concern into new registers and realms. He places us in the subject positions of sleek game fish, hard-bitten fishermen, and a threatened fox, and asks us to imagine the vulnerabilities that define and link us all, not just as humans but as living creatures.

In 1909, Homer's own death was a year away. In mid-November, he wrote his brother Arthur to inform him that he would not be able to join the family for Thanksgiving: "I have little time for anything—many letters unanswered and work unfinished. I am painting."[65] The picture that he was working on with such urgency and concentration was *Driftwood* (fig. 80).[66] He shipped it to Knoedler at the end of November. It would be his last painting, as he realized when he was working on it. Once he had laid on the last stroke, he smeared his palette and hung it on his studio wall.

Prout's Neck was Homer's home for more than twenty-five years, a place he knew by heart. Its geography and his work were inseparable, each inlet and highland associated with particular paintings. The month before his death, he roamed the peninsula with the New York dealer William Macbeth, pointing out, "From this point I painted 'The Fox Hunt,' from over there 'The Undertow.'"[67] *Driftwood*, Philip Beam has determined, represents Kettle Cove, a property not far from his studio, where Homer had built a house, as he put it, "to die in."[68] This is the view that he had imagined looking out on when he took his last breath.

Under leaden, stormy skies, a man in foul weather gear has made his way down to the shore, where crashing waves have flung a huge tree trunk against the dark ledges. He carries a coil of rope, presumably to secure the log for future use. Yet the rope seems inadequate to the task, and the prize hardly worth the risk. Footing must be precarious on the wet, kelp-covered rocks, and the wind is driving in powerful waves that are high enough to dwarf him. The leading edge of the closest wave is smashing into foam, but the lagging edge still towers threateningly above him, and behind it roll the whitecaps of many more. Yet he looks down, so focused on his chore that he seems oblivious to the danger. Is he courageous or foolhardy? Resourceful or woefully unprepared? In Homer's final assessment, is this what matters—pursuing one's work against all odds? Doing something with what one has been given, whatever the risks?

Homer was surely thinking himself into this figure as he gave him form. He is another of Homer's *Rückenfiguren*: faceless, his back turned toward us. But this time Homer has pressed him into a corner of the picture, distant and separate from us, his gaze not aligned with ours. He is alone. If this man is swept out to sea, will any one know? The single seagull, riding the breezes above his head, might bear witness, but the only other human presence in the scene—the passengers and crew of the tiny steamship, barely visible on the leftward horizon, will continue on their journey, unaware of his fate (fig. 81).

Yet Homer was always keenly appreciative of the beauty of the world, respectful of, reverential toward, the majesty and wonder of nature even at its most formidable and intimidating. In *Driftwood*, the figure's head is lowered, but we and Homer can see, above him, the heart-stopping turquoise of a rising wave, edged with lacy foam. This greatest of American painters was sentimental to the end.

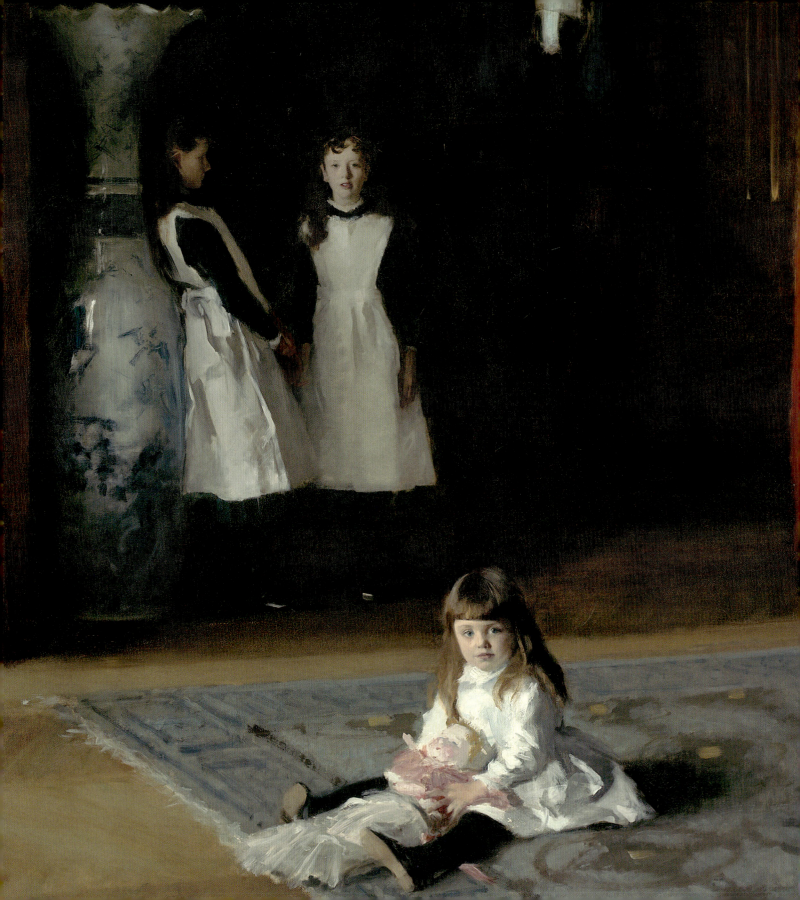

Strategic Sentimentalism

John Singer Sargent and Mary Cassatt

CHAPTER SIX

To American artists and architects, the sentimental was still a widely valued, politically charged, and socially engaged aesthetic when, in 1846, Charles Baudelaire (1821–1867) published his barbed review of that year's Paris Salon. Writing from within the French art world, he took aim at a group of genre painters he termed "the apes of sentiment," accusing them of "aping" emotions they did not feel but rather derived from maudlin popular literature. He assailed them for producing canvases of vapid prettiness, calculated to appeal to "aesthetically-minded ladies." Formulating a powerful but facile equation that is still deployed today, he proclaimed: "The apes of sentiment are, in general, bad artists. If it were otherwise, they would do things other than sentimentalize."[1] "The cry of feeling," he asserted, "is always absurd."[2]

Baudelaire launched a crucial semantic shift in the meanings of the sentimental within art criticism. Recast as a term of derision, it found purchase among members of the European avant-garde before taking patchy hold in the United States at the turn of the century. The American artists who responded first to the newly formulated understanding of the sentimental were those working abroad, particularly in Paris, including the expatriates who are the focus of this chapter, John Singer Sargent and Mary Cassatt.

THE TURN AGAINST THE SENTIMENTAL

The Parisian avant-gardes that took shape in the decades following Baudelaire's outburst embraced his stance against the sentimental, binding it to notions of conventionality and bourgeois appeasement. Realist writers and artists and, later, the naturalists, denigrated sentimental art's appeal for emotional engagement as well as what they perceived to be its clichéd subjects. The naturalist writer Émile Zola (1840–1902) argued that artists should be scientifically objective; that is, they should approach modern life with the cool, detached gaze of the sociologist gathering data, observing it in all its commonplace ugliness and brutality. The ambition of the artist, as both "an observer and an experimentalist," should be neither to move the viewer nor to moralize about social conditions, but to present original observations.[3]

The advocates of art for art's sake, with their formalist orientation, adopted a different but related perspective.[4] They rejected the empathetic engagement with subject matter so essential to the sentimental in favor of an aesthetic engagement with form. James A. M. Whistler (1834–1903), who had close ties to Courbet, Édouard Manet, and other leaders of the Parisian avant-garde, argued in 1878, "Art . . . should stand alone, and appeal to the artistic sense of eye or ear, without confounding this with emotions entirely foreign to it, as devotion, pity, love, patriotism, and the like."[5]

Yet for all the abuse heaped on the sentimental by avant-garde writers, artists, and critics, it remained popular with the great mass of the public and with more conservative critics. This was to some extent true in Paris itself, and the farther one traveled from Paris, the truer it became. Even Parisian proponents of the avant-garde could at times yield to the appeal of a sentimental address, responding positively to a work's representation or evocation of the gentler emotions. Moved by such images, these critics would laud their "sympathy" and "tenderness," yet would conclude by stating explicitly that the works were "not sentimental." In this new—and sometimes elusive—formulation, genuinely moving works of art were excluded from the category.

Increasingly, the word "sentimental" was wielded as a pejorative, applied to works of art that made an obvious appeal to the viewer's emotions without eliciting a genuine emotional response or extracting responses considered shallow, exaggerated, ineffectual, or self-indulgent. It also came to be used more broadly as a blunt instrument to bludgeon works adjudged feminine, commercial, populist, pretty, idealized, or simply bad.

The transformation in the term's denotations and connotations took place fitfully and incompletely. This was especially true in the United States, as we have seen in the previous chapter in the context of Winslow Homer's reception. There, the word continued to

be used in its older positive or descriptive sense, particularly in relation to art, into the early twentieth century. But already in the 1870s, some American artists and art critics began to adopt the antisentimentalist stance of the European avant-garde and to deploy the term derogatorily. This created a situation in which the word's meanings were so varied, even contradictory, that only within the specific context of its use can one discern its intended sense. In 1907, the American critic Charles Caffin, following Baudelaire and Zola, argued for the "place of so-called ugliness in art," and lauded "the effort of a few of our younger painters [Sloan, Henri, Glackens] to shake themselves free from the fetters of prettiness and sentimentality in which much American art is confined."[6] Yet that same year, a writer for the *Boston Daily Globe* praised Augustus St. Gaudens for his "many great specimens of sculpture, martial, sentimental, heroic, and beautiful."[7] The term could retain its earlier positive associations, even as, through this same period, sentimental art itself was changing, losing its forward-looking political charge and its commitment to social reform, with notable exceptions, such as the work of Henry Ossawa Tanner.

SARGENT AND CASSATT

In the 1860s and 1870s, at this moment of upheaval in attitudes toward the sentimental, John Singer Sargent (1856–1925) and Mary Cassatt (1844–1926) both moved to Paris to pursue artistic training and launch their careers. They became aware of and participated in the antisentimentalism of their era. Critics—their contemporaries and ours—have admired and, at times, lamented their unsentimental approach to their subjects. Cassatt, according to an American critic writing in 1881, manifested an "incapacity for the poetic and sentimental."[8] In 1919, the American art historian John C. Van Dyke offered a similar assessment of Sargent, whom he says "is not a poet in paint, nor does he indulge in sentiment, feeling or emotion."[9] In more recent decades, certainly since the 1970s, Sargent's and Cassatt's unsentimental stances have been consistently assessed as strengths, validating the artists' places in a modernist genealogy that begins with Courbet and Manet. Barbara Dayer Gallati, a sensitive critic of Sargent's works, writes that he "resuscitated child imagery from the smothering effects of Victorian sentimentality."[10] Frances Pohl, in a recent survey text of American art, locates the artistic merit of Cassatt's subjects in their distance from the sentimental: "Cassatt's paintings of mothers and children are not sentimental depictions, but rather serious, and often monumental, renditions of the processes of nurturing that were women's socially prescribed tasks."[11]

Artistic greatness in our time resides only at a perceived remove from the sentimental. Indeed, for many decades now, the validation of artistic quality has come close to requiring an assurance that the works under discussion are sentimentality free. Thus considerations of Sargent and Cassatt very often begin with "Without being sentimental, . . ." Yet, as aware as Cassatt and Sargent were of the antisentimental biases of the avant-garde, they also understood the sentimental's commercial potential and popular appeal, and were not immune to the lure of the tender and the touching. Moreover, we know that both were very ambitious artists who sought continually to challenge themselves. One challenge they took on, I will argue here, was a negotiation and interrogation of the sentimental. They entered into a dialectical relation with it: engaging it, critiquing it, distancing themselves from it, and in the process transforming it.

Both Sargent and Cassatt were savvy, accomplished artists who could deploy the sentimental to good effect when they chose but could also evade and subvert it when that suited their purposes. We can think of them as "strategic sentimentalists," but equally as "strategic antisentimentalists," moving adroitly and in complicated ways between those positions according to their artistic aims and audiences. This is a crucial dimension of Sargent's and Cassatt's work that critics and scholars have neglected or misinterpreted. As I hope to show here, when we isolate and examine the interactions of these two artists with the sentimental, we gain a fuller, more rounded, and more complex understanding not only of their work, but also of the sentimental itself. The status of the sentimental as a recognizable and available aesthetic mode, which artists could turn to or against as they chose, was undergoing rapid changes in the later nineteenth century, as it shed its socially transformative ambitions and became increasingly allied with nostalgia. Finally, the sentimental was variously reimagined and reworked to align it with the formalist interests of the avant-garde and with the newly emergent scientific field of psychology.

JOHN SINGER SARGENT IN PARIS

On a visit to Boston in 1890, Sargent told a family friend, a seventeen-year-old aspiring artist named Lucia Fairchild, that when he was her age he was "sentimental—oh, maudlin sentimental!" She asked him how he "got over it." He replied that "Paris was not the place for that kind of thing," but confessed that he still "naturally took a sentimental view of things."[12]

In this exchange Sargent—a man who rarely made disclosures about his inner life— seems to have been assessing his own personality, specifically his sensitivity to his own and others' feelings. Those closest to him from childhood onward described him in consistently

similar terms: sentimental, tenderhearted, sympathetic. A childhood friend recalled him as a "big-eyed, sentimental, charming boy."[13] To his later friend and biographer Evan Charteris, he was "generous to a fault in deed and judgment. His kindness of heart was exceptional." Yet, Charteris went on, "his compassion, though deep, was concealed by shyness; his eye might kindle with sympathy, his voice change when confronted with suffering, but he shunned expression of deep feeling." In France, sketching near the battlefront during World War I, "faced with sights to which he was acutely sensitive, and suffering in its most poignant form, he continued to maintain his habit of reserve."[14]

Sargent's practice of self-containment led those outside his intimate circle to perceive him as reticent, distant, even cold. His harshest critics have charged his art with related failings, finding his portraits dazzling but superficial, exhibiting a detachment from and lack of sympathy for his subjects. A critic for the *New York Tribune*, writing in 1899, admired Sargent's portraits as "so powerfully drawn, so original, so brilliant!" Yet, he went on, "What is it that is missing? Imagination, tenderness, passion, deep human feeling—these things are, on the whole, absent."[15] In 1916, a British critic similarly faulted the portraits for "their tendency towards impersonal, slightly heartless evaluation of externals rather than brooding appreciation of fundamentals."[16]

What were Sargent's own views about the appropriate role of sentiment in art? When his childhood friend, the accomplished aesthetic theorist Vernon Lee, advocated in her book *Belcaro* (1881) a purely formalist approach to art, denying subject matter and its attendant emotions any role in the true appreciation of art, Sargent disagreed: "I think your theory of the all-importance of beauty and its independence of or hostility to sentiments applies admirably to the antique and to the short great period of art in Italy. . . . It is another question & I suppose a matter of personal feeling whether that state of things is more interesting than another; . . . There are some like Durer and Rembrandt & the French Millet who are very 'inquiétants' [disquieting] for one who thinks as you do. For their talent is enormous too, and they have intimité [intimacy]."[17]

That expression of his views can be connected to others. In 1889, when the musician George Henschel wrote to thank Sargent for his recently completed portrait, Sargent replied: "I should be quite satisfied with my portrait if it created in you the sentiment of sympathy which prompted me to do it."[18] Sympathy generated the portrait, and Sargent hoped that it would elicit corresponding feelings in the subject, reminding him of, and thus continually renewing, the bonds between them. The following year, on a visit to Boston, Sargent passed an afternoon visiting an exhibition of the works of the Russian historical painter Vasili Vereshchagin (1842–1904), who produced huge antiheroic battle scenes that emphasized the terrible brutalities of war. Sargent pronounced them, in general, "very good,"

but singled out one as "too sentimental."[19] With the single word "too," he indicated that he had not adopted "sentimental" as a term of condemnation in itself. Sentiment, tenderness, sympathy—these to him had a significant role in art. Yet they needed to be handled judiciously—weighed, considered, kept in check—which for Sargent was in keeping with his guardedness about his own feelings. This would be his approach to the sentimental throughout his career, appraising its use in relation to particular conditions of production and reception.

Sargent painted *The Daughters of Edward Darley Boit* in Paris, the city that he knew was "not the place" for the sentimental (fig. 82). He completed the canvas in 1882, when he was twenty-six and seeking to establish his career and find his niche within the many competing factions of the Parisian art world. He described himself at this time to his friend Vernon Lee as "an impressionist and an 'intransigeant,'" thus linking himself to the French avant-garde.[20] Yet his uncertainty about his artistic identity is suggested by the painting's exhibition history. He showed it first in 1882 at the galleries of Georges Petit, known for hosting works by artists of the *juste milieu* who were seeking a middle way between the academic and the avant-garde. The next year it was his only submission to the Salon of 1883.[21]

Sargent's most haunting and psychologically complex work, *The Daughters of Edward Darley Boit* is consistently described in the Sargent literature as "unsentimental," and for good reason: it positions itself against the sentimental in manifold ways. But the painting is all the more noteworthy for the work with the sentimental that Sargent does in it, engaging the tradition as he distances himself from it.

His subject, four "pretty little girls" in a domestic setting, carried with it expectations of the sentimental.[22] Quite a number of early commentators read the painting according to those expectations, finding in it a narrative of happy childhood, of children "surprised at their games."[23] To a *London Morning Post* critic, for example, it presented a "happy Eldorado of childhood," with the small vases on the mantel "probably filled with jams."[24]

More recent scholars have located within the painting another sentimental narrative. Sargent's scattering of the children within the depicted space necessitates that the viewer encounter each one as an individual rather than as part of an inseparable family group. The movement of our eyes and thoughts from one girl to the next across the canvas and into its pictorial space metonymically evokes a passage of time and a narrative of maturation. We move from four-year-old Julia sitting in a foreground flooded with light—looking out and up at us with the openness of early childhood—to eight-year-old Mary Louisa on the left, more self-consciously and obediently posed, to twelve-year-old Jane and fourteen-year-old Florence set further back still, in the threshold of a shadowed anteroom. Jane faces us, but Florence, seemingly sunk into adolescent sullenness, leans back against an outsize vase, her features, like her thoughts, obscured in shadow. On the vase, a bird spreads its wings in

Fig. 82.
John Singer Sargent, *The Daughters of Edward Darley Boit*, 1882. Oil on canvas, 87 ⅜ × 87 ⅝ in. (221.93 × 222.57 cm). Museum of Fine Arts, Boston. Gift of Mary Louisa Boit, Julia Overing Boit, Jane Hubbard Boit, and Florence D. Boit in memory of their father, Edward Darley Boit. 19.124. Photograph © 2018 Museum of Fine Arts, Boston.

flight. The painting, in this narrative reading, offers adult viewers (and parents, in particular) a deeply affecting reminder of the ways in which our children grow up and away from us.

This theme—the evanescence of childhood and the way that its passing disrupts and destabilizes family bonds—was by then a well-established sentimental subject, treated at the time and later by artists such as Thomas Hovenden in his *Breaking Home Ties*, the most popular painting at Chicago's World's Columbian Exposition in 1893 (see fig. 1). Yet, while Hovenden treats the theme in the conventional sentimental mode, evoking the tenderness of familial bonds and the pain of their breaking, Sargent neither assures us nor even hints that such affective family bonds have ever united the Boit family. His presentation of the girls seems calculated not to invite empathetic engagement, but rather to frustrate and deflect it. The children pose before us, the three youngest more respectfully than the eldest, awaiting judgment or dismissal. Ambiguity, mystery, and an undefined yet pervasive unease disrupt ready sentimental responses. One French critic wrote of the painting: "The portraits . . . have something about them that is . . . cold and cruel. They disturb me."[25]

The setting is a home, the foyer of the expatriate Boits' Paris apartment, yet it is strikingly devoid of conventional sentimental associations with home: shelter, warmth, comfort, nurturance, love. Instead Sargent seems to be deliberately denying such expectations. The painting implies the unsettling precariousness of childhood: the presence of fragile, vulnerable psyches, lonely and unmoored in an atmosphere of brooding melancholy.

Susan Sidlauskas has written insightfully about the psychological expressiveness of the hollowed-out, too-large space in which these children have been set adrift.[26] The almost aggressively assertive presence of the room's objects charges it with further psychic tensions. Within the muffled darkness of the anteroom, the sidewall with its mantelpiece seems to have swung unaccountably forward. The huge vases, made in Arita, Japan, specifically for the Western market, are the largest "figures" in the room.[27] With their corporeal shapes, they assume a sentinel status, seemingly cast as parental surrogates. Yet they are armless, hard-surfaced, and empty. The screen is paired visually with Mary Louisa, its angular, piercing edges and its vivid, insistent orange both echoing and intensifying the crisp starched edges of her pinafore and the brick red of her dress. The screen's form, poised precariously on a single sharp point, suggests instability, while its very presence evokes ideas of the concealed and the mysterious.

The linking and likening of the girls to the vases and the screen raise the specter of commodification.[28] With their starched pinafores and stiff poses, the girls reminded some of Sargent's contemporaries of dolls, with one caricaturist showing them mounted on stands next to rows of ceramic vessels (fig. 83). The children, in this reading, take on the status of possessions, of rarefied objets d'art, of symbolic capital—markers of their parents'

Fig. 83.
Caricature of Sargent's *The Daughters of Edward Darley Boit*, published in *Le Journal Amusant*, May 26, 1883.

Fig. 84.
Diego Velásquez, *Las Meninas*, 1656. Oil on canvas, 10 ft. 5 in. × 9 ft. (318 × 276 cm). Museo del Prado, Madrid, Spain.

SARGENT.

²⁴ Grand déballage de porcelaines, objets chinois, jouets d'enfants, etc., etc.

affluence and taste. What counts is not the affective bond of the parents with their children but, instead, the parents' successful molding of the children into well-disciplined, well-dressed, socially presentable models of bourgeois girlhood.

As many of Sargent's contemporaries recognized, behind the Boit painting's unnerving, enigmatic imagery lies Diego Velázquez's *Las Meninas*, 1656 (fig. 84). Sargent knew the painting well, having copied it during an extended visit to Spain in 1879. In France, where Velázquez drew admiration across the artistic spectrum, Sargent could hope, in evoking that masterpiece, to appeal simultaneously to both conservative and avant-garde taste.[29] In recalling *Las Meninas*'s anxious subjects arrayed in a vast, shadowed space—subjects called to attention by the presence of the king and queen shown only in the background mirror—he could also open an array of interpretative vectors in his own work.[30] Among these

are considerations of parents and parental power, simultaneously present and absent. The allusion also further destabilizes the viewer's position and role. In most of Sargent's portraits, the implied presence before the canvas is the artist himself; his subjects are captured in the act of posing for him. While this is still a possibility in the Boit painting, the allusion to *Las Meninas* heightens the perception that we are assuming the place of the girls' parents. Unsettlingly, the girls' response to their parents, if that is what we are to represent, is not one of affectionate greeting, but rather of wooden obedience and sullen withdrawal.

By now we may seem to be far from the sentimental, which is so fundamentally about human connectedness. But it would be misleading to suggest that the Boit painting is unsentimental, utterly disengaged from this tradition. Sargent does not permit us the fiction that we know the Boit children or that we have access to their individual psyches. The girls are detached from us, and seem to prefer to keep their distance. And yet the artist opens avenues to empathy. Currents of feeling, dislocated from the children, suffuse the scene. They rise, in part, from the jarring unexpectedness of Sargent's compositional choices: the small size of the girls in relation to the lowering space; their scattered, asymmetrical placement; the strange dark void at the center disgorging shadows that lurk behind the screen and eddy about the two older girls; and the sharp-angled thrusts of rug and screen and pinafores that instead of directing attention to the girls as often as not point away from them and even out of the frame. These forms provoke feelings of instability, disquiet, and unease. While nothing in the girls' facial expressions or postures suggests that they share these feelings, the emotions reside with them, heightening impressions of their vulnerability. As materially well-cared-for as the children obviously are, viewers attentive to these psychological currents may feel that they are in need of affection and protection. Thus, in the most subtle and tangential of ways, Sargent taps into the sentimental theme of vulnerable innocence, and solicits concern, while deflecting, denying, and destabilizing it.

The Daughters of Edward Darley Boit is a consummately ambiguous, subtle, elusive work of art, full of charged feelings whose sources are hard to locate with precision. In this painting, Sargent dwells simultaneously inside and outside the sentimental, capitalizing on and valuing it for the emotion it dramatizes, but not embracing it. He is scrutinizing and probing the tradition that, in crucial respects, his painting relies on for its power, for its hold on us.

If one of Sargent's aims with the Boit painting was to draw the attention and approbation of the avant-garde, he succeeded. At the time of its exhibition, Mary Cassatt asked him to tea at her Paris apartment, and Berthe Morisot recommended to her brother, Tiburce, that he include Sargent, along with Cassatt, Pierre-Auguste Renoir, Claude Monet, Alfred Sisley, Edgar Degas, and others, in an exhibition of "modern art" he was attempting to organize to travel to the United States. Sargent accepted Cassatt's invitation, but the exhibition never came off.[31]

Fig. 85.
John Singer Sargent, *Madame X
(Madame Pierre Gautreau)*, 1883–84.
Oil on canvas, 82⅛ × 43¼ in.
(208.6 × 109.9 cm). The Metropolitan
Museum of Art, New York. Arthur
Hoppock Hearn Fund, 1916.

The next year, Sargent submitted to the Salon his portrait of *Madame X (Madame Pierre Gautreau)*, 1883–84 (fig. 85). The scathingly hostile response crushed Sargent's hopes of cultivating a flourishing portrait practice in Paris. His cousin, Ralph Curtis, reported the reaction from the halls of the exhibition: "She looks decomposed. All the women jeer. Ah voilà 'la belle'! 'Oh quel horreur!'"[32] While this animosity had primarily to do with his choice of subject—the Louisiana-born Mme. Gautreau, married to a French banker, was then shocking conventional Parisians with her provocatively seductive self-presentations—Sargent was so devastated by the viciousness of the attacks that he considered giving up painting altogether. But fortunately, with the aid and support of friends such as Henry James, he resettled and regrouped in England.

Fig. 86.
John Singer Sargent, *Carnation, Lily, Lily, Rose*, 1885–86. Oil on canvas, 68 ½ in × 60 ½ in. (174 × 153.7 cm). Tate Britain, London. Presented by the Trustees of the Chantrey Bequest, 1887.

Fig. 87. (below left)
John Everett Millais, *Bubbles*, 1885–86. Oil on canvas, 43 × 31 in. (109.2 × 78.7 cm). Unilever Collection on loan to the Lady Lever Art Gallery, Port Sunlight, England.

Fig. 88. (below right)
Sir Joshua Reynolds, *The Age of Innocence*, ca. 1788. Oil on canvas, 30 × 25 in. (76.5 × 63.8 cm). Tate Britain, London. Presented by Robert Vernon, 1847.

Sargent was not initially sanguine about opportunities in Britain. He wrote to a friend in 1885: "It might be a long struggle for my painting to be accepted. It is thought beastly French." He added, "Just now I am in a country village. . . . I am trying to paint a charming thing I saw the other evening."[33] The painting he refers to is *Carnation, Lily, Lily, Rose*, 1885–86, the first resounding success of his English career and, not coincidentally, the most sentimental of all of his paintings (fig. 86). It was purchased for the British national collection directly from the 1887 Royal Academy exhibition where it had its debut.[34]

Once again, Sargent's subject is the fragility and evanescence of childhood, but this time he treats it not with the unsettling mysteries and disquieting psychological penetration of the Boit picture, but rather with a tenderly poignant nostalgia. Erica Hirshler aptly describes it as "a translation of his portrait of the Boit girls from a French vocabulary into English terms."[35]

What did Sargent mean when he said that his work was labeled "French," and what, additionally, is Hirshler suggesting in her use of this term? In Britain, Sargent encountered an artistic environment much more receptive to the sentimental than Paris had been. On his arrival, Henry James shepherded him to the studios of various Pre-Raphaelite painters, including John Everett Millais (financially successful creator of sentimental genre scenes, such as *Bubbles*, 1885–86), and through a major exhibition of the works of Sir Joshua Reynolds, whose images of innocent childhood, products of the eighteenth-century culture of sensibility, were still much admired (figs. 87, 88).[36] Perhaps, in this new setting, Sargent

felt that he could release his native impulse toward the sentimental. *Carnation, Lily, Lily, Rose* could thus serve as an example of his "strategic sentimentalism," a painting calculated to appeal to the Victorian affection for sentimental art. If this was his ambition, he was triumphantly successful. Even previously hostile critics melted before the painting. Charles Caffin praised "the affectionate tenderness with which the children and flowers are represented," locating the painting's charms not in the subject but in his impression of the artist's sympathetic presence.[37]

As with the Boit painting, the composition centers on identically clad sisters, here eleven-year-old Polly and seven-year-old Dolly, the daughters of an artist friend, Frederick Barnard. Sargent painted them in the tiny Cotswold village of Broadway, where for two long seasons in 1885 and 1886 he joined a convivial and familial group of friends in an impromptu artists' colony. In the painting, the girls stand in the midst of an enchanted garden, companionably absorbed in their task, lighting lanterns for an evening party. The warm glow of the paper globes counters the cool blues of the descending dusk, creating chromatic complexities that Sargent referred to as "fearful difficult."[38]

The flowers surrounding the girls, like the furnishings in the Boits' foyer, seem nearly animate with sentient life. The floral presences, however, appear benign and protective rather than menacing. The heavy-headed lilies nod downward, opening their faces to the girls. Carnations and roses brush lightly against their dresses, seeming almost to merge and grow with them. The girls themselves, their black-clad legs barely visible, might have sprung like the flowers from the fertile garden soil. With their heads poised on slender necks emerging from petal-like collars, they echo the lilies above them. The painting exudes such an air of magic that were the girls to sprout wings, it would hardly seem incongruous.

Richard Ormond has written of the painting, "Everything breathes that time passes: the beauty and youth of the girls, the fragility of the paper lanterns, the fading light, the flowers in full bloom and on the verge of falling apart and dying."[39] The impression of evanescence is reinforced by the painting's doubled perspective. From the elevated vantage point, hovering above the scene, we may savor its beauty from a distance, but not enter. It is poignantly inaccessible to all but our gaze. At the lower perspective, the grasses reach out to meet our feet, tempting us to enter. Yet were we to do so, our adult presence would immediately break the spell. The almost alarming ease with which we could disrupt and disperse the scene's magic renders palpable the adult viewer's irrecoverable distance from childhood. The painting bears witness to Sargent's command of the sentimental mode, to his understanding of its emotional resonance and power, and to his awareness of his audience's fondness for it.

In the years following the triumph of *Carnation, Lily, Lily, Rose*, Sargent concentrated his attention primarily on portraiture. He would become one of the most successful and admired portraitists of his age, often hailed as "the greatest contemporary portrait painter."[40] British grandees, Boston Brahmins, newly made American millionaires, industrialists, philanthropists, diplomats, and society hostesses—members of the social and economic elite on both sides of the Atlantic—pressed him to paint their portraits. They were beguiled by his ability to endow his sitters with an aura of wealth and social distinction, of cosmopolitan refinement and stylish glamour. His very success has led many critics, then and since, to belittle him as a flatterer, a "dismissible portraitist of the vain and vapid," churning out likenesses that are "all surface and no soul."[41] But such assessments miss altogether the social and psychological complexities at play in these images—complexities that enable the portraits to engage and disengage the sentimental in knotty ways.

Sargent might deploy seductively luscious brushwork, shimmering light, and luxurious fabrics, but he was no flatterer. Underneath those billowing satins often lies a serrated edge, though Sargent would no more have admitted this than he avowed any ability to transfer to canvas his sitter's subjectivity. According to a story often repeated during his lifetime, when it was once suggested to him that he had "seen through the veil" to the inner life of one of his sitters, he objected, countering, "If there were a veil, I should paint the veil; I can only paint what I see."[42] Surely, there is truth in this. More literally perhaps than any other portraitist of his time, Sargent painted what he saw before him: someone posing for his or her portrait. He painted social selves, people readying themselves to be looked at, while conveying the shallowness and fragility, the barely-held-together quality of those crafted personae.

Does he invite our empathy for his subjects? Does he proffer the possibility of human connectedness? Sargent summons before us living presences. A startling animation, an impression of psychological and physical immediacy, vitalizes his portraits. To many of Sargent's contemporaries, this was his greatest strength, the most astonishing and compelling aspect of his work. A critic for the *Worcester Daily Spy* stood mesmerized before Sargent's portrait of the actress Ada Rehan, 1894 (The Metropolitan Museum of Art): "She lives and breathes. The flesh vibrates with life, the exquisitely moulded neck and bosom seem to rise and fall with the breath of life. Her perfect form seems ready to move on from view or to step down and out of the frame. This is why Sargent is supremely great. Because his pictures live!"[43]

Many observers were similarly struck by *Mrs. Hugh Hammersley*, 1892, a portrait so highly valued by Sargent himself that he sought to borrow it for the 1893 World's Columbian Exposition in Chicago (fig. 89). The vivacious London hostess perches on the edge of a gold-upholstered neoclassical settee. Figure and furniture wittily echo each other: the sofa is as lightly poised on its slender tapering legs as Mrs. Hammersley is in her white satin

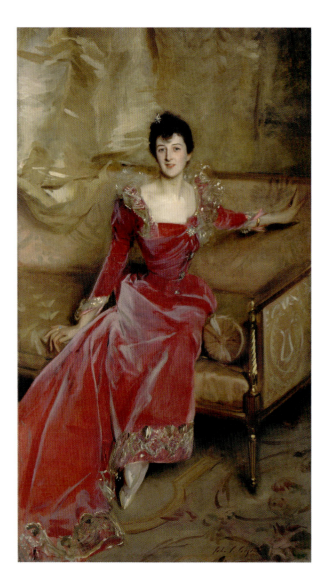

Fig. 89.
John Singer Sargent, *Mrs. Hugh Hammersley*, 1892. Oil on canvas, 81 × 45½ in. (205.7 × 115.6 cm). The Metropolitan Museum of Art, New York. Gift of Mr. and Mrs. Douglass Campbell, in memory of Mrs. Richard E. Danielson, 1998.

pointed-toe shoes. Kit Anstruther-Thomson described the painting in a letter to Violet Paget: "Mrs. Hammersley has just sat down on that peach coloured sofa for *one* minute— she will be up again fidgeting about the room the next moment, but *meanwhile* Mr. Sargent has painted her!!"[44] To the London *Times* critic, "The very head literally vibrates with life; never has the spirit of conversation been more actually and vividly embodied."[45] The sitter leans forward in her rose-colored gown, her gaze meeting ours, her lips parted as though to speak. And yet, despite the vividness of her presence, our engagement with her feels newly made, as though we have just been introduced, and she is rising to greet us. The portrait offers a tantalizing impression of incipient, potential connectedness, yet that

potential must always remain unfulfilled; we cannot move beyond this painted moment.

While Sargent teases us with and simultaneously forecloses the possibility of deeper acquaintance with his subject, he offers another mode of connection: bodily, kinesthetic empathy. Mrs. Hammersley, like so many of Sargent's subjects, has been captured in a momentary, twisted, barely balanced pose. With our memories of our own muscular movements, we can sense the torsion in her torso, the strain in her left arm extended behind her, and the pressure of her fingertips against the sofa. The vertiginously uptilted floor, the swirling carpet design, and the composition's helter-skelter diagonals reinforce the feeling of tension and instability.

To Sargent's contemporaries, such portraits spoke not only of the restive alertness and nervous strain of the subject, but also to the tenor of the times. The critic Royal Cortissoz, surveying the array of Sargent's portraits, including *Mrs. Hugh Hammersley*, displayed at the Copley Society in Boston in 1899, identified "restlessness" as the "dominant note" of the exhibition. It was, he wrote, a "restlessness that keeps the observer of it keyed up to an almost painful pitch of nervous tension, out of sheer sympathy for the high-strung spirit that exhales from the portraits. One cannot help but sympathize. That is one of Mr. Sargent's gifts."[46] Sympathy, that keynote of the sentimental, was, for Cortissoz, catalyzed by the subjects' taut poses and Sargent's own "nervous" style. Looking on the portraits, the critic shared in their restless affect, a feeling that he characterized as "intensely modern," the defining spirit of his age.

Reviewing Sargent's oeuvre in 1906, the critic Christian Brinton felt the same frisson of recognition. Among Sargent's portraits, he encountered "women about to start suddenly from their chairs and men on the very point of speaking. . . . All is restless, vivid, spontaneous. One and all, these creatures vibrate with the nervous tendencies of the age." Sargent, he went on, "has lured us into a new world, a world which we ourselves know well—perhaps too well—but a world hitherto undiscovered by art. . . . While you may feel keenly the lack of repose in these portraits, you cannot deny their actuality."[47] For Brinton, as for Cortissoz and many others, Sargent's portraits elicited empathy for the subjects' brittle jangling nerves. They recognized those sensations; they knew them; they had, likely, experienced them themselves. They felt connected to Sargent's subjects through an acknowledgment of shared feelings, a mode of connectedness that belongs to the sentimental.

Yet what of tenderness and affection, the emotions more usually associated with the sentimental? Do these have a place in Sargent's art? For many critics, their absence constituted one of the most striking failings of his work. Charles Caffin, for example, sensed in Sargent's portraits an "elegant shallowness" that arose from his "aloofness" from his subjects.[48] He and others detected in Sargent's stance before his sitters the "cool," "incisive," "pitiless" gaze of the realist, perhaps harboring even "a touch of malice."[49] Yet most also acknowledged that, now and then, Sargent encountered sitters who broke through his

Fig. 90.
John Singer Sargent, *Mr. and Mrs. John White Field*, 1882. Oil on canvas, 44⅞ × 32 in. (114 × 81.3 cm). The Pennsylvania Academy of the Fine Arts, Philadelphia. Gift of Mr. and Mrs. John White Field.

Fig. 91.
John Singer Sargent. *Mrs. Edward L. Davis and Her Son, Livingston Davis*, 1890. Oil on canvas, 86⅛ × 48¼ in. (218.8 × 122.6 cm). Los Angeles County Museum of Art. Frances and Armand Hammer Purchase Fund.

Fig. 92. (right)
John Singer Sargent, *Beatrice Goelet*, 1890. Oil on canvas, 64 × 34 in. (162.6 × 86.3 cm). Private Collection.

reserve and engendered his sympathy. Sargent's cousin Mary Hale described *Mr. and Mrs. John White Field*, 1882, as "a presentation of enduring love, confidence, and protection" (fig. 90).[50] The elderly couple's black-clad bodies meld into a single stable shape, their hands joined at the center, wedding rings prominent, the whole giving the impression of lives long merged in a union of mutual comfort and support. *Mrs. Edward L. Davis and Her Son, Livingston Davis*, 1890, among the paintings that won Sargent a medal at the World's Columbian Exposition, was likewise perceived as expressing familial affection in a manner unusual in Sargent's work (fig. 91). Mother and son wrap their arms around each other, the boy's suntanned hand clasping his mother's, in a pose that conveys their easy camaraderie and shared affection.

But it was Sargent's portrait of four- or five-year-old Beatrice Goelet of 1890 that most thoroughly disarmed American critics when it was shown at the Society of American Artists exhibition in 1891 (fig. 92). In the words of John C. Van Dyke, "All of his technical

skill, all of his taste, all of the sentiment and emotional feeling that may be in his personality, seem to be shown in this beautiful child portrait. . . . It shows the painter at his very best."[51] Echoing and challenging the child portraits of Velázquez, or Goya, Sargent dressed the tiny heiress in a stiff brocaded gown with a strand of thick pearls around her neck, and posed her in a dark, amorphous space. Having absorbed, in a childlike way, the gravity of the occasion, the tender-faced girl stands obediently still, her fingers pressed together before her. A rose-breasted cockatoo swings in its cage beside her. Light glimmers on the cage's golden bars as it does on the folds of Beatrice's gown, a linking of forms that perhaps suggests the social strictures that confined such children of privilege.

The critic Mariana van Rensselaer was moved to tears before the portrait: "Mr. Sargent had seen not only form and color with clearness and acuteness, but also the baby soul behind them; and he had reproduced them all so beautifully that, when the tears came in one's eyes from sheer delight, it was hard to tell whether emotion was more touched by the work of nature or the work of art."[52] She concluded that the artist was a "sensitive" painter of "character and soul."[53] Sargent, for his part, was so stirred by van Rensselaer's response that when her review came into his hands, he took out his stationery and wrote to thank her. He told her "how much pleasure" her words had given him, for, he said, "very few writers give me credit for insides so to speak."[54]

In the last decades of his life, Sargent sought—with limited success—to retire from the portrait business, writing to Ralph Curtis, "No more paughtraits. . . . I abhor and abjure them and hope never to do another especially of the Upper Classes."[55] He found respite in major mural commissions for public institutions, such as the Boston Public Library and the Museum of Fine Arts, Boston, and in watercolor painting pursued for his own enjoyment. Many scholars have concluded that the sentimental played no part in Sargent's works of these years, yet traces of it persist, reappearing, for example, in his mural-sized canvas *Gassed*, 1919 (fig. 93). According to Charteris, this image of gas-blinded soldiers being led to an aid station carried "a great deal of sentimental significance. [Sargent] has shown us some of the horror of War, much of the moral quality of those taking part in it, and has interpreted the emotional intensity of a scene calculated to rouse compassion in the onlooker."[56] Indeed, early viewers wept and fainted before *Gassed*, their sorrow and grief as they viewed it testifying to the sentimental—the tragically sentimental—impact of Sargent's scene of mass suffering, of men ravaged and blinded by modern war.[57]

The painting was commissioned by the British War Memorials Committee to hang in the Hall of Remembrance at the Imperial War Museum. The original request had been for a scene commemorating British and American cooperation. Sargent, traveling in northern France behind the front lines during the summer of 1918, expressed his exasperation

Fig. 93.
John Singer Sargent, *Gassed*, 1919.
Oil on canvas, 7 ft. 7 in. × 20 ft. 1 in.
(231 × 611 cm). Imperial War Museum,
London.

with the assigned subject: "Though historically and sentimentally the thing happens, the naked eye cannot catch it in the act."[58]

Late that August, he and his traveling companion, the artist Henry Tonks, encountered what Sargent described as a "harrowing sight."[59] Tonks elaborated: "At the Corps dressing station at le Bac-du-Sud there were a good many gassed cases. . . . The dressing station was situated on the road and consisted of a number of huts and a few tents. Gassed cases kept coming in, led along in parties of about six. . . . They sat or lay down on the grass, there must have been several hundred, evidently suffering a great deal."[60] Sargent, Tonks recalled, "immediately began making sketches and a little later he asked me if I would mind his making this essentially medical subject his, and I told him that I did not mind in the least."[61]

Across a twenty-foot-wide canvas, ten blinded soldiers process haltingly in single file, each clasping the shoulder of the man before him. A medical orderly guides them along duckboards toward a casualty clearing station, its presence indicated only by guy wires extending into the scene from the right. A second line of gassed soldiers converges on the station from the right middle distance, their forms, like those of the main group, silhouetted against the pale yellows and pinks of a late afternoon sky. To either side of the duckboards, more blinded victims crowd the ground, lying on the bare earth, body touching body, eyes bandaged, their heads cradled by their packs. Far behind, the sun hovers low on the horizon and a soccer game is under way in the fading light.

This solemn, pathetic procession of the maimed finds echoing chords in the great art of the past: in ancient classical friezes, in Auguste Rodin's *Burghers of Calais*, in Pieter Bruegel's *The Parable of the Blind Leading the Blind*. Such allusions allow the scene to

resonate with themes of heroism, sacrifice, and folly—the infinite, incalculable folly of "civilized" societies turning science and technology to the destruction of their young, to producing poison gas that seers and blisters inside and out—blinding, castrating, and killing. These Tommies, stumbling and retching, unable to walk unguided, present a tragic perversion of the ubiquitous wartime images of young men marching off to battle.

Sargent painted these young men onto his canvas with a palpable tenderness. He effaces his own presence, subduing the virtuosic flourishes of his portrait style. He restrains his brushstrokes, limits his palette to strains of khaki, and softens the light, allowing no reflections to gleam from cartridge belts or rifle barrels, no highlighting that could suggest a glorification of war. Mustard gas has swollen and sealed the soldiers' eyes, shuttering each in his own darkness. Yet Sargent leaves not one alone. In their fraternity of sightlessness and pain, they all have the touch of a comrade. Some lead their fellows, some rest their heads against another, some simply lie side by side. Small gestures—a hand to the head, a tilted canteen—hint at the physical anguish of searing burns, headaches, thirst, and nausea. In the distant group, one soldier bends over, vomiting. Likely the soldier in the central group who turns his back to us and leans over has been similarly overcome. He cannot see, as we can, that his vomit will spew onto the blinded men on the ground beside him. So restrained is Sargent in his presentation of this detail that few viewers seem to have noticed it.

Gassed was first shown to the public in the Royal Academy exhibition of 1919, where it was chosen "the picture of the year."[62] Few who saw it doubted that Sargent had been genuinely and deeply moved by his subject. Sir Claude Phillips wrote admiringly in the *London Daily Telegraph*: "Reticent as the artist has been in the expression of supreme tragedy—perhaps, indeed, on account of this very reticence—he attains to a height of pathos such as has not been reached as yet in any war picture. True, the subject is in itself unutterably, almost intolerably, pathetic; but the painter adds to its poignancy by the subtle expression of his own intense sympathy."[63]

Responding very differently, the modernists of London's Bloomsbury group, in keeping with the antisentimentalism of the avant-garde, were repelled by the painting's emotional appeals. Virginia Woolf chided, "In order to emphasize his point that the soldiers wearing bandages around their eyes cannot see, and therefore claim our compassion, he makes one of them raise his leg to the level of his elbow in order to mount an inch or two above the ground." This "little piece of overemphasis," this emotionally manipulative detail, was, for her, "the last straw" that sent her fleeing the exhibition for "the comparative sobriety of Piccadilly."[64] Sargent, so long castigated for his emotional reserve, was here, at the end of his career, both praised and censured for being sentimental, for giving expression to his own empathy and compassion, and asking, however quietly, for ours.

The sentimental is a significant, and complex, dimension of Sargent's oeuvre. Through-out his career, he was both drawn to and wary of the sentimental, attracted, it seems, by its promise of emotional intimacy yet uncertain whether this connectedness was either possible or desirable. He seems to have longed for that connection at the same time that he held himself back. Looking at *Gassed* and *Carnation, Lily, Lily, Rose*, one can feel his desire to lie down among the blinded men or join the children in the garden, yet in each case what he emphasizes is his and the viewer's apartness from these scenes of unspoken sympathy and camaraderie. Human connectedness, the central theme of the sentimental, was at the heart of Sargent's art, present or, more often, present through its absence.

MARY CASSATT

In contrast to Sargent, when Mary Cassatt's close friends and family members chose words to describe her character, "sentimental" and "sympathetic" were not the first that sprang to mind. "Selfish," "bitingly critical," "executive," and "powerfully intelligent" struck them as more apt.[65] Yet, while the sentimental seems not to have been a native element of Cassatt's character, as it was with Sargent, from her school years on she was intent on making her living from her art, and she well understood its popular, critical, and commercial appeal. In her earliest works, dating from the 1860s, Cassatt revealed both familiarity and facility with the sentimental mode.

Like Winslow Homer, Cassatt was drawn early in her career to the work of Pierre-Édouard Frère, creator of conventionally sentimental images of children, such as *The Little Cook*, 1858 (see fig. 61). Whereas Homer had studied Frère's work in a Boston gallery, Cassatt settled for more than a year, beginning in April 1867, in the French village of Écouen, where Frère and another painter of similar sentimental scenes, Paul Constant Soyer, made their homes. Frère opened his house two evenings a week to Écouen's colony of art students, and Cassatt mentions in her letters seeking his advice about her submission to the 1869 Salon; Soyer agreed to take her on as a pupil (fig. 94).[66]

Two Children at the Window, a pastel of about 1868 (location unknown), has been attributed to this period in Cassatt's career (fig. 95). In a nursery or bedroom, two young children, a blond boy and a smaller, dark-haired girl, stand before an open window, its gauzy curtains pulled to the side. With their backs turned to the viewer, the siblings have drawn together in tender sympathy, their heads inclined and their arms around each other. The forward tilt of the boy's head suggests that they are looking at something below that has impelled them to support and comfort each other. The deep space behind them and

Fig. 94.
Paul Constant Soyer, *Little Girl Reading*,
1864. Watercolor with graphite under-
drawing on beige, thick, smooth wove
paper, 7 ⅝ × 6 ⅛ in. (19.3 × 15.5 cm). The
Walters Art Museum, Baltimore.

Fig. 95.
Mary Cassatt (attr.), *Two Children at
the Window*, ca. 1868. Pastel on paper,
28 × 20 in. (71.2 × 50.8 cm). Location
unknown. Reproduced in Adelyn
Dohme Breeskin, *Mary Cassatt:
A Catalogue Raisonné of the Oils,
Watercolors and Drawings* (1970).

unfathomable whiteness before them render their vulnerability more palpable and their join-
ing more poignant. With its invitation to empathetic engagement, its evocation of tender
feeling, and its anecdotal details, this pastel belongs firmly within the sentimental tradition.

Alert to the popularity and marketability of child imagery and perhaps seeking to
attract portrait clients, Cassatt submitted to the 1875 Paris Salon a portrait of a young girl,
Mlle E. C., now known only through a caricature (fig. 96). In the cartoon, a fashionably
dressed little girl, wearing a ruffled collar and beribboned bonnet, leans nonchalantly against
the arm of a large, thronelike chair. With a hand on her hip and one leg casually crossed
over the other, her pose calls to mind the stances of Gainsborough's insouciant gentlemen
(fig. 97). The caption reads, "What I find charming about childhood is its naïveté." Presum-
ably, the caricaturist, in a mocking tone, implies that what he saw in Cassatt's portrait is
not naïveté, but contrived and calculated cuteness. He puts Cassatt on notice that ingra-
tiating coyness, an unduly sentimental bid for popularity, could be carried too far. Might
it be, however, that Cassatt, in keen awareness that charming images of childhood were
exactly what was expected of women artists and demanded by the market, and deeply ambiv-
alent about conforming to such expectations, exaggerated the cuteness in an undertow
of defiance? This would be in keeping with her relation to the sentimental throughout her
career as she alternately, and sometimes simultaneously, engaged and rejected it.

Two years later, in 1877, when Cassatt accepted Degas's invitation to join the impres-
sionist group, she turned away from the sentimental's emotional, empathetic agenda to
adopt the cooler, more distancing approach of the realist avant-garde. She was ecstatic at
the opportunity Degas had extended to her: "I accepted with joy. At last I could work with
absolute independence, without worrying about the possible opinion of a jury! I already

Fig. 96.
STOP (pseudonym of L.P.G.B. Morel-Retz), caricature of Cassatt's *Mlle. E. C.*, shown in the Salon of 1875, published in *Le Journal Amusant*, June 26, 1875.

Fig. 97.
Thomas Gainsborough, *John Augustus, Lord Hervey*, ca. 1779. Oil on canvas, 87 × 59 in. (221 × 150 cm). National Trust, Ickworth, accepted in lieu of tax by HM Treasury and transferred to the National Trust, 1956.

knew my true masters. I admired Manet, Courbet, and Degas. I hated conventional art. I began to live."[67] Embracing Zola's model of the artist as "an observer and an experimentalist," she began to approach her modern-life subjects with a sharp-eyed interest in social observation and psychological investigation.

Cassatt's well-known *In the Loge*, 1878, painted in the months immediately following her acceptance of Degas's offer, is perhaps her boldest statement of her impressionist anti-sentimentalism (fig. 98). It represents a woman in profile, seated in a theater box, dressed for an afternoon performance in a sober black dress, black hat, and pale tan embroidered gloves; the single pearl of her earring glints in the artificial light. She leans forward, her right elbow propped on the stall's railing, her opera glasses lifted to her eyes, gazing intently at the boxes across the way. Even as Cassatt makes clear that the woman is looking and thinking, she reveals neither the object of the woman's gaze nor her thoughts about it. The painting conveys an impression of interiority, of intelligence and dignified self-containment, while rendering that inner life inaccessible to us.

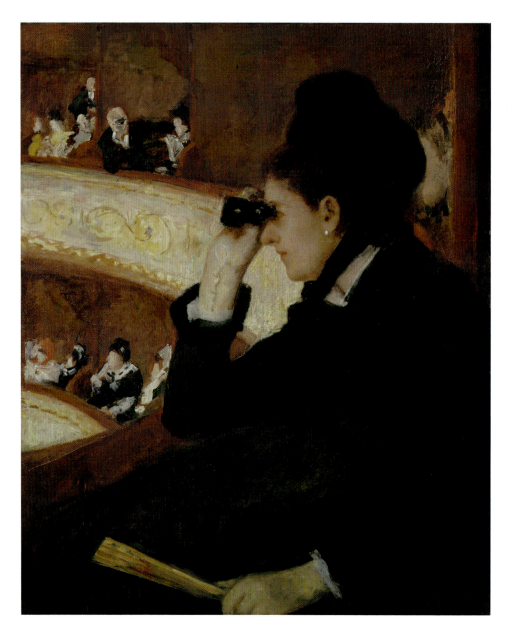

Fig. 98.
Mary Cassatt, *In the Loge [Woman in Black at the Opera]*, 1878. Oil on canvas, 32 × 26 in. (81.28 × 66.04 cm). Museum of Fine Arts, Boston. The Hayden Collection—Charles Henry Hayden Fund. Photograph © 2018 Museum of Fine Arts, Boston.

The sentimental is premised on the knowability of others, on our capacity to project ourselves empathetically into another's thoughts and feelings. Here Cassatt seems to deny both the actuality and the possibility of such access. Rather, she anticipates and gives visual expression to ideas that the philosopher and psychologist William James, whose works the artist would come to greatly admire, articulated in *The Principles of Psychology* (1890): "The breach from one mind to another is perhaps the greatest breach in nature." James

elaborates: "No thought even comes into direct sight of a thought in another personal consciousness than its own. . . . Neither contemporaneity, nor proximity in space, nor similarity of quality and content are able to fuse thoughts together which are sundered by this barrier of belonging to different personal minds."[68] Cassatt makes this breach palpable, deflecting any sentimentalist desire that might incline us to make connection to her subject.

Cassatt's choices in composing *In the Loge* underscore the observer's separation from the subject. Our inability to see what is absorbing the woman's attention excludes us. Her profile pose renders her facial expression less legible, while the flat, decorative treatment of her body resists corporeal identification. At the same time, the flatness of the woman's form against the picture plane, coupled with the blurring of the space behind it, approximates the visual effect of looking through binoculars, as though Cassatt wanted us to imagine ourselves gazing at this woman through our own opera glasses. This would help explain why this operagoer, who appears to be so close to us, in no way acknowledges our presence. Our gaze, like the woman's, is cool, distant, disengaged, and appraising.

Cassatt presumably regarded *In the Loge* as an important statement of her aesthetic principles, since she chose it to represent her in major displays in the United States, including the Massachusetts Charitable Mechanics Association exhibition in 1878, the Society of American Artists exhibition in New York in 1881, and her first one-person exhibition at Durand-Ruel in New York in 1895. It was likely the first painting in her new impressionist style to be shown in this country, and it drew considerable attention from critics, a number of whom noted its striking rejection of the sentimental. William Brownell, who admired it at the Society of American Artists exhibition, described it as "a good example of the better sort of 'impressionism.'" Yet, he went on, "many people will temper their acknowledgement and appreciation of Miss Cassatt's success with the recognition of her neglect of, or incapacity for, the poetic and sentimental, not to say spiritual side of painting."[69] Some years later, a Boston critic, responding to Cassatt's 1898 one-woman exhibition at the St. Botolph Club, which included *In the Loge*, described her style as "extremely modern" and "realistic." He too noted the absence of the sentimental in her art, describing her style as lacking "tenderness" and "almost cruel in its exactitude," yet he greatly admired it as "bold and keen, cool and firm." He was particularly struck by the aloofness and reserve of her figures: "Her heads are intellectual, but not emotional; her people are as cold-blooded and self-centered as the traditional aristocrats of Boston. They have the impudence to care not a jot what you think of them. They mind their own affairs, and ask nothing better than that all the rest of the world should do the same."[70] Cassatt, this critic implies, merits special praise and attention because she is not sentimental. Her figures are self-sufficient—not open to us, not drawn to solicit our empathy.

CASSATT IN HER LATER IMPRESSIONIST AND POSTIMPRESSIONIST YEARS

In the early 1880s, Cassatt began to reengage with the sentimental. For the rest of her career, she would create her works in a constant negotiation and renegotiation with the sentimental's terms, even as she sought to maintain allegiance to the basic principles of "our group," as she always referred to the impressionists. This is for me the most complex and absorbing feature of Cassatt's career—the acute intelligence with which she explores the sentimental, the avant-garde, and the relationship between them, at times, it seems, challenging herself to take on the sentimental and make it modern.

William Walton, one of the most insightful critics of Cassatt's work, noted her shift toward the sentimental as he surveyed the works in her 1895 retrospective in New York. In her most recent paintings, he detected "that directness and vigor of presentation which has caused this lady to be claimed by the impressionists," as well as an "affectation of being only painter's studies, with that aversion to the appearance of being sentimental so characteristic of the works of the artist of the day." And yet, he goes on, "In all of them may be felt a certain sentiment, or charm, or poetry." Among the paintings of adult women, he singled out one, known today as *Woman with a Red Zinnia*, 1891, as a "fine sentimental picture" (fig. 99).[71] It represents a young woman sitting on a park bench, against a backdrop of green meadow and trees, gazing at a flower that she holds stiffly in her right hand. Walton's esteem for the work affords us insight into Cassatt's intention and into the contemporary response to her art.

Woman with a Red Zinnia engages a traditional sentimental subject: a young woman holds a flower, often a rose, symbolizing the evanescence of youth and beauty and the desire to find love before they fade, as in Lily Martin Spencer's *We Both Must Fade*, 1869 (fig. 100). Walton notes, however, that Cassatt defies viewers' expectations of this subject in her lack of "regard for that mere prettiness of expression that was once thought so requisite in similar subjects." He connects this to "the moderns['] . . . haunting fear of falling into the pretty-pretty." This hatless redhead, her face blotched with pink as though she has been too long in the sun, struck Walton as even less attractive than Cassatt's usual models: "Of that youthful charm and grace, which were formerly considered indispensable under these circumstances, there is scarcely a trace." Yet he suspects that Cassatt has replaced conventional prettiness with something better, something more moving, more poignant— "the suggestion perhaps of the upspringing of all these tender, youthful, feminine longings and aspirations, and half-formed ideas in some soul more worthy of our interest than the usual one."[72] Taking a conventional sentimental subject, but disrupting its conventions through her attention to the real, Cassatt has, in the end, deepened our empathy for her subject.

Fig. 99.
Mary Cassatt, *Woman with a Red Zinnia*, 1891. Oil on canvas, 29 × 23 ¾ in. (73.6 × 60.3 cm). National Gallery of Art, Washington, DC. Chester Dale Collection.

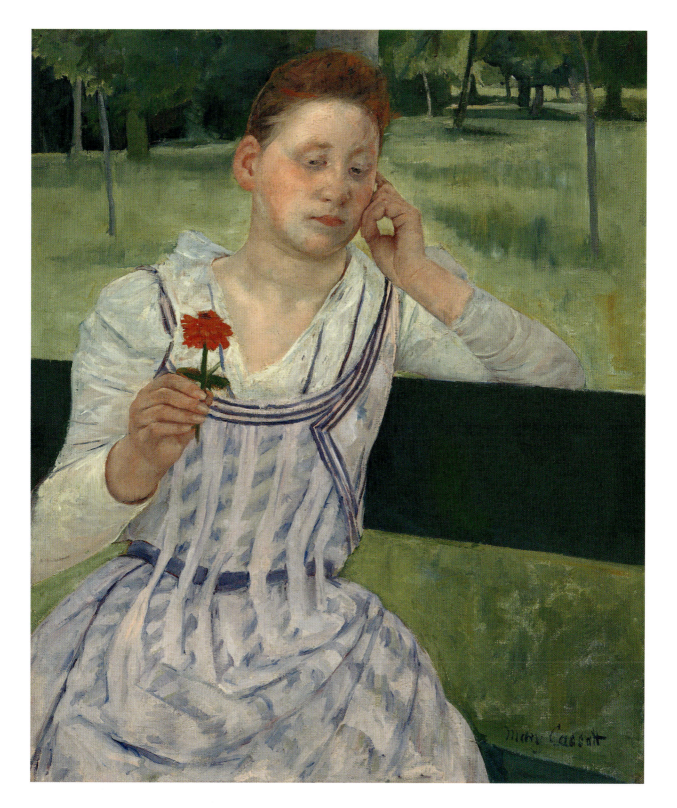

Fig. 100.
Lily Martin Spencer, *We Both Must Fade
(Mrs. Fithian)*, 1869. Oil on canvas,
72 × 53.75 in. (182.88 × 136.52 cm).
Smithsonian American Art Museum,
Washington, DC.

This would also be Cassatt's approach in her many and multifaceted mother-and-child images, the subject with which she has come to be most closely identified.[73] Cassatt first exhibited a work with this theme, the stunning pastel *A Goodnight Hug*, 1880, at the Sixth Impressionist Exhibition in 1881 (fig. 101). As though reluctant, or even embarrassed, to treat a subject of such emotional intensity, she made the radical, unexpected choice to turn the subjects' faces away from us. At the same time, she vividly conveys the near-consuming strength of the mother's love through the merging of the two figures. The mother crushes the baby to her, their cheeks pressed together, and their arms encircling each other. With the upholstered armchair they form a triangular shape, a single outline encompassing them both. A soft red glow radiates from the place where their faces touch, both marking the boundary between them and suggesting an almost frightening melting of the two beings into one. The extraordinary animation of the pastel strokes that define the wallpaper and upholstery heightens the emotional charge of the scene.[74] One French critic found Cassatt's representation of the embrace both "accurate" and "audacious." Another confessed, "This pastel leaves me singularly moved."[75]

Fig. 101.
Mary Cassatt, *A Goodnight Hug*, 1880.
Pastel on paper, 16 ½ × 24 in.
(41.91 × 60.96 cm). Private Collection.

From the mid-1880s, particularly in the wake of the final impressionist exhibition in 1886 and the disbanding of the already-fracturing group, Cassatt turned to mothers and children as her central theme. Like Monet with his grainstacks and Degas with his ballet dancers, she treated the subject serially, probing its physical and psychological nuances. She adhered in these works to the naturalistic principles of impressionism, offering keen-eyed, penetrating observations of modern life: these are contemporary mothers, nurses, and children, dressed in the latest fashions and carrying out their routines in well-appointed bourgeois interiors and carefully maintained gardens. In keeping with the practices of realist investigation, Cassatt explored forms and moments of consciousness, varying her emphases from one work to the next. One French critic described her as "a master in her own right, of variations on a theme: mother and child."[76]

Yet from the 1890s onward, Cassatt increasingly drew upon old master precedents in shaping these compositions, embedding in them allusions to Raphael's Madonnas and to the chalky surfaces of Renaissance frescoes. Her twinned interests in the psychological and the sacred, in the contemporary and the classical, allowed her to situate herself in relation to the emerging symbolist movement. She became known as the painter of the "Modern Madonna," which, as art historian Pamela Ivinski explains, was a "figure seen by most critics as successfully negotiating the demands of both an Impressionist-derived naturalism with which the artist remained associated and the new Symbolist quest for a more abstract

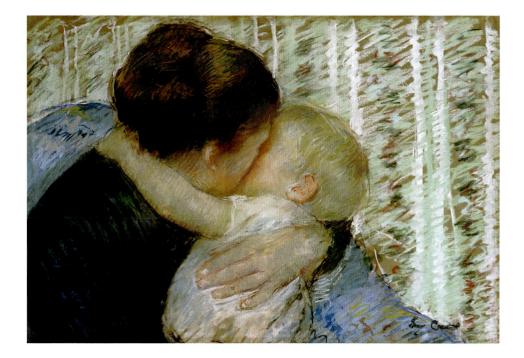

and universal language of meaning."[77] In these same years, Cassatt was also, as she told her mother, "intent on fame and money," and her images of mothers and children brought her both critical acclaim and ready sales.[78]

In assessing her mother-and-child images, Cassatt's most severe critics chastised her for her "brutal realism" and for her choice of unattractive models, hailing her as "the apostle of the ugly woman in art."[79] For others, the homeliness of her figures deepened their appeal, enhancing the invitation to empathetic response: "Perhaps they are not always beautiful, but they are human—real flesh and blood—just such children and women as we all know."[80] Most reviewers, in both France and the United States, spoke of the "sympathy," "tenderness," and "charm" of her works, and of love as her theme. Sometimes, in a seeming paradox, they referred to her mother-and-child paintings as "sentimental," at other times as "not sentimental." Quite notably, the words in both instances were intended as high praise. In 1917, one American critic singled out Cassatt's *The Reading Lesson*, ca. 1901, as the "high water-mark" of her career, remarkable for its "sentimental and human interest" (fig. 102).[81] A few years earlier, however, another critic, having adopted the derogatory meaning of the word, praised Cassatt's works for their "sympathy" and "tenderness," but noted that

Fig. 102.
Mary Cassatt, *The Reading Lesson*, ca. 1901. Oil on canvas, 26 ¼ × 32 ¼ in. (67.31 × 81.92 cm). Dallas Museum of Art. Lent by the Pauline Allen Gill Foundation.

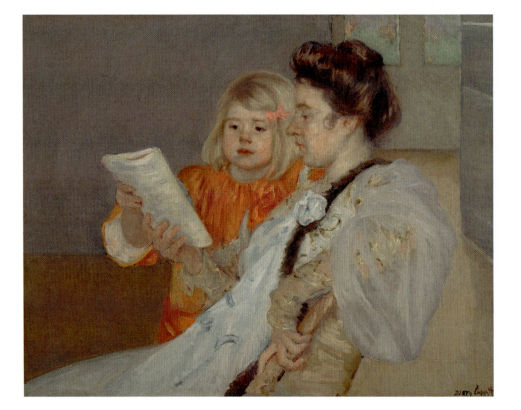

they display not "the smallest suggestion of sentimentality. Miss Cassatt's art always sounds a deeper note than . . . 'sugary sweetness.'" She adds, "The mind of the onlooker is left entirely free to concern itself . . . with the deep, underlying human emotions . . . , yet it is by no means compelled to consider anything but the unstudied simplicity of the composition, the sure, virile outlines and the luminous harmonies of the scheme of color."[82] In the last years of the nineteenth century and opening years of the twentieth, as formalist approaches took hold in critical circles, Cassatt's defenders pointed out that one could set aside the sentimental aspects of her art and engage with considerable satisfaction in a purely aesthetic appreciation of her forms.

One of Cassatt's finest and most admired works from this later period, approved by the French critic Félix Fénéon as not "too sentimental," is *The Caress*, a pastel of 1891 (fig. 103).[83] In a composition immediately evocative of Renaissance prototypes, a young mother with gleaming dark hair holds a nude baby on her lap. Her triangular form completely encloses her son's plump body. His hair is matted to his forehead as though still damp from the bath. He reaches up with a gesture instantly familiar to anyone experienced with babies and grasps his mother's chin. Gazing down at him, she presses her lips to his palm. We sense here Cassatt's keen interest in the psychology of infanthood, in the baby's exploration and expanding consciousness of his world. He is integrating his senses of sight and touch, gazing up at his mother as he sinks his fingers into her cheeks, all with a dawning awareness of her separateness from him. We perceive the truth of this moment, made vivid and concrete through Cassatt's own masterful integration of penetrating, assessing gaze, and sure, powerful touch.

This pastel issues a compelling invitation to empathetic engagement: emotional, psychological, and bodily. It expresses the tender, passionate, sensual love that binds the mother and son, yet it also allows us to sense the weight of his body on her lap, the pressure of her thumb sinking into his pudgy foot, and the grip of his small fingers on her face. Cassatt marks these sites of pressured touch, sites where skin meets skin, with heavy black marks that stand out against the dominant pink, blue, and white palette of the work. The everperceptive William Walton noted that it was her exceptional talent in painting human flesh that summons before us the bodily sensations she depicts: "By wise and vigorous painting, with the full strength of her palette and a careful observance of the local variations, she secures the intrinsic qualities of her fleshy tones—so that you can well imagine that her rendering would feel under your fingers much as the naked body does in life."[84]

In *The Caress*, the softly blended, velvety strokes of pink and blue render nearly palpable the tender plumpness of the baby's cheeks, the fold of flesh beneath his chin, and the gently yielding chubbiness of his bare torso. Yet as we move outward from the conjoined gaze and cupped chin that are the emotional and psychological center of the work, the

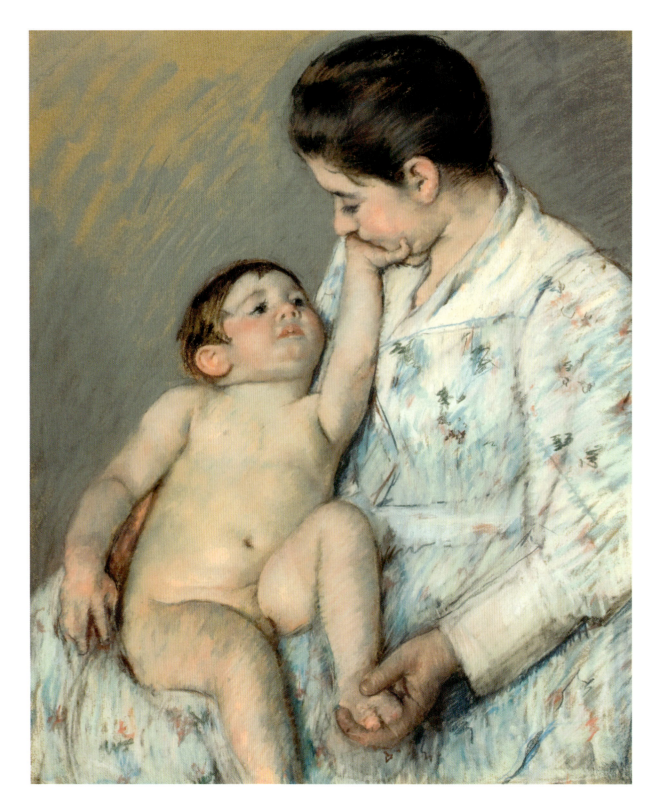

pastel strokes change, and the illusionism begins to dissolve. The strokes become broader, more separate, more energetic, drawing our attention from the touches being exchanged between mother and son to Cassatt's own pressured touch on the paper. We become aware of her presence, of her probing mind and shaping hand.

In works such as this, Cassatt takes possession of the sentimental, transforming it and making it her own. She doubles its empathetic reach, allowing us both to project ourselves sympathetically into the mother-child bond and to imagine kinesthetically the artist's hand moving across the paper, increasing and decreasing the pressure of the crayon in long diagonals or scrawling waves. As Walton writes, in certain of her paintings and pastels, "the artist seemed to move and live, as it were, behind the mask of her works, and the spectator was impressed by a new personality with which he was brought almost in contact."[85]

CASSATT'S LATE WORKS

In the first decade of the twentieth century, Cassatt's resistance to the sentimental seems to have dissolved, along with her tough-minded efforts to complicate, elevate, and dignify it. She produced in these years at least seventy pastels and oils representing little girls in big hats (fig. 104). Pretty, docile, polite, well-dressed, and groomed, they sit with their backs straight and their hands neatly folded, sometimes accompanied by small dogs and cats that are as tame and obedient as they. Often they look directly out at us, bathed in soft luminous light, wearing their bonnets like haute couture halos.

Cassatt animates the best of these images with the power and sureness of her touch, with her ability to capture the solid curve of a brow or the play of light on tender skin. Yet they offer few hints of the psychological investigation and the compositional experimentation that had marked her work of the previous decades. The "homely" figures and "brutal" handling that had offended critics in previous years have been banished. The figures convey no sense of the coming into consciousness, the struggles for mastery of the self, the resistance to social proprieties, and the disciplining of the body that had so interested Cassatt in earlier years. These innocent, untroubled children belong more to the conservative sentimental tradition that Sargent had encountered on his move to Britain in 1884—the tradition established by artists such as Sir Joshua Reynolds and Thomas Gainsborough in the eighteenth century and carried into the late Victorian era by such immensely popular painters as John Everett Millais (fig. 105). These new works by Cassatt were snapped up by collectors and dealers, including Durand-Ruel and Ambroise Vollard, who bought a large group on a visit to her studio in 1906.[86]

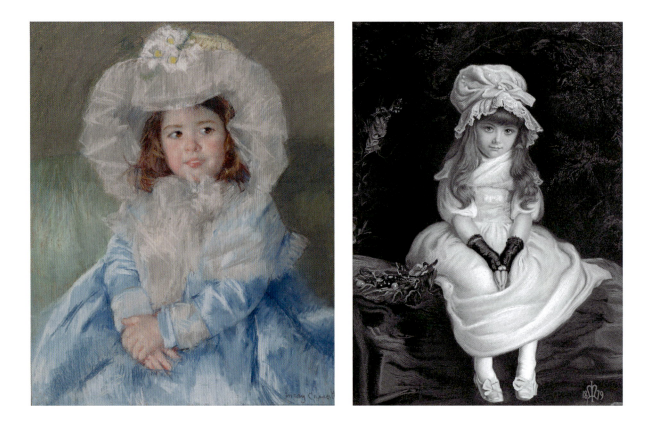

When Cassatt looked back on this period from the vantage point of the early 1910s, she seems to have recognized that she had capitulated to the demands of the market, to the desires of a conservative audience for works that, as Durand-Ruel put it, did not "shock."[87] When a young American art student, Anna Thorne, visited Cassatt at her country home in 1913 and sought to compliment the elderly artist with the remark "Oh, but everyone loves your paintings!" Cassatt erupted, "with an emotion of hatred, or grievous resentment," to say that "'I sold my soul to the dealers, that's all. It was the dealers who stole my life!'"[88]

Yet to close here would be an injustice to Cassatt, for even in these late years, she now and then pushed back against the demand for pleasing, unchallenging works. Her continuing resistance is evident in paintings such as her late *Mother and Child*, ca. 1905, (fig. 106). The subject matter might raise expectations of a scene of sentimental tenderness, but this is not what Cassatt offers here. She has dressed the mother in the aesthetic mode. Her hair is softly upswept and her yellow gown loose, while at her breast is pinned an outsize artificial sunflower, symbol of the aesthetic movement with its exaltation of beauty. A nude blonde infant sits upright on her mother's lap and grasps in both hands a gilded hand mirror. Her mother steadies it and helps the child tilt it so that she can see her reflection, though

Fig. 104.
Mary Cassatt, *Margot in Blue*, 1902. Pastel on paper, 24 1/8 × 19 1/4 in. (61.3 × 50.2 cm). Walters Art Museum, Baltimore.

Fig. 105.
After John Everett Millais, *Cherry Ripe*, 1879. Chromolithograph. Elida Gibbs Collection, London.

Fig. 106. (right)
Mary Cassatt, *Mother and Child*, ca. 1905. Oil on canvas, 36 1/4 × 29 in. (92.1 × 73.7 cm). National Gallery of Art, Washington, DC. Chester Dale Collection.

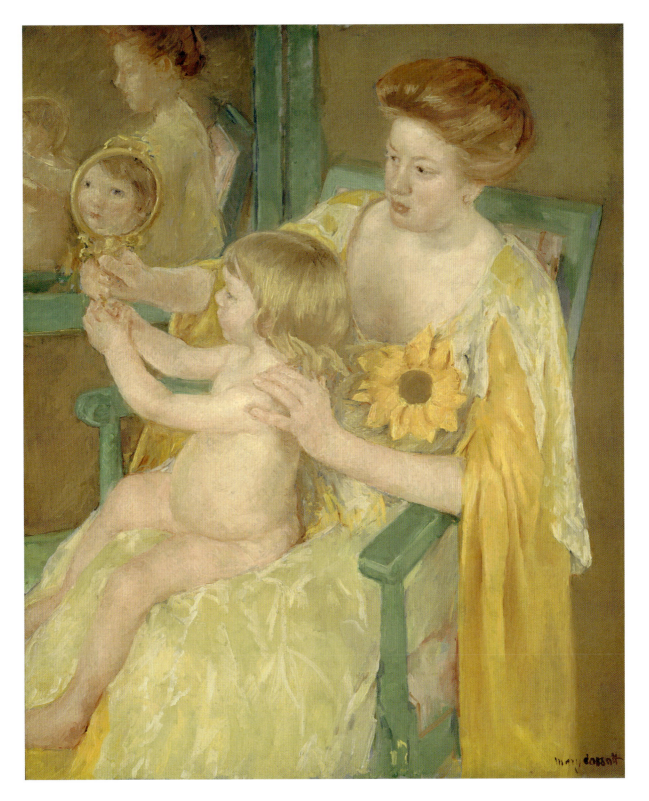

from the vantage point of the viewer the child's eyes in the mirror seem to be looking out at us, acknowledging the presence of an observer. On the wall just beside the pair, a second large mirror reflects their action. With the doubled mirrors, the multiplication of gazes, and the eye-catching gown, the painting seems to be returning us to the theme of *In the Loge*, that of looking and being looked at, yet now the female subjects, instead of ignoring, resisting, or taking ownership of the gaze, submit to it. The mother initiates her child into the subjectivity of the objectified, into a lifetime of being judged by her attractiveness. Cassatt, however, fights the demand for attractiveness, above all in her paint handling. Short, scumbled strokes edged with hard ridges produce a rough and agitated surface (fig. 107). Close up, hands and feet dissolve into scaly slabs of meaty pink pigment (fig. 108), so raw that they could have been lifted from a painting by Willem de Kooning. Cassatt challenges us to find beauty in, or in spite of, the nearly repellent quality of her facture. Here we encounter Cassatt at the end of her career still skirmishing with the sentimental, conceding enough to it in her subject matter to attract its audience, yet lashing at it with her brush.

Fig. 107.
Detail of paint handling. Mary Cassatt, *Mother and Child*, ca. 1905. Oil on canvas, 36 ¼ × 29 in. (92.1 × 73.7 cm). National Gallery of Art, Washington, DC. Chester Dale Collection.

Fig. 108.
Detail of the child's foot. Mary Cassatt, *Mother and Child*, ca. 1905. Oil on canvas, 36 ¼ × 29 in. (92.1 × 73.7 cm). National Gallery of Art, Washington, DC. Chester Dale Collection.

Throughout their careers, Sargent and Cassatt worked in constant awareness of the sentimental. To cast them as unsentimental, as is consistently done today, is thus to repress and deny a significant aspect of their art. At a time of extraordinary instability both in attitudes toward the sentimental and in the very meaning of the word, they charted wavering courses between attraction and resistance. They valued its appeal to tender feelings, its evocations of sympathy, its invitations to empathetic engagement. They engaged it, but for the most part on their own terms. Both artists took on conventional sentimental subjects, yet rendered them unfamiliar and sometimes even strange, impelling us to see subjects afresh and to connect to them in unexpected ways. They did not practice the politically charged, activist sentimentalism of Andrew Jackson Downing, Harriet Beecher Stowe, and other writers and artists of the pre–Civil War era; instead they appropriated it for their own aesthetic and psychological investigations. They perceived and understood the sentimental as a strategic resource for their art, providing an array of themes and subjects they could seize on and deftly explore, making the sentimental new and modern.

EPILOGUE

To close this book with Sargent and Cassatt, without a glance beyond their era, could perpetuate another misapprehension about the sentimental, one that is conveyed in both older and recent histories of the art of the United States: that it belongs to the past, or that if it continues into the twentieth and twenty-first centuries, it does so only in the form of popular art—Norman Rockwell illustrations, Thomas Kinkade prints, and Steven Spielberg films. The truth about the sentimental, however, is much more interesting and complex. Not only does the sentimental run as a wide current through the regionalist and social realist art of the 1930s, exemplified by Dorothea Lange's *Migrant Mother*, 1936, which was created to help rouse sympathy for the nation's "poorest agricultural folk," but it also frequently makes its presence felt in modernist art and architecture.[1]

Among modernist painters, Marsden Hartley's work pulses with sentimental emotions —affection, grief, yearning, nostalgia, and, most of all, a keening desire for human connect-edness, too often frustrated. His *Portrait of a German Officer*, 1914, draws on the vocabularies of cubism and German expressionism to create a poignant memorial to love and loss (fig. 109). A collage-like arrangement of boldly colored geometric forms evokes the waving banners, bristling epaulets, and patriotic flags of Berlin's pre–World War I military pag-eantry—sights that enthralled and aroused Hartley during his time in the imperial capital. Step back from the canvas, however, and these forms resolve into a three-quarter-length abstracted human form set against a stark black backdrop. The initials "K v. F" identify the figure as the young Prussian lieutenant Karl von Freyburg, whom Hartley had loved;

Fig. 109.
Marsden Hartley, *Portrait of a German Officer*, 1914. Oil on canvas, 68 ¼ × 41 ⅛ in. (173.4 × 105.1 cm). The Metropolitan Museum of Art, New York. Alfred Stieglitz Collection, 1949.

he was killed in action on the western front during the first weeks of the war. The concentric circles that constitute the figure's head, suggesting a target or halo, are sliced through by the top of the canvas. From its side, a ribbon of red pigment flows like unstaunched blood. Militaristic triumphalism meets and merges with violence and devastating grief.[2]

In architecture, the most compelling example of the sentimental is Frank Lloyd Wright (1867–1959).[3] In the 1970s, the respected architectural historian William Jordy praised Wright for discarding the "flabby sentimentality" of earlier shingle style homes, and his buildings with their open plans, walls of glass, and innovative use of new materials and construction techniques have been hailed as masterpieces of modern design.[4] Yet at their core his works are sentimental, concerned with issues of belonging and connectedness.

Fig. 110.
Frank Lloyd Wright, Robie House,
1909–10, Chicago.

Wright described himself as "the most sentimental person I ever knew." He was, he said, the "sentimental son of a sentimental mother grown up in the midst of a sentimental family planted on free soil by a grandly sentimental grandfather."[5] His houses, such as the Robie House in Chicago, 1909–10, employ an approach to and vocabulary of domestic design remarkably similar to that of Andrew Jackson Downing (fig. 110). Wright's houses are hearth centered, with prominent chimneys and broad, overhanging eaves, which give visual and symbolic expression to a domestic ideal of warmth, comfort, togetherness, shelter, and protection. Also like Downing, Wright cared deeply that his buildings express an intimate relationship with their sites. They were meant to look as though they had grown naturally from them, as though they were, as Wright put it, "married" to them. They speak to a desire for rootedness. Inhabitants, house, and land belong to each other.

Fig. 111.
Frank Lloyd Wright, Fallingwater,
designed 1934–35, constructed 1936–37.
Bear Run, PA.

Wright's Fallingwater, 1936–37, might well be not only the greatest building ever con-
structed in the United States, but also one of the most sentimental (fig. 111). It is located
in the mountains of southwestern Pennsylvania where a spring-fed stream called Bear Run
tumbles over a limestone ledge in a series of waterfalls. Built as a weekend retreat for the
Pittsburgh department store magnate Edgar J. Kaufmann and his family, Fallingwater
took its inspiration, according to Wright, from his client's "love for the beautiful site."[6]
They visited the spot together and Wright was struck by Kaufmann's fond recollections of
sunbathing, swimming, and picnicking there, as well as his delight in the sound of the falls.

Wright designed a building that melded with the beloved place: it was constructed
of its very stone, and anchored in its bedrock, the falls cascading behind and beneath the
house, as though part of it. Kaufmann's son wrote of Fallingwater, "House and site together
form the very image of man's desire to be at one with nature, equal and wedded."[7] At the
same time, the house is a memory palace, a container and evoker of sweet recollections.
The construction of the house shifted the Kaufmanns' memories into the register of nos-
talgia, because with the building now present on this site, they could never experience
Bear Run as they had in the past, when they sunned on the rock that had become their
living room hearth.

The sentimental has persisted in photography as well. The famous 1975 exhibition *New Topographics: Photographs of a Man-Altered Landscape* gathered the work of ten artists who, the exhibition's curator William Jenkins maintained, were leading landscape practice in a new direction. In contrast to the sublime wilderness vistas of Ansel Adams, these artists were training their cameras on the ordinary landscapes of 1970s America, on industrial parks, housing developments, parking lots, and power lines. Their style, according to Jenkins, was detached and dispassionate, "eschewing entirely the aspects of beauty, emotion and opinion."[8]

In championing the works' neutral documentary style, Jenkins deflected attention from their emotional and ethical depths.[9] Empathy, concern, and a thwarted and longed-for connectedness shaped much of the *New Topographics* work, above all that of Robert Adams (b. 1937). From its beginning, his photographic practice has been grounded in his emotional response to the human damage inflicted on the natural world. He took his first photographs in 1963, impelled by the disappearance of the Colorado he had known in his boyhood: "The places where I had worked, hunted, climbed, and run rivers were all being destroyed, and for me the desperate question was, how do I survive this?"[10] He forced himself to look unflinchingly at the degraded environment, as fields and forests were bulldozed to make way for new residential and commercial developments, and he sought in the wreckage signs and moments of grace, joy, and redemption.

Adams was both aware of and, in some measure, skeptical of the modernist aversion to the sentimental. Of his own tendency to find "intimations of mercy" in radiant light, old trees, and a few kumquat bushes surviving beneath a California interchange, he mused, "In order to guard against sentimentality—the vice of allowing minor consolations more emotional significance than they deserve—perhaps we should turn away from improbabilities." He added: "What is the excess, however, that defines sentimentality? What is too much respect for a juniper or a cottonwood? What is the worth of evidence that allows hope?"[11] Adams explained his overarching goals in these terms: "On the one hand, to show what has gone wrong in the contemporary western landscape so we'll want to change it and do better; but I also hope to show what has remained right in that landscape so we will care for it and take guidance from it and *take home* in it."[12]

Adams's sentimental attachment to the natural world suffuses his photographs. In the gelatin silver print *The Cottonwood, Longmont, Colorado*, 1973–74, open grassland stretches to a distant horizon where a cottonwood spreads its limbs against a cloudless sky (fig. 112). A truck is parked in the tree's leafy shade. Other forms punctuate the horizon to the far right and left. On the right, a few sharp-edged buildings cluster near a tree. On the left, a tractor chugs forward, its plume of diesel smoke echoing the shape of the trees. The trac-

Fig. 112.
Robert Adams, *The Cottonwood, Longmont, Colorado*, 1973–74, printed 2009. Gelatin silver print, 6 × 7 ¹¹⁄₁₆ in. (15.2 × 19.5 cm). Yale University Art Gallery, New Haven. Gift of the artist, 2011.225.17.

tor simultaneously stills and destabilizes the picture. Formally, it provides a counterpoint to the tree on the right, balancing the composition. Narratively, it intimates movement and change.

Adams's caption clarifies what the tractor's presence portends: "The cottonwood had many visitors during the years I checked on it, especially children and birds. One afternoon, however, a man parked his truck in its shade and using a tractor and grader, destroyed the adjoining field in order to make way for new housing. Among the many losses that day was an irrigation ditch that sustained the tree."[13] A photograph taken one year later centers on the hacked stump of the once majestic tree (fig. 113). These images call us to account for our acts of thoughtless destruction, for the damage that we have done both to nature and to ourselves. Yet even as they reproach us, Adams's photographs summon our empathy and urge us to expand the compass of our care to include and learn to cherish the ordinary landscapes of everyday life.

The historian William Reddy, in his book *The Navigation of Feeling*, argues that cultures and communities define their own "emotional regimes," a coherent set of prescriptions and proscriptions for emotions and their expression in what he calls "a collective effort to

Fig. 113.
Robert Adams, *The Same Tree, One Year Later, Longmont, Colorado*, 1975. Gelatin silver print, 8 15/16 × 11 3/16 in. (22.7 × 28.4 cm). Yale University Art Gallery, New Haven. Purchased with a gift from Saundra B. Lane, a grant from the Trellis Fund, and the Janet and Simeon Braguin Fund.

mold feeling."[14] Modernism's emotional regime valorized a stance of cool, ironic distance. Yet it did not censure the expression of all emotion in art; many modernist masterpieces are keyed to angst, agony, rage, fear, and disgust. It was the softer, connective emotions of the sentimental that were proscribed. But these emotions are too fundamentally, even biologically, part of our human identities to be fully suppressed. Even within an avant-garde that has scorned the sentimental for more than a century, it persists, emerging in art where we least expect it. Once we begin looking, it is difficult to identify any body of work that excludes it completely.

Tenderness, care, sympathy, empathy, and compassion may be turned to misguided and destructive ends as well as laudable ones. Yet they are by and large part of our better natures, moving us to reach out and connect with others across the divides and distinctions that separate us. They have been powerful forces for both personal transformation and social change, as many American artists from Peale and Trumbull to Tanner and Sargent and on into the present have understood. There are times when we want and need to be moved to tears.

NOTES

INTRODUCTION

1 Marian Shaw, *World's Fair Notes: A Woman Journalist Views Chicago's 1893 Columbian Exposition* (St. Paul, MN: Pogo Press, 1992), 70. Other contemporary accounts of the painting include "The Great Fair," *Kansas Weekly Capital and Farm Journal* (Topeka), July 6, 1893; "Romance. Representative Art," *Sunday Inter Ocean* (Chicago), October 15, 1893; "Ethel Ingalls Writes," *Dallas Morning News* (Dallas, TX), September 10, 1893. On the painting and its reception, see Michael Leja, *Looking Askance: Skepticism and American Art from Eakins to Duchamp* (Berkeley: University of California Press, 2006), 212–19; Sarah Burns, *Inventing the Modern Artist: Art and Culture in Gilded Age America* (New Haven, CT: Yale University Press, 1996), 302–21.

2 "About the Studios," *Sunday Inter Ocean* (Chicago), April 14, 1893.

3 Clement Greenberg, "Art and Kitsch," *Partisan Review* 6 (1939): 34–49.

4 Harold Rosenberg, *The Tradition of the New* (New York: Horizon Press, 1959), 262.

5 Mark Stevens, "The Way of All Flesh," *New York Magazine*, November 25, 2007; Sally Mann, *Hold Still* (New York: Little, Brown, 2015), 83.

6 "Essays on Men and Manners," *Boston Gazette*, February 11, 1811.

7 My understanding of the term "sentimental" has been significantly shaped by works such as Joanne Dobson, "Reclaiming Sentimental Literature," *American Literature* 69, no. 2 (June 1997): 263–88; June Howard, "What Is Sentimentality?," *American Literary History* 11, no. 1 (Spring 1999): 63–81; Shirley Samuels, ed., *The Culture of Sentiment: Race, Gender and Sentimentality in Nineteenth-Century America* (New York: Oxford University Press, 1992); Robert C. Solomon, *In Defense of Sentimentality* (New York: Oxford University Press, 2004); Janet Todd, *Sensibility: An Introduction* (London: Methuen, 1986).

8 The scholarship on literary sentimentalism is extensive. Important work on British authors includes G. J. Barker-Benfield, *The Culture of Sensibility: Sex and Society in Eighteenth-Century Britain* (Chicago: University of Chicago Press, 1992); Barbara M. Benedict, *Framing Feeling: Sentiment and Style in English Prose Fiction, 1745–1800* (New York: AMS Press, 1994); R. F. Brissenden, *Virtue in Distress: Studies in the Novel of Sentiment from Richardson to Sade* (New York: Harper & Row, 1974); Markman Ellis, *The Politics of Sensibility: Race, Gender and Commerce in the Sentimental Novel* (Cambridge, UK: Cambridge University Press, 1996); Fred Kaplan, *Sacred Tears: Sentimentality in Victorian Literature* (Princeton, NJ: Princeton University Press, 1987); John Mullan, *Sentiment and Sociability: The Language of Feeling in the Eighteenth Century* (New York: Oxford University Press, 1988). On Anglo-American literature of the long

eighteenth century, see Julie Ellison, *Cato's Tears and the Making of Anglo-American Emotion* (Chicago: University of Chicago Press, 1999). On American sentimental literature: Gregg Camfield, *Sentimental Twain: Samuel Clemens in the Maze of Moral Philosophy* (Philadelphia: University of Pennsylvania Press, 1994); Faye Halpern, *Sentimental Readers: The Rise, Fall, and Revival of a Disparaged Rhetoric* (Iowa City: University of Iowa Press, 2013); Glenn Hendler, *Public Sentiments: Structures of Feeling in Nineteenth-Century American Literature* (Chapel Hill: University of North Carolina Press, 2001); Lori Merish, *Sentimental Materialism: Gender, Commodity Culture, and Nineteenth-Century American Literature* (Durham, NC: Duke University Press, 2000); Jane Tompkins, *Sensational Designs: The Cultural Work of American Fiction, 1790–1860* (New York: Oxford University Press, 1985); Cindy Weinstein, *Family, Kinship, and Sympathy in Nineteenth-Century American Literature* (New York: Cambridge University Press, 2004).

9 Glenn Hendler describes Washingtonianism (or the Washington Temperance Society) as "the first massively popular movement organized around the experience of sympathy." See his "Bloated Bodies and Sober Sentiments," in *Sentimental Men: Masculinity and the Politics of Affect in American Culture*, ed. Mary Chapman and Glenn Hendler (Berkeley: University of California Press, 1999), 125–48.

10 Samuels, *Culture of Sentiment*, 3. About the word "sentimentalism": it originated, as did "sentimentality," in late eighteenth-century Britain as a pejorative term, indicating shallow, insincere, and self-indulgent emotionalism. Since the 1970s, however, scholars have recast it as a descriptive, nonjudgmental term that refers to the cluster of feelings and modes of expression associated with the sentimental. Literary scholars often use it to refer to the genre of sentimental writing. Janet Todd defines it more broadly as "the movement discerned in philosophy, politics and art, based on the belief in or hope of the natural goodness of humanity and manifested in a humanitarian concern for the unfortunate and helpless." See *Sensibility*, 7. I use the word in Todd's sense.

11 "The Charity of Abolitionists," *Georgia Telegraph* (Macon), August 1, 1848; "Particular Notice," *Emancipator and Free American* (Boston, MA), April 20, 1843.

12 "General Taylor and the Late Whig Party," *National Era* (Washington, DC), June 22, 1848; "Mr. Polk," *Georgia Telegraph* (Macon), August 31, 1847.

13 "Opponents call Cage–Free Egg Ballot Question Rotten,"

Boston Globe, April 28, 2016.

14 I base this statement on my extensive study of the use of the word in American newspapers and periodicals from the eighteenth century into the early years of the twentieth century through online databases such as America's Historical Newspapers and American Periodical Series. I have not made a similar study of publications in other countries, so I feel confident speaking only of the United States. Secondary sources, however, suggest that the word "sentimental" was used as a negative term much earlier and more extensively in France and Britain than in the United States. See Todd, *Sensibility*, 6–9.

Sentimentalism was an international project extending outward from Europe to its current and former colonies. Scholars have been attentive to Americans' adoption of various aspects of British sentimental philosophy and culture, but they have produced few comparative studies examining the different ways that the sentimental was manifested between and across cultures and countries.

15 Denis Diderot, quoted in Solomon, *In Defense of Sentimentality*, 8; John Ruskin, *Modern Painters*, vol. 4 (1856) in *The Works of John Ruskin*, ed. E. T. Cook and Alexander Wedderburn, 39 vols. (London: George Allen, 1903–12), 6:19; "Editor's Table," *Appletons' Journal*, February 1878, 195.

16 Suzanne Clark, *Sentimental Modernism: Women Writers and the Revolution of the Word* (Bloomington: Indiana University Press, 1991), 1.

17 Charles H. Caffin, *The Story of American Painting: The Evolution of Painting in America from Colonial Times to the Present* (New York: Frederick A. Stokes Company, 1907); Sadakichi Hartmann, *A History of American Art*, 2 vols. (Boston: L. C. Page, 1901).

18 On turn-of-the-century concerns about the feminization of American culture, see Earl Barnes, "The Feminizing of Culture," *Atlantic Monthly* 109 (June 1912): 770–76; Gail Bederman, *Manliness and Civilization: A Cultural History of Gender and Race in the United States, 1880–1917* (Chicago: University of Chicago Press, 1995).

19 Caffin, *Story of American Painting*, 231; Hartmann, *History of American Art*, 1:204. On the sentimental strain in Eakins's art, see Martin A. Berger, "Sentimental Realism in Thomas Eakins's Late Portraits," in Chapman and Hendler, *Sentimental Men*, 244–58.

20 Wayne Craven, *American Art: History and Culture*, rev. ed. (Boston: McGraw-Hill, 2003), 336.

21 Angela Miller, Janet Berlo, Bryan Wolf, and Jennifer Roberts, *American Encounters: Art, History, and Cultural Identity* (Upper Saddle River, NJ: Pearson Prentice Hall, 2008), 171. I use this quotation to call attention to a long-entrenched historiographic position; I mean in no way to disparage this textbook, which I greatly admire.

22 Frances K. Pohl, *Framing America: A Social History of American Art*, 3rd ed. (New York: Thames and Hudson, 2012), 313.

23 Stuart Davis, "Abstract Art in the American Scene," *Parnassus* 13, no. 3 (March 1941): 100–103.

24 Samuels, *Culture of Sentiment*.

25 Burns, *Inventing the Modern Artist*, 302.

26 Solomon, *In Defense of Sentimentality*, viii.

27 Michael Bell, *Sentimentalism, Ethics, and the Culture of Feeling* (New York: Palgrave, 2000); David J. Denby, *Sentimental Narrative and the Social Order in France, 1760–1820* (Cambridge, UK: Cambridge University Press, 1994); Ellis, *The Politics of Sensibility*; Sarah Knott, *Sensibility and the American Revolution* (Chapel Hill: University of North Carolina Press for the Omohundro Institute of Early American History and Culture, Williamsburg, VA, 2009); David Marshall, *The Frame of Art: Fictions of Aesthetic Experience, 1750–1815* (Baltimore: Johns Hopkins University Press, 2005); John Mullan, *Sentiment and Sociability: The Language of Feeling in the Eighteenth Century* (New York: Oxford University Press, 1988); William M. Reddy, *The Navigation of Feeling: A Framework for the History of Emotions* (New York: Cambridge University Press, 2001).

28 James Chandler, *An Archeology of Sympathy: The Sentimental Mode in Literature and Cinema* (Chicago: University of Chicago Press, 2013).

29 Lynn Festa, *Sentimental Figures of Empire in Eighteenth-Century Britain and France* (Baltimore: Johns Hopkins University Press, 2006); Renato Rosaldo, "Imperialist Nostalgia," *Representations* 26 (Spring 1989): 107–22; Laura Wexler, "Tender Violence: Literary Eavesdropping, Domestic Fiction, and Educational Reform," in Samuels, *Culture of Sentiment*, 9–38; Marcus Wood, *Blind Memory: Visual Representations of Slavery in England and America, 1780–1865* (Manchester, UK: Manchester University Press, 2000).

30 On such traits see, for example, Tompkins, *Sensational Designs*, and Dobson, "Reclaiming Sentimental Literature." Chandler, in *An Archeology of Sympathy*, describes formal devices, such as "careful management of points of view," which he finds consistently employed by creators of sentimental works from Laurence Sterne to Frank Capra, yet he does not define the sentimental by the use of such forms and techniques.

31 Among these contributions, Emma Barker's *Greuze and the Painting of Sentiment* (Cambridge, UK: Cambridge University Press, 2005) stands out as exemplary.

CHAPTER 1

1 "Boston," *Massachusetts Centinel*, March 6, 1790.

2 On a portrait of Hamilton as sentimental, see "Bust of Hamilton," *Repertory* (Boston, MA), December 7, 1804. On tributes to George Washington as sentimental, see "Washington's Birth-Day," *Independent American* (Ballston Spa, NY), March 5, 1811; David Waldstreicher, *In the Midst of Perpetual Fetes: The Making of American Nationalism, 1776–1820* (Chapel Hill: University of North Carolina Press for the Omohundro Institute of Early American History and Culture, Williamsburg, VA, 1997), esp. 117–73; John P. Kaminski and Jill Adair McCaughan, *A Great and Good Man: George Washington in the Eyes of His Contemporaries* (Madison, WI: Madison House, 1989), esp. 114–25, 145–96.

3 On the philosophical foundations of eighteenth-century sentimentalism, see Barker-Benfield, *The Culture of Sensibility*; Bell, *Sentimentalism, Ethics, and the Culture of Feeling*; Ellis, *The Politics of Sensibility*; Terence Martin, *The Instructed Vision: Scottish Common Sense Philosophy and the Origins of American Fiction* (Bloomington: Indiana University Press, 1961); Todd, *Sensibility*.

4 On sentimental political union, see "An Essay on the Means of Promoting Federal Sentiments in the United States by a Foreign Spectator," *Independent Gazetteer* (Philadelphia, PA), September 4, 1787; Nathaniel Chipman, *Sketches of the Principles of Government* (Rutland, VT: J. Lyon, 1793). Thomas Paine refers to the "sentimental union" of the colonies in "The American Crisis. Number III," *New-England Chronicle* (Boston) 9, no. 456 (May 15, 1777). See also Andrew Burstein, *Sentimental Democracy: The Evolution of America's Romantic Self-Image* (New York: Hill and Wang, 1999) and Waldstreicher, *In the Midst of Perpetual Fetes*.

5 Chipman, *Sketches of the Principles of Government*, 234–36.

6 Lillian B. Miller, ed., *The Selected Papers of Charles Willson Peale and His Family*, 5 vols. (New Haven, CT: Yale University Press for the National Portrait Gallery, Smithsonian Institution, Washington, DC, 1983), 1:32.

7 Benedict Anderson, *Imagined Communities*, rev. ed. (New York: Verso, 1991), 7.

8 Adam Smith, *The Theory of Moral Sentiments*, 6th ed. (London: A. Strahan, 1812), 257.

9 Charles Coleman Sellers, *The Artist of the Revolution: The Early Life of Charles Willson Peale* (Hebron, CT: Feather and Good, 1939), 13. Other scholars too have remarked on and discussed Peale's sentimentalism and his relation to the eighteenth-century culture of sensibility, including David C. Ward, in his *Charles Willson Peale: Art and Selfhood in the Early Republic* (Berkeley: University of California Press, 2004).

10 John Adams to Abigail Adams, August 21, 1776. Adams Family Papers, an Electronic Archive, Massachusetts Historical Society, http://www.masshist.org/digitaladams/archive/doc?id=L17760821ja.

11 On *The Peale Family*, see Edgar P. Richardson, Brooke Hindle, and Lillian B. Miller, *Charles Willson Peale and His World* (New York: Harry N. Abrams, 1983), 196–97; David R. Brigham, *Public Culture in the Early Republic: Peale's Museum and Its Audience* (Washington, DC: Smithsonian Institution Press, 1995), 122–24; and an entry on the painting on the New York Historical Society website, http://www.nyhistory.org/exhibit/peale-family.

12 That Peale was well aware of these new ideals, and gave them expression in his portraits, does not necessarily mean that he followed through on them in his own life. In contrast to his self-presentation as a devoted and sympathetic father in his autobiography and other writings, recent literature about the Peale family has portrayed him in a less flattering light, as an imperious and controlling figure engaged in fraught relationships with many of his children. See, for example, Phoebe Lloyd, "Philadelphia Story," *Art in America* 76 (November 1988): 155–70, 195–98, 200–202; Kenneth Haltman, *Looking Close and Seeing Far: Samuel Seymour, Titian Ramsay Peale, and the Art of the Long Expedition, 1818–1823* (University Park: Pennsylvania State University Press, 2008).

13 Quoted in Ward, *Charles Willson Peale*, 12.

14 The affectionate regard in which the Peale siblings held Peggy Durgan is suggested by St. George Peale's will, in which he left her one hundred pounds, the same amount he left to each of his three nieces. See Miller, *Selected Papers*, 1:281 n129.

15 Ibid., 265–66, diary entry, February 14, 1778.

16 From those seven sittings, Peale produced at least seventy-seven portraits of Washington. See David Ward, "Creating a National Culture: Charles Willson Peale's George Washington at Princeton," *Record of the Princeton University Art Museum* 70 (2011): 13.

17 "Resolve of the Supreme Executive Council to Commission a Portrait of Washington. Philadelphia, January 18, 1779," in Miller, *Selected Papers*, 1:302–3. On this portrait, see Ward, "Creating a National Culture"; Paul Staiti, *Of Arms and Artists: The American Revolution through Painters' Eyes* (New York: Bloomsbury Press, 2016), 37–41.

18 On smiling and its relationship to the eighteenth-century culture of sensibility, see Colin Jones, *The Smile Revolution in Eighteenth Century Paris* (Oxford, UK: Oxford University Press, 2014), esp. chap. 2.

19 See Wendy C. Wick, *George Washington: An American Icon. The Eighteenth-Century Graphic Portraits* (Washington, DC: Smithsonian Institution, 1982), 10–16.

20 For examples of many such affectionate phrases that Washington's contemporaries applied to him (our dearest friend, our father, our brother, our beloved), see Kaminski and McCaughan, *A Great and Good Man*; T. H. Breen, *George Washington's Journey* (New York: Simon & Schuster, 2016); Waldstreicher, *In the Midst of Perpetual Fetes*. The phrase "Our Friend, Washington" appears in George Blake, *A Masonic Eulogy on the Life of the Illustrious Brother George Washington* (Boston: John Russell, 1800), 8.

21 Through the pages of Peale's diaries, one can witness the evolution of his attitude toward slavery over the years. In 1764, he purchased a slave girl named Lydia for thirty-five pounds. Between 1769 and 1775, he acquired a couple named Scarborough and Lucy; their son, Moses Williams, was born into slavery in Peale's household. By 1778, however, Peale was remarking on slavery's corrupting influence on the morals and manners of slave owners (*Selected Papers*, 1:301); in 1779–80, as a member of the Pennsylvania state legislature, he voted for the abolition of slavery. He would eventually manumit his slaves, freeing Lucy and Scarborough in 1786 (though he sought to be reimbursed by the state for their value). According to David Brigham, Peale did not free Moses Williams until 1802, when required to by law. Brigham, *Public Culture in the Early Republic*, 70–71. On Moses Williams, see Gwendolyn DuBois Shaw, "'Moses Williams, Cutter of Profiles': Silhouettes and African American Identity in the Early Republic," *Proceedings of the American Philosophical Society* 149, no. 1 (March 2005): 22–39; on Peale's complex, ambivalent attitude toward slavery, see Ward, *Charles Willson Peale*, 66–67.

22 *The Autobiography of Charles Willson Peale*, in Miller, *Selected Papers*, 5:89.

23 Waldstreicher, *In the Midst of Perpetual Fetes*, 1–2.

24 See Miller, *Selected Papers*, 1:351–55.

25 Charles Willson Peale, "Diary of a Journey from Maryland to Massachusetts," entry for August 1765, in Miller, *Selected Papers*, 1:44.

26 "Arnold and the Devil," *Pennsylvania Packet* (Philadelphia), October 3, 1780, in Miller, *Selected Papers*, 1:354–55.

27 "Mr. Charles W. Peale," *Freeman's Journal* (Philadelphia, PA), December 12, 1781.

28 "Philadelphia, April 22," *New-York Packet*, May 1, 1789. My description of the event comes from this source.

29 David Waldstreicher discusses ways that "newspapers transformed the very rituals that they might seem to merely describe." They amplified and linked local events into a "national popular political culture." Waldstreicher, *In the Midst of Perpetual Fetes*, 11.

30 "Celebration of the 4th July," *Greensburgh & Indiana Register* (Greensburg, PA), July 16, 1812.

31 "Procession," Boston, October 19, 1789, and "Order of Procession," Newburyport, October 28, 1789. Broadsides in the collection of the Library of Congress, Washington, DC.

32 "Salem, July 3," *Salem Mercury* (Salem, MA), July 3, 1787.

33 David Hume, *Essays, Moral, Political, and Literary* (1792), ed. Eugene F. Miller (Indianapolis: Liberty Fund, 1987), 9.

34 Waldstreicher, in *In the Midst of Perpetual Fetes*, offers a comprehensive and nuanced account of the role such events played in the development of American nationalism as well as in more divisive political contests. On the nation as an "imagined community," see Anderson, *Imagined Communities*.

35 David Brigham, while documenting Peale's claims for his museum's democratic openness, also offers evidence that the audience was significantly circumscribed in terms of social rank and race. Brigham, *Public Culture in the Early Republic*, 2. See also Brandon Brame Fortune, "Charles Willson Peale's Portrait Gallery: Persuasion and the Plain Style," *Word & Image* 6, no. 4 (October–December 1990): 308–24; Sidney Hart and David C. Ward, "The Waning of an Enlightenment Ideal: Charles Willson Peale's Philadelphia Museum, 1790–1820," in *New Perspectives on Charles Willson Peale*, ed. Lillian B. Miller and David C. Ward (Pittsburgh: University of Pittsburgh Press, 1990), 219–35; David Steinberg, "Charles Willson Peale Portrays the Body Politic," in *The Peale Family: Creation of a Legacy 1770–1870*, ed. Lillian B. Miller (New York: Abbeville Press in association with the Trust for Museum Exhibitions and the National Portrait Gallery, Smithsonian Institution,

Washington, DC, 1996), 118–33; Ward, *Charles Willson Peale*, esp. 95–110.

36 Brigham, *Public Culture in the Early Republic*, 151–57.

37 Ibid., 140.

38 Richardson, Hindle, and Miller, *Charles Willson Peale and His World*, 80; Brigham, *Public Culture in the Early Republic*, 128, 107–8.

39 Ward, *Charles Willson Peale*, 102.

40 Peale to Andrew Ellicott, February 28, 1802, quoted in Ward, *Charles Willson Peale*, 101.

41 David Steinberg calls attention to the visual and thematic unity of the portraits in his essay "Charles Willson Peale Portrays the Body Politic," in Miller, *Peale Family*, 118–33.

42 Surprisingly little has been written about Trumbull. Important secondary sources include Staiti, *Of Arms and Artists*; Helen A. Cooper, *John Trumbull: The Hand and Spirit of a Painter* (New Haven, CT: Yale University Press for the Yale University Art Gallery, 1982); Irma B. Jaffe, *John Trumbull: Patriot-Artist of the American Revolution* (Boston: New York Graphic Society, 1975).

For the political context of this period, see Robert Middlekauf, *The Glorious Cause: The American Revolution, 1763–1789*, rev. ed. (New York: Oxford University Press, 2005); Gordon S. Wood, *Empire of Liberty: A History of the Early Republic, 1789–1815* (New York: Oxford University Press, 2009); and Stanley Elkins and Eric McKitrick, *The Age of Federalism: The Early American Republic, 1789–1800* (New York: Oxford University Press, 1993).

43 The Society of the Cincinnati is the oldest hereditary organization in the United States. It was formed in 1783 by officers of the Continental Army and their French counterparts, who served together in the Revolutionary War. Its founding principles were "the defense of liberty, the promotion of union, and the preservation of friendships forged in war." Membership passed from eldest son to eldest son. In its early years, critics found the society to be "anti-egalitarian, and, at worst, a nefarious shadow government seeking to overthrow the Confederation." See Patrick Allan Pospisek, "Society of the Cincinnati," on the Mount Vernon website, http://www.mountvernon.org/digital-encyclopedia/article/society-of-the-cincinnati/.

44 The subjects of the eight painting of the original series are listed by Trumbull in an appendix to his *Autobiography* as The Battle of Bunker's Hill, The Death of General Montgomery at Quebec, The Declaration of Independence, The Battle of Trenton, The Battle of Princeton, The Surrender of General

Burgoyne, The Surrender of Lord Cornwallis, and Washington Resigning his Commission. John Trumbull, *Autobiography, Reminiscences and Letters of John Trumbull from 1756 to 1841* (New York: Wiley and Putnam, 1841), 291.

45 On Jefferson's belief in the important role of the social affections in the creation of national unity, see Jan Lewis, "'Those Scenes for which Alone my Heart was Made': Affection and Politics in the Age of Jefferson and Hamilton," in *An Emotional History of the United States*, ed. Peter N. Stearns and Jan Lewis (New York: New York University Press, 1998); on Trumbull's purchase of Sterne's works, see his *Autobiography*, 157.

46 Trumbull, *Autobiography*, 12.

47 On Harvard's use of Fordyce's text, see Norman S. Fiering, "Irresistible Compassion: An Aspect of Eighteenth-Century Sympathy and Humanitarianism," *Journal of the History of Ideas* 37, no. 2 (April–June 1976): 206–7 n33.

48 David Fordyce, *Elements of Moral Philosophy* (London: R. and J. Dodsley, 1754), 68.

49 Ibid., 125.

50 Ibid., 200–201.

51 Ibid., 129.

52 Trumbull, *Autobiography*, 158.

53 Ibid.

54 Ibid., 27–28.

55 On military sentimentalism, see Sarah Knott, "Sensibility and the American War for Independence," *American Historical Review* 109, no. 1 (February 2004): 19–40; Philip Carter, "Tears and the Man," in *Women, Gender, and Enlightenment*, ed. Sarah Knott and Barbara Taylor (New York: Palgrave Macmillan, 2005), 156–73.

56 Knott, *Sensibility and the American Revolution*, chap. 4.

57 Trumbull, *Autobiography*, 33–35.

58 Scholars who have noted this theme include Jaffe, in *John Trumbull*, and Cooper, in *John Trumbull*.

59 Abigail Adams to her sister Elizabeth Smith Shaw, London, March 4, 1786, in *Adams Family Correspondence*, 12 vols. (Cambridge, MA: Harvard University Press, 2005), 7:82. See also G. J. Barker-Benfield, *Abigail and John Adams: The Americanization of Sensibility* (Chicago: University of Chicago Press, 2010).

60 Benjamin Silliman, "Notebook" (1857–58), 65–67. Typescript in Silliman Family Papers, Manuscripts and Archives, Sterling Library, Yale University, New Haven, CT.

61 "Communication: Historical Painting," *Boston Daily Advertiser*, March 12, 1817.

62 David Hackett Fischer, *Washington's Crossing* (New York: Oxford University Press, 2004), 255; Varnum Lansing Collins, ed., *A Brief Narrative of the Ravages of the British and Hessians at Princeton 1776–1777* (Princeton: University Library, 1906), 36–37, provides a firsthand account of the aftermath of the battle when Washington and some of his men appeared at the writer's door with two wounded enemy soldiers, whom they cared for "very tenderly" before departing.

63 Silliman, "Notebook," 73–74.

64 Trumbull, *Autobiography*, 420.

65 See, for example, "Philadelphia, 24th September 1792," *Federal Gazette* (Philadelphia, PA), September 24, 1792; "Liberal Sentiments, Extracted from a Lecture on the Belles Letters, Lately Delivered in New-York," *Columbian Courier* (New Bedford, MA), December 5, 1800; "Literary Intelligence," *Port-Folio* 4, no. 37 (September 15, 1804): 294.

66 Hugh Blair, "Sermon II: On Sensibility," *Sermons*, 3 vols. (London: A. Strand and T. Cadell; Edinburgh: W. Creech, 1790), 3:22–27. After the *Spectator*, Blair's *Sermons* were "the best-selling work in the English language written in the eighteenth century," according to John Dwyer, *Virtuous Discourse: Sensibility and Community in Late Eighteenth-Century Scotland* (Edinburgh: John Donald Publishers, 1987), 19.

67 John Trumbull to his brother Jonathan Trumbull, September 13, 1785, quoted in Jaffe, *John Trumbull*, 81.

68 Trumbull, *Autobiography*, 161.

CHAPTER 2

1 Michael N. Barnett, *Empire of Humanity* (Ithaca, NY: Cornell University Press, 2011), 49.

2 Adam Smith, *The Theory of Moral Sentiments*, ed. Knud Haakonssen (Cambridge, UK: Cambridge University Press, 2002), 44.

3 Amy Coplan, "Understanding Empathy: Its Features and Effects," in *Empathy: Philosophical and Psychological Perspectives*, ed. Amy Coplan and Peter Goldie (Oxford, UK: Oxford University Press, 2011), 5. This book offers an excellent overview of diverse perspectives and current debates on empathy.

4 C. Daniel Batson, David A. Lishner, and Eric L. Stocks, "The Empathy–Altruism Hypothesis," in *The Oxford Handbook of Prosocial Behavior*, ed. David A. Schroeder and William G. Graziano (New York: Oxford University Press, 2015), 259–77.

5 Paul Bloom, in *Against Empathy: The Case for Rational Compassion* (New York: Ecco, 2016), argues that empathy is a poor guide to moral or political decision making and may result in

bias, cruelty, and injustice. He promotes instead a more distanced "rational compassion." Adam Smith and other Enlightenment moral sentiment philosophers would not have disagreed with Bloom on the value of modulating sympathy with rational deliberation. Bloom's critics point out, however, that the compassion he argues for cannot occur without empathy. See Lynn E. O'Connor and Jack W. Berry, "Forum Response: Against Empathy," *Boston Review* 39, no. 5 (September 10, 2014), http://bostonreview.net/forum/against-empathy/lynn-e-oconnor-jack-w-berry-response-against-empathy-oconnor.

6 Angelina Grimké, *Appeal to Christian Women of the South* (New York: American Anti-Slavery Society, 1836), 28.

7 "From the Herald of Freedom: 'Pictorials,'" *Emancipator* (New York, NY), February 1, 1836.

8 On antislavery almanacs, see Teresa A. Goddu, "The Antislavery Almanac and the Discourse of Numeracy," *Book History* 12 (2009): 129–55, and "Anti-Slavery's Panoramic Perspective," *MELUS: Multi-Ethnic Literature of the U.S.* 39, no. 2 (Summer 2014), doi: 10.1093/melus/mlu015.

9 It should be noted that the text continues, "The slaves suffer, in such cases, FAR MORE than we, for they have few pleasures except those they derive from their companions in wo [*sic*]." This additional line was surely meant to deepen readers' sympathy for the print's subjects, yet it also underscores their distance and difference from the enslaved.

10 *The New England Anti-Slavery Almanac for 1841* (Boston: J. A. Collins, 1841). These directives are printed on the back of the paper cover. Most extant copies are missing their covers, but the one at the Boston Athenaeum is intact.

11 Wood, *Blind Memory*; Marcus Wood, *Slavery, Empathy, and Pornography* (Oxford, UK: Oxford University Press, 2002).

12 James Baldwin, "Everybody's Protest Novel," in *Notes of a Native Son* (Boston: Beacon Press, 1955), 13–23.

13 Wexler, "Tender Violence," in Samuels, *Culture of Sentiment*, 15.

14 James Lane Allen, "Mrs. Stowe's 'Uncle Tom' at Home in Kentucky," *Century Magazine* 34 (October 1887): 852–67.

15 Ibid., 867.

16 Important sources on Tanner include Marcus Bruce, *Henry Ossawa Tanner: A Spiritual Biography* (New York: Crossroad Publishing Company, 2002); Jennifer Harper, "The Early Religious Paintings of Henry Ossawa Tanner: A Study of the Influences of Church, Family, and Era," *American Art* 6, no. 4 (Fall 1992): 68–85; Anna O. Marley, ed., *Henry Ossawa Tanner: Modern Spirit* (Berkeley: University of California Press; Phil-

adelphia: Pennsylvania Academy of Fine Arts, 2012); Marcia Matthews, *Henry Ossawa Tanner: American Artist* (1969) (Chicago: University of Chicago Press, 1994); Dewey F. Mosby and Darrell Sewell, *Henry Ossawa Tanner* (New York: Rizzoli International Publications; Philadelphia: Philadelphia Museum of Art, 1991); Romare Bearden and Harry Henderson, *A History of African-American Artists from 1792 to the Present* (New York: Pantheon Books, 1993); Kelly Jeannette Baker, "Henry Ossawa Tanner: Race, Religion, and Visual Mysticism" (MA thesis, Florida State University, 2003).

17 Information about the Congress on Africa, the speakers, and their speeches is drawn from "The Dark Continent: Light upon Africa in the Ethnological Congress," *Daily Inter Ocean* (Chicago, IL), August 15, 1893; Frederick Perry Noble, "The Chicago Congress on Africa," *Our Day* 12 (October 1893): 279–300. Noble was the originator and secretary of the Chicago Congress. On African American participation in the World's Columbian Exposition, including the Congress, see Christopher Robert Reed, *"All the World Is Here!" The Black Presence in the White City* (Bloomington: Indiana University Press, 2000).

18 Noble, "The Chicago Congress on Africa," 289.

19 William Seraile, *Fire in His Heart: Bishop Benjamin Tucker Tanner and the A.M.E. Church* (Knoxville: University of Tennessee Press, 1998), 35, 144.

20 On the reasons for Tanner's turn to African American subjects at this time, see Albert Boime, "Henry Ossawa Tanner's Subversion of Genre," *Art Bulletin* 75, no. 3 (September 1993): 415–41; Mosby and Sewell, *Henry Ossawa Tanner*, 91.

21 "Tanner Exhibits Paintings: Negro Artist Shows Pictures at Grand Central Art Galleries," *New York Times*, January 27, 1924.

22 H. O. Tanner, "The Story of an Artist's Life, Part II," *World's Work* 18, no. 3 (July 1909): 11774, H. O. Tanner Papers, Archives of American Art, Smithsonian Institution, Washington, DC.

23 H. O. Tanner, 1897 notebook, quoted in Matthews, *Henry Ossawa Tanner*, 83. Original notebook in H. O. Tanner Papers, AAA.

24 Unfinished draft of a letter from Tanner to an unnamed recipient, probably his friend Atherton Curtis, transcribed in Matthews, *Henry Ossawa Tanner*, 156.

25 Benjamin Tucker Tanner, *Theological Lectures* (Nashville, TN: Publishing House, A.M.E. Church Sunday School Union, 1894), 83.

26 Ruth McEnery Stuart, "Uncle Tim's Compromise on Christmas," *Harper's Young People* 15, no. 736 (December 5, 1893): 82–84.

The relationship between this story and Tanner's *The Banjo Lesson*, 1893, was pointed out by Will South, "A Missing Question Mark: The Unknown Henry Ossawa Tanner," *Nineteenth-Century Art Worldwide* 8, no. 2 (Autumn 2009), http://www.19thc-artworldwide.org/autumn09/a-missing-question-mark.

27 Important work on *The Banjo Lesson* includes Boime, "Henry Ossawa Tanner's Subversion of Genre"; Leo G. Mazow, ed., *Picturing the Banjo* (University Park, PA: Palmer Museum of Art and Pennsylvania State University Press, 2005); South, "A Missing Question Mark"; Judith Wilson, "Lifting the 'Veil': Henry O. Tanner's The Banjo Lesson and The Thankful Poor," in *Critical Issues in American Art: A Book of Readings*, ed. Mary Ann Calo (Boulder, CO: Westview Press, 1998), 199–219.

28 Statement in Tanner's hand in the files of the Pennsylvania School for the Deaf, Philadelphia, quoted in Mosby and Sewell, *Henry Ossawa Tanner*, 116.

29 W.S. Scarborough, "Henry Ossian [*sic*] Tanner," *Southern Workman* 31 (December 1902): 665–66.

30 Mosby and Sewell, *Henry Ossawa Tanner*, 149.

31 Seraile, *Fire in His Heart*, 49.

32 Ibid., 49, 21. On the assessments of Bishop Tanner's views, see Seraile's chap. 2.

33 H.O. Tanner, "The Story of an Artist's Life, Part I," *World's Work* 18, no. 2 (June 1909): 11665.

34 Quoted in Bearden and Henderson, *History of African-American Artists*, 97.

35 Important considerations of Tanner's *The Resurrection of Lazarus* include Alan C. Braddock, "Painting the World's Christ: Tanner, Hybridity, and the Blood of the Holy Land," *Nineteenth-Century Art Worldwide* 3, no. 2 (Autumn 2004), http://www.19thc-artworldwide.org/autumn04/67-autumn04/autumn04article/298-painting-the-worlds-christ-tanner-hybridity-and-the-blood-of-the-holy-land; Harper, "The Early Religious Paintings of Henry Ossawa Tanner"; Kristin Schwain, *Signs of Grace: Religion and American Art in the Gilded Age* (Ithaca, NY: Cornell University Press, 2008); Marc Simpson, "The Resurrection of Lazarus from the Quartier Latin to the Musée du Luxembourg," in Marley, *Henry Ossawa Tanner*, 69–78; Naurice Frank Woods, Jr., "Embarking on a New Covenant," *American Art* 27, no. 1 (Spring 2013): 94–103.

36 "An Afro-American Painter Who Has Become Famous in Paris," *Current Literature* 45, no. 4 (October 1908): 405.

37 Lucy Allen, "The Race Problem," *Cleveland* [OH] *Gazette*, June 9, 1900.

38 Simpson, "Resurrection of Lazarus," in Marley, *Henry Ossawa Tanner*, 78 n43.

39 Hale Woodruff, "My Meeting with Henry O. Tanner," *Crisis* 77, no. 11 (January 1970): 7–12. Woodruff met with Tanner in the spring of 1928.

40 See, for example, William Francis Allen, *Slave Songs of the United States* (New York: A. Simpson, 1867), 98, on "I Want to Die like-a Lazarus Die."

41 Philip S. Foner and Robert James Branham, eds., *Lift Every Voice: African American Oratory, 1787–1900* (Tuscaloosa: University of Alabama Press, 1998), 228–29.

42 "Henry Ward Beecher on the Importance of the Common School in the Southern States," *American Freedman* (New York, NY), June 1, 1867.

43 W.H. Burgess, III, *The Hyde Collection* (Glen Falls, NY: Hyde Collection, 1972), 7, quoted in Mosby and Sewell, *Henry Ossawa Tanner*, 138. This quotation appears in many publications about Tanner, but I have yet to locate a copy of the original publication. Both Mosby in *Henry Ossawa Tanner*, 135–39, and Harper in "The Early Religious Paintings of Henry Ossawa Tanner," expand on Burgess's insight to connect Tanner's *The Resurrection of Lazarus* to an African American pulpit tradition that linked biblical stories to contemporary concerns, allowing us, Harper writes, to read it as "symbolic of the rebirth of hope for equality experienced by black Americans after the Emancipation Proclamation of 1863" (77).

44 Benjamin Tucker Tanner, *The Negro's Origin and Is the Negro Cursed?* (Philadelphia: African M.E. Book Depository, 1869).

45 Benjamin T. Tanner, *The Negro in Holy Writ* (Philadelphia: A.M.E. Book Concern, 1902), 22, 32.

46 Braddock, "Painting the World's Christ," n.p.

47 Translated from the original French by Marc Simpson and quoted by him in "The Resurrection of Lazarus," in Marly, *Henry Ossawa Tanner*, 72.

48 Scarborough, "Henry Ossian [*sic*] Tanner," 666.

49 Elbert Francis Baldwin, "A Negro Artist of Unique Power," *Outlook* 64, no. 14 (April 7, 1900): 795.

50 In describing how he imagined the child Jesus, Tanner recalled a visit to Jerusalem, where he ran across "a little Yemenite Jew. Where could a better type [for Jesus] be found than this swarthy child of Arabia, of purest Jewish blood." Henry Ossawa Tanner, "The Mothers of the Bible—By H.O. Tanner. The Last of a Series of Four Great Biblical Paintings: Mary," *Ladies Home Journal*, January 1903, 13, quoted in Braddock, "Painting the World's Christ," n.p.

51 *Boston Herald*, June 13, 1897, quoted in Naurice Frank Woods, Jr., "Henry Ossawa Tanner's Negotiation of Race and Art: Challenging 'The Unknown Tanner,'" *Journal of Black Studies* 42, no. 6 (September 2011): 896–97.

52 "An Afro-American Painter Who Has Become Famous in Paris," 405.

53 Baldwin, "A Negro Artist of Unique Power," 795.

54 Florence L. Bentley, "Henry O. Tanner," *Voice of the Negro* 3, no. 11 (November 1906): 480–82.

55 Information on the Dreyfus affair is drawn from Norman L. Kleebatt, ed., *The Dreyfus Affair: Art, Truth, and Justice* (Berkeley: University of California Press, 1987), and Jean-Max Guieu, "Chronology of the Dreyfus Affair," May 2000, Georgetown University website, http://faculty.georgetown.edu/guieuj/DreyfusCase/Chronology%20of%20the%20Dreyfus%20Affair.htm.

56 Kleebatt, *Dreyfus Affair*, 158.

57 Louisine W. Havemeyer, *Sixteen to Sixty: Memoirs of a Collector*, ed. Alyson Stein (New York: Ursus Press, 1993), 275–77.

58 "Dreyfus at Last Gets Vindication," *Appeal* (St. Paul, MN), October 23, 1915. Many articles about and references to the Dreyfus affair appeared in the African American press between 1894 and 1915. A particularly large number were published around 1906, when parallels were drawn between the Dreyfus case and the Brownsville incident, in which members of the US Army's black Twenty-Fifth Infantry Regiment were framed, unjustly convicted, and dishonorably discharged for their supposed involvement in a shooting in Brownsville, Texas. See, for example, "How Should the Negroes Vote?," *Broad Axe* (Chicago, IL), October 3, 1908: "These soldiers have been as greatly outraged as was Captain Dreyfus of France, because he was a Jew."

59 Bruce, *Henry Ossawa Tanner*, 111–12; Mosby and Sewell, *Henry Ossawa Tanner*, 94; Harper, "The Early Religious Paintings of Henry Ossawa Tanner," 72; Schwain, *Signs of Grace*, 55. For an extended discussion of Tanner's *Daniel in the Lion's Den* and its biblical source, see Bruce, *Henry Ossawa Tanner*, 107–11.

60 Marcus Bruce writes movingly about the role of domesticity in Tanner's religious works in "A New Testament," in Marley, *Henry Ossawa Tanner*, 109–26.

61 Helen Cole, "Henry O. Tanner, Painter," *Brush and Pencil* 6, no. 3 (June 1900): 101.

62 "The Academy's Annual Show Paintings and Sculpture in the Broad Street Gallery—A Notable Display," *Philadelphia Inquirer*, January 15, 1899.

63 "Annual Meeting of the National Association," *Broad Axe* (Chicago, IL), February 1, 1913; Bruce, *Henry Ossawa Tanner*, 152.

CHAPTER 3

1 Samuels, *Culture of Sentiment*, 4. An earlier version of this chapter was published in *The Cultured Canvas: New Perspectives on American Landscape Painting*, ed. Nancy Siegel (Durham: University of New Hampshire Press, 2011), 85–114.

2 Andrew Jackson Downing, *The Architecture of Country Houses* (1850) (New York: Dover Publications, 1969), xx. The most essential sources for the study of Downing's ideas are his own writings, especially *The Architecture of Country Houses*; *A Treatise on the Theory and Practice of Landscape Gardening, Adapted to North America* (New York: Wiley & Putnam, 1841); *Cottage Residences* (New York: Wiley & Putnam, 1842); and his editorials for the *Horticulturist*, most of which were collected in *Rural Essays* (1853), University of Michigan Historical Reprint Series (New York: George A. Leavitt, 1969). Important secondary sources include Clifford Edward Clark, Jr., *The American Family Home, 1800–1960* (Chapel Hill: University of North Carolina Press, 1986); John Conron, "The American Dream Houses of Andrew Jackson Downing," *Canadian Review of American Studies* 18 (1987): 9–40; Arthur Channing Downs, *Downing and the American House* (Newton Square, PA: Downing & Vaux Society, 1988); David P. Handlin, *The American Home: Architecture and Society, 1815–1915* (Boston: Little, Brown and Company, 1979); Rochelle L. Johnson, *Passions for Nature: Nineteenth-Century America's Aesthetics of Alienation* (Athens: University of Georgia Press, 2009); Judith K. Major, *To Live in the New World: A. J. Downing and American Landscape Gardening* (Cambridge, MA: MIT Press, 1997); David Schuyler, *Apostle of Taste: Andrew Jackson Downing, 1815–1852* (Baltimore: Johns Hopkins University Press, 1996); Adam W. Sweeting, *Reading Houses and Building Books: Andrew Jackson Downing and the Architecture of Popular Antebellum Literature, 1835–1855* (Hanover, NH: University Press of New England, 1996); George B. Tatum and Elisabeth Blair MacDougall, eds., *Prophet with Honor: The Career of Andrew Jackson Downing, 1815–1852* (Washington, DC: Dumbarton Oaks, 1989).

3 For versions of this account, see Reddy, *The Navigation of Feeling*; Denby, *Sentimental Narrative and the Social Order in France*.

4 Downing, *Rural Essays*, 304.

5 See, for example, Nina Baym, *Woman's Fiction: A Guide to Novels by and about Women in America, 1820–1870* (Ithaca, NY: Cornell University Press, 1978); Lora Romero, *Home Fronts: Domesticity and Its Critics in the Antebellum United States* (Durham, NC: Duke University Press, 1997); Mary P. Ryan,

The Empire of the Mother: American Writing about Domesticity, 1830–1860 (New York: Harrington Park, 1985); Tompkins, *Sensational Designs*.

6 See, for example, Chapman and Hendler, *Sentimental Men*; Cathy N. Davidson and Jessamyn Hatcher, eds., *No More Separate Spheres!* (Durham, NC: Duke University Press, 2002); Milette Shamir and Jennifer Travis, eds., *Boys Don't Cry? Rethinking Narratives of Masculinity and Emotion in the U.S.* (New York: Columbia University Press, 2002).

7 Washington Irving, "The Legend of Sleepy Hollow," in *The Sketch Book of Geoffrey Crayon, Gent.* (New York: George P. Putnam, 1848); the book was first published in paperbound installments with this story appearing in the sixth installment of March 1820. Downing was both an acquaintance and a great admirer of Irving. He mentions Irving numerous times in his writings, and includes a wood engraving and appreciative description of Irving's home, Sunnyside, in his *Landscape Gardening*. In his discussion of Sunnyside, Downing notes that it was the model for the home of Baltus Van Tassel in "The Legend of Sleepy Hollow" and describes the tale as "delightfully told" (379). On Downing's relationship with Irving, see Sweeting, *Reading Houses and Building Books*, esp. 7–8, 133–39.

8 James F. W. Johnston, *Notes on North America: Agricultural, Economical, and Social*, 2 vols. (Edinburgh: William Blackwood, 1851), 1:162, quoted in Sarah Burns, *Pastoral Inventions: Rural Life in Nineteenth-Century American Art and Culture* (Philadelphia: Temple University Press, 1989), 51.

9 J. H. Hammond, *The Farmer's and Mechanic's Practical Architect* (Boston: John P. Jewett and Company, 1858), 27, quoted in Clark, *American Family Home*, 23.

10 Downing, *Rural Essays*, 294, 14.

11 Ibid., 15.

12 "Home expression" and "moral influence" are phrases that Downing uses repeatedly. He discusses his ideas about "home expression" at some length in "On the English Rural Cottage," *Horticulturist* 2 (August 1847): 66–67.

13 Downing, *A Treatise on the Theory and Practice of Landscape Gardening, Adapted to North America*, 5th ed. (New York: G.P. Putnam & Co., 1853), ix.

14 Downing, *Architecture of Country Houses*, 263. Although the quoted passages refer specifically to a villa for a "man of feeling," Downing makes very similar remarks about farmhouses, cottages, and other types of homes. See, for example, his *Cottage Residences*, 82.

15 In the more than two dozen British pattern books that I have read, I found only one passage comparable to Downing's in its sentimentalized references to the home. Edmund Bartell, in his *Hints for Picturesque Improvements in Ornamented Cottages* (London: J. Taylor, Architectural Library, 1804), writes: "Perhaps, of all situations, the romantic retirement of a rural cottage is likely to produce the highest and most refined relish for social happiness: 'True and social happiness,' says Zimmerman, 'resides only in the bosom of love, or in the arms of friendship; and can only be really enjoyed by congenial hearts and kindred minds in the domestic bowers of privacy and retirement'" (ix–x).

16 James Malton, *An Essay on British Cottage Architecture* (London: Hookham and Carpenter, 1798), 6–7.

17 See, for example, Bartell, *Hints for Picturesque Improvements*; Richard Elsam, *Hints for Improving the Condition of the Peasantry* (London: R. Ackerman, 1816); John Buonarotti Papworth, *Rural Residences*, 2nd ed. (London: R. Ackermann, 1832).

18 On such critiques of Downing's work, see Schuyler, *Apostle of Taste*, 72.

19 John C. Loudon, *An Encyclopedia of Cottage, Farm, and Villa Architecture and Furniture* (London: Longman, Rees, Orme, Brown, Green, & Longman, 1835), 1112–13.

20 On Downing's elitism, see Clark, *American Family Home*, 52; George William Curtis, "Memoir," in *Rural Essays*, xxix–xxxii.

21 A search for the word "home" in the online databases American Historical Newspapers and American Periodical Series for the period 1810–60 yields literally thousands of entries. I have read hundreds of poems, short stories, sermons, and essays on the subject of home, but will refrain from listing them here. A few examples of poems that depict the idealized home as a vine-covered rural cottage are "The Cotter's Home," in *The Amaranth; or Masonic Garland* 1 (June 1828): 85; "The Home of the Heart," in *Knickerbocker; or New York Monthly Magazine* 6 (November 1835): 400; "My Cottage Home," *Genesee Farmer and Gardener's Journal* 7 (April 22, 1837): 128. In Payne's song, the home is a thatched-roof cottage.

22 "The Horticultural Festival at Faneuil Hall, Boston," *Horticulturist* 3 (November 1848): 224–38.

23 Downing discusses the two images in "Rural Architecture—Suburban Cottages," *Horticulturist* 2 (December 1847): 272–73.

24 Downing, *Architecture of Country Houses*, 113.

25 Ibid., 49–52. Downing considered board and batten construction more truthful because it visually expressed the vertical orientation of the main timbers of the house.

26 Downing, *Cottage Residences*, 14, and "Rural Architecture—Suburban Cottages," 273.

27 Downing, *Cottage Residences*, 12, and *Landscape Gardening*, 374.

28 Downing illustrates and discusses this pair of images in *Architecture of Country Houses*, 78–81.

29 Downing, "Letters from England," *Rural Essays*, 514.

30 Downing, *Architecture of Country Houses*, 79.

31 Downing, "On the Drapery of Cottages and Gardens," in *Rural Essays*, 90.

32 Downing, *Architecture of Country Houses*, 79.

33 Downing, "On the Drapery of Cottages and Gardens," 89.

34 Downing, *Cottage Residences*, 82.

35 Downing, "Trees in Towns and Villages," in *Rural Essays*, 304.

36 "Major Patrick's Address before the Jefferson County Agricultural Society," approvingly quoted by Downing in "The Home Education of the Rural Districts," in *Rural Essays*, 399–403.

37 Gervase Wheeler, *Homes for the People in Suburb and Country: The Villa, the Mansion, and the Cottage* (1855) (New York: Arno Press, 1972), 302.

38 John Locke, *Some Thoughts Concerning Education and Of the Conduct of the Understanding* (1693), ed. Ruth W. Grant and Nathan Tarcov (Indianapolis: Hackett, 1996), 10. On Locke's impact on American ideas about childhood and family, see Jay Fliegelman, *Prodigals and Pilgrims: The American Revolution against Patriarchal Authority, 1750–1800* (New York: Cambridge University Press, 1982).

39 [N. H. Eggleston], "Domestic Architecture," *New Englander* 9 (February 1851): 59.

40 A. J. Downing, "Rural Architecture: Design for Improving an Ordinary Country House," *Horticulturist* 1 (July 1846): 14.

41 [Eggleston], "Domestic Architecture," 59.

42 Wheeler, *Homes for the People*, 331.

43 [Eggleston], "Domestic Architecture," 60.

44 Downing, "Hints to Rural Improvers," in *Rural Essays*, 111.

45 Downing, *Architecture of Country Houses*, 258.

46 Downing, "A Chapter on Agricultural Schools," in *Rural Essays*, 410.

47 "Landscape Gardening and Rural Architecture in America," *United States Magazine and Democratic Review*, n.s., 16 (April 1845): 348–64.

48 A. J. Downing, "On the Color of Country Houses," *Horticulturist* 1 (May 1847): 491.

49 Pope's words are from his *Epistle to Lord Burlington* (1731). Pope's ideas about landscape gardening were well known to Downing, who discusses and quotes Pope in his *Landscape Gardening* (1841), 16, 50. See Major, *To Live in the New World*, 40–42.

50 Downing, "The Improvement of Country Villages," in *Rural Essays*, 230.

51 Some might expect to see in this list Catherine Beecher's *Treatise on Domestic Economy* (1841) and *The American Woman's Home* (1869), which she cowrote with her sister, Harriet Beecher Stowe, but these publications do not sentimentalize the home as Downing does, concentrating instead on professionalizing women's housework, setting it on a more scientific footing, and arranging the home more conveniently and healthfully.

52 On *Godey's Lady's Book*'s model house plans, see George L. Hersey, "*Godey's* Choice," *Journal of the Society of Architectural Historians* 18 (October 1959): 104–11.

53 I should qualify this by noting that, in the 1840s, the majority of the house designs reproduced in *Godey's* were borrowed from British publications such as those by John Claudius Loudon. The text is limited to straightforward descriptions of construction and room function. Although many of the designs present the projecting eaves and ornamental chimneys that were central to Downing's sentimental domestic architecture, no sentimentalist rationales are presented to shape the readers' understanding of the designs, as they are in Downing's publications.

54 "Home Education and Home Influence," *Ohio Cultivator* 8 (April 1, 1852): 107–8.

55 "An Ornamental Farm House," *Southern Planter* 4 (July 1844): 157–58.

56 Fredrika Bremer, *The Homes of the New World: Impressions of America*, trans. Mary Howitt, 2 vols. (New York: Harper & Brothers, 1854), 1:46, quoted in Schuyler, *Apostle of Taste*, 72.

CHAPTER 4

1 "Looking Ahead," *Providence* [RI] *Patriot*, December 13, 1834.

2 Barbara Novak, *American Painting of the Nineteenth Century* (New York: Praeger, 1969), 138.

3 G. W., "Grave Yards," *Knickerbocker; or New York Monthly Magazine* 7, no. 4 (April 1836): 373; "Burial-Grounds," *Cincinnati Mirror, and Western Gazette of Literature, Science, and the Arts* 5, no. 2 (February 6, 1836): 9.

4 Joseph Story, "Address at the Consecration of Mount Auburn," in *The Picturesque Pocket Companion and Visitor's Guide through Mount Auburn* (Boston: Otis, Broaders and Company, 1839), 69. Here Story translates "cemetery" as "places of repose."

5 T. F., "Reminiscences of a Recent Journey from Cincinnati to

Boston," *Knickerbocker; or New York Monthly Magazine* 2, no. 4 (October 1833): 242.

6 Blanche M.G. Linden, *Silent City on a Hill: Picturesque Land-scapes of Memory and Boston's Mount Auburn Cemetery* (1989) (Boston: University of Massachusetts Press, 2007), 150.

7 "Church-Yard Sketches," in *Picturesque Pocket Companion*, 194.

8 Story, "Address," 72.

9 Ibid., 69.

10 "Mount Auburn: Article VIII," *American Quarterly Observer* 3, no. 5 (July 1, 1834): 149.

11 Story, "Address," 34.

12 John Pierpont, "The Grave and the Tomb," in *Picturesque Pocket Companion*, 219.

13 A.J. Downing, "Public Cemeteries and Public Gardens" (1849), in *Rural Essays*, 155.

14 Review of *Greenwood Illustrated*, in *Horticulturist* 1, no. 5 (November 1846): 228. Downing was the editor of this journal and wrote most of its content.

15 On nostalgia, see Svetlana Boym, *The Future of Nostalgia* (New York: Basic, 2001); Barbara Cassin, *Nostalgia: When Are We Ever at Home?*, trans. Pascale-Anne Brault (New York: Ford-ham University Press, 2016); Fred Davis, *Yearning for Yesterday: A Sociology of Nostalgia* (New York: Free Press, 1979); Helmut Illbruck, *Nostalgia: Origins and Ends of an Unenlightened Disease* (Evanston, IL: Northwestern University Press, 2012); Christopher Lasch, "The Politics of Nostalgia," *Harper's* 269, no. 1614 (November 1984): 65–70; Constantine Sedikides, Tim Wild-schut, and Denise Baden, "Nostalgia: Conceptual Issues and Existential Functions," in *Handbook of Experimental Existential Psychology* (New York: Guildford, 2004): 200–214; John J. Su, *Ethics and Nostalgia in the Contemporary Novel* (New York: Cambridge University Press, 2005); Stuart Tannock, "Nostalgia Critique," *Cultural Studies* 9 (October 1995): 453–64.

16 "Sanitary Memoirs of the War," U.S. Sanitary Commission, New York, 1867; David Anderson, "Dying of Nostalgia: Home-sickness in the Union Army during the Civil War," *Civil War History* 56, no. 3 (2010): 247–82.

17 Boym, *Future of Nostalgia*, 8.

18 Rosaldo, "Imperialist Nostalgia." Rosaldo refers to "the senti-mental discourse I have called imperialist nostalgia."

19 Constantine Sedikides, Tim Wildschut, Jamie Arndt, and Clay Routledge, "Nostalgia: Past, Present, and Future," *Current Direc-tions in Psychological Science* 17, no. 5 (October 2008): 304–7; Wing-Yee Cheung, "Back to the Future: Nostalgia Increases

Optimism," *Personality and Social Psychology Bulletin* 39 (Novem-ber 1, 2013): 1484–96.

20 Davis, *Yearning for Yesterday*; Tannock, "Nostalgia Critique." One might not expect the Marxist literary critic Fredric Jameson to rise to the defense of nostalgia, but he has. Fascists, he makes clear, deployed it for their nefarious ends, but in the hands of others, such as Walter Benjamin, it could provide a stimulus to Marxist revolution. Fredric Jameson, "Walter Benjamin, or Nostalgia," *Salmagundi*, no. 10/11 (Fall 1969–Winter 1970): 52–68.

21 Samuel Osgood, "Our Artists," *Harper's New Monthly Maga-zine* 28 (January 1864): 242–43.

22 Joshua Bates to Thomas Cole, October 17, 1839. Thomas Cole Papers, Archives of American Art, Smithsonian Institution, Washington, DC, microfilm reel ALC2.

23 Mark Skinner to Asher Durand, November 1, 1854, quoted in David B. Lawall, *Asher B. Durand: A Documentary Catalogue of the Narrative and Landscape Paintings* (New York: Garland Publishing, 1978), 104.

24 Manchester (VT) Historical Society, *Manchester* (Charleston, SC: Arcadia, 2011), 209. The entry on Mark Skinner notes that his "Americana collection was destroyed in the great Chicago fire."

25 Pierre Nora, "Between Memory and History: *Les Lieux de Mémoire*," *Representations* 26 (Spring 1989): 7–24.

26 Quoted in David B. Lawall, *Asher Brown Durand: His Art and Art Theory in Relation to His Times* (New York: Garland Publishing, 1977), 499–500.

27 "Letters on Landscape Painting. Letter IV," *Crayon* 1 (Febru-ary 14, 1855): 98.

28 *New-York Daily Times*, March 31, 1854, quoted in Lawall, *Asher B. Durand*, 99.

29 "Letters on Landscape Painting. Letter IV," *Crayon* 1 (Febru-ary 14, 1855): 98.

30 On Cole's lamentations over the passing of wilderness, see Alan Wallach, "Thomas Cole's 'River in the Catskills' as Antipasto-ral," *Art Bulletin* 84, no. 2 (2002): 334–50.

31 Angela Miller, "The Fate of Wilderness in American Land-scape Painting," in *A Keener Perception: Ecocritical Studies in American Art History*, ed. Alan Braddock and Christoph Irmscher (Tuscaloosa: University of Alabama Press, 2009), 98.

32 John Wylie, *Landscape* (London: Routledge, 2007), 30.

33 For an example of this, see "The Fine Arts: Pictures in New York—The Fifty-Eighth Exhibition of the National Acad-

emy of Design," *Boston Evening Journal*, April 11, 1883.

34 "Art in Boston," *Art Amateur: A Monthly Journal Devoted to Art in the Household* 16, no. 1 (December 1886): 3.

35 "Art Notes," *Philadelphia Inquirer*, November 25, 1894.

36 "Editor's Table," *Appletons' Journal* 6 (May 1879): 469.

37 Important recent writings on Inness include Adrienne Baxter Bell, *George Inness and the Visionary Landscape* (New York: George Braziller, 2003); Nicolai Cikovsky, Jr., *George Inness* (New York: Harry N. Abrams, 1993); Nicolai Cikovsky, Jr., and Michael Quick, *George Inness* (Los Angeles: Los Angeles County Museum of Art, 1985); Rachael Z. DeLue, *George Inness and the Science of Landscape* (Chicago: University of Chicago Press, 2004); Michael Quick, *George Inness: A Catalogue Raisonné*, 2 vols. (New Brunswick, NJ: Rutgers University Press, 2007); Marc Simpson, *Like Breath on Glass: Whistler, Inness, and the Art of Painting Softly* (New Haven, CT: Yale University Press, 2008).

38 Samuel Isham, *The History of American Painting* (New York: Macmillan, 1905), 475.

39 "Fine Arts: Annual Exhibition at the Athenaeum," *Boston Daily Advertiser*, May 5, 1860.

40 "A Painter on Painting," *Harper's New Monthly Magazine*, February 1878, in *George Inness: Writings and Reflections on Art and Philosophy*, ed. Adrienne Baxter Bell (New York: George Braziller, 2006), 60.

41 E., "Mr. Inness on Art-Matters," *Art Journal* (1879), in Bell, *George Inness: Writings and Reflections*, 79.

42 On Inness and Swedenborg, see DeLue, *George Inness and the Science of Landscape*; Bell, *George Inness and the Visionary Landscape*; Sally M. Promey, "The Ribband of Faith: George Inness, Color Theory, and the Swedenborgian Church," *American Art Journal* 26, no. 1/2 (1994): 45–65; Robert Jolly, "George Inness's Swedenborgian Dimension," *Southeastern College Art Conference Review* 11 (1986): 14–22; Michael Quick, "George Inness: The Spiritual Dimension," in *George Inness: Presence of the Unseen* (Montclair, NJ: Montclair Art Museum, 1994), 29–32. Swedenborg expressed his ideas about God as love in *Vera Christiana Religio* (Amsterdam, 1771), chap. 1, trans. from the Latin as *The True Christian Religion*, http://www.swedenborg digitallibrary.org/contets/tcrtc.html.

43 E., "Mr. Inness on Art-Matters," *Art Journal* (1879), in Bell, *George Inness: Writings and Reflections*, 79.

44 Inness to the critic Ripley Hitchcock, 1884, quoted in DeLue, *George Inness and the Science of Landscape*, 22.

45 "A Painter on Painting," *Harper's New Monthly Magazine*, February 1878, in Bell, *George Inness: Writings and Reflections*, 67–68.

46 John C. Van Dyke, "George Inness," *Outlook* (1903), in *Masters in Art: A Series of Illustrated Monographs* (Boston: Bates & Guild, 1908), 247.

47 Wanda Corn, "The Color of Mood: American Tonalism, 1880–1910," in Simpson, *Like Breath on Glass*, 229.

CHAPTER 5

1 Lloyd Goodrich, *Winslow Homer* (New York: George Braziller, 1959), 15; Craven, *American Art*, 336; Randall C. Griffin, *Winslow Homer: An American Vision* (New York: Phaidon, 2006), 171. As these citations indicate, many of the best and most insightful scholars of Homer's art have taken this stance, and I am greatly indebted to their work.

2 Lloyd Goodrich, *Winslow Homer* (New York: Macmillan for the Whitney Museum of American Art, 1944), 202.

3 "Local Items," *Albany* [NY] *Evening Journal*, December 1, 1853. It might at first seem ironic that Hawthorne would be included in a lecture on sentimentalism, since he bitterly complained about the undue attention that sentimental women writers received. But literary scholars have for some time been exploring Hawthorne's complex relationship with the sentimental. See, for example, Emily Miller Budick, *Women Writers and the Hawthorne Tradition, 1850–1900* (New Haven, CT: Yale University Press, 1994).

4 "Songs for the Campaign: Scott and Graham Songster," *Albany* [NY] *Evening Journal*, August 26, 1852.

5 Advertisement for a new journal, the *Garland*, in *Portland* [ME] *Advertiser*, March 26, 1825; "Ellen Louise Chandler," *Liberator* (Boston, MA), May 26, 1854; "Practical Sermon for Christmas," *Boston Courier*, December 22, 1859.

6 "Matrimonial Hoax at Loads," *Albany* [NY] *Journal*, October 21, 1852.

7 Lionel [pseud.], "The Artists' Fund Society, Fourth Annual Exhibition," *New Path* 1, no. 8 (December 1863): 95, quoted in Marc Simpson, *Winslow Homer: Paintings of the Civil War* (San Francisco: Fine Arts Museums of San Francisco, 1988), 147.

8 [George William Curtis], "The Lounger: The National Academy of Design," *Harper's Weekly* 7 (May 2, 1863): 274, quoted in Simpson, *Winslow Homer*, 140.

9 Multiple times, Homer opened an avenue of connection to his pictures through titles that mustered memories of well-known

songs. Other examples include *Uncle Ned*, which referenced a Steven Foster song, and *Summer Night*, which Homer originally titled *Buffalo Girls*. The title of a watercolor of a boy in a pumpkin patch, *For to Be a Farmer's Boy*, 1887 (Art Institute of Chicago), alluded to "an old song," a critic noted in "The Gallery," *Art Amateur* 18, no. 4 (March 1888): 82.

10 "National Academy of Design," *Evening Post* (New York, NY), June 12, 1863, quoted in Simpson, *Winslow Homer*, 147.

11 Goodrich, *Winslow Homer* (1944), 19; Lloyd Goodrich and Abigail Booth Gerdts, *Record of Works by Winslow Homer*, vol. 1, *1846 through 1866* (New York: Spanierman Gallery, 2005), 226–28.

12 Homer to O'Brien and Son, October 23, 1893, quoted in Kevin M. Murphy, "Winslow Homer as Entrepreneur," *Winterthur Portfolio* 37, no. 2/3 (Summer/Autumn 2002): 147. This article offers an excellent discussion of Homer's businesslike approach to his art.

13 Homer to M. Knoedler and Company, December 1900. Winslow Homer letters to M. Knoedler and Company, 1900–1904, Archives of American Art, Smithsonian Institution, Washington, DC. The identification of *The Fisher Girl* as the painting referred to in the letter as *Fog* comes from Phillip C. Beam, *Winslow Homer at Prout's Neck* (Boston: Little Brown, 1966), 117.

14 Lloyd Goodrich and Abigail Booth Gerdts, *Record of Works by Winslow Homer*, vol. 5, *1890 through 1910* (New York: Goodrich-Homer Art Education Project, 2014), 180.

15 William Howe Downes, *The Life and Works of Winslow Homer* (New York: Houghton Mifflin, 1911), 29.

16 See M. D. Conway, "Edouard Frère, and Sympathetic Art in France," *Harper's New Monthly Magazine* 43 (November 1871): 801–15; John Ruskin, "Cestus of Aglaia and The Queen of the Air," in *The Complete Works of John Ruskin*, ed. E. T. Cook and Alexander Wedderburn, 39 vols. (London: George Allen, 1905), 19:199–200, 270.

17 Conway, "Edouard Frère, and Sympathetic Art in France," 807.

18 "Art Matters in Boston," *Evening Post* (New York, NY), August 7, 1858.

19 Glenn Hendler, "Bloated Bodies and Sober Sentiments: Masculinity in 1840s Temperance Narratives," in Chapman and Hendler, *Sentimental Men*, 127.

20 Samuels, *Culture of Sentiment*, 6.

21 Festa, *Sentimental Figures of Empire*; Wexler, "Tender Violence," in Samuels, *Culture of Sentiment*, 9–38.

22 Festa, *Sentimental Figures of Empire*, 8.

23 Important work on Homer's African American subjects include Jo-Ann Morgan, "Winslow Homer Visits Aunt Chloe's Old Kentucky Home," *Southeastern College Art Conference Review* 14, no. 5 (December 2005): 439–51, in which the author argues that Homer's Reconstruction images of African Americans "are complicit in re-enforcing post-war views of racial relationships by re-inscribing prewar social hierarchies" (441). Paul Staiti, in "Winslow Homer and the Drama of Thermodynamics," *American Art* 15, no. 1 (2001): 11–33, writes that "it would be a mistake to think of [Homer] sharing the felt experience of African Americans. . . . For all his heartfelt sympathy and compassion, and moral engagement with African-American culture, Homer nonetheless believed in racial difference" (24, 26). See also David Park Curry, "Winslow Homer: Dressing for the Carnival," *Studies in the History of Art* 26 (1990): 90–113; Kenneth Haltman, "Antipastoralism in Early Winslow Homer," *Art Bulletin* 80, no. 1 (1998): 93–112; Peter H. Wood and Karen C. C. Dalton, *Winslow Homer's Images of Blacks: The Civil War and Reconstruction Years* (Austin: University of Texas Press for the Menil Collection, 1988); Peter H. Wood, *Weathering the Storm: Inside Winslow Homer's Gulf Stream* (Athens: University of Georgia Press, 2004); Peter H. Wood, *Near Andersonville: Winslow Homer's Civil War* (Cambridge, MA: Harvard University Press, 2010).

24 On Homer's relation to Millet, see Erica E. Hirshler, "North Atlantic Drift: A Meditation on Winslow Homer and French Painting," in *Weatherbeaten: Winslow Homer and Maine*, ed. Thomas A. Denenberg (New Haven, CT: Yale University Press, 2012), 71–83; Henry Adams, "Winslow Homer's 'Impressionism' and Its Relation to His Trip to France," in *Winslow Homer: A Symposium, Studies in the History of Art* 26 (Washington, DC: National Gallery of Art, 1990), 61–89.

25 On Homer's relation with La Farge, see Adams, "Winslow Homer's 'Impressionism' and Its Relation to His Trip to France," 73. For La Farge's views on Homer and Millet, see John La Farge, *The Higher Life in Art: A Series of Lectures on the Barbizon School of France* (New York: McClure Co., 1908), 171, 68, 72, 90.

26 On Hunt's Mercantile Building studio and his receptions there, see Martha A. S. Shannon, *The Boston Days of William Morris Hunt* (Boston: Marshall Jones, 1923), 64.

27 On Homer's relationship with Johnson, and on the relationship of both to Frère, see Sarah Burns, "In Whose Shadow? Eastman Johnson and Winslow Homer in the Postwar Decades," in *Eastman Johnson Painting America*, ed. Teresa A. Carbone

and Patricia Hills (Brooklyn Museum of Art in association with Rizzoli International Publications, 1999), 185–213, esp. 192.

28 Henry T. Tuckerman compares Benson's *Fireside Reveries* to Frère in *Book of the Artists* (New York: G. P. Putnam & Sons, 1867), 406. On Benson's work as a critic, see Robert J. Scholnick, "Between Realism and Romanticism: The Curious Career of Eugene Benson," *American Literary Realism* 14, no. 2 (Autumn 1981): 242–61.

29 For insight into Benson's reference to Charlotte Brontë, see Cree LeFavour, "'Jane Eyre' Fever: Deciphering the Astonishing Popular Success of Charlotte Brontë in Antebellum America," *Book History* 7 (2004): 113–41, which discusses the sentimental circuitry that bound readers to both the author and her main character.

30 Pictor Ignotus [Eugene Benson], "Art in Boston," *Round Table* 2, no. 28 (June 25, 1864): 26.

31 Nicolai Cikovsky, Jr., and Franklin Kelly, *Winslow Homer* (New Haven, CT: Yale University Press, 1995), 54.

32 On nineteenth-century wheat farming in New York State, see Andrea K. Zimmerman, "Nineteenth Century Wheat Production in Four New York State Regions: A Comparative Examination," *Hudson Valley Regional Review* 5, no. 2 (September 1988): 49–61.

33 On *The Veteran in a New Field*, see Christopher Kent Wilson, "Winslow Homer's *The Veteran in a New Field:* A Study of the Harvest Metaphor and Popular Culture," *American Art Journal* 17, no. 4 (Autumn 1985): 2–27; Eleanor Jones Harvey, *The Civil War and American Art* (Washington, DC: Smithsonian American Art Museum in association with Yale University Press, 2012), 225–29. *The Veteran in a New Field* reminded Eugene Benson of Millet's work in its "large, simple, and expressive style." See Cikovsky and Kelly, *Winslow Homer*, 28.

34 Civil War historian J. David Hacker argues that the traditional estimate of 620,000 dead should be raised to 750,000; see his "A Census-Based Count of the Civil War Dead," *Civil War History* 57, no. 4 (December 2011): 307–48.

35 "The Academy Exhibition: Second Article," *New York Leader* 10, no. 18 (April 30, 1864): 1, quoted in Simpson, *Winslow Homer*, 172.

36 See Drew Gilpin Faust, *This Republic of Suffering: Death and the American Civil War* (New York: Alfred A. Knopf, 2008).

37 "Editor's Table," *Appletons' Journal* 4 (February 1878): 195, quoted in Margaret C. Conrads, *Winslow Homer and the Critics: Forging a National Art in the 1870s* (Princeton, NJ: Princeton University Press, 2001), 136. Conrads offers an excellent discussion of

American art criticism in the 1870s, especially as it relates to Homer's work.

38 Conrads, *Winslow Homer and the Critics*, 40.

39 "School-Children," *Aldine* 5 (October 1872): 133, quoted in Conrads, *Winslow Homer and the Critics*, 40.

40 Claire Perry, *Young America: Childhood in 19th-Century Art and Culture* (New Haven, CT: Yale University Press, 2006), 182–83. Nicolai Cikovsky also discusses the nostalgic appeal of Homer's schoolhouse paintings in "Winslow Homer's School Time: 'A Picture Thoroughly National,'" in *In Honor of Paul Mellon, Collector and Benefactor: Essays*, ed. John Wilmerding (Washington, DC: National Gallery of Art, 1986), 46–67.

41 Boym, *Future of Nostalgia*, 8.

42 "The Arts: The Academy Exhibition," *Appletons' Journal* 15 (April 22, 1876): 539.

43 "The Fine Arts. Fifty-First Annual Exhibition of the National Academy of Design," *New York Tribune*, April 1, 1876, quoted in Conrads, *Winslow Homer and the Critics*, 95–96.

44 Allen Weller, "Winslow Homer's Early Illustrations," *American Magazine of Art* 28, no. 7 (1935): 412–48.

45 Burns, "In Whose Shadow?," 185, 188.

46 "Sketches and Studies," *Art Journal*, n.s., 6 (1880): 108.

47 Clarence Cook, "The Fine Arts. The National Academy of Design. Fiftieth Annual Exhibition. Third Notice," *New York Tribune*, April 29, 1875, quoted in Margaret C. Conrads, "'In the Midst of an Era of Revolution': The New York Art Press and the Annual Exhibitions of the National Academy of Design in the 1870s," in *Rave Reviews: American Art and Its Critics*, ed. David Dearinger (New York: National Academy of Design, 2000), 93.

48 William Dean Howells, *The Rise of Silas Lapham* (Boston: Ticknor, 1885), 277–79.

49 Kenyon Cox, "Winslow Homer," *Metropolitan Museum of Art Bulletin* 5, no. 11 (November 1910): 255.

50 Hartmann, *History of American Art*, 1:193–94.

51 Caffin, *Story of American Painting*, 832; Frank Jewett Mather, *Modern Painting* (1927), quoted in Bruce Robertson, *Reckoning with Winslow Homer: His Late Paintings and Their Influence* (Cleveland, OH: Cleveland Museum of Art in cooperation with Indiana University Press, Bloomington, 1990), 50.

52 Much recent scholarship on Homer has drawn out his receptivity to artistic sources ranging from Currier and Ives prints to Japanese ink painting. See, for example, John Wilmerding, "Winslow Homer's *Right and Left*," *Studies in the History of*

Art 9 (1980): 59−85; Judith Walsh, "Innovation in Homer's Late Watercolors," in Cikovsky and Kelly, *Winslow Homer*, 283−99, on his debt to Japanese art.

53 See Ronald G. Pisano, *The Tile Club and the Aesthetic Movement in America* (New York: Harry N. Abrams, 1999).

54 John W. Beatty, "Recollections of an Intimate Friendship," in Goodrich, *Winslow Homer* (1944), 213.

55 The purchase of *La Curée* by the Allston Club, in Boston, under the presidency of William Morris Hunt, generated considerable press in both Boston and New York. See, for example, "Paris," *New-York Tribune*, June 11, 1866.

56 "The Fine Arts," *Boston Daily Advertiser*, December 2, 1886.

57 On Homer's preference for a wagon, see Beam, *Winslow Homer at Prout's Neck*, 233; on the telephone, see Goodrich, *Winslow Homer* (1944), 218.

58 Homer to M. Knoedler, quoted in Goodrich, *Winslow Homer* (1944), 109.

59 "The Wane of the Adirondacks," *Forest and Stream* 37, no. 6 (August 27, 1891): 101. On Homer's Adirondack paintings, see Theodore E. Stebbins, Jr., "Winslow Homer: Time in the Adirondacks," in *Winslow Homer: Artist and Angler*, ed. Patricia Junker with Sarah Burns (New York: Thames and Hudson, 2002), 95−123; David Tatham, *Winslow Homer in the Adirondacks* (Syracuse, NY: Syracuse University Press, 1996).

60 Helen A. Cooper, *Winslow Homer Watercolors* (New Haven, CT: Yale University Press, 1986), 190. Cooper said this of another Adirondack painting, *The Pioneer*, 1900, but the words seem equally applicable to *Old Friends*.

61 "Fine Arts," *Independent*, December 23, 1886, quoted in Cikovsky and Kelly, *Winslow Homer*, 230; unidentified newspaper clipping from the scrapbook of Homer's reviews held by Bowdoin College, quoted in Cikovsky and Kelly, *Winslow Homer*, 266.

62 Downes, *Life and Works of Winslow Homer*, 142.

63 David Marshall, *The Surprising Effects of Sympathy: Marivaux, Diderot, Rousseau, and Mary Shelley* (Chicago: University of Chicago Press, 1988), 3.

64 Simpson, *Winslow Homer*, 181.

65 Winslow Homer to Arthur Homer, November 19, 1909, quoted in Cikovsky and Kelly, *Winslow Homer*, 406.

66 On *Driftwood*, see Henry Adams, "Mortal Themes: Winslow Homer," *Art in America* 71 (February 1983): 112−26; Griffin, *Winslow Homer*, 215; Elizabeth Johns, *Winslow Homer: The Nature of Observation* (Berkeley: University of California Press, 2002), 163, 166; Robertson, *Reckoning with Winslow Homer*,

41−42; Theodore E. Stebbins, Jr., "*Driftwood*: Winslow Homer's Final Painting," *Magazine Antiques* 150 (July 1996): 70−79.

67 Downes, *Life and Works of Winslow Homer*, 248.

68 Beam, *Winslow Homer at Prout's Neck*, 254. For more on Homer's cottage at Kettle Cove, see Kenyon C. Bolton III, "'The Right Place': Winslow Homer and the Development of Prout's Neck," in Denenberg, *Weatherbeaten*, 29−47.

CHAPTER 6

1 Charles *Baudelaire*, "On M. Ary Scheffer and the *Apes of Sentiment*," in *Art in Paris, 1845−1862*, ed. and trans. Jonathan Mayne (London: Phaidon, 1965), 99. The only artist Baudelaire targets by name is Ary Scheffer (1795−1858), then an admired and popular painter of religious, literary, and genre subjects. The original French for my quotations is "les femmes esthétiques" and "Les singes du sentiment sont, en général, de mauvais artistes. S'il en était autrement, ils feraient autre chose que du sentiment."

2 Quoted in Moshe Barash, *Modern Theories of Art I: From Winckelmann to Baudelaire* (New York: New York University Press, 1990), 376.

3 Émile Zola, "The Experimental Novel" (1880), in *The Experimental Novel and Other Essays*, trans. Belle M. Sherman (New York: Cassell Publishing, 1893), 8.

4 For a succinct discussion of the French avant-garde's unification of realism and art for art's sake, see Charles Rosen and Henri Zerner, "Enemies of Realism," *New York Review of Books*, March 4, 1982.

5 James Abbott McNeill Whistler, "The Red Rag," in *The Gentle Art of Making Enemies* (London: William Heinemann, 1892), 128. Originally published in the *World*, May 22, 1878. The formalist dismissal of narrative and emotionality as legitimate artistic concerns would intensify and rigidify in the following decades. One of Paul Cézanne's champions, the British formalist critic Clive Bell, in his *Art* (1914), argued that art elicits "aesthetic emotion" through "significant form." He declared the "emotions of life" irrelevant to the appreciation of art, and a recourse to them a sign of feebleness on the part of an artist. This led him to pronounce Cimabue superior to Giotto, because the latter "is so dreadfully obsessed by the idea that the humanity of the mother and child is the important thing about them." Clive Bell, *Art* (New York: Frederick A. Stokes Co., 1914), 138.

6 Caffin, *Story of American Painting*, 373.

7 "St. Gauden's Riddle," *Boston Daily Globe*, August 11, 1907.

8 W[illiam] C[ary] Brownell, "The Younger Painters of America.

III," *Scribner's Monthly* 22 (July 1881): 321–35.

9 Quoted in Carter Ratcliff, *John Singer Sargent* (New York: Abbeville Press, 1982), 18.

10 Barbara Dayer Gallati, *Great Expectations: John Singer Sargent Painting Children* (Brooklyn, NY: Brooklyn Museum in association with Bulfinch Press, 2004), 65.

11 Frances K. Pohl, *Framing America: A Social History of American Art* (New York: Thames & Hudson, 2002), 299.

12 Lucia Miller, "John Singer Sargent in the Diaries of Lucia Fairchild," *Archives of American Art Journal* 26, no. 4 (1987): 5.

13 Mrs. Hugh [Mary Crawford] Fraser, *A Diplomatist's Wife in Many Lands*, 2 vols. (London, Hutchinson & Co., 1911), 1:143.

14 Evan Charteris, *John Sargent* (New York: Charles Scribner's Sons, 1927), 217.

15 R[oyal] C[ortissoz], "John S. Sargent: The Exhibition in Boston of His Portraits and Studies," *New York Tribune*, February 21, 1899.

16 Charles Aitken, "A Monthly Chronicle," *Burlington Magazine* 29 (August 1916): 219, quoted in Trevor J. Fairbrother, *John Singer Sargent and America* (New York: Garland Publishing, 1986), 380.

17 John Sargent to Vernon Lee, March 24, 1882, quoted in Richard Ormond, "John Singer Sargent and Vernon Lee," *Colby Quarterly* 9, no. 3 (1970): 171.

18 Quoted in Richard Ormond and Elaine Kilmurray, *John Singer Sargent: Complete Paintings*, vol. 1, *The Early Portraits* (New Haven, CT: Yale University Press, 1998), 185.

19 Miller, "Sargent in the Diaries of Lucia Fairchild," 9.

20 Vernon Lee [Violet Paget], "J.S.S. in Memoriam," in Charteris, *John Sargent*, 251.

21 Exhibition history from Ormond and Kilmurray, *John Singer Sargent*, vol. 1, *The Early Portraits*, 242.

22 Charles Bigot, writing for the *Gazette des Beaux-Arts* in 1883, quoted in Erica E. Hirshler, *Sargent's Daughters: The Biography of a Painting* (Boston: Museum of Fine Arts, Boston, 2009), 105. Hirshler's book offers an invaluable account of the painting's production and reception.

23 Unattributed review in the Brussels journal *L'Art Moderne*, quoted in Hirshler, *Sargent's Daughters*, 108.

24 Quoted in Hirshler, *Sargent's Daughters*, 108–10.

25 Philippe Burty, *Le Salon de 1883* (Paris: Librairie d'Art, 1883), 103–4, quoted in Hirshler, *Sargent's Daughters*, 107.

26 Susan Sidlauskas, *Body, Place, and Self in Nineteenth-Century Painting* (New York: Cambridge University Press, 2000), chap. 3.

27 On the vases and their history, see Hirshler, *Sargent's Daughters*, 81.

28 On issues of commodification in relation to impressionist paintings of children, see Greg Thomas, *Impressionist Children: Childhood, Family, and Modern Identity in French Art* (New Haven, CT: Yale University Press, 2010), chap. 2.

29 On Sargent and Velázquez, see Hirshler, *Sargent's Daughters*, esp. 85–89, and M. Elizabeth Boone, "Why Drag in Velázquez?: Realism, Aestheticism, and the Nineteenth-Century American Response to *Las Meninas*," in *Velázquez's "Las Meninas"*, ed. Suzanne L. Stratton-Pruitt (Cambridge, UK: Cambridge University Press, 2003), esp. 101–8.

30 While *Las Meninas* has invited multiple and divergent interpretations, this reading of the canvas—as representing the princess and her entourage appearing before the king and queen, whose portraits Velázquez is painting—was presented in the Museo del Prado collection catalogues from 1843 into the twentieth century. See Alisa Luxenberg, "The Aura of a Masterpiece," in Stratton-Pruitt, *Velázquez's" Las Meninas"*, 31.

31 On Sargent's visit with Cassatt on October 13, 1883, see Nancy Mowll Mathews, *Mary Cassatt: A Life* (New Haven, CT: Yale University Press, 1994), 171. On Morisot's recommendation, see Anne Higonnet, *Berthe Morisot* (Berkeley: University of California Press, 1995), 171–72.

32 Quoted in Charteris, *John Sargent*, 61–62.

33 Sargent to Edwin Russell, September 1885, quoted in Charles Merrill Mount, *John Singer Sargent: A Biography* (1955) (New York: W. W. Norton, 1969), 104.

34 For extended discussions of *Carnation, Lily, Lily, Rose* from its genesis through its reception, see Richard Ormond and Elaine Kilmurray, *John Singer Sargent: Complete Paintings*, vol. 5, *Figures and Landscapes, 1883–1899* (New Haven, CT: Yale University Press, 2010), 120–35, and Stanley Olson, Warren Adelson, and Richard Ormond, *Sargent at Broadway: The Impressionist Years* (London: John Murray, 1986).

35 Hirshler, *Sargent's Daughters*, 122.

36 On Sargent's visits with Henry James, see Gallati, *Great Expectations*, 84–85. According to the Tate Britain website entry for Joshua Reynolds, *The Age of Innocence*, ca. 1788, "In the nineteenth century it was deeply admired and frequently copied, National Gallery records revealing that between its acquisition [in 1847] and the end of the century no fewer than 323 full-scale copies in oil were made." This work is reproduced in the current volume as fig. 88.

37 Quoted in William Howe Downes, *John S. Sargent: His Life and Work* (Boston: Little, Brown, and Company, 1925), 140. Downes

also quotes Sir Claude Phillips offering a similar assessment in the *Gazette des Beaux-Arts*: "In the two delightful types of young girls he manifests a tenderness which he has not often shown us."

38 Quoted in Ormond and Kilmurray, *John Singer Sargent*, vol. 5, *Figures and Landscapes, 1883–1899*, 128.

39 Ibid., 130.

40 Charles H. Caffin, "John S. Sargent: The Greatest Contemporary Portrait Painter," *World's Work* 7 (November 1903): 409.

41 Michael Gormley, "John Singer Sargent: A World of Grace in Changing Times," *American Artist* 74, no. 810 (June 2010), http://www.artistdaily.com/american-artist-magazine/september-2010; *New York Times* review from 1888, quoted in Gary A. Reynolds, "Sargent's Late Portraits," in *John Singer Sargent*, ed. Patricia Hills (New York: Whitney Museum of American Art in association with Harry N. Abrams, 1987), 162.

42 Kenyon Cox, *Old Masters and New: Essays in Art Criticism* (New York: Fox, Duffield & Company, 1905), 264.

43 "Loan Portraits," *Worcester* [MA] *Daily Spy*, March 11, 1896.

44 Quoted in Richard Ormond and Elaine Kilmurray, *John Singer Sargent: Complete Paintings*, vol. 2, *Portraits of the 1890s* (New Haven, CT: Yale University Press for the Paul Mellon Centre for Studies in British Art, 2002), 63.

45 London *Times*, May 1, 1893, quoted in Ormond and Kilmurray, *John Singer Sargent*, vol. 2, *Portraits of the 1890s*, 63.

46 C[ortissoz], "John S. Sargent."

47 Christian Brinton, "Sargent and His Art," *Munsey's Magazine* 36, no. 3 (December 1906): 261.

48 Charles H. Caffin, *American Masters of Painting* (New York: Doubleday, Page & Company, 1902), 60. See also H.B., "London Letter," *Critic* 5 (May 22, 1886): 258–59: "He is apt to regard his sitters merely as combinations of light and color, or, if he takes an interest at all in their humanity, to be rather superior . . . and, it may be, a trifle unkind as well."

49 Evan Mills, "A Personal Sketch of Mr. Sargent," *World's Work* 7 (November 1903): 4117, quoted in Fairbrother, *John Singer Sargent and America*, 360.

50 Mary Newbold Patterson Hale, "The Sargent I Knew," in *World Today*, November 1927, reproduced in Ratcliff, *John Singer Sargent*, 237.

51 Quoted in Downes, *John S. Sargent*, 162.

52 [Mariana Griswold] van Rensselaer, "John S. Sargent," *Century Illustrated Magazine* 44 (March 1892), 798.

53 Mariana Griswold van Rensselaer, "Another Portrait by Sargent," *Harper's Weekly* 3, no. 1826 (December 19, 1891): 1012,

quoted in Ratcliff, *John Singer Sargent*, 124–25; van Rensselaer, "John S. Sargent."

54 Charteris, *John Sargent*, 109–10.

55 Quoted in ibid., 155.

56 Ibid., 215–16.

57 On the contemporary response, see Ratcliff, *John Singer Sargent*, 203.

58 Charteris, *John Sargent*, 214.

59 Sargent to Charteris, September 11, 1918, quoted in Charteris, *John Sargent*, 213.

60 Henry Tonks to Alfred Yockney, March 19, 1920, quoted in the entry for Sargent's *Gassed* on the Imperial War Museum website, http://www.iwm.org.uk/collections/item/object/23722.

61 Henry Tonks, quoted in Charteris, *John Sargent*, 212.

62 "Special Correspondence from the *London Times*, Sargent Holds Lead," *Washington Post*, June 1, 1919.

63 "Notes on Current Art," *New York Times*, June 8, 1919.

64 Virginia Woolf, "The Royal Academy," *Athenaeum* 4660 (1919): 774–76.

65 On assessments of Cassatt's personality, see Mathews, *Mary Cassatt*, esp. 68–70, 99, 101, 117.

66 On Cassatt's time in Écouen, see Mathews, *Mary Cassatt*, 44–46, and Nancy Mowll Mathews, *Cassatt and Her Circle: Selected Letters* (New York: Abbeville Press, 1984), 19–20, 43, 47, 62–63. On Frère's relationship with the Écouen colony of art students, see C.H. Stranahan, *A History of French Painting from Its Earliest to Its Latest Practice* (New York: Charles Scribner's Sons, 1907), 393.

67 Achille Segard, *Un peintre des enfants et des mères, Mary Cassatt* (Paris: P. Ollendorff, 1913), 8. The original French is: "J'acceptai avec joie. Enfin je pouvais travailler avec une indépendance absolue sans m'occuper de l'opinion éventuelle d'un jury! Déjà j'avais reconnu quels étaient mes véritables maîtres. J'admirais Manet, Courbet et Degas. Je haïssais l'art conventionnel. Je commençais à vivre."

68 William James, *The Principles of Psychology*, 2 vols. (New York: Henry Holt, 1890), 1:237, 226. On Cassatt's admiration for James, see Mary Cassatt to Theodate Pope, October 2 [1910], in Mathews, *Cassatt and Her Circle*, 300.

69 Brownell, "The Younger Painters of America. III."

70 "The Fine Arts, Miss Cassatt's Exhibition at the St. Botolph Club," *Boston Evening Transcript*, March 24, 1898.

71 William Walton, "Miss Mary Cassatt," *Scribner's Magazine* 19 (March 1896): 353–71, quotations from 354, 356.

72 Ibid., 356.

73 On Cassatt's mother-and-child subjects, see Pamela A. Ivinski, "Mary Cassatt, the Maternal Body, and Modern Connoisseurship" (PhD diss., City University of New York, 2003); Griselda Pollock, "Mary Cassatt: The Touch and the Gaze, or Impressionism for Thinking People," in *Women Impressionists*, ed. Ingrid Pfeiffer and Max Hollein (Frankfurt: Hatje Cantz, 2008), 154–67.

74 For an excellent discussion of this work and the critical response to it, see Ivinski, "Mary Cassatt, the Maternal Body, and Modern Connoisseurship," 15. Ivinski, in her psychoanalytic analysis of Cassatt's works, notes "that the sense of union between the figures is both comforting and overwhelming, suggesting the plenitude of the original bond with the mother and the difficulty of loosening it." Pamela A. Ivinski, "'So Firm and Powerful a Hand': Mary Cassatt's Techniques and Questions of Gender," in Pfeiffer and Hollein, *Women Impressionists*, 185.

75 Henry Tiranon, "Sixième Exposition de Peinture par un Groupe d'Artistes," *Le Constitutionnel*, April 24, 1881; Armand Silvestre, "Le Monde des arts: Sixième Exposition des Artistes Indépendents," *La Vie Moderne*, April 16, 1881, both quoted in and translated in Ivinski, "Mary Cassatt, the Maternal Body, and Modern Connoisseurship," 191.

76 G.L., "Expositions à Paris, Pastellistes Français, Peintres-Graveurs, Camille Pissarro, Mary Cassatt," *L'Art Moderne* (1891), translated and quoted in Ivinski, "Mary Cassatt, the Maternal Body, and Modern Connoisseurship," 312.

77 Ivinski, "Mary Cassatt, the Maternal Body, and Modern Connoisseurship," 254.

78 Katherine Cassatt to Alexander Cassatt, July 23, 1891, in Mathews, *Cassatt and Her Circle*, 222.

79 "Art Exhibitions. Opening of the Season—Paintings by Mary Cassatt and Louis Loeb," *New York Daily Tribune*, November 11, 1903; "The Cassatt Oils and Pastels, Ugly Women in Curious Gowns and Babies in No Gowns at All," *New York Times*, November 6, 1903, quoted in Ivinski, "Mary Cassatt, the Maternal Body, and Modern Connoisseurship," 276.

80 American critic writing from Paris to the *Chicago Post*, quoted in "The Most Eminent of Living American Women Painters," *Current Literature* 56, no. 2 (February 1909): 427.

81 "An American Woman's Unique Achievement in Modern Art," *Current Opinion* 62, no. 6 (June 1917): 426.

82 Elizabeth Anna Semple, "Mary Cassatt's Art," *Harper's Bazaar*, November 1911, 490.

83 Félix Fénéon, "Cassatt, Pissarro," in *Oeuvres plus que Complètes*, ed. Joan Halperin, vol. 1 (Geneva: Librairie Droz, 1970), quoted and translated into English in Ivinski, "Mary Cassatt, the Maternal Body, and Modern Connoisseurship," 323–24. The original French passage reads, "L'on n'est pas devant une scène . . . trop sentimentale," 324 n186.

84 Walton, "Miss Mary Cassatt," 358–59.

85 Ibid., 353.

86 On Cassatt's relationship with Vollard, see Jay E. Cantor et al., *Art in a Mirror: The Counterproofs of Mary Cassatt* (New York: Adelson Galleries, 2004).

87 Camille Pissarro to his son Lucien, April 3, 1891, in which he writes that Durand-Ruel attributed Monet's great success to "not shocking the collectors!" In another letter to Lucien, July 17, 1891, Pissarro reports, "Miss Cassatt says that Renoir, all of whose work he [Durand-Ruel] takes, is very annoyed and has to make pictures which please!" From John Rewald, *Camille Pissarro's Letters to His Son Lucien* (New York, Da Capo Press, 1995), 159, 181.

88 Anna Thorne, "My Afternoon with Mary Cassatt," *School Arts*, May 1960, 10–12.

EPILOGUE

1 Rexford Tugwell, director of the New Deal's Resettlement Agency, quoted in Maren Stange, *Symbols of Ideal Life: Social Documentary Photography in America, 1890–1950* (New York: Cambridge University Press, 1989), 129

2 Important sources on this painting include Donna M. Cassidy, *Marsden Hartley: Race, Region, and Nation* (Hanover, NH: University Press of New England, 2005), 228–34; Ilene Susan Fort, *Marsden Hartley: The German Paintings 1913–1915* (Los Angeles: Los Angeles County Museum of Art, 2014); Patricia McDonnell, "'Essentially Masculine': Marsden Hartley, Gay Identity, and the Wilhelmine German Military," *Art Journal* 56, no. 2 (Summer 1997): 62–68.

3 Ada Louise Huxtable, *Frank Lloyd Wright: A Life* (New York: Lipper/Viking, 2004), writes insightfully about the sentimental dimension of Wright's late work.

4 William H. Jordy, *American Buildings and Their Architects: Progressive and Academic Ideals at the Turn of the Century* (New York: Oxford University Press, 1972), 185.

5 Frank Lloyd Wright, *Frank Lloyd Wright: An Autobiography* (1943) (Petuluma, CA: Pomegranate Communications, 2005), 202, 60.

6 Quoted in Franklin Toker, *Fallingwater Rising: Frank Lloyd Wright, E. J. Kaufmann, and America's Most Extraordinary House*

(New York: Knopf, 2003), 134.

7 Quoted in Donald Hoffmann, *Frank Lloyd Wright's Falling-water: The House and Its History* (New York: Dover Publications, 1978), 92.

8 William Jenkins, *New Topographics: Photographs of a Man-Altered Landscape* (Rochester, NY: International Museum of Photography, 1975), 5.

9 While Jenkins's interpretation of the *New Topographics* work as detached and unsentimental has persisted to the present, many of the essays in Greg Foster-Rice and John Rohrbach, eds., *Reframing the New Topographics* (Chicago: University of Chicago Press, 2010), call attention to its empathic and ethical dimensions; see, esp., Toby Jurovics, "Same as It Ever Was: Re-reading *New Topographics*," and Finis Dunaway, "Beyond Wilderness: Robert Adams, *New Topographics*, and the Aesthetics of Ecological Citizenship."

10 Robert Adams, *Robert Adams: The Place We Live, A Retrospective Selection of Photographs 1964–2009*, 3 vols. (New Haven, CT: Yale University Press, 2010), 3:132.

11 Ibid., 2:208.

12 Robert Adams, interview (1994), quoted in Thomas Andrews, "On Robert Adams's New West Landscapes," *Environmental History* 16, no. 4 (2011): 710.

13 Adams, *Robert Adams*, 3:frontispiece.

14 Reddy, *The Navigation of Feeling*, 59.

SELECTED BIBLIOGRAPHY

Adams, Henry. "Mortal Themes: Winslow Homer." *Art in America* 71 (February 1983): 112–26.

———. "Winslow Homer's 'Impressionism' and Its Relation to His Trip to France." In *Winslow Homer: A Symposium*, Studies in the History of Art 26, 61–89. Washington, DC: National Gallery of Art, 1990.

Adams, Robert. *Robert Adams: The Place We Live, A Retrospective Selection of Photographs 1964–2009.* 3 vols. New Haven, CT: Yale University Press, 2010.

Anderson, Benedict. *Imagined Communities.* Rev. ed. New York: Verso, 1991.

Anderson, David. "Dying of Nostalgia: Homesickness in the Union Army during the Civil War." *Civil War History* 56, no. 3 (2010): 247–82.

Andrews, Thomas. "On Robert Adams's New West Landscapes." *Environmental History* 16, no. 4 (2011): 710.

Baker, Kelly Jeannette. "Henry Ossawa Tanner: Race, Religion, and Visual Mysticism." MA thesis, Florida State University, 2003.

Baldwin, James. "Everybody's Protest Novel." In *Notes of a Native Son.* Boston: Beacon Press, 1955.

Barker, Emma. *Greuze and the Painting of Sentiment.* Cambridge, UK: Cambridge University Press, 2005.

Barker-Benfield, G. J. *Abigail and John Adams: The Americanization of Sensibility.* Chicago: University of Chicago Press, 2010.

———. *The Culture of Sensibility: Sex and Society in Eighteenth-Century Britain.* Chicago: University of Chicago Press, 1992.

Barnes, Earl. "The Feminizing of Culture." *Atlantic Monthly* 109 (June 1912): 770–76.

Barnett, Michael N. *Empire of Humanity.* Ithaca, NY: Cornell University Press, 2011.

Baudelaire, Charles. *Art in Paris, 1845–1862.* Edited and translated by Jonathan Mayne. London: Phaidon, 1965.

Baym, Nina. *Woman's Fiction: A Guide to Novels by and about Women in America, 1820–1870.* Ithaca, NY: Cornell University Press, 1978.

Beam, Phillip C. *Winslow Homer at Prout's Neck.* Boston: Little Brown, 1966.

Bearden, Romare, and Harry Henderson. *A History of African-American Artists from 1792 to the Present.* New York: Pantheon Books, 1993.

Bederman, Gail. *Manliness and Civilization: A Cultural History of Gender and Race in the United States, 1880–1917.* Chicago: University of Chicago Press, 1995.

Bell, Adrienne Baxter. *George Inness and the Visionary Landscape.* New York: George Braziller, 2003.

———, ed. *George Inness: Writings and Reflections on Art and Philosophy.* New York: George Braziller, 2006.

Bell, Clive. *Art*. New York: Frederick A. Stokes Co., 1914.

Bell, Michael. *Sentimentalism, Ethics, and the Culture of Feeling*. New York: Palgrave, 2000.

Benedict, Barbara M. *Framing Feeling: Sentiment and Style in English Prose Fiction, 1745–1800*. New York: AMS Press, 1994.

Benson, Eugene [Pictor Ignotus, pseud.]. "Art in Boston." *Round Table* 2, no. 28 (June 25, 1864): 26.

Berger, Martin A. "Sentimental Realism in Thomas Eakins's Late Portraits." In Chapman and Hendler, *Sentimental Men*, 244–58.

Berlant, Lauren. *The Female Complaint: The Unfinished Business of Sentimentality in American Culture*. Durham, NC: Duke University Press, 2008.

Bermingham, Ann, ed. *Sensation and Sensibility: Viewing Gainsborough's Cottage Door*. New Haven, CT: Yale University Press, 2005.

Blair, Hugh. "Sermon II: On Sensibility." In *Sermons*. 3 vols. London: A. Strand and T. Cadell; Edinburgh: W. Creech, 1790.

Bloom, Paul. *Against Empathy: The Case for Rational Compassion*. New York: Ecco, 2016.

Boime, Albert. "Henry Ossawa Tanner's Subversion of Genre." *Art Bulletin* 75, no. 3 (September 1993): 415–41.

Bolton, Kenyon C., III. "'The Right Place': Winslow Homer and the Development of Prout's Neck." In Denenburg, *Weatherbeaten*, 29–47.

Boone, M. Elizabeth. "Why Drag in Velázquez?: Realism, Aestheticism, and the Nineteenth-Century American Response to *Las Meninas*." In *Velázquez's "Las Meninas"*, edited by Suzanne L. Stratton-Pruitt, 80–122. Cambridge, UK: Cambridge University Press, 2003.

Boym, Svetlana. *The Future of Nostalgia*. New York: Basic, 2001.

Braddock, Alan C. "Painting the World's Christ: Tanner, Hybridity, and the Blood of the Holy Land." *Nineteenth-Century Art Worldwide* 3, no. 2 (Autumn 2004), http://www.19thc-artworldwide.org/autumn04/67-autumn04/autumn04article/298-painting-the-worlds-christ-tanner-hybridity-and-the-blood-of-the-holy-land.

Branch, E. Douglas. *The Sentimental Years, 1836–1860*. New York: D. Appleton-Century Company, 1934.

Breen, T. H. *George Washington's Journey*. New York: Simon & Schuster, 2016.

Brigham, David R. *Public Culture in the Early Republic: Peale's Museum and Its Audience*. Washington, DC: Smithsonian Institution Press, 1995.

Brissenden, R. F. *Virtue in Distress: Studies in the Novel of Sentiment from Richardson to Sade*. New York: Harper & Row, 1974.

Bruce, Marcus. *Henry Ossawa Tanner: A Spiritual Biography*. New York: Crossroad Publishing Company, 2002.

Burgett, Bruce. *Sentimental Bodies: Sex, Gender, and Citizenship in the Early Republic*. Princeton, NJ: Princeton University Press, 1998.

Burns, Sarah. "Barefoot Boys and Other Country Children: Sentiment and Ideology in Nineteenth-Century American Art." *American Art Journal* 20, no. 1 (1988): 24–50.

———. *Inventing the Modern Artist*. New Haven, CT: Yale University Press, 1996.

———. "In Whose Shadow? Eastman Johnson and Winslow Homer in the Postwar Decades." In Carbone and Hills, *Eastman Johnson Painting America*, 185–213.

———. *Pastoral Inventions: Rural Life in Nineteenth-Century American Art and Culture*. Philadelphia: Temple University Press, 1989.

———. "Yankee Romance: The Comic Courtship Scene in Nineteenth-Century American Art." *American Art Journal* 18, no. 4 (Autumn 1986): 51–75.

Burstein, Andrew. *Sentimental Democracy: The Evolution of America's Romantic Self-Image*. New York: Hill and Wang, 1999.

Caffin, Charles H. *The Story of American Painting*. New York: Frederick A. Stokes Company, 1907.

Camfield, Gregg. *Sentimental Twain: Samuel Clemens in the Maze of Moral Philosophy*. Philadelphia: University of Pennsylvania Press, 1994.

Cantor, Jay E., et al. *Art in a Mirror: The Counterproofs of Mary Cassatt*. New York: Adelson Galleries, 2004.

Carbone, Teresa A., and Patricia Hills, eds. *Eastman Johnson Painting America*. New York: Brooklyn Museum of Art in association with Rizzoli International Publications, 1999.

Carey, Brycchan. *British Abolitionism and the Rhetoric of Sensibility: Writing, Sentiment, and Slavery, 1760–1807*. New York: Palgrave MacMillan, 2005.

Cassidy, Donna M. *Marsden Hartley: Race, Region, and Nation*. Hanover, NH: University Press of New England, 2005.

Cassin, Barbara. *Nostalgia: When Are We Ever at Home?* Translated by Pascale-Anne Brault. New York: Fordham University Press, 2016.

Chandler, James. *An Archeology of Sympathy: The Sentimental Mode in Literature and Cinema*. Chicago: University of Chicago Press, 2013.

Chapman, Mary, and Glenn Hendler, eds. *Sentimental Men: Masculinity and the Politics of Affect in American Culture.* Berkeley: University of California Press, 1999.

Charteris, Evan. *John Sargent.* New York: Charles Scribner's Sons, 1927.

Cherniavsky, Eva. *That Pale Mother Rising: Sentimental Discourses and the Imitation of Motherhood in 19th-Century America.* Bloomington: Indiana University Press, 1995.

Cheung, Wing-Yee. "Back to the Future: Nostalgia Increases Optimism." *Personality and Social Psychology Bulletin* 39 (November 1, 2013): 1484–96.

Chipman, Nathaniel. *Sketches of the Principles of Government.* Rutland, VT: J. Lyon, 1793.

Cikovsky, Nicolai, Jr. *George Inness.* New York: Harry N. Abrams, 1993.

———. "Winslow Homer's School Time: 'A Picture Thoroughly National.'" In *In Honor of Paul Mellon, Collector and Benefactor: Essays,* edited by John Wilmerding, 46–67. Washington, DC: National Gallery of Art, 1986.

Cikovsky, Nicolai, Jr., and Franklin Kelly. *Winslow Homer.* New Haven, CT: Yale University Press, 1995.

Cikovsky, Nicolai, Jr.. and Michael Quick. *George Inness.* Los Angeles: Los Angeles County Museum of Art, 1985.

Clark, Clifford Edward, Jr. *The American Family Home, 1800–1960.* Chapel Hill: University of North Carolina Press, 1986.

Clark, Suzanne. *Sentimental Modernism: Women Writers and the Revolution of the Word.* Bloomington: Indiana University Press, 1991.

Conrads, Margaret C. "'In the Midst of an Era of Revolution': The New York Art Press and the Annual Exhibitions of the National Academy of Design in the 1870s." In *Rave Reviews: American Art and Its Critics,* edited by David Dearinger, 93–105. New York: National Academy of Design, 2000.

———. *Winslow Homer and the Critics: Forging a National Art in the 1870s.* Princeton, NJ: Princeton University Press, 2001.

Conron, John. "The American Dream Houses of Andrew Jackson Downing." *Canadian Review of American Studies* 18 (1987): 9–40.

Conway, M.D. "Edouard Frère, and Sympathetic Art in France." *Harper's New Monthly Magazine* 43 (November 1871): 801–15.

Cooper, Helen A. *John Trumbull: The Hand and Spirit of a Painter.* New Haven, CT: Yale University Press for the Yale University Art Gallery, 1982.

———. *Winslow Homer Watercolors.* New Haven, CT: Yale University Press, 1986.

Coplan, Amy, and Peter Goldie, eds. *Empathy: Philosophical and Psychological Perspectives.* Oxford, UK: Oxford University Press, 2011.

Cox, Kenyon. *Old Masters and New: Essays in Art Criticism.* New York: Fox, Duffield & Company, 1905.

———. "Winslow Homer." *Metropolitan Museum of Art Bulletin* 5, no. 11 (November 1910): 255.

Curry, David Park. "Winslow Homer: Dressing for the Carnival." *Studies in the History of Art* 26 (1990): 90–113.

Davidson, Cathy N. *Revolution and the Word: The Rise of the Novel in America.* New York: Oxford University Press, 2004.

Davidson, Cathy, and Jessamyn Hatcher, eds. *No More Separate Spheres!* Durham, NC: Duke University Press, 2002.

Davis, Fred. *Yearning for Yesterday: A Sociology of Nostalgia.* New York: Free Press, 1979.

Davis, Stuart. "Abstract Art in the American Scene." *Parnassus* 13, no. 3 (March 1941): 100–103.

DeLue, Rachael Z. *George Inness and the Science of Landscape.* Chicago: University of Chicago Press, 2004.

Denby, David J. *Sentimental Narrative and the Social Order in France, 1760–1820.* Cambridge, UK: Cambridge University Press, 1994.

Denenberg, Thomas A., ed. *Weatherbeaten: Winslow Homer and Maine.* New Haven, CT: Yale University Press, 2012.

Dobson, Joanne. "Reclaiming Sentimental Literature." *American Literature* 69, no. 2 (June 1997): 263–88.

Downes, William Howe. *John S. Sargent: His Life and Work.* Boston: Little, Brown, and Company, 1925.

———. *The Life and Works of Winslow Homer.* New York: Houghton Mifflin, 1911.

Downing, Andrew Jackson. *The Architecture of Country Houses.* New York, 1850. Reprint, New York: Dover Publications, 1969.

———. *Cottage Residences.* New York: Wiley & Putnam, 1842.

———. *Rural Essays.* New York, 1853. Reprint, University of Michigan Historical Reprint Series. New York: George A. Leavitt, 1969.

———. *A Treatise on the Theory and Practice of Landscape Gardening, Adapted to North America.* New York: Wiley & Putnam, 1841.

Dwyer, John. *Virtuous Discourse: Sensibility and Community in Late Eighteenth-Century Scotland.* Edinburgh: John Donald Publishers, 1987.

Elkins, James. *Pictures and Tears: A History of People Who Have Cried in Front of Paintings.* London: Routledge, 2004.

Ellis, Markman. *The Politics of Sensibility: Race, Gender and Commerce in the Sentimental Novel.* Cambridge, UK: Cambridge University Press, 1996.

Ellison, Julie. *Cato's Tears and the Making of Anglo-American Emotion.* Chicago: University of Chicago Press, 1999.

Fairbrother, Trevor J. *John Singer Sargent and America.* New York: Garland Publishing, 1986.

Faust, Drew Gilpin. *This Republic of Suffering: Death and the American Civil War.* New York: Alfred A. Knopf, 2008.

Festa, Lynn. *Sentimental Figures of Empire in Eighteenth-Century Britain and France.* Baltimore: Johns Hopkins University Press, 2006.

Fiering, Norman S. "Irresistible Compassion: An Aspect of Eighteenth-Century Sympathy and Humanitarianism." *Journal of the History of Ideas* 37, no. 2 (April–June 1976), 195–218.

Fisher, Philip. *Hard Facts: Setting and Form in the American Novel.* New York: Oxford University Press, 1985.

Fliegelman, Jay. *Prodigals and Pilgrims: The American Revolution against Patriarchal Authority, 1750–1800.* New York: Cambridge University Press, 1982.

Foner, Philip S., and Robert James Branham, eds. *Lift Every Voice: African American Oratory, 1787–1900.* Tuscaloosa: University of Alabama Press, 1998.

Fordyce, David. *Elements of Moral Philosophy.* London: R. and J. Dodsley, 1754.

Fort, Ilene Susan. *Marsden Hartley: The German Paintings 1913–1915.* Los Angeles: Los Angeles County Museum of Art, 2014.

Fortune, Brandon Brame. "Charles Willson Peale's Portrait Gallery: Persuasion and the Plain Style." *Word & Image* 6, no. 4 (October–December 1990): 308–24.

Foster-Rice, Greg, and John Rohrbach, eds. *Reframing the New Topographics.* Chicago: University of Chicago Press, 2010.

Gallati, Barbara Dayer. *Great Expectations: John Singer Sargent Painting Children.* Brooklyn, NY: Brooklyn Museum in association with Bulfinch Press, 2004.

Goddu, Teresa A. "The Antislavery Almanac and the Discourse of Numeracy." *Book History* 12 (2009): 129–55.

_____. "Anti-Slavery's Panoramic Perspective." *MELUS: Multi-Ethnic Literature of the U.S.* 39, no. 2 (Summer 2014), doi: 10.1093/melus/mluo15.

Goodrich, Lloyd. *Winslow Homer.* New York: Macmillan for the Whitney Museum of American Art, 1944.

Goodrich, Lloyd, and Abigail Booth Gerdts. *Record of Works by Winslow Homer.* Vol. 1, *1846 through 1866.* New York: Spanierman Gallery, 2005.

_____. *Record of Works by Winslow Homer.* Vol. 5, *1890 through 1910.* New York: Goodrich-Homer Art Education Project, 2014.

Greenberg, Clement. "Art and Kitsch." *Partisan Review* 6 (1939): 34–49.

Griffin, Randall C. *Winslow Homer: An American Vision.* New York: Phaidon, 2006.

Grimké, Angelina. *Appeal to Christian Women of the South.* New York: American Anti-Slavery Society, 1836.

Hacker, J. David. "A Census-Based Count of the Civil War Dead." *Civil War History* 57, no. 4 (December 2011): 307–48.

Halpern, Faye. *Sentimental Readers: The Rise, Fall, and Revival of a Disparaged Rhetoric.* Iowa City: University of Iowa Press, 2013.

Haltman, Kenneth. "Antipastoralism in Early Winslow Homer." *Art Bulletin* 80, no. 1 (1998): 93–112.

Harper, Jennifer. "The Early Religious Paintings of Henry Ossawa Tanner: A Study of the Influences of Church, Family, and Era." *American Art* 6, no. 4 (Fall 1992): 68–85.

Hartmann, Sadakichi. *A History of American Art.* 2 vols. Boston: L.C. Page, 1901.

Harvey, Eleanor Jones. *The Civil War and American Art.* Washington, DC: Smithsonian American Art Museum in association with Yale University Press, 2012.

Havemeyer, Louisine W. *Sixteen to Sixty: Memoirs of a Collector.* Edited by Alyson Stein. New York: Ursus Press, 1993.

Hendler, Glenn. *Public Sentiments: Structures of Feeling in Nineteenth-Century American Literature.* Chapel Hill: University of North Carolina Press, 2001.

Hills, Patricia, ed. *John Singer Sargent.* New York: Whitney Museum of American Art in association with Harry N. Abrams, 1987.

Hirshler, Erica E. "North Atlantic Drift: A Meditation on Winslow Homer and French Painting." In Denenberg, *Weatherbeaten,* 71–83.

_____. *Sargent's Daughters: The Biography of a Painting.* Boston: Museum of Fine Arts, Boston, 2009.

Hoffmann, Donald. *Frank Lloyd Wright's Fallingwater: The House and Its History.* New York: Dover Publications, 1978.

Howard, June. "What Is Sentimentality?" *American Literary History* 11, no. 1 (Spring 1999): 63–81.

Howells, William Dean. *The Rise of Silas Lapham.* Boston: Ticknor, 1885.

Hume, David. *Essays, Moral, Political, and Literary*. Edited by Eugene F. Miller. Indianapolis: Liberty Fund, 1987.

Huxtable, Ada Louise. *Frank Lloyd Wright: A Life*. New York: Lipper/ Viking, 2004.

Illbruck, Helmut. *Nostalgia: Origins and Ends of an Unenlightened Disease*. Evanston, IL: Northwestern University Press, 2012.

Isham, Samuel. *The History of American Painting*. New York: Macmillan, 1905.

Ivinski, Pamela A. "Mary Cassatt, the Maternal Body, and Modern Connoisseurship." PhD diss., City University of New York, 2003.

———. "'So Firm and Powerful a Hand': Mary Cassatt's Techniques and Questions of Gender." In *Women Impressionists*, edited by Ingrid Pfeiffer and Max Hollein, 178–205. Frankfurt: Hatje Cantz, 2008.

Jaffe, Irma B. *John Trumbull: Patriot-Artist of the American Revolution*. Boston: New York Graphic Society, 1975.

Jameson, Fredric. "Walter Benjamin, or Nostalgia." *Salmagundi*, no. 10/11 (Fall 1969–Winter 1970): 52–68.

Jefferson, Mark. "What Is Wrong With Sentimentality?" *Mind*, n.s., 92, no. 368 (October 1983), 519–29.

Jenkins, William. *New Topographics: Photographs of a Man-Altered Landscape*. Rochester, NY: International Museum of Photography, 1975.

Johns, Elizabeth. *Winslow Homer: The Nature of Observation*. Berkeley: University of California Press, 2002.

Johnson, Rochelle L. *Passions for Nature: Nineteenth-Century America's Aesthetics of Alienation*. Athens: University of Georgia Press, 2009.

Jolly, Robert. "George Inness's Swedenborgian Dimension." *Southeastern College Art Conference Review* 11 (1986): 14–22.

Jones, Colin. *The Smile Revolution in Eighteenth Century Paris*. Oxford, UK: Oxford University Press, 2014.

Jordy, William H. *American Buildings and Their Architects: Progressive and Academic Ideals at the Turn of the Century*. New York: Oxford University Press, 1972.

Kaplan, Fred. *Sacred Tears: Sentimentality in Victorian Literature*. Princeton, NJ: Princeton University Press, 1987.

Kleebatt, Norman L., ed. *The Dreyfus Affair: Art, Truth, and Justice*. Berkeley: University of California Press, 1987.

Knott, Sarah. *Sensibility and the American Revolution*. Chapel Hill: University of North Carolina Press for the Omohundro Institute of Early American History and Culture, Williamsburg, VA, 2009.

———. "Sensibility and the American War for Independence." *American Historical Review* 109, no. 1 (February 2004): 19–40.

Knott, Sarah, and Barbara Taylor, eds. *Women, Gender, and Enlightenment*. New York: Palgrave Macmillan, 2005.

La Farge, John. *The Higher Life in Art: A Series of Lectures on the Barbizon School of France*. New York: McClure Co., 1908.

Lasch, Christopher. "The Politics of Nostalgia." *Harper's* 269, no. 1614 (November 1984): 65–70.

Lawall, David B. *Asher B. Durand: A Documentary Catalogue of the Narrative and Landscape Paintings*. New York: Garland Publishing, 1978.

———. *Asher Brown Durand: His Art and Art Theory in Relation to His Times*. New York: Garland Publishing, 1977.

Leja, Michael. *Looking Askance: Skepticism and American Art from Eakins to Duchamp*. Berkeley: University of California Press, 2006.

Levine, Neil. *The Architecture of Frank Lloyd Wright*. Princeton, NJ: Princeton University Press, 1996.

Linden, Blanche M. G. *Silent City on a Hill: Picturesque Landscapes of Memory and Boston's Mount Auburn Cemetery*. Boston: University of Massachusetts Press, 2007.

Lloyd, Phoebe. "Philadelphia Story." *Art in America* 76 (November 1988): 155–70, 195–98, 200–202.

Locke, John. *Some Thoughts Concerning Education and Of the Conduct of the Understanding* (1693). Edited by Ruth W. Grant and Nathan Tarcov. Indianapolis: Hackett, 1996.

Loudon, John C. *An Encyclopedia of Cottage, Farm, and Villa Architecture and Furniture*. London: Longman, Rees, Orme, Brown, Green, & Longman, 1835.

Lubin, David M. *Picturing a Nation: Art and Social Change in Nineteenth-Century America*. New Haven, CT: Yale University Press, 1994.

Major, Judith K. *To Live in the New World: A. J. Downing and American Landscape Gardening*. Cambridge, MA: MIT Press, 1997.

Mann, Sally. *Hold Still*. New York: Little, Brown, 2015.

Marley, Anna O., ed. *Henry Ossawa Tanner: Modern Spirit*. Berkeley: University of California Press; Philadelphia: Pennsylvania Academy of Fine Arts, 2012.

Marshall, David. *The Frame of Art: Fictions of Aesthetic Experience, 1750–1815*. Baltimore: Johns Hopkins University Press, 2005.

———. *The Surprising Effects of Sympathy: Marivaux, Diderot, Rousseau, and Mary Shelley*. Chicago: University of Chicago Press, 1988.

Martin, Terence. *The Instructed Vision: Scottish Common Sense Philosophy and the Origins of American Fiction*. Bloomington: Indiana University Press, 1961.

Mathews, Nancy Mowll. *Cassatt and Her Circle: Selected Letters*. New York: Abbeville Press, 1984.

———. *Mary Cassatt: A Life*. New Haven, CT: Yale University Press, 1994.

Matthews, Marcia. *Henry Ossawa Tanner: American Artist*. Chicago: University of Chicago Press, 1994.

Mazow, Leo G., ed. *Picturing the Banjo*. University Park, PA: Palmer Museum of Art and Pennsylvania State University Press, 2005.

McDonnell, Patricia. "'Essentially Masculine': Marsden Hartley, Gay Identity, and the Wilhelmine German Military." *Art Journal* 56, no. 2 (Summer 1997): 62–68.

Merish, Lori. *Sentimental Materialism: Gender, Commodity Culture, and Nineteenth-Century American Literature*. Durham, NC: Duke University Press, 2000.

Miller, Angela. "The Fate of Wilderness in American Landscape Painting." In *A Keener Perception: Ecocritical Studies in American Art History*, edited by Alan Braddock and Christoph Irmscher, 85–109. Tuscaloosa: University of Alabama Press, 2009.

Miller, Lillian B., ed. *The Peale Family: Creation of a Legacy 1770–1870*. New York: Abbeville Press in association with the Trust for Museum Exhibitions and the National Portrait Gallery, Smithsonian Institution, Washington, DC, 1996.

———, ed. *The Selected Papers of Charles Willson Peale and His Family*. 5 vols. New Haven, CT: Yale University Press for the National Portrait Gallery, Smithsonian Institution, Washington, DC, 1983.

Miller, Lillian B., and David C. Ward, eds. *New Perspectives on Charles Willson Peale*. Pittsburgh: University of Pittsburgh Press, 1990.

Miller, Lucia. "John Singer Sargent in the Diaries of Lucia Fairchild." *Archives of American Art Journal* 26, no. 4 (1987): 2–16.

Moody, Joycelyn. *Sentimental Confessions: Spiritual Narratives of Nineteenth-Century African American Women*. Athens: University of Georgia Press, 2001.

Morgan, Jo-Ann. "Winslow Homer Visits Aunt Chloe's Old Kentucky Home." *Southeastern College Art Conference Review* 14, no. 5 (December 2005): 439–51.

Mosby, Dewey F., and Darrell Sewell, *Henry Ossawa Tanner*. New York: Rizzoli International Publications; Philadelphia: Philadelphia Museum of Art, 1991.

Mount, Charles Merrill. *John Singer Sargent: A Biography*. New York: W. W. Norton, 1969.

Mullan, John. *Sentiment and Sociability: The Language of Feeling in the Eighteenth Century*. New York: Oxford University Press, 1988.

Murphy, Kevin M. "Winslow Homer as Entrepreneur." *Winterthur Portfolio* 37, no. 2/3 (Summer/Autumn 2002): 147–60.

Noble, Frederick Perry. "The Chicago Congress on Africa." *Our Day* 12 (October 1893): 279–300.

Nora, Pierre. "Between Memory and History: *Les Lieux de Mémoire*." *Representations* 26 (Spring 1989): 7–24.

Olson, Stanley, Warren Adelson, and Richard Ormond. *Sargent at Broadway: The Impressionist Years*. London: John Murray, 1986.

Ormond, Richard. "John Singer Sargent and Vernon Lee." *Colby Quarterly* 9, no. 3 (1970): 154–78.

Ormond, Richard, and Elaine Kilmurray. *John Singer Sargent: Complete Paintings*. Vol. 1, *The Early Portraits*. New Haven, CT: Yale University Press for the Paul Mellon Centre for Studies in British Art, 1998.

———. *John Singer Sargent: Complete Paintings*. Vol. 2, *Portraits of the 1890s*. New Haven, CT: Yale University Press for the Paul Mellon Centre for Studies in British Art, 2002.

———. *John Singer Sargent: Complete Paintings*. Vol. 5, *Figures and Landscapes, 1883–1899*. New Haven, CT: Yale University Press for the Paul Mellon Centre for Studies in British Art, 2010.

Perry, Claire. *Young America: Childhood in 19th-Century Art and Culture*. New Haven, CT: Yale University Press, 2006.

Pollock, Griselda. "Mary Cassatt: The Touch and the Gaze, or Impressionism for Thinking People." In *Women Impressionists*, edited by Ingrid Pfeiffer and Max Hollein, 154–77. Frankfurt: Hatje Cantz, 2008.

Promey, Sally M. "The Ribband of Faith: George Inness, Color Theory, and the Swedenborgian Church." *American Art Journal* 26, no. 1/2 (1994): 45–65.

Quick, Michael. *George Inness: A Catalogue Raisonné*. 2 vols.. New Brunswick, NJ: Rutgers University Press, 2007.

———. "George Inness: The Spiritual Dimension." In *George Inness: Presence of the Unseen*, 29–32. Montclair, NJ: Montclair Art Museum, 1994.

Ratcliff, Carter. *John Singer Sargent*. New York: Abbeville Press, 1982.

Reddy, William M. *The Navigation of Feeling: A Framework for the History of Emotions*. New York: Cambridge University Press, 2001.

Reed, Christopher Robert. *"All the World Is Here!" The Black Presence in the White City*. Bloomington: Indiana University Press, 2000.

Rewald, John. *Camille Pissarro's Letters to His Son Lucien*. New York: Da Capo Press, 1995.

Richardson, Edgar P., Brooke Hindle, and Lillian B. Miller. *Charles Willson Peale and His World*. New York: Harry N. Abrams, 1983.

Robertson, Bruce. *Reckoning with Winslow Homer: His Late Paintings and Their Influence.* Cleveland, OH: Cleveland Museum of Art in cooperation with Indiana University Press, Bloomington, 1990.

Romero, Lora. *Home Fronts: Domesticity and Its Critics in the Antebellum United States.* Durham, NC: Duke University Press, 1997.

Rosaldo, Renato. "Imperialist Nostalgia." *Representations* 26 (Spring 1989): 107–22.

Rosenberg, Harold. *The Tradition of the New.* New York: Horizon Press, 1959.

Rosenwein, Barbara H. "Worrying about Emotions in History." *American Historical Review* 107, no. 3 (2002): 821–45.

Samuels, Shirley, ed. *The Culture of Sentiment: Race, Gender and Sentimentality in Nineteenth-Century America.* New York: Oxford University Press, 1992.

Scarborough, W. S. "Henry Ossian [*sic*] Tanner." *Southern Workman* 31 (December 1902): 665–66.

Scholnick, Robert J. "Between Realism and Romanticism: The Curious Career of Eugene Benson." *American Literary Realism* 14, no. 2 (Autumn 1981): 242–61.

Schroeder, David A., and William G. Graziano, eds. *The Oxford Handbook of Prosocial Behavior.* New York: Oxford University Press, 2015.

Schuyler, David. *Apostle of Taste: Andrew Jackson Downing, 1815–1852.* Baltimore: Johns Hopkins University Press, 1996.

Schwain, Kristin. *Signs of Grace: Religion and American Art in the Gilded Age.* Ithaca, NY: Cornell University Press, 2008.

Sedikides, Constantine, Tim Wildschut, Jamie Arndt, and Clay Routledge. "Nostalgia: Past, Present, and Future." *Current Directions in Psychological Science* 17, no. 5 (October 2008): 304–7.

Sedikides, Constantine, Tim Wildschut, and Denise Baden. "Nostalgia: Conceptual Issues and Existential Functions." In *Handbook of Experimental Existential Psychology*, 200–214. New York: Guildford, 2004.

Segard, Achille. *Un peintre des enfants et des mères, Mary Cassatt.* Paris: P. Ollendorff, 1913.

Sellers, Charles Coleman. *The Artist of the Revolution: The Early Life of Charles Willson Peale.* Hebron, CT: Feather and Good, 1939.

Seraile, William. *Fire in His Heart: Bishop Benjamin Tucker Tanner and the A.M.E. Church.* Knoxville: University of Tennessee Press, 1998.

Shamir, Milette, and Jennifer Travis, eds. *Boys Don't Cry? Rethinking Narratives of Masculinity and Emotion in the U.S.* New York: Columbia University Press, 2002.

Shannon, Martha A. S. *The Boston Days of William Morris Hunt.* Boston: Marshall Jones, 1923.

Shi, David E. *Facing Facts: Realism in American Thought and Culture, 1850–1920.* Oxford, UK: Oxford University Press, 1995.

Sidlauskas, Susan. *Body, Place, and Self in Nineteenth-Century Painting.* New York: Cambridge University Press, 2000.

Simpson, Marc. *Like Breath on Glass: Whistler, Inness, and the Art of Painting Softly.* New Haven, CT: Yale University Press, 2008.

———. "The Resurrection of Lazarus from the Quartier Latin to the Musée du Luxembourg." In Marley, *Henry Ossawa Tanner*, 69–78.

———. *Winslow Homer: Paintings of the Civil War.* San Francisco: Fine Arts Museums of San Francisco, 1988.

Smith, Adam. *The Theory of Moral Sentiments.* Edited by Knud Haakonssen. Cambridge, UK: Cambridge University Press, 2002.

Solomon, Robert C. *In Defense of Sentimentality.* New York: Oxford University Press, 2004.

Sontag, Susan. *Regarding the Pain of Others.* New York: Picador, 2003.

South, Will. "A Missing Question Mark: The Unknown Henry Ossawa Tanner." *Nineteenth-Century Art Worldwide* 8, no. 2 (Autumn 2009), http://www.19thc-artworldwide.org/autumn09/a-missing-question-mark.

Staiti, Paul. *Of Arms and Artists: The American Revolution through Painters' Eyes.* New York: Bloomsbury Press, 2016.

———. "Winslow Homer and the Drama of Thermodynamics." *American Art* 15, no. 1 (2001): 11–33.

Stearns, Peter N., and Jan Lewis, eds. *An Emotional History of the United States.* New York: New York University Press, 1998.

Stebbins, Theodore E., Jr. "*Driftwood*: Winslow Homer's Final Painting." *Magazine Antiques* 150 (July 1996): 70–79.

———. "Winslow Homer: Time in the Adirondacks." In *Winslow Homer: Artist and Angler*, edited by Patricia Junker with Sarah Burns, 95–123. New York: Thames and Hudson, 2002.

Stern, Julia A. *The Plight of Feeling: Sympathy and Dissent in the Early American Novel.* Chicago: University of Chicago Press, 1997.

Stranahan, C. H. *A History of French Painting from Its Earliest to Its Latest Practice.* New York: Charles Scribner's Sons, 1907.

Su, John J. *Ethics and Nostalgia in the Contemporary Novel.* New York: Cambridge University Press, 2005.

Sweeting, Adam W. *Reading Houses and Building Books: Andrew Jackson Downing and the Architecture of Popular Antebellum Literature, 1835–1855.* Hanover, NH: University Press of New England, 1996.

Tanner, Benjamin Tucker. *The Negro in Holy Writ.* Philadelphia: A.M.E. Book Concern, 1902.

_____. *The Negro's Origin and Is the Negro Cursed?* Philadelphia: African M.E. Book Depository, 1869.

_____. *Theological Lectures*. Nashville, TN: Publishing House, A.M.E. Church Sunday School Union, 1894.

Tanner, Henry Ossawa. "The Story of an Artist's Life, Part I." *World's Work* 18, no. 2 (June 1909), 11661–66. Available in the H.O. Tanner Papers, Archives of American Art, Smithsonian Institution, Washington, DC.

_____. "The Story of an Artist's Life, Part II." *World's Work* 18, no. 3 (July 1909): 11769–75. Available in the H. O. Tanner Papers, Archives of American Art, Smithsonian Institution, Washington, DC.

Tannock, Stuart. "Nostalgia Critique." *Cultural Studies* 9 (October 1995): 453–64.

Tatham, David. *Winslow Homer in the Adirondacks*. Syracuse, NY: Syracuse University Press, 1996.

Tatum, George B., and Elisabeth Blair MacDougall, eds. *Prophet with Honor: The Career of Andrew Jackson Downing, 1815–1852*. Washington, DC: Dumbarton Oaks, 1989.

Thomas, Greg. *Impressionist Children: Childhood, Family, and Modern Identity in French Art*. New Haven, CT: Yale University Press, 2010.

Thorne, Anna. "My Afternoon with Mary Cassatt." *School Arts*, May 1960, 10–12.

Todd, Janet. *Sensibility: An Introduction*. London: Methuen, 1986.

Toker, Franklin. *Fallingwater Rising: Frank Lloyd Wright, E.J. Kaufmann, and America's Most Extraordinary House*. New York: Knopf, 2003.

Tompkins, Jane. *Sensational Designs: The Cultural Work of American Fiction, 1790–1860*. New York: Oxford University Press, 1985.

Trumbull, John. *Autobiography, Reminiscences and Letters of John Trumbull from 1756 to 1841*. New York: Wiley and Putnam, 1841.

Tuckerman, Henry T. *Book of the Artists*. New York: G.P. Putnam & Sons, 1867.

Van Dyke, John C. "George Inness." *Outlook* (1903). In *Masters in Art: A Series of Illustrated Monographs*. Boston: Bates & Guild, 1908.

van Rensselaer, Mariana Griswold. "John S. Sargent." *Century Illustrated Magazine* 44 (March 1892): 798.

Van Sant, Ann Jessie. *Eighteenth-Century Sensibility and the Novel: The Senses in Social Context*. New York: Cambridge University Press, 1993.

Waldstreicher, David. *In the Midst of Perpetual Fetes: The Making of American Nationalism, 1776–1820*. Chapel Hill: University of North Carolina Press for the Omohundro Institute of Early American History and Culture, Williamsburg, VA, 1997.

Wallach, Alan. "Thomas Cole's 'River in the Catskills' as Antipastoral." *Art Bulletin* 84, no. 2 (2002): 334–50.

Ward, David C. *Charles Willson Peale: Art and Selfhood in the Early Republic*. Berkeley: University of California Press, 2004.

_____. "Creating a National Culture: Charles Willson Peale's George Washington at Princeton." *Record of the Princeton University Art Museum* 70 (2011): 4–17.

Weinstein, Cindy. *Family, Kinship, and Sympathy in Nineteenth-Century American Literature*. New York: Cambridge University Press, 2004.

Weller, Allen. "Winslow Homer's Early Illustrations." *American Magazine of Art* 28, no. 7 (1935): 412–48.

Wexler, Laura. "Tender Violence: Literary Eavesdropping, Domestic Fiction, and Educational Reform." In Samuels, *The Culture of Sentiment*, 9–38.

Whistler, James Abbott McNeill. *The Gentle Art of Making Enemies*. London: William Heinemann, 1892.

Wick, Wendy C. *George Washington: An American Icon. The Eighteenth-Century Graphic Portraits*. Washington, DC: Smithsonian Institution, 1982.

Wilkie, Brian. "What Is Sentimentality?" *College English* 28, no. 8 (May 1967): 564–75.

Wilson, Christopher Kent. "Winslow Homer's *The Veteran in a New Field*: A Study of the Harvest Metaphor and Popular Culture." *American Art Journal* 17, no. 4 (Autumn 1985): 2–27.

Wilson, Judith. "Lifting the 'Veil': Henry O. Tanner's The Banjo Lesson and The Thankful Poor." In *Critical Issues in American Art: A Book of Readings*, edited by Mary Ann Calo, 199–219. Boulder, CO: Westview Press, 1998.

Wood, Gordon S. *Empire of Liberty: A History of the Early Republic, 1789–1815*. New York: Oxford University Press, 2009.

Wood, Marcus. *Blind Memory: Visual Representations of Slavery in England and America, 1780–1865*. Manchester, UK: Manchester University Press, 2000.

_____. *Slavery, Empathy, and Pornography*. Oxford, UK: Oxford University Press, 2002.

Wood, Peter H. *Near Andersonville: Winslow Homer's Civil War*. Cambridge, MA: Harvard University Press, 2010.

_____. *Weathering the Storm: Inside Winslow Homer's Gulf Stream*. Athens: University of Georgia Press, 2004.

Wood, Peter H., and Karen C. C. Dalton. *Winslow Homer's Images of Blacks: The Civil War and Reconstruction Years*. Austin: University of Texas Press for the Menil Collection, 1988.

Woodruff, Hale. "My Meeting with Henry O. Tanner." *Crisis* 77, no. 11 (January 1970): 7–12.

Woods, Naurice Frank, Jr. "Embarking on a New Covenant." *American Art* 27, no. 1 (Spring 2013): 94–103.

Woolf, Virginia. "The Royal Academy." *Athenaeum* 4660 (1919): 774–76.

Wright, Frank Lloyd. *Frank Lloyd Wright: An Autobiography* (1943). Petuluma, CA: Pomegranate Communications, 2005.

Wylie, John. *Landscape*. London: Routledge, 2007.

Zimmerman, Andrea K. "Nineteenth Century Wheat Production in Four New York State Regions: A Comparative Examination." *Hudson Valley Regional Review* 5, no. 2 (September 1988): 49–61.

Zola, Émile. "The Experimental Novel" (1880). In *The Experimental Novel and Other Essays*, translated by Belle M. Sherman. New York: Cassell Publishing, 1893.

Peale, St. George, 18, 184 n14

Peale, Titian Ramsay, *The Long Room, Interior of Front Room in Peale's Museum*, **26**

Peale family, 184 n14

Pennsylvania Academy of the Fine Arts, 46

Pennsylvania Constitution of 1776, 21

Pennsylvania State House, 25

Perry, Claire, 117

Perry, Enoch Wood, 119

Peter, 58

Petit, Georges, 138

Philadelphia Inquirer, 62, 98

Phillips, Sir Claude, 154

Pissarro, Camille, 199 n87

pity, 6, 14, 39, 43, 65. *See also* sympathy

Pohl, Frances, 135

politics, 9, 13, 15, 44, 133, 135; and J. Adams, 16; and Downing, 66, 81; and Enlightenment, 14; and Fordyce, 29; in Jacksonian era, 39; and C. Peale, 15, 21, 22, 27, 28, 36, 37; and public spectacles, 21; and sensibility, 14, 15; and sentimental as positive term, 5; and Trumbull, 15, 28, 36, 37; and victory at Yorktown, 22

Pope, Alexander, 79

pornography, 43

Pre-Raphaelite painters, 145

Price, Uvedale, 71

progress, 83, 86, 88, 96

psychology, 136; and Cassatt, 157, 163, 165, 167, 171; and W. Homer, 121, 128; and Sargent, 140, 142, 145, 147, 171; and H. Tanner, 48

public celebrations, 14, 23, 28

public gatherings: and C. Peale's illuminations, 22; and social affections, 25; and Washington's presidential tour of 1789, 22–25

public good, 14

public parks, 5, 83

public spectacles, 9; and politics, 21; Turgot on necessity of, 25

public sphere, 13; activist role of art in, 8; and Downing, 80–81; and Fordyce, 29

race, 30, 43, 110; and Baldwin, 43; and B. Tanner, 55–56; and H. Tanner, 46, 49, 52, 53, 56, 57, 63; and Wexler, 43; and World's Columbian Exposition, 46

racism, 9; and Rosaldo, 88; and B. Tanner, 55; and H. Tanner, 47, 53, 56. *See also* segregation

Rall, Johann, 33

Raphael, 163

rational compassion, 186 n5

rationality, 5, 8, 66, 99

realism, 134; and Cassatt, 156, 159, 163, 164; in 1880s art world, 122–23; and Hartmann, 123; and W. Homer, 122–25; and Hovenden, 1; and Howells, 123; and La Farge, 111; and Millet, 111; and modernism, 6; rise of, 3; and Sargent, 149; and sentimental as negative term, 6

Reconstruction era, 116, 118

Reddy, William, 11; *The Navigation of Feeling*, 178–79

Rehan, Ada, 147

Rembrandt Harmenszoon van Rijn, 137; *The Hundred Guilder Print (Christ Healing the Sick)*, **35**, 55

Renaissance, 163, 165

Renoir, Pierre-Auguste, 142

Rensselaer, Mariana van, 152

republicanism, 25, 26, 36, 70

Revolutionary War, 3, 8, 13, 37; patriotism after, 39; and C. Peale, 16, 18, 21; political and social instability after, 14; and Trumbull, 28, 30

Reynolds, Sir Joshua, 78–79, 145, 167; *The Age of Innocence*, **145**

Richards, I. A., *Practical Criticism*, 1

Rochambeau, Jean-Baptiste Donatien de Vimeur, comte de, 22

Rockwell, Norman, 173

rococo style, 18

Rodin, Auguste *Burghers of Calais*, 153

Rosaldo, Renato, 11, 88, 96

Rosenberg, Harold, 3

Rousseau, Jean-Jacques, 14

Royal Academy, exhibition of 1919, 154

Rückenfigur (figure seen from behind), 121, 131

rural cemeteries, 5, 10, 83, 84–86

rural/country life, 11; and British architectural pattern books, 69; and Downing, 68, 77–81; and Durand, 93; and W. Homer's circle, 119; and Hovenden, 1; and Inness, 100; and Osgood, 88

Ruskin, John, 5, 6, 109, 123

Russian Jews, 52

sadomasochism, 43

Salem Mercury, 25

Salon of 1869, 155

Salon of 1875, 156

Salon of 1883, 138

Samuels, Shirley, 5, 9, 65; *The Culture of Sentiment*, 10

Sargent, John Singer, 9, 10, 133, 135–55, 171, 179; *Ada Rehan*, 147; *Beatrice Goelet*, **151**, 151–52; *Carnation, Lily, Lily, Rose*, **144**, 145–47, 155; and Cassatt, 142, 155, 167; character of, 136–37, 154, 155; *The Daughters of Edward Darley Boit*, 138–42, **139**, 145, 146; in England, 143, 145; *Gassed*, 152–54, **153**, 155; *Madame X (Madame Pierre Gautreau)*, 143, **143**; *Mr. and Mrs. John White Field*, **150**, 151; *Mrs. Edward L. Davis and Her Son, Livingston Davis*, **150**, 151; *Mrs. Hugh Hammersley*, 147–49, **148**; in Paris, 135, 136–43

Scarborough, William S., 51–52, 56

Scheffer, Ary, 196 n1

science, 6, 8, 99, 126, 134, 154

Scottish Enlightenment, 29, 34

Sedgwick, Catharine, 81

segregation, 46, 56. *See also* racism

PHOTO CREDITS